**Computers
in the Humanities**

COMPUTERS
IN THE HUMANITIES

edited by
J.L.MITCHELL

University of Minnesota Press
Minneapolis

© 1974
Edinburgh University Press
ISBN 0-8166-0731-1

Published in North America by the
University of Minnesota Press, Minneapolis

Library of Congress
Catalog Card Number 74-81009

Printed in Great Britain at
The Aberdeen University Press

Contents

Preface

Humanists have been notoriously undeterred by the mere magnitude of a given undertaking: witness the existence of the *OED*, a labour of some eighty years; or the Manly-Rickert collation of all eighty-three manuscripts of the Canterbury Tales to produce *The Text of the Canterbury Tales*, a task that took fifteen years. Yet one is forced to admit that, since the advent of the computer, scholars have with equanimity been tackling projects which are by any standards monumental.

Examples come easily to mind: the recently completed *Index Thomisticus*, based upon 179 works in medieval Latin comprising about eleven million words; or the Computer Archive of Modern English Texts (CAMET), a one-million-word corpus now being compiled at the University of Lancaster to complement the Brown-Kučera corpus of American English (see Kučera and Francis 1967). One of the most impressive projects is the *Dictionary of Old English* (*DOE*: see Frank and Cameron 1973) which has entailed the collection at the University of Toronto of microfilm copies of the 500 or so extant Old English manuscripts (itself quite an accomplishment!). Optical scanning has facilitated the preparation of the data, so that to date about 80 per cent of the three million word corpus is in computer-readable form. Eventually, we are told, 'the archive will serve as a distributable data base for linguistic and literary research' (Venezky, in Frank and Cameron 1973, 311).

What all such computer projects have in common, is that they are largely cooperative enterprises. Busa (1964), for example, estimated that close to sixty people were employed at the *Centro Automazione Analisi Linguistica*, and many universities are now following the example of Cambridge University in setting up special purpose, non-numerical computing centres. Although most of the papers delivered at the *International Conference on Computers in the Humanities* (University of Minnesota, Minneapolis, July 20–22, 1973) reported on projects of more modest proportions than those just mentioned, many of them are the result of extended collaboration among scholars from quite different disciplines. Nor should this be surprising: archaeologists, for example, are unlikely to be computer programmers, and semitic scholars are rarely statisticians. What was surprising however, and most heartening, was the number of papers written by scholars from outside the humanities. Among the papers included in the volume, the reader will find one in

the Linguistics section on Chinese orthography by an electrical engineer and one in the Literary Stylistics section on Dante's poetry by a psychologist.

It was the intention of the ICCH organizing committee that the conference be multi-disciplinary in nature, focus on results, and have a non-European orientation. The statistics speak for themselves: there were 115 papers read by participants from thirty-five states of the USA and eight foreign countries (Australia, Canada, Japan, Holland, France, Germany, Italy and Great Britain). A fair measure of the diversity of interests represented can be obtained merely by listing the academic affiliations of the contributors to this book: English, French, Russian, Classics, Computer Science, Art, Linguistics, Mathematics, Music, Psychology, Physics and Electrical Engineering.

A different arrangement of the twenty-nine selected pieces would have been possible, but it was felt that the organization adopted well reflected the major emphases of the conference itself. General pedagogical considerations would seem to suggest that the reader should start with the sections on Information Retrieval and Systems for the Humanities, which contain information pertinent to almost any discipline in the humanities, before proceeding to the more specialized contributions in the other sections. But the absolute beginner would be well advised to consult in advance the inexpensive pamphlet put out by IBM, entitled appropriately *Introduction to Computers in the Humanities* (pamphlet no. GE20-0382-0). In conjunction with this, the present volume should be appropriate for use in such courses in 'Computers and the Humanities' as are now found in many major American and European universities.

Furthermore, the present volume complements two earlier collections of papers (Wisbey 1971, and Aitken *et al.* 1973), which have a much narrower focus of interest. Where, for example, they explicitly eschewed 'computer-based studies of language in its non-literary form' (Wisbey 1971, ix) our conference committee encouraged the submission of such papers. As a result, three sections of the book (Linguistics, Lexicography and Language, and Systems for the Humanities) include studies of non-literary language.

Among these 'linguistic' papers are two that require special comment. Neither Wang nor Sankoff devotes much attention to the role of the computer itself in his work. But in discussing issues central to theoretical linguistics—phonological change and inherent variability—both are forced to come to terms with the role of quantification in linguistics. And that, of course, is precisely where the computer comes in. The fact is, until recently, few theoretical linguists would have been prepared to admit that quantification had any place in linguistic theory. However, Labov's 1969 paper on copula contraction and deletion changed the situation. He pointed out that the traditional assumption of dialecto-

logists that an individual either had or did not have a particular linguistic feature simply did not hold when subjected to empirical investigation—thus the proposal that a feature could be inherently variable. Sankoff's paper is an attempt to evaluate two alternatives for analysing a set of data—specifically a frequency table on the deletion of complementizer *que* in Montreal French. Wang's paper reflects something of a new mood among linguists working within the generative-transformational tradition—a move away from what he labels 'the excessive concern with formalism' (p.39) and back to anchoring 'the study of speech sounds solidly on the empirical foundations of physical and social observations' (p.39). Though this apparent change of direction may surprise those familiar with some of Wang's earlier work (Wang 1968), his interest in 'the quantitative study of sound change' (p.48) derives directly from an essentially theoretical concern—the nature of phonological change (see further Wang 1969, and King 1969, chapter 5)—and leads naturally to the use of the computer.

It is true that the computer has been utilized before by linguists of various persuasions: as a grammar-testing device (Friedman 1971), for the study of pathological language (Wachal and Spreen 1970), and increasingly for dialect studies (see Houck 1970 and Wood 1970—both of whom read papers on the topic at the conference). But attempts to extrapolate from the way a computer processes a sentence to claims about the way that language is coded in the brain have not been successful. A good example is Yngve's hypothesis (see Lyons 1970, p. 100) which predicates the existence of transformations in language on the psychological complexity of sentences with left-recursive structures. And the gap between linguists and those working in Artificial Intelligence (AI) remains considerable. The latter have more pragmatic interests than the former: the creation of semantic networks, question-answering systems and so on. But the gap is being bridged by the work of some of those whose papers are included here. Berry-Rogghe (pp. 16–25) for example, approaches the vexing linguistic question of structural ambiguity from the viewpoint of a computer scientist, and is, perhaps for that reason, inclined to seek a solution in the Firthian notion of *collocation*. Jordan (pp. 205–14), on the other hand, in spite of her behaviourist terminology, sounds positively Chomskyan in describing her 'system [which] observes "correct" language behaviour and tries to discover underlying patterns or rules . . .' (p.205). Finally, Maxwell and Smith (pp.124–30) offer an admittedly heuristic response to the need for 'a comprehensive theory of meaning'. But they bring considerable linguistic sophistication to the construction of a *Core Dictionary*, based upon a lexical theory which they claim, 'corresponds to current linguistic theories . . . and to Piaget's developmental psychology principles' (p.130).

Readers who turn to the Literary Stylistics section may be reminded of Swift's eccentric Professor of Language who 'had made the strictest computation of the general proportion there is in books between the number of particles, nouns and verbs, and other parts of speech' (*Gullivers Travels*, 1726; also mentioned by Bailey, pp. 283–94). There is, incidentally, a nice irony here in that Swift himself was to become the subject of a quantitative study (see Milic 1967). Most critics today, of course, are willing to recognize that informed quantification of literary language is an enterprise not without merit. As Markman (1964) puts it: 'I know of no reputable literary judgement . . . which does not draw its strength from a broad base of data' (p. 39). Nonetheless, there still remain some, such as Hough (1969), who are ever ready to descend with Swiftian vehemence upon those they consider guilty of 'misplaced statistical fetishism' (p. 57).

The use of the computer to sort and count the data for literary studies has by no means solved all the problems; it has just changed them. The problem has become what to make of the word counts, the type-token ratios, the syllable-, word- and sentence-length statistics now so readily available. The solution is, perhaps, easiest, though by no means easy, for those undertaking some form of authorship-attribution study: compare the evidence from author X with that from the study of authors A and B. This is essentially the procedure followed by Baillie in a paper which is moving towards a resolution of the problem of whether Shakespeare or Fletcher wrote *Henry VIII*. Allen's attribution problem is somewhat different—he is interested in the unity or lack thereof in the *Chanson de Roland*. If his preliminary and properly cautious conclusions are substantiated by statistical tests of significance, this paper could prove to be of considerable importance to Old French scholars.

The Art and Poetry section offers a pot-pourri of computer-based creative activities. The pieces by Kawano and Leavitt were part of an exhibition of computer art held in conjunction with the ICCH Conference; the photograph by Layzer is a frame from an unusually effective experimental film shown during the conference; and the sample from Donohue and Skelton illustrates the kind of output possible using SPLAT, a computer language designed specifically for teaching computer art. Finally, Bailey's views on computer poetry should come as a relief to those who fear the imminent deification of the machine. Properly sceptical of the artistic merit of the poems he examines, he also reminds us that 'computers are merely iterative devices designed to execute specific instructions' (p. 293).

Acknowledgements
I would like to express the gratitude of the organizing committee to the following corporations whose generous contributions made the con-

ference possible: CalComp, Control Data, IBM, Northwestern Bell Telephone, Pillsbury, and Univac. I am further indebted to my Research Assistants Jim Meunier and Veronica Guarnera for their invaluable assistance in editing and proof-reading; to Florie-Ann Wild for translating work; and to Kinley Larntz, Department of Applied Statistics, for evaluating a paper.

REFERENCES

Aitken, A. J., Bailey, R. W. & Hamilton-Smith, N., eds (1973) *The Computer and Literary Studies*. Edinburgh: Edinburgh University Press.

Busa, R. (1964) An Inventory of Fifteen Million Words. *Literary Data Processing Conference* (eds Bessinger, Jess *et al.*). New York: IBM Corporation.

Frank, R. & Cameron, A. (1973) *A Plan for the Dictionary of Old English*. Toronto: University of Toronto Press.

Friedman, J. (1971) *A Computer Model of Transformational Grammar*. New York: American Elsevier.

Houck, C. L. (1970) *A Statistical and Computerized Methodology for Analyzing Dialect Materials*. PhD diss., University of Iowa.

Hough, G. (1969) *Style and Stylistics*. London: Routledge & Kegan Paul.

King, R. D. (1969) *Historical Linguistics and Generative Grammar*. New Jersey: Prentice-Hall.

Kučera, H. & Francis, W. N. (1967) *Computational Analysis of Present-Day American English*. Providence, Rhode Island.

Lyons, J. (1970) *Noam Chomsky*. New York: The Viking Press.

Markman, A. (1964) Litterae ex Machina. *Literary Data Processing Conference* (eds Bessinger, Jess *et al.*). New York: IBM Corporation.

Milic, L. T. (1967) *A Quantitative Approach to the Style of Jonathan Swift*. The Hague: Mouton.

Wachal, R. S. & Spreen, O. (1970) *A Computer-Aided Investigation of Linguistic Performance: Normal and Pathological Language*. THEMIS-UI-TR-29, contract N00014-68-A-05000.

Wang, W. S-Y. (1968) Vowel Features, Paired Variables, and the English Vowel Shift. *Language*, **44**, 695–708.

Wang, W. S-Y. (1969) Competing Changes as a Cause of Residue. *Language*, **45** (1), 9–25.

Wisbey, R. A., ed (1971) *The Computer in Literary and Linguistic Research*. Cambridge: Cambridge University Press.

Wood, G. R. (1970) On Ways to Examine the Local Language. *Computer Studies in the Humanities and Verbal Behavior*, **3** (ii), 100–10.

Linguistics

D. SANKOFF
P. ROUSSEAU

A method for assessing variable rule and implicational scale analyses of linguistic variation

Recent studies of linguistic variability have given rise to two competing analyses of frequency data on optional rules. The kind of frequency data used is the same in both cases; it is produced by noting all applications of a given rule in a speech sample of a number of individuals in a community, and comparing these to the total number of instances in which the rule was eligible to apply. Classifying utterances according to relevant features in the environment of the variable affected by the rule results in the type of table appearing, for example, in Labov's classic paper on copula contraction and deletion (1969). The two ways of interpreting such tables can be summarized as follows.

VARIABLE RULE ANALYSIS

Labov's original hypothesis, as rephrased by Cedergren and Sankoff (1974), would have the statistically patterned variation apparent in the table reflect an underlying probabilistic component in the competence of each speaker. The probability of rule application would be a well-defined function of the features present in the environment of the variable. Some functions which have been used in this respect are:

1. The 'additive model'. Let p be the probability that the rule applies in a given environment. Then:

$$p = p_0 + \alpha + \beta + \ldots + \omega$$

where p_0 is an 'input probability' pertinent to individual speakers and reflecting social, stylistic, etc., factors, and $\alpha, \beta, \ldots, \omega$ each represent a contribution from a single feature present in the linguistic environment of the variable. Each of these contributions is incorporated in the formula if and only if the corresponding feature is present, independent of the presence or absence of other features. Since probabilities must be numbers between zero and one inclusive, if the formula produces a value greater than one, the rule application probability is considered to be one. If the additive formula predicts a value less than zero, the probability is considered to be zero.

2. The multiplicative non-application probabilities model:

$$1 - p = (1 - p_0) \times (1 - \alpha) \times (1 - \beta) \times \ldots \times (1 - \omega)$$

In this model, the parameters $\alpha, \beta, \ldots, \omega$ are restricted to lie between zero and one. The feature which corresponds to parameter α can be interpreted as being able to 'cause' the rule to apply with probability equal to α. Each feature present in the environment is responsible for a success or failure trial for rule application. The rule applies if at least one

of these trials is a success. Implicit in this model is the assumption that
the features act independently in their effects on rule application.

3. *The multiplicative application probabilities model:*

$$p = p_0 \times \alpha \times \beta \times \ldots \times \omega$$

This model is similar to the previous one except that each feature is
considered to 'permit' the rule to apply (instead of cause it). The rule
applies only when it is permitted by all the features present, i.e. all the
trials are successes.

Though one of the above models may be more appropriate to a given
data set than the other models, and the estimates of the parameters will
vary somewhat depending on the model used, experience in variable
rule analysis shows that in general, the different models produce fairly
consistent results. That is, if a given feature is much more compatible
with rule application than another, as estimated in one of the models,
this pattern will usually show up in any of the other models as well.

Examples of variable rule analysis are to be found in Labov (1969,
1973a, b and c), Labov, Cohen, Robins and Lewis (1968), Fasold (1970,
1971), all on dialects of English; Cedergren (1973a and b) on Panama-
nian Spanish phonology; G. Sankoff (1973a) on syntactic and semantic
variables in Montreal French and New Guinea *tok pisin;* Lavandera
(1972) on *si*-clauses in Buenos Aires Spanish; and in Cedergren and
Sankoff (1974).

IMPLICATION SCALES

As exemplified by Bickerton (1971), the alternative explanation con-
siders the statistical variation in a table of frequencies as an artefact of
grouping speakers with discretely different grammars. The regularity in
the data is ascribed to a scaling relation which holds among the possible
grammars. That is, the various environments possible for the variable
in question are implicationally related so that all speakers applying the
rule in one environment must also apply it categorically (always) in all
implied (i.e. more favourable) environments. Conversely, for speakers
who do not apply the rule in a certain environment, the rule must never
apply in any less favourable environments. Speakers can then be scaled
according to the environments in which they apply the rule.

In the theory of which scale construction is the methodology, it is
claimed that the implicational ordering of environments forms part of
competence so that diachronic, stylistic, and geographical variation
proceed from one environment to the one closest to it in the implica-
tional scale. Indeed, this type of analysis has strong links with Bailey's
(1970) wave model for the generalization and diffusion of rule innova-
tions.

Examples of implicational scale analysis are to be found in Bickerton
(1971, 1973), Day (1973), Labov (1971), Peet (1973).

THE BEST MODEL

Were either analysis adhered to in its extreme form, it would be relatively easy to choose between them by analysing individual data. Perfect scalability of all individuals within a general implicational ordering would confirm the artefactual nature of the variable rule analysis and a single scaling 'error' would disprove the scaling hypothesis. Unfortunately, from the chooser's viewpoint, or fortunately, for linguistic reality, both sides hedge. Those who employ variable rules usually find a number of speakers who categorically apply or do not apply the rule in a given environment. Furthermore, they readily admit the existence of scales in some contexts and themselves often employ scaling, e.g. Labov (1971).

On the other hand, those who feel that variable rules are not valid nonetheless generally allow the existence of a limited number of environments in which the rule applies variably. These are implicationally ordered between those in which it never applies and those in which it always applies (e.g. Bickerton 1971, 1973). They are not usually interested in the statistical details and postulate that such environments are transitional, so that speakers are considered to be using two slightly different categorical rules in free variation, preliminary to settling on one for that environment. Furthermore, practitioners of scaling are willing to allow a degree of non-scalability of the data, by invoking the notion of performance error.

How then can we rate the two approaches with respect to a given set of data? Each approach has made use of statistical criteria to judge its performance, in the case of variable rules a chi-square comparison of predicted versus observed frequencies, and in the case of scaling an index of scalability. These criteria, however, are checks internal to their respective models and neither is of any use in a comparison of the models. A high chi-square may indicate that the formula for p is not appropriate but will not indicate that scaling is preferred over adjusted probabilistic models. Similarly, a low degree of scalability tends simply to influence the scaling analyst to postulate a high rate of performance error. The meaninglessness of indices of scalability in this regard has been pointed out most clearly by Carden (1972).

The problem of judging between models is complicated by the fact that, especially on the syntactic level, large data sets are difficult to come by. To find one example of a particular construction may involve hours of listening to recorded speech. And with sparse data sets even the variable rule model predicts large numbers of individuals will appear to fit into a scale simply because with only one, two or three examples in a given environment, we are very likely to find 100 per cent or 0 per cent rule application depending on whether the rule probability

is high or low. Furthermore, with such data, the proportion of environments of which we have no examples can always be incorporated into a scaling scheme.

A RIGOROUS METHOD OF COMPARISON
We can, however, take all these facts into account in a fairly rigorous statistical test. This proceeds as follows:
 1. Do a variable rule analysis of the data.
 2. Set up an implicational scaling model for the data.
 3. Using the probabilities predicted by the variable rule, calculate the errors to be expected in fitting data into the proposed scale. This calculation can be carried out by Monte Carlo simulation methods.
 4. See whether the actual number of scaling errors is significantly less than expected under 3. If so, we reject the variable rules analysis in favour of scaling hypothesis. If not, there is no statistical reason to prefer the scaling method.

It should be pointed out that this procedure is somewhat asymmetric with respect to the two alternatives. It is capable only of rejecting a variable rule in favour of a scale. It would be helpful in having a test applicable to scales to see whether they could be rejected in favour of a variable rule. This would require, however, some assumptions about the rate of 'performance error', and once such assumptions are made the scaling model becomes a notational equivalent of a variable rule model, albeit possibly a different one from the additive and multiplicative models we have discussed.

THE EXAMPLE
In comparing two opposing analytical approaches, it is rare to find a data set which both sides consider supportive of their own point of view. Fortunately, in our case, such a data set exists. Data on the deletion of complementizer QUE in Montreal French have been used to illustrate the principles of variable rule analysis by G. Sankoff (1973b) and by Cedergren and Sankoff (1974). The same data have been thoroughly reworked by Bickerton (1973), who concludes that the phenomena of QUE deletion provides convincing evidence for the utility of scaling methodology.

The theoretical linguistic aspects of this controversy have been expounded at length in the references we have cited. Here we intend primarily to analyse the data set and to see how well it accords with one approach or the other in terms of the statistical criterion we have developed.

THE BACKGROUND OF THE PROBLEM
In Montreal French, the complementizer QUE is often deleted with no change of meaning, e.g.: *Au début je pense ça a été plutôt un snobisme*, and

au début je pense que ça a été plutôt un snobisme. The distribution of these types of sentences (i.e. with and without QUE) is subject to both linguistic and social constraints. Cedergren and Sankoff (1973) investigated these in terms of a rule of the form

$$\text{QUE} \rightarrow \langle \emptyset \rangle / \left\langle \begin{matrix} S \\ C \\ V \end{matrix} \right\rangle \# \# \underline{\quad}_{[+\text{compl}]} \# \# \left\langle \begin{matrix} S \\ C \\ V \end{matrix} \right\rangle$$

where the angled brackets around \emptyset indicate a rule which applies variably, and the pairs of angled brackets around the preceding and following phonological environments contain lists of variable constraints, i.e. sibilants (S), other consonants (C), and vowels (V). The data used in that paper consisted of all occurrences of complementizer QUE, including sentences from which this complementizer was considered to have been deleted, in half an hour's recorded speech of each of sixteen individuals. These represent a subsample of the 120 French-speaking Montrealers interviewed for a study of variation in Montreal French (G. Sankoff and Cedergren 1972; D. Sankoff and G. Sankoff 1973).

	working class men			working class women		
	−S	−C	−V	−S	−C	−V
S−	$\frac{0}{11}(0{\cdot}0)$	—	$\frac{4}{7}(0{\cdot}57)$	$\frac{0}{7}(0{\cdot}0)$	$\frac{1}{2}(0{\cdot}5)$	$\frac{6}{6}(1{\cdot}0)$
C−	$\frac{1}{12}(0{\cdot}08)$	$\frac{2}{2}(1{\cdot}0)$	$\frac{8}{8}(1{\cdot}0)$	$\frac{3}{15}(0{\cdot}2)$	$\frac{0}{2}(0{\cdot}0)$	$\frac{11}{11}(1{\cdot}0)$
V−	$\frac{6}{15}(0{\cdot}4)$	$\frac{4}{7}(0{\cdot}57)$	$\frac{6}{8}(0{\cdot}75)$	$\frac{20}{31}(0{\cdot}64)$	$\frac{17}{20}(0{\cdot}85)$	$\frac{37}{37}(1{\cdot}0)$
	professional class men			professional class women		
S−	$\frac{3}{4}(0{\cdot}75)$	$\frac{7}{7}(1{\cdot}0)$	$\frac{9}{10}(0{\cdot}9)$	$\frac{11}{24}(0{\cdot}47)$	$\frac{4}{4}(1{\cdot}0)$	$\frac{14}{15}(0{\cdot}93)$
C−	$\frac{5}{7}(0{\cdot}71)$	$\frac{5}{6}(0{\cdot}83)$	$\frac{9}{9}(1{\cdot}0)$	$\frac{5}{9}(0{\cdot}56)$	$\frac{5}{6}(0{\cdot}83)$	$\frac{9}{9}(1{\cdot}0)$
V−	$\frac{26}{26}(1{\cdot}0)$	$\frac{11}{12}(0{\cdot}92)$	$\frac{16}{16}(1{\cdot}0)$	$\frac{20}{21}(0{\cdot}95)$	$\frac{15}{16}(0{\cdot}93)$	$\frac{42}{42}(1{\cdot}0)$

Table 1. Presence of QUE in complement over total number of complements in nine phonological environments. Relative frequencies in parentheses. Four speakers in each category.

Cross-classifying the data by preceding and following phonological environment of the variable QUE, and by occupational approach and sex of the informant, resulted in a table of frequencies (table 1). This was punched on cards as input to a program which calculates the effects of each variable constraint on the rule application probability, using a successive approximation method to arrive at maximum likelihood values.

With this example, we used a multiplicative application probabilities model which was far more consistent with the data than a non-application model, as measured by a chi-square comparison of predicted versus observed frequencies. This results in a clear picture of the interplay of linguistic and social factors as summarized in table 2. Preceding and

following sibilants freely permit QUE deletion, while the loss of [+sib] and [+cns] tends to progressively restrict rule application so that preceding and following vowels make for very conservative environments. This phenomenon strongly resembles Labov's rule (14) for the simplification of –sK clusters (1969).

input probability	$p_0 = 1$		
preceding environment:	S–	C–	V–
effect	1	0·85	0·37
following environment:	–S	–C	–V
effect	1	0·50	0·10
occupational class:	workers	professional	
effect	1	0·35	
sex:	women	men	
effect	1	1	

Table 2. Effect of each factor influencing QUE deletion in Montreal French. The probability of QUE deletion in an environment containing a number of specified features is the product of all the effects associated with these features

The occupational characteristics of a speaker also tend to affect the rule. Working class informants tend to delete the variable more frequently. On the other hand, the sex of the informant appears to have no effect on the operation of the rule.

This analysis was quite consistent with the data, in that the rule application frequencies predicted by the model using the estimated values of the parameters are generally quite close to the observed frequencies in table 1. This includes a number of environments where the rule is categorically applied (S–S for working class subjects) or never applied (e.g. V–V and C–V among professionals).

The next discussion of the QUE data was provided by G.Sankoff (1973b). Critics of variable rule analysis had suggested that the systematic relationships apparent between entries in frequency tables are artefacts of aggregating speakers with different grammars. According to these critics, an analysis of individual data would most probably show that each speaker behaves categorically in all environments, except in at most one (transitional) environment, and that because these environments can be implicationally scaled, aggregation of the data of speakers having fairly similar grammars into subgroups would lead to the regular patterns of greater and lesser rule frequencies observed, for example, in table 1. In response to these suggestions, G.Sankoff published the QUE data disaggregated for the sixteen individuals. Nine of these sixteen individuals showed variability in more than one environment, and three of the remaining speakers applied the rule in environments which were

clearly less favourable than some in which they did not apply it. Having thus shown that there is no reasonable way of constructing a categorical implicational scale of environments, she stressed that this does not detract from the systematic nature of the data. Insofar as each individual speaker seemed to follow (subject to statistical fluctuation) the same general phonological constraints as discovered for the aggregate data of table 1, she considered this additional support for the variable rule approach.

BICKERTON'S REANALYSIS

In his comparison of variable rule and scaling methods, Bickerton (1973) attempted to show how the QUE data are particularly amenable to a categorical scaling analysis, despite G. Sankoff's evidence to the contrary.

His motives for this seem to be three-fold. First, in line with the assumption that all rule variability in a speech community can be automatically interpreted as on-going change, Bickerton wanted to use the scale to reveal the way in which the rule is spreading through the Montreal speech community. Second, to justify his conviction that the human mind does not have 'the power to handle variability on a very large scale', Bickerton wished to show that there are not so many variable environments, after all. Third, it must be pointed out that Bickerton's criticism of the original QUE analysis appears to be, at least in part, in response to our critiques of his own scaling work (see Cedergren and Sankoff 1974, and G. Sankoff 1973b).

In his reanalysis of the QUE data, Bickerton follows two separate lines of argument. He argues first that the data are a lot less variable and a lot more scalable than would seem from our own work from the variable rule perspective. Second, he modifies the scalability hypothesis by claiming that an analysis of the errors of 'deviations' from an ideal scale leads to a correct wave theory analysis of the spread of the QUE deletion rule.

Details aside, it suffices to say that except for his insistence on the non-existence of variable environments and his assumptions about on-going change, Bickerton's relinquishment of the strict scaling hypothesis begins to approach our own analysis. That is, if a speaker has very few cases of QUE deletion these will tend to show up in the environment S–S; the next environments in which they are likely to occur are C–S, S–C, and/or C–C; and that –V is an environment resistant to the rule. Indeed, so much is entirely evident in the raw data; it is not clear what the intervention of the scale contributes, other than an attempt to salvage some categorical implicational relationship between environments. The mathematical structure of these relationships can no longer be a complete, one-dimensional order; it is a much weaker partial order.

The main point of the present article is to discuss scalability, so we will conclude our discussion of Bickerton's second type of argument by remarking on the relevance of the 'dynamic' viewpoint for QUE deletion. Despite the assumption inherent in Bickerton's theory that all variation is change, there are no grounds for assuming that QUE deletion is a change in progress. Rather, it seems to be a stable phenomenon, with parallels in other French speech communities, and is a special case of a widely applicable and generally stable variable consonant cluster simplification rule. Trying to force such rules into a rule-change analytical framework is unnatural and does a disservice to a methodology which can shed much light on genuine change situations.

speaker	phonological environment								
	1 C–V	2 V–V	3 S–V	4 V–S	5 V–C	6 C–C	7 S–C	8 C–S	9 S–S
12	0/1	0/1	0/3	0/5	0/8	0/1	0/3	—	0/3
16	0/5	0/15	0/2	0/9	0/2	—	—	1/1	0/1
13	0/1	0/10	1/12	0/3	0/4	1/2	0/3	0/1	8/17
15	0/2	0/6	—	0/5	—	0/3	—	0/2	2/3
10	0/1	0/2	—	0/8	—	1/1	0/2	0/1	—
1	0/3	—	—	3/4	0/1	0/1	—	—	—
11	0/2	0/3	—	0/4	1/3	0/3	0/1	1/2	—
9	0/5	0/10	1/7	0/9	0/1	0/1	0/1	1/4	1/1
6	0/2	0/15	0/3	5/17	0/7	—	0/1	1/3	5/5
14	0/1	0/11	0/1	1/4	1/10	0/1	0/1	3/5	3/3
4	0/3	1/3	2/5	1/2	0/1	0/1	—	4/5	7/7
8	0/3	0/11	—	0/3	0/5	—	—	2/2	1/1
3	0/2	1/4	1/1	1/4	0/2	—	—	4/4	—
5	0/2	0/6	0/1	0/3	2/5	1/1	1/1	1/2	—
7	0/4	0/5	0/2	6/8	1/3	1/1	—	8/8	1/1
2	—	0/1	0/1	4/5	3/3	—	—	3/3	4/4

Table 3. Number of QUE deleted / total number of complementizer QUE in each of nine phonological environments for each of sixteen speakers (— indicates no data).

Returning to our main point, let us examine how Bickerton justifies his claim that the data are largely scalable. He obtained the QUE data from a graphic display in a preprint version of G. Sankoff (1973b). In extracting this information, he introduced a number of changes, probably due to the poor quality of the diagram reproduction in the preprint. These changes, however, would seem to bear little on his analysis, except that they decrease by one the number of variable environments. To set the record straight, we present in table 3 a definitive list of the data.

The next step in Bickerton's analysis was to simplify the data pre-

sentation in such a way as to classify each environment only as being categorical for QUE deletion, categorical for retention, or variable, for each speaker. We do the same for the corrected data in table 4. The arrangement of rows and columns in tables 3 and 4 is Bickerton's notion of what the ideal scale should look like. For each speaker, he considers all environments (from left to right) up to and including the last one in which QUE is categorically present in the data as being *ideally* non-application environments. The next environment is possibly transitional (i.e. variable) but all the rest are *ideally* categorical QUE deletion environments. For some speakers, there is some freedom of choice in the position of the boundary between non-deletion and deletion environments, partly due to a lack of cases in some environments, but other than this minor point, the criteria just stated are those by which Bickerton classifies environments. For each speaker, all environments to the left of the transitional one which are either variable or categorical for deletion *in the data* are considered as errors. Similarly, all environments to the right of the transitional one which are variable or categorical for non-deletion are also errors. This analysis is summarized in table 4.

speaker	phonological environment								
	1 C–V	2 V–V	3 S–V	4 V–S	5 V–C	6 C–C	7 S–C	8 C–S	9 S–S
12	0	0	0	0	0	0	0	–	0
16	0	0	0	0	0	–	–	*1*	0
13	0	0	*01*	0	0	*01*	0	0	01
15	0	0	–	0	–	0	–	0	01
10	0	0	–	0	–	*1*	0	0	–
1	0	–	–	*01*	0	0	–	–	–
11	0	0	–	0	*01*	0	0	01	–
9	0	0	*01*	0	0	0	0	01	1
6	0	0	0	*01*	0	–	0	01	1
14	0	0	0	*01*	*01*	0	0	01	1
4	0	*01*	*01*	*01*	0	0	–	01	1
8	0	0	–	0	0	–	–	1	1
3	0	*01*	*1*	*01*	0	–	–	1	–
5	0	0	0	0	01	1	1	*01*	–
7	0	0	0	01	*01*	1	–	1	1
2	–	0	0	01	1	–	–	1	1

Table 4. Classification of environments in the data-based parts of Bickerton's ideal scale. 1 = rule application, 0 = non-application, 01 = variable application. Environments to the left of heavy lines are postulated to be ideally categorical for non-application; those to the right categorical for application; and those between are transitional or variable. Italic environments represent data which do not fit into the postulated implicational scale

There are a total of eighteen such errors. Most of Bickerton's paper is devoted to explaining these errors using the following devices: the column responsible for the most errors (six errors, including speaker 7) is column 4, so Bickerton simply postulates that instead of the rule spreading in an orderly way along the scale, those speakers with errors in this column generalize from S–S to –S. The next most error-laden column is number 3 with four errors. To account for these, he posits that another 'quite unconnected' pattern of rule generalization is possessed by the speakers showing this error. Yet another pattern of innovation is conjectured to explain the two errors in column 2. This leaves five errors (six in the corrected data). Rather than try to account for these, Bickerton judges that they are performance errors, i.e. that the native speakers must have been mistaken when they uttered these sentences.

Summarizing Bickerton's approach to scaling errors, he selects those column(s) containing many errors and hypothesizes a separate implicational configuration for the speakers responsible for the errors in each column. The remaining few errors can then be blamed on performance anomalies.

THE TEST

One serious question does remain in relation to Bickerton's first line of argumentation: are the eighteen errors significantly few enough to reject a variable rule approach and hence lend some meaning to the implicational scale?

To answer this we applied our test as follows. Rather than use the multiplicative model, which gives the best variable rule fit to the QUE data, we chose, to be neutral and for simplicity's sake, an additive model. Maximum likelihood estimates of each individual's input probability and the effects of the variable constraints are given in table 5. Exemplifying our earlier discussion, the variable constraints pattern in the same way in this model as in the multiplicative model (see table 2). To calculate an individual's rule application probability in a given environment, we simply add together his or her input parameter with the contribution of the preceding segment and that of the following segment. Sums greater than one or less than zero are suitably truncated.

Each simulation run is carried out as follows: for each speaker, in each environment, the number of cases N is noted as given in table 3, as well as the probability p calculated as in the preceding paragraph. Then N random numbers between zero and one are generated. Those that are less than p are counted as rule applications and the rest as non-applications.

Once a complete simulated data set is thus created, a classification of environments for each speaker is carried out in the same way as Bickerton did for the real data. An error count follows and the results are stored.

preceding environment:	S–	C–	V–					
effect	0·105	0·057	−0·163					
following environment:	–S	–C	–V					
effect	0·279	0·061	−0·341					
individuals:	12	16	13	15	10	1	11	9
input	−1·00	−0·68	0·06	−0·29	−0·31	0·27	0·06	0·05
individuals:	6	14	4	8	3	5	7	2
input	0·03	0·08	0·32	−0·22	0·23	0·25	0·54	0·79

Table 5. Effect of each factor influencing QUE deletion
according to an additive model

This simulation was carried out 1000 times, with the results which appear in figure 1. It is quite striking that the most probable number of errors is exactly eighteen. In other words, our variable rule model predicts that if we try to scale a typical data set having the number of cases we have in the real data, we can expect somewhere between, say, thirteen and twenty-four errors, and most likely eighteen. The error analysis of the real data, then, falls exactly where the variable rule predicts. The number of variable cells in excess of one per speaker, together with other scaling errors, are no more and no less than we would expect.

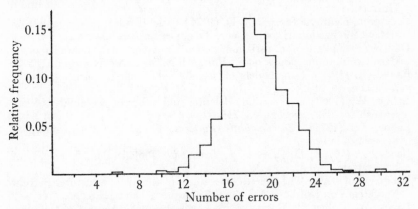

Figure 1. Distribution of number of scaling errors
in Bickerton's ideal scale as calculated by Monte
Carlo simulation

CONCLUSION
The method we have developed provides a definitive solution to Carden's problem: how many errors can an implicational scale contain and still remain valid? In the case of a rule which applies with different frequencies in different environments, these environments can be categorically scaled meaningfully only if the number of scaling errors is significantly fewer than some appropriate probabilistic model.

For complementizer QUE deletion in Montreal French, the number of scaling errors in Bickerton's ideal scale is exactly what one would expect from a variable rule analysis. There is then no empirical justification to prefer a categorical scale in this situation. It is true that Bickerton has speculated about the significance of each of these errors for his theory of the spread of the rule in the speech community, but it is equally clear that his conjectural methods are capable of explaining away any reasonable pattern of errors such as would be generated by a variable rule.

REFERENCES

Bailey, C-J.N. (1970) Building rate into a dynamic theory of linguistic description. *University of Hawaii Working Papers in Linguistics 2/9*, 161–233.

Bickerton, D. (1971) Inherent variability and variable rules. *Foundations of Language*, 7, 457–92.

Bickerton, D. (1973) Quantitative versus dynamic paradigms: the case of Montreal 'QUE'. *New Ways of Analyzing Variation in English* (ed. Bailey, C. & Shuy, R.). Georgetown University.

Carden, G. (1973) Paper read at the Expanding Domain of Linguistics Conference, Austin, Texas.

Cedergren, Henrietta (1973a) Interplay of social and linguistic factors in Panama. PhD dissertation, Cornell.

Cedergren, Henrietta (1973b) On the nature of variable constraints. *New Ways of Analyzing Variation in English* (ed. Bailey, C. & Shuy, R.). Georgetown University.

Cedergren, Henrietta & Sankoff, D. (1974) Variable rules: performance as a statistical reflection of competence. To appear in *Language*.

Day, R. (1973) Patterns of variation in copula and tense in the Hawaiian post-Creole continuum. *University of Hawaii Working Papers in Linguistics 5/2*.

Fasold, R. (1970) Two models of socially significant linguistic variation. *Language*, **46**, 551–63.

Labov, W. (1969) Contraction, deletion and inherent variability of the English copula. *Language*, **45**, 715–62.

Labov, W. (1973a) *Sociolinguistic Patterns*. Philadelphia: University of Pennsylvania Press.

Labov, W. (1973b) *Language in the Inner City*. Philadelphia: University of Pennsylvania Press.

Labov, W. (1973c) The quantitative study of linguistic structure. Second Conference on Nordic and General Linguistics, Umea, Sweden.

Labov, W., Cohen, P., Robins, C. & Lewis, J. (1968) A study of the non-standard English of Negro and Puerto Rican speakers in New York City. *Cooperative Research Report 3288*.

Lavandera, B. (1972) Paper read to the Annual Meeting, Linguistic Society of America.

Peet, W. (1973) Paper read to the Annual Meeting, South-East Conference on Linguistics.

Sankoff, D. & Sankoff, G. (1973) Sample survey methods and computer assisted analysis in the study of grammatical variation. *Canadian Languages in their Social Context*. (ed Darnell, R.), 7–63.

Sankoff, G. (1973a) Above and beyond phonology in variable rules. *New Ways of Analyzing Variation in English* (ed. Bailey, C. & Shuy, R.). Georgetown University.

Sankoff, G. (1973b) A quantitative paradigm for the study of communicative competence. Conference on the Ethnography of Speaking, Austin, Texas. To appear in *Proceedings*.

Sankoff, G. & Cedergren, H. (1972) Sociolinguistic research on French in Montreal. *Language in Society*, **1**, 173–4.

Automatic identification of phrasal verbs

I would like to consider the problem of phrasal verbs from a semantic rather than from a syntactic point of view. My concern is with solving the general problem facing automatic linguistic analysis of identifying the 'lexical item' as opposed to the mere graphic unit. The project is an extensive one, including not only the problem of lemmatization but that of homography, polysemy, idiom, etc. The particular aspect of the problem that I am attempting to solve is the identification of 'phrasal verbs'; by phrasal verbs I mean those occurrences of a verb followed by a particle which are idiomatic, such as *look after*, *give in*, as opposed to non-idiomatic co-occurrences of verbs plus particle as in the case of *look at* or *give to*.

I would like to consider briefly the grammatical criteria usually invoked to distinguish the idiomatic from the non-idiomatic cases, and to show that in many instances such criteria are inadequate and that perhaps a different approach based on semantic criteria may be more successful.

The main syntactic criteria used in modern structural grammar, as summarized from Palmer's (1968) work on the English verb, are as follows:

1. The 'phrasal verb' normally admits of the *passive transformation*.
idiomatic: They arrived at a decision → A decision was arrived at
non-idiomatic: They arrived at the station → * The station was arrived at
exception: The chair was sat on. The bed was slept in
2. The 'phrasal verb' does not normally admit of *inversion* of the particle.
non-idiomatic: He came out → Out he came
idiomatic: It stood out → * Out it stood
exception: He looked out → * Out he looked
3. The 'phrasal verb' can normally be *replaced by a single item* which is synonymous to it.
idiomatic: They arrived at a decision → They made a decision
exception: They went into the room → They entered the room

Chomsky (1965, 101–6) similarly proposes to disambiguate the sentence: *They decided on the boat*, by distinguishing between 'verb-complement' and 'VP-complement', allowing the passive transformation in the one case but not in the other.

The above criteria, as well as a few additional ones, have been used in another exercise at automatic identification of phrasal verbs by Carvell

and Svartvik (1969). This study consists of a statistical analysis based on biological taxonomic strategies of the responses of informants to the various grammatical criteria suggested to them. My own project will be text-based. But one of the conclusions they draw confirms my own assumption, namely that 'idiomaticalness is not absolute but rather a matter of degree'.

The question I have been asking is: Is there a way of automatically constructing a lexicon of phrasal verbs given a vast amount of modern English textual data and adequate statistical procedures? Why the problem should be tackled with statistical methods rather than with syntactic criteria needs some justifying. As already shown above, the most powerful syntactic criteria usually invoked seem inadequate. This has been acknowledged by Palmer himself, at the end of his chapter on phrasal verbs: 'Apart from their semantic unity and the collocational restrictions on the occurrence of the verb and particle, there is nothing that will establish which are phrasal verbs and which are not' (1968, 185).

The very mention of collocational restrictions interested me greatly, as I had myself been engaged in the study of collocations and their relevance to a theory of meaning. I began to wonder whether the same methods could be applied to the problem of the phrasal verb. I should first say a few words on the semantic notion of 'meaning by collocation'. The notion is a typically British one, first introduced by J. R. Firth (1957). It states that the meaning of a word can best be explained in terms of its habitual co-occurrence with certain other words. It is in fact a 'distributional theory of meaning', similar to a distributional theory of grammar. Whereas it has been relatively easy for the latter to be formulated due to the relative small number of grammatical classes, the distributional theory of lexis can only begin to be made explicit with the advent of the computer, because of the relatively infrequent recurrence of the same relations. It seems likely that such a theory can be formulated in statistical terms.

The general statistical procedures I propose to use are outlined in Berry-Rogghe (1973). In statistical terms, 'collocation' can be defined as:

> 'The syntagmatic association of two graphic items quantifiable textually as the probability that there will occur at n removes (i.e. a distance of n items) from the item x, the items a, b, c, \ldots'

In other words, for every item in the text we can construct an ordered set of its 'significant' collocates. The degree of significance can be computed by taking the 'z-score' as a normal approximation of the binomial distribution. The variables and formulae used are summarized here:

$Z:$ total number of words in the text
$A:$ a given item occurring in the text Fn times
$B:$ a collocate of A occurring in the text Fc times

K: number of co-occurrences between B and A
S: span size, i.e. the maximum distance allowed between A and B
p: the probability of B occurring at any place in the text
 (exclusive of A); $p = Fc/(Z-Fn)$
E: expected number of co-occurrences between B and A; $E = p.Fn.S$
z: strength of collocation or degree of affinity between A and B;
 $z = (K-E)/\sqrt{Eq}$ where $q = (1-p)$

By way of illustration, table 1 shows an example of the collocational set
of *house* derived from Dickens's *A Christmas Carol*. (By definition the
sum of all z-scores should be zero; the reason why this is not the case
in the present example is because all items co-occurring only once were
excluded.) It was my aim then to apply the same techniques to phrasal
verbs in the hope that the strength of collocational affinity between
particular verbs and particles might provide a measure of the degree of
their idiomaticalness.

sold	24·0500	only	2·0441	did	0·6462
commons	21·2416	could	1·9807	about	0·5363
decorate	19·9000	something	1·9026	but	0·3641
this	13·3937	up	1·8829	not	0·3221
empty	11·9090	have	1·8689	like	0·2833
buying	10·5970	in	1·7299	his	−0·0385
painting	10·5970	Myra	1·7239	was	−0·0890
opposite	8·5192	other	1·6889	know	−0·1038
loves	6·4811	before	1·6451	all	−0·1060
outside	5·8626	Tony	1·4459	well	−0·1209
lived	5·6067	ghost	1·3916	for	−0·1794
family	4·3744	more	1·3740	if	−0·2197
remember	3·9425	much	1·3227	it	−0·4368
full	3·8209	where	1·2896	they	−0·5175
my	3·6780	one	1·2879	yes	−0·5818
into	3·5792	get	1·1949	be	−0·6557
the	3·2978	out	1·1348	I	−0·6865
has	2·9359	or	0·9316	do	−0·6993
're	2·5333	people	0·9220	with	−0·9090
nice	2·3908	of	0·9096	to	−1·6660
years	2·3712	mother	0·8558	that	−1·8030
is	2·1721	see	0·8503	you	−2·6034
every	2·0736	been	0·7713	and	−2·6488

Table 1. Collocates of 'house' in decreasing order of
significance

Before proceeding with the analysis a few words must be said about
the texts used. In principle, if a sample of text is so large that it can be
taken as representing properties of the language rather than of the

```
AW  77  29                                          BELIEVE IN NOTHING, CARE ABOUT NOTHING: BUT KEEP
AW 112   2  ON'T KNOW WHAT SORT OF THINGS I         BELIEVE IN: ONLY I KNOW IT'S NOT WHAT THE CHAPEL
ES 1255              DO YOU KNOW, THIS LOT STILL     BELIEVE IN IT'.
ES 1253      THERE AND TELLING ME YOU STILL         BELIEVE IN = JESUS'.
ES 1774              I DONT SEE HOW THEY CAN         BELIEVE IN IT.
ES   45     LED FOR SOMETHING YOU DONT EVEN         BELIEVE IN.
AW  77  31               THERE IS NOTHING TO        BELIEVE IN, SO LET US UNDERMINE EVERYTHING.
ES 1355         I WAS PROBABLY WRONG NOT TO         BELIEVE IN CORPORAL PUNISHMENT FOR CHILDREN,
AW 112   3   IT'S NOT WHAT THE CHAPEL=FOLKS         BELIEVE IN.
AW 112   4                 WE NONE OF US            BELIEVE IN THEM WHEN IT COMES TO EARNING A LIVIN
AW 105  14        'I NEVER SAID I DIDN'T            BELIEVE IN GOD.
AW 113   3                       I DON'T            BELIEVE IN GOD AND BEING GOOD AND GOING TO HEAVE
AW 105  13             'AND YOU DON'T               BELIEVE IN GOD.
ES 1102     FTEN I 'VE TOLD YOU THAT I DONT         BELIEVE IN THIS = YOU CAN DO MORE BY QUIETLY PUL
ES   44                  WELL!  YOU DONT            BELIEVE IN IT.
ES 2198     RENT GOING TO SAY THAT YOU DONT         BELIEVE IN INTERFERING WITH OTHER PEOPLE'S LIVES
ES  70  33  GOT NO ANSWER, SHE ADDED: 'YOU          BELIEVE IN THE DEVIL, DON'T YOU?' 'I NEVER MET H
ES   47     ETTING KILLED FOR SOMETHING YOU         BELIEVE IN IS SURELY A BIT OF A LUXURY THESE DAY
AW 105   5  SEI TELL ME,' SHE SAID, 'DO YOU         BELIEVE IN GOD?' 'IN GOD!' HE SAID, WONDERING.
ES 1107                    SO NOW YOU BELIEVE IN PULLING STRINGS.
ES 1687              SHE DIDN'T QUITE GIVE IN TO WHAT SHE SAW IN THE BOIS DE BOULOG
ES 1687     FIRST MOMENT OF WEAKNESS SO YOU 'LL GIVE IN AND MARRY HIM,
AW 127  22  'AND DON'T YOU WANT TO MAKE THEM GIVE IN TO YOU?' 'NOT ME,' HE SAID,
AW  22  10  IS LIFE, NEVER GIVE WAY, AND NEVER GIVE IN,
AW 127  19  WOMEN = THEY ONLY WANT TO MAKE YOU GIVE IN TO THEM, SO THAT THEY FEEL ALMIGHTY,
AW  71  32                  WE'RE NOT REALLY ALIVE, IN THE SENSE THAT THEY WERE ALIVE.
ES  818     NEVER HAVE BELIEVED ONCE THAT I 'D LIVE IN ONE PLACE FOR FIFTEEN YEARS = IT 'S D
AW 2564     NOW WE 'LL HAVE TO LEAVE HERE AND LIVE IN SOME = DAMNED PRETTY LITTLE FLAT SOME
AW  72  18  SHUT IT UP AND THANKED MY STARS I LIVE IN NINETEEN=TWENTY ODD, NOT IN SOME OTHE
AW  56  38                       BUT I CAN LIVE IN SPITE OF IT.
AW  81   6  RIAD CONSPIRATORS, WHO CONSPIRE TO LIVE IN ABSOLUTE PHYSICAL SAFETY, WHILST WILL
ES 2558                          YOU LIVE IN A MESS LIKE A PIG, MOTHER,
ES 2557                          YOU LIVE IN A MESS OF LOVE AFFAIRS AND COMMITTEES
AW 121  22  CESS IN LONDON, AND ONE OUGHT TO ARRIVE IN NEW YORK READY=MADE AS A FAMOUS AND I
AW  20   7  SHE REALIZED THAT HE WAS SENSITIVE, IN SPITE OF HIS FLAMING, HEALTHY STRENGT
AW 156  23  NONSENSE ABOUT JESUS AND A GOD OF LOVE, IN A PLACE LIKE THIS! THIS IS MORE AWFUL
ES 2551     SUSPECT THAT THERE 'S ONE THING I LOVE IN THIS WORLD, AND IT 'S THIS HOUSE,
ES 2562     COME DOWN THE STAIRS I FEEL EVERY NERVE IN MY BODY SHRIEKING,
AW 159  28  E, THE CORPSE OF HER NEW ENGLAND BELIEF IN A WORLD ULTIMATELY ALL FOR LOVE.
AW 159  26  ED HER FOR EVER IN HER HOPE, HER BELIEF IN PARADISE ON EARTH,
AW 163  16  =NAKED  AT A PUBLIC SHOW, AND GOING OFF IN A TAXI TO SLEEP WITH SOME HALF=DRUNKE
AW 117  10  MOST PROSAICALLY ROMANTIC, SETTING OFF IN A RUBBER CAPE, FOLLOWED BY LEWIS,
AW 137   5                  'HE'S GOT THE STUFF IN HIM, HE SURE HAS,' SAID THE MAN,
AW  40  15  ACK, ALL THE TIME, UNCONSCIOUSLY, AS IF IN HIS VERY BEING THERE WAS SOME SECRET,
AW  20   1             FOR SHE WAS ALREADY HALF IN LOVE WITH ST MAWR,
AW  31  10  WAY HE RIDES? HE SEEMS TO SINK HIMSELF IN THE HORSE,
AW 141  18                  HE WAS HIMSELF IN THIS COUNTRY: IMPASSIVE, DETACHED, SE
AW  14  15  AND SARDONIC=ALLY  ESTABLISHED HERSELF IN A SUITE IN A QUIET BUT GOOD=CLASS HOT
AW  22  12  K IN HER, SHE WENT HOME AND HID HERSELF IN HER ROOM, AND JUST CRIED,
AW 156  16  SHE LOOKED AT IT, SHE SAID TO HERSELF, IN SPITE OF HERSLEF: THERE IS NO ALMIGHT
AW 133  19           ELSE YOU FOUND YOURSELF IN A RAILWAY STATION AND A 'CENTRE OF CI
AW 122   8  E, AND HOW UNPOPULAR I SHALL BE MYSELF, IN A LITTLE WHILE.
ES  465     H, NOT THE LIES I 'LL BE TELLING MYSELF IN FIVE YEARS' TIME WHEN I 'VE PUT DOWN
```

Figure 1. Extract from concordance of 'in'

particular text, it seems reasonable to hypothesize some semantic relation whenever a statistically significant association is found. A textual data base at least as large as the Brown corpus (see Kucera and Francis 1967) would be required to be adequately representative. As I did not have at my disposal such a large quantity of text I made use of any modern English text in machine readable form available at the Laboratory. These included the following three main texts: *Each his own Wilderness* by Doris Lessing, *St Mawr* by D. H. Lawrence, and *Joseph Andrews* by Henry Fielding. Some pecularities of the results can be shown to be due to the choice of texts. The data provided a total of 202377 words.

Rather than obtaining collocational sets of every verb in the text (which would be impossible anyway without grammatical taggings), it

seems a more sensible approach to start by examining the particles of which there is only a limited set and to investigate their left-order collocates. This may well yield nouns and adjectives as well as verbs, but there seems no reason to prejudice the analysis by presupposing grammatical categories. The particle selected for this pilot study was *in*, mainly because it is the most frequent (2304 occurrences recorded) and can function as a preposition or as an adverb.

The program to do the collocational analysis is a modification of the general-purpose concordance package COCOA written by me. In order to aid interpretation of the results a concordance of *in*, sorted on the left-hand context, was obtained first. Figure 1 shows an extract of this concordance. The set of all significant first-order left-hand side collocates of *in* whose *z*-score is greater than 3·00 is shown in table 2. A superficial look at this table confirms our intuitions, namely that items such as *interested* and *believe* are more closely associated with *in* than such items as *walk* or *sit*.

collocate	z-score	K	Fc	collocate	z-score	K	Fc
interested	19·5417	10	15	sat	6·0168	7	60
versed	15·6253	4	4	died	5·5652	4	25
lived	10·8156	12	62	interest	5·5016	5	38
believe	10·4247	21	180	life	5·4178	14	220
found	9·7332	15	107	rode	4·7597	4	32
live	9·6771	9	44	stood	4·3505	6	73
ride	8·6582	9	53	walk	4·3205	4	37
living	7·9694	8	49	find	4·3059	6	74
dropped	7·3877	4	12	house	3·9535	11	213
appeared	7·2358	6	34	arrived	3·8899	4	43
travelled	6·9987	4	17	came	3·4035	9	184
die	6·3513	6	42				

Table 2. Significant left-hand collocates of 'in'

The next observation concerns the grouping together of items belonging to the same lemma: *live*, *lived*, *living* and *life* should be collated, and their collocates should appear in a single set. I have not done this for two reasons; the first one being purely practical, namely that I have yet no lemmatization program available and I would like to keep the computational intricacy to a minimum, excluding any dictionary look-up or pre-editing. The second reason is theoretical, and hinges on the fact that the various inflectional forms of an item may well contract different collocational relations, thus precluding the possibility of isolating idioms (e.g. *shake hands* is different from *shake a hand*). Similarly in our example of the collocates of *in*, we might wish to say that *live in* and *lived in* are the same lexical item, but this would not be the case with *versed in* and *verse in*. We expect that, given a large enough sample, all the different

forms of a verb which have identical meanings will roughly exhibit the same collocational associations. However, although I wish to state the principle of keeping different inflectional forms apart for this sort of analysis, in some parts of the subsequent experiment I do conflate some forms, as the scarcity of each form separately would not yield any valid results. Looking at the list in table 2, we must ask whether the information contained here is sufficient to identify those combinations of verb + *in* which are idiomatic and those which are not? Although *interested in* and *versed in* might indeed be deemed more idiomatic than *found in*, we feel that perhaps *believe in* is more of a phrasal verb than *live in*, although the table suggests the contrary. It is difficult to make any predictions about what a truly representative sample would reveal, but it is likely to be the case that, say, *look after* would be fairly low down in the set of collocates of *after* on account of the relatively high frequency of *look* with particles other than *after*. Hence we need to refine our method to obtain a more clear-cut division between idioms and non-idioms.

How is an idiom usually defined and how can it be defined in collocational terms? An expression is said to be idiomatic when the meaning of the whole differs from the meaning of the parts separately; in collocational terms, this would be the case if the expression contracts a sufficiently different set of collocates from the sets of each of the parts. A case in point would be *hot dog* collocating with *eat, mustard, stalls, . . .* whereas *hot* is likely to collocate with *water, weather, air, . . .* and *dog* with *bark, tail, . . .*

I should like, however, to include a second type of idiom, perhaps not normally considered as such; namely those expressions which contract the same collocational sets as the sets of one of the parts. In fact, this means those expressions where the occurrence of one item *always* entails the occurrence of the other. An example from our texts would be *versed in, versed* never occurring without *in*. From a computational point of view, the latter instances would be very easy to isolate, namely by checking whether K is equal to Fc. However, such instances only account for a very small proportion of phrasal verbs, but I would like to suggest that such combinations as *interested in* and *believe in* are very similar to *versed in*; the only difference being that the former verbs can occur without the addition of *in* when used intransitively, e.g. *I am very interested* (*in what you have just mentioned* being understood), or when followed by an object clause e.g. *I believe that . . .* It would be nice to have a single measure which would identify this type of phrasal verb as well as, say, *look after*, perhaps not giving a clear-cut division between idiomatic and non-idiomatic occurrences but leaving the investigator to draw his own limit of significance. I should like to propose the following definition of phrasal verb: those combinations of verb + particle are to be considered as constituting a single lexical item when they contract

different collocational relations from those of the particle as a separate entity. This definition only checks half the normally accepted definition of idiom, namely the meaning of the whole being different from the meanings of *each* of the parts. This would involve establishing that particles have a definite meaning of their own which is independent from that of the verbs they may be associated with. I think intuitively it is accepted that *in* expresses some concept of 'enclosure' in place or time, or *after* expresses follow-up of events. Thus, if it can be shown that *after* habitually collocates with such items as *concert, meal, performance,* . . . but that *look after* habitually collocates with *children, cat, garden,* . . . it is no longer necessary to demonstrate in addition that the latter set would also differ from the set of collocates of just *look* (which would presumably include *happy, unhappy, good, at, in,* . . .). Similarly, if it is clear that the collocational set of *versed in* includes items referring to some skill or academic discipline, whereas the set of *in* mainly includes place names, there is no need to extend the investigations any further and find out whether the set of *versed* differs from that of *versed in*.

collocate	z-score	K	Fc	collocate	z-score	K	Fc
spring	28·1354	3	4	world	9·8196	8	203
spite	26·9920	5	12	London	7·3727	3	53
short	25·4783	10	53	country	7·2987	4	93
reality	24·1014	5	15	voice	7·0130	3	58
afternoon	23·3767	7	31	opinion	6·8814	3	60
fact	21·6487	7	36	pocket	6·8355	2	28
daytime	21·6483	2	3	way	6·7730	5	160
vain	20·3351	6	30	garden	6·3556	2	23
Russia	18·7215	2	4	town	6·3556	2	23
summer	17·5262	4	18	minutes	6·2503	2	33
manner	16·4620	7	61	road	5·6985	2	39
case	14·4996	4	26	night	5·5240	3	88
order	13·5211	5	46	book	5·4666	2	42
morning	13·0070	7	95	America	5·3249	2	44
sense	11·7287	4	39	days	5·3249	2	44

Table 3. Significant right-hand collocates of 'in'

The first step then is to establish the meaning of *in* in terms of the collocational theory. This was done by considering all first and second order collocates of all those instances of *in* which were *not* preceded by some verb, noun or adjective, as these might bias the results by imposing their own collocational relations. Thus only those occurrences of *in* were selected where *in* was preceded by a punctuation mark, denoting that it constituted an adverbial phrase. The total number of such occurrences amounted to 285, and table 3 shows some of the right-hand collocates of *in* in decreasing order of significance.

Without making any specific classification it seems clear that the collocates fall broadly into three semantic categories:

1. idiomatic phrases such as *in fact, in order, in vain, in spite, . . .* (the identification of which I shall not go into).

2. nouns denoting a time span (e.g. morning, evening, summer, . . .).

3. nouns denoting places (Russia, town, London, . . .).

The next step is to examine the collocates of each of the items in table 2 and compare them among themselves and with those of *in*.

interested in (15)	find in (21)	sat in (7)
architecture	ditch	seat
politics	*book	coach
housing	health	corner
Philip	*pocket	middle
R=0/4=0	*world	
	R=3/5=0·6	stood in (6)
versed in (4)		garden
politics	ride in (13)	place
history	park	
Greek	chariot	walk in (4)
R=0/3=0	coach	fields
	front	neighbourhood
live in (43)		sleep
hut	dropped in (4)	
house		house in (11)
*town	appeared in (6)	*village
*country	parish	*parish
*London	road	*London
*room	doorway	Westminster
*world		yard
*place	travelled in (4)	kingdom
family	coach	R=3/6=0·5
happiness	company	
ignorance		arrived in (4)
R=6/11=0·54	die in (10)	coach
	prison	America
believe in (21)	torture	park
witchcraft	defence	minutes
God	sleep	
Jesus	*minutes	came in (9)
Devil	R=1/5=0·2	
Paradise		
R=0/6=0		

Table 4. Collocational sets of all items significantly followed by 'in'. Asterisks denote collocates also appearing in table 3.

Table 4 shows the collocational sets of all items significantly followed by *in*. The span size is calculated to be two items to the right but not

exceeding the sentence boundaries (this allows for intervening articles and pronouns). It appears that a few items do not have any right-hand collocates. This must obviously be the case where *in* terminates the sentence and hence functions as an adverbial particle. The two instances of adverbial *in* in our data are *dropped in* and *came in*. Since there are so few of them I propose to dismiss a detailed study of these instances for the time being in order to concentrate on the prepositional cases. However, one suggestion which might be worth considering and which presents a computationally very simple solution is to consider all occurrences of verb + adverbial particle as 'phrasal verbs'. I would not object to a lexical analysis which treated *come in, come out, come over, come up*, . . . as separate entries from *come*. Indeed, this view of their status is borne out by the fact that most of them respond positively to at least one of the criteria mentioned at the beginning, namely the possibility of replacement by a single item (e.g. *come in* by *enter, come out* by *leave, come up* by *mount*, etc.).

	in	find in	appear in	arrive in	stand in	walk in	travel in	ride in	sit in	live in	house in	die in	interested in	versed in	believe in
conurbation terms	*	*	*	*	*	*	*	*		*	*	*			
habitation terms	*	*	*	*	*					*	*	*			
environment terms	*	*	*	*	*	*	?	*	*	*	*	*			
vehicles	*	*	*	*				*	*	*		*			
long time lapse	*	*	*	*			*	*	*	*		*			
short time lapse	*	*	*	*			*	*	*			*			
objects	?	*	*												
moods										*		*			
supernatural													?		*
academic disciplines														*	*

Table 5. Intersections of the different collocational sets

However, I am only throwing in this suggestion for discussion as it seems an easy solution which may to some extent be a plausible one. Returning now to the other items on the list, it is obvious that the results are very limited and that far more data should be analysed before any solution can be reached. It seems that some collocates are shared by more than one verb, such as *coach* by *arrive in, ride in*, etc.

I attempted to draw up a matrix showing on the vertical axis all collocates of all the different phrases as well as those of *in* separately, and on the horizontal axis all phrases, marking the intersections of shared collocates. As such a matrix would be unwieldy and large, I had to limit myself to grouping together items under some embracing

concept, such as *summer, spring, night, morning* under 'long time lapses' and *minute, hour, instant* under 'short time lapses'. Table 5 shows a matrix of the intersections of the different collocational sets.

I shall not go into detail of how semantic groupings emerge, such as (*walk, travel, ride*) or (*live, house, die*). I have already shown (Berry-Rogghe and Crawford 1973) how a collocational analysis can be used to construct a thesaurus. The part of this diagram I am interested in is that which shows that three items are completely disconnected, although perhaps mutually related, namely *interested in, versed in* and *believe in*. This seems to present clear proof of their idiomatic character. However, in order to construct a computerized lexicon, some more precise way of formulating this difference is called for.

The method proposed is simply to calculate the ratio between the number of collocates which are shared with *in* and those which are unique. If no single collocate is shared, then the ratio will be zero, regardless of the extent of the set. Thus *versed in, interested in* and *believe in* all get zero ratings. What this ratio in fact measures is not so much the degree of idiomaticalness as the degree to which the phrase derives its meaning from the meaning of the particle. Perhaps it would not be correct to say that *live in* is more idiomatic than *die in*, but it signifies that in the latter case the meaning of *die* is more dominant in defining the co-occurrences, whereas in the case of *live in* the meaning of *in* plays a greater part in the selection of the collocates.

I think we can fairly confidently predict that other instances of phrasal verbs such as *look after* would emerge with zero ratings. But nevertheless the approach suggested here needs to be tested with a far more extensive corpus. It has the advantage of being simple from a computational point of view. Finally I would like to suggest that having established the 'phrasal verbs' in the English language as a whole, the same technique might be applied to particular texts in order to point out the idiosyncratic use of particular combinations of verb + particle for stylistic effects.

REFERENCES

Berry-Rogghe, G.L.M. (1971) The scope of semantics. *Linguistics*, **73**.

Berry-Rogghe, G.L.M. (1973) The computation of collocations and their relevance in lexical studies. *The Computer and Literary Studies* (ed Aitken, A.J. *et al.*). Edinburgh: Edinburgh University Press.

Berry-Rogghe, G.L.M. & Crawford, T.D. (1973a) Developing a machine-independent concordance program for a variety of languages. *The Computer and Literary Studies* (ed Aitken, A.J., *et al.*). Edinburgh: Edinburgh University Press.

Berry-Rogghe, G.L.M. & Crawford, T.D. (1973b) *COCOA Manual.* Atlas Computer Laboratory, Chilton, and University College, Cardiff.

Carvell, H.T. & Svartvik, J. (1969) *Computational Experiments in Grammatical Classification.* The Hague: Mouton.

Chomsky, N. (1965) *Aspects of the Theory of Syntax*. MIT Press.

Firth, J. R. (1957) Modes of meaning. *Papers in Linguistics 1934–51*. London: Longmans.

Kučera, H. & Francis, W. N. (1967) *Computational Analysis of Present Day American English*. Providence: Brown University Press.

Palmer, F. R. (1965) *A Linguistic Study of the English Verb*. London: Longmans.

K. L. Su

The creation of a set of alphabets
for the Chinese language

The elements of the Chinese written language are called characters. One peculiarity of the Chinese written language is that each character, no matter how simple or how complex, occupies the same rectangular block. The uniformity of the character size has its advantages. But it is a technical and engineering nightmare. The following is a summary of several aspects of the language that have challenged scholars and engineers for a long time.

LEXICOGRAPHY
There are three groups of systems in use in indexing the characters for dictionary purposes.

The radical system. This is the oldest and the most commonly used system. In this system, each character is said to have a dominating component which is the radical of the character. In a dictionary using this system, all characters having the same radical are grouped together. There are, however, many shortcomings in this system. For example: (a) there is no simple rule to enable one to tell which part of a character is the radical; (b) the radical of a character does not always appear in its original form; (c) some radicals are identical in appearance and yet are considered different; (d) the numbers of characters grouped according to the radicals vary widely.

The phonetic systems. There are several indexing systems in use that are based on the pronunciation of the characters. One of them is the *Chinese National Phonetic Script* adopted by the government in 1920 and still in wide use, and there are several versions of Romanized phonetic systems.

Another peculiarity of the language is the fact that each character is monosyllabic. Moreover, the number of phonetic syllables used in the language is amazingly small. In the Peking dialect, on which the official pronunciation is based, there are only approximately 420 syllables, some of which are so similar that they can only be distinguished by highly trained ears. There are numerous other practical difficulties with the use of a dictionary based on pronunciation: (a) minor variations in pronunciation do and will probably continue to exist from region to region in a country, and from country to country; (b) there is no permanency in the way characters are pronounced; (c) there are a large number of homonyms in Chinese; (d) some characters have several different pronunciations; (e) a person with a rather small vocabulary

in Chinese or a person who does not speak Chinese will not find a phonetic indexing system very useful.

The stroke-form systems. There are several systems that are either in use or being proposed. These systems are typically quite effective since they are based strictly on the geometrical appearance of a character or the sequencing of its strokes. One major drawback of such systems is that they are useful for searching purposes only, but not for identification.

TYPEWRITING

Chinese cannot be typed in the same way as alphabetized languages. A mechanical Chinese typewriter consists of a collection of types of frequently-used characters. Certain mechanisms are provided to pick up one type at a time and strike the paper under a ribbon. These machines are bulky, their operation cumbersome, and their applications very limited.

Several types of electronic typewriter have been reported in recent years. A number of such typewriters use the grouping or classifying method of selecting the character to be typed. Another has a keyboard of 4600 Chinese characters and 200 other symbols (Kierman and Barber 1969). The depression of a key sends a series of digital signals corresponding to an address in a read-only memory (ROM). These signals cause the printer to print a dot matrix based on the information stored in the ROM.

TELECOMMUNICATION

For nearly a century the workhorse in sending messages in Chinese through wire or radio has been the Standard Telegraph Code. Some 8000 characters are listed in a code book in which a four-digit number is assigned to each character. The text of a message is encoded in the form of a series of numbers which are then transmitted via Morse Code or Teletype.

Electronic typewriters that use intermediate digital signals are directly adaptable to telecommunication purposes. In principle, teletypewriting would be achieved if a communication channel were inserted between the keyboard and the electronic printer. Hardware is apparently being developed for this application.

TYPESETTING

The traditional manual typesetting of Chinese texts is a slow and cumbersome process. Recently, however, semiautomated and electronicized schemes have been developed.

A distinct advantage in mechanizing the Chinese writing system is the fact that all characters are of uniform size. Thus the problem equivalent to that of justifying both margins does not exist. This makes it possible to type any written material and then print it by photolithography. Hence the automation of typesetting is very closely related to the development of typewriting.

COMPUTER APPLICATIONS

The only computer processing of any magnitude known to us which uses Chinese characters is the effort associated with the machine translation of Chinese into English (Wang *et al.* 1971). The problem here is mainly that of inputting Chinese characters through codes which the machine can digest.

We know of no successful computer-oriented project that makes exclusive use of the Chinese language. Apparently no system has yet been developed in which the programming language, compiler, software, and input and output hardware all employ Chinese as the basic medium between the computer and its users.

PEDAGOGY

The teaching and learning of written Chinese has always been a tedious and trying process. The acquisition of a recognition vocabulary sufficient to enable a person to read the newspaper will typically require six or more years; and the memorization of several thousand ideograms and their associated meaning will require many hours of hard work during those years.

A CASE FOR DISASSEMBLING THE CHARACTERS

One of the most difficult aspects of written Chinese is the fact that the positioning of the constituent components of a character is so irregular. Instead of the constituent components appearing serially as in an alphabetical language, they are generally arranged in a pyramid fashion until a rectangle is filled in a balanced and pleasing manner. From an engineering point of view, this arrangement is extremely unfortunate. The price we pay for uniformity of character size is the cumbersomeness encountered at every stage when we try to systematize or mechanically process the written language.

We have found that for many technical purposes, the pyramid-like arrangement is not essential. Hence we can treat Chinese as if it were an alphabetized language without ever altering the language itself. A brief parlor game with a few persons who know the Chinese language will quickly demonstrate that the components of a character can be rearranged without affecting their recognizability. The reader will merely mentally rearrange the components in their conventional combinations. Based on this observation, we proposed that the Chinese characters be represented by a set of symbols which are components of the original characters. These components can be arranged sequentially in the same order as they are written naturally. This makes the writing of any Chinese document in terms of these symbols a very simple matter. For many purposes, such as computer outputting or telegraphy, it would be sufficient to leave the output or the message in the disassembled form. A person who is versed in the language could readily read the material in

this form with no special training and with no mechanical or referential aid.

As a first step toward developing the set of symbols (Su 1972), we decided to take a set of frequently used characters and divide them one by one into smaller entities. The set of characters chosen was the 4600 character-set included on the keyboard of the electronic typewriter designed by C.C. Kao.

Figure 1. Examples of components from Chinese characters

Obviously, there are two alternatives we can take in dividing the set of characters. On the one hand, we could divide each character up into rather large chunks. Some examples are shown in figure 1(a). In this way, we would expect to end up with a fairly long list of symbols (in the order of 1000).

On the other hand, we could divide each character up very finely until each symbol approaches a single stroke. If we did this, the list of symbols would be fairly short (in the neighborhood of thirty). But the number of symbols required to represent most characters would be too large. Furthermore, the task of reassembling a sequence of strokes to form the character whence they came would be almost an impossible task.

Obviously, a happy medium would be a compromise between these two extremes. As a first step we divided the 4600 characters into smaller entities. Some subjective but judicious decisions had to be made as to how finely we should divide each character. Several random examples are shown in figure 1(b).

The 481 entities resulting from this round of division are termed *subcharacters*. These subcharacters are summarized in table 1. The average length of this breakdown is 3·56 subcharacters per character. We are now in a position to scrutinize this list and see how far we can further reduce the number of symbols.

For reasons of readability and clarity, we found it desirable to adopt a notation '←'. This notation will be used to indicate that the component to the right is to go inside the one to the left. Two examples are shown in figure 1(c).

In the second round of subdivision, the following schemes have been used:

1. Natural stroke sequence. Many subcharacters in table 1 are composites of other subcharacters. They can be subdivided in exactly the same way subcharacters in table 1 were obtained from the characters. Several examples are shown in figure 1(d).

2. Modification of subcharacters by one or two strokes. A large number of subcharacters in table 1 differ from other subcharacters by only one or two strokes. These additional strokes can be transcribed separately and the subcharacters subdivided. Several examples are shown in figure 1(e).

3. Disengagement. Another group of subcharacters are also combinations of subcharacters. Strokes of subcharacters of this typically intersect each other. Or else, strokes of a second component are started before those of the first component have been completed. We shall indicate this type of combination by the '*' sign. The component to the left of the '*' sign is the one whose initial stroke precedes the initial stroke of the component to the right. Several examples are shown in figure 1(f).

4. Dissection. A rather bold step is taken in this type of subdivision. A subcharacter is cut into two or more components each of which is another subcharacter. In this process, strokes are invariably severed and the number of total strokes of the components is larger than the strokes of the original subcharacter. We shall indicate this type of subdivision with a '→' sign. This sign indicates that the two components were

SPELLING

SUBCHARACTER

Table 1. Subcharacters and Chinese *alphabets*

originally physically connected together in some way. A few examples are shown in figure 1(g).

5. Creation of new subcharacters. Components that are common to several subcharacters but are not subcharacters in the first round of division can be introduced to reduce the total number of subcharacters. These subcharacters are shown in figure 1(h).

6. Substitution. A number of subcharacters or their components in table 1 are sufficiently similar that one may be replaced by another without loss of clarity when used with other subcharacters to represent certain characters. Three examples are shown in figure 1(i).

The result of the second-round of subdivision is summarized in the column marked SPELLING in table 1.

The result of this analysis is a set of symbols which can represent practically all Chinese characters. These symbols are actually graphemic components of the Chinese characters. Except for the pronunciation, this set of 210 symbols plays a role very similar to that of the conventional alphabet. Until a more suitable term is coined, we shall call these symbols the *alphabets* of the Chinese written language. They are tabulated in table 2.

We checked this set of *alphabets* against a dictionary which contains approximately 15 000 characters including some traditional simplified

為 門 鳥 亞 其 門 血 隹 卑 金 臼 身
鳥 曲 甫 酉 耳 西 臣 且 巳 曲 曲 四
臼 舟 㕣 夕 亥 丑 丯 甘 戊 北 业 以
目 由 申 甲 电 田 央 昌 四 皿 片 牛
丘 广 冫 永 阝 氺 毋 羊 丯 天 夫 王
主 廿 业 木 屯 止 疋 曰 日 中 四 牛
手 毛 土 斤 彡 月 勹 灬 火 衤 心 辶
尹 屮 月 尸 巴 丑 毋 三 于 丯 工 士
土 艹 扌 廾 大 丈 弋 山 少 小 囗 口
山 巾 巾 千 夂 川 巛 犭 久 夂 夕 ㄑ
忄 氵 灬 ㇏ 彐 尸 屮 己 已 巳 弓 也
女 又 匕 八 亚 阝 乃 乡 幺 孑 巛 二
十 亅 丁 亍 厂 丆 丆 匚 弋 弋 卜 丿
丿 卜 门 几 乚 亻 刂 人 亅 八 入 乂
儿 乜 勹 九 乚 勹 勹 亠 丷 冫 𡿨 宀
匕 コ ユ 屮 卩 凵 厂 又 刀 力 匸 厶
乛 卩 了 一 丨 亅 丿 乀 丶 乛 乚 乙
乙 乛 乚 乛 丨 乛

Table 2. Tentative Chinese *alphabets*

characters. Yet we found only about a dozen characters that are not readily spellable by this set of *alphabets*. These characters are shown in figure 2. Most of these characters are archaic and are of no practical importance.

The set of *alphabets* in table 2 is by no means final. Many of them can be further subdivided. With some further subdivisions, the number of *alphabets* can be reduced to approximately 160. A little more effort could easily reduce this number to 140, and the ultimate goal of 120 is not unthinkable.

SOME OBSERVATIONS AND APPLICATIONS

The set of characters we used to derive our *alphabets* are standard characters. In the People's Republic of China, an abbreviated version is now in use. A survey of the abbreviated characters used in China now shows that almost all of them can already be accounted for by our *alphabets* (Hsia 1956). We have found only those simplified characters shown in figure 1(j) difficult to represent with our *alphabets*. We may

外 (酉) 月 (帽) 冄 (再) 卍 (萬) 斨 (斷) 簾

眀 (明) 栯 (栯) 示 (祇) 半 (呼) 褒 (襃) 兩

Figure 2. Some ancient characters not readily spellable.
Contemporary version is shown in parentheses.

either treat such characters as additional *alphabets*, or use mostly single-
stroke representations, or else we may revert to the standard representa-
tion of them.

Figure 3 shows an example of a passage written in both the standard
and the spelled-out forms. Perhaps one of the most appealing features
of this system of spelling is the fact that the *alphabets* are derived from
the characters themselves. Hence characters expressed in terms of these
alphabets are directly readable. For a person to learn to read the spelled-
out version, he only needs to be told that the components of each
character have been rearranged and to have the three notations (←, *,
→) explained to him.

大學之道在明明德，在親民，在止於至善.

大 臼ㄨㄨⴱ了一 之 辶ㆍㄒ目 ナ丨土

日月 日月 ノイ十四一心， ナ丨土

亠ㆍ一木目儿 ㄅㄴㄟ， ナ丨土 止

亠力人ㆍㆍ 一厶土 ㆍ王艹口.

Figure 3. A Chinese passage also written in terms of
the *alphabets*

With the development of this set of *alphabets*, two immediate applica-
tions are possible: telecommunication and computer input/output. The
slight loss in readability in these applications when the spelled-out
Chinese is used is not of any grave consequence. Telegraphic messages
are typically short and the addressee usually has a good idea what to
look for in the message. The vocabulary used by an individual computer
user is typically small. Even if this were not the case, a slightly slower
reading speed is of no serious handicap in off-line applications.

On the other hand, the advantages of using the spelled-out form of
Chinese are quite significant. The use of an intermediate code unrelated
to Chinese is eliminated. The training cycle of operators is very short.

And above all, the cost of terminal equipment is greatly reduced. As a demonstration of these advantages we are now in the process of constructing a set of prototype equipment, which will consist of a paper-tape puncher and a tape interpreter.

The puncher will have a keyboard with 256 keys, which will be allocated in the following manner: 210 Chinese *alphabets*, 26 English letters, 10 numerals, 10 notations and punctuations, including, of course, a blank. The depression of a key will punch an 8-bit binary code on a standard computer paper tape.

The interpreter will read a punched tape and electronically convert the series of 8-bit codes into dot matrices. The dot matrices are seven dots wide with variable heights, up to eleven dots for some *alphabets*. The printer is a 7-line dot printer with its electronic circuits modified to provide for variable horizontal spacing. The interface between the tape reader and the dot printer is simulated by a minicomputer.

Since most existing teletypewriting equipment uses 8-bit binary codes, our experimental equipment is all that is needed to transmit Chinese. In an off-line operation, tapes with Chinese encoded on it may be prepared separately. Then the tape may be fed into a teletypewriting system. A replica of the tape is produced at the receiving end. The reproduced tape can then be interpreted by an off-line interpreter.

In computer inputting, the tape-punching mechanism will be replaced by an interfacing circuit. In outputting, another interfacing circuit is all that is needed between the computer and the dot printer.

The cost of the equipment required for these applications is much less than any other form of hardware that uses Chinese directly. For example, the Chinese electronic typewriter that is used in some projects in the US costs approximately $25000. The equipment using the spelled-out characters can be produced for less than $1000 if the number of units produced is sufficiently large.

Another application of these *alphabets* is as an aid to learning the written Chinese. A person can first learn the *alphabets*. After that it should be easier for him, both psychologically and technically, to learn the characters because he can recognize the characters in terms of the *alphabets*. We do not believe that the learning of the Chinese written language could ever be made as easy as learning truly alphabetical languages. However, it would be a great help for a student to realize that the symbols contained in written Chinese are actually quite limited in number.

Some of the *alphabets* are already pronounceable. Others need to be given pronunciations. When the final set of alphabets is firmly established, the sequencing of the *alphabets* can possibly be done on the basis of certain rhythmic and tonal qualities. Then the *alphabets* can be

ordered such that they can be easily chanted and memorized. Once this is achieved, Chinese dictionaries based on the *alphabets* can be organized.

CONCLUSIONS

The main purpose of this paper is to demonstrate that a direct symbolic representation of written Chinese by a set of *alphabets* is possible. Although the number of *alphabets* is still considerably larger than the characters of most alphabetical languages, it is still far smaller than the tens of thousands of Chinese characters.

In recent decades, linguists, philologists and engineers have devoted considerable effort to the various aspects of mechanizing or systematizing the language with no major success. To this writer, one of the main reasons for their lack of success is that no matter which application was at hand, investigators insisted on dealing with the characters as they were. Thus the complexity of the symbology and the task of producing the tens of thousands of complicated ideograms apparently consumed most of their time and energy. Our analysis enables us to divide that formidable task of representation into several smaller steps. Our spelling technique is merely the first of several steps necessary before the entire problem can be satisfactorily solved.

In our research, we have dealt only with the problem of how to recognize, analyze, and handle Chinese characters as a set of symbols. Our procedure is based on the observation that the pronunciation of a character is largely unrelated to its shape or form. Hence it is our belief that written Chinese and spoken Chinese must be dealt with separately. The dichotomy of spoken and written Chinese makes the spelling of Chinese with our *alphabets* very different from the spelling of a truly alphabetical language, in that the spelling of a Chinese character gives practically no information on its pronunciation.

The ultimate goal in most applications is to have the characters output in the assembled form *economically*. Considerable work has been done in the area of generating complete characters using general-purpose computers (Hayshi *et al.* 1968, Fujimura 1970, Chang 1973). To take advantage of results in this area, all we need is an indexing scheme to call up the information required each time a character is being written. However, the memory storage requirement for this approach is typically quite extensive. In situations where this requirement can be met, our spelling method appears to be a good system to use.

An alternative approach is to input the components of each character as well as the appropriate information regarding the relative positioning of these components. Some scheme is then devised to synthesize the character based on these inputs. The disadvantage of this scheme is the length and complexity of the input for each character. Also it appears that the synthesis schemes have yet to be perfected. Hence the most

promising approach to the eventual satisfactory solution of this problem appears to hinge on the following:

1. A topological analysis of all useful characters so that they can be classified according to the way their components are situated within each character or with respect to one another. Once this is done the positional information can be pre-stored in a machine. Only components need be input. The positional information would be automatically coupled with each set of character components input. If this is done, both the length of the input and the size of the storage required would be greatly reduced.

2. The perfection of a synthesizer to render a character from its components and positional information thereof. For preliminary research, this could be simulated on a general-purpose computer. Ultimately it would be desirable if the synthesizer could be fabricated in hardware form, either digitally or by taking advantage of some physical properties of certain materials or devices. To this writer, this would be the major breakthrough that could really make the difference.

REFERENCES

Chang, S. K. (1973) IEEE Trans. on Systems, Man, and Cybernetics, SMC-3, 257–65.

Fujimura, O. (1970) A pattern structural code for Kanji. Presented at the Tokyo International Conference on Input/Output Systems for Japanese/Chinese.

Hayshi, H., Duncan, S. & Kuno, S. (1968) *Communications of the ACM*, **11**, 613–8.

Hsia, T-T. (1956) *China's language reforms.* (Mirror series A, 21) New Haven, Conn: Yale University.

Kierman Jr, F. A. & Barber, E. (1969) *Unicorn*, **3**, 29–73.

Su, K. L. (1972) Symbolic representation of the Chinese written language. *Research Report No. E21-620-SU-1.* Georgia Institute of Technology, Atlanta, Georgia 30332.

Wang, W. S-Y. *et al.* (1971) Research in Chinese-English Machine Translation. *Research Report No. RADC-TR-71-211.* University of California, Berkeley, California 94720.

Why and how do we study the sounds of speech?

Perhaps not everyone will recognize that the title of my paper is borrowed from an article contributed by Morris Halle at a Georgetown Round Table Meeting. In echoing his words of 1954 to pose these fundamental problems in all of phonology, I wish to call attention to the immense influence that Halle has had on the subject during these two decades, including, of course, on my own development in this field. I can remember clearly the satisfaction I felt in first reading that article by Halle, which enabled me to see much more lucidly than before the goals and the methodology of phonology.

Of the many things in that 1954 article that impressed me, above all else was the uncompromising position that Halle took in embedding phonology in its physical and social context. Here are some quotations that exemplify that position:

'No matter how we explicate the term *phonetically similar*, it requires that we appeal explicitly to physical reality: to articulatory positions, to acoustic phenomena. We, therefore, conclude that phonemics . . . appeals explicitly to physical reality, and hence cannot be concerned solely with the *incorporeal* aspects of language.'

'A science of phonetics that disregards the social function of the language is as trivial and barren as a science of phonemics that refuses to take into consideration the material aspect of language, its sounds.'

These firm statements by the chief protagonist of generative phonology, one would think, should have anchored the study of speech sounds solidly on the empirical foundations of physical and social observations. Paradoxically, however, the development of generative phonology over these two decades has gone far astray from these empirical foundations. *The Sound Pattern of English* (Chomsky and Halle 1968), it would seem, illustrates exactly the sort of excessive concern with formalism that Halle himself warned us against in 1954, when he wrote:

'Students of language, no matter what their field of specialization, are interested in the question of how human beings communicate by means of language in general, and by means of a given language in particular. . . . This primary interest also makes it impossible for us to discount physical considerations, since *real languages are not minimal redundancy codes invented by scholars fascinated by the*

powers of algebra, but social institutions serving fundamental needs of living people in a real world' (emphasis added).

An extreme example of the seductive powers of pseudo-algebra is the appendix on formalism that appears at the end of chapter 8 in *The Sound Pattern of English*. In the fascination with all the variables, abbreviatory devices, and simplicity measures, the linguist's fundamental concern with the sounds of speech is completely submerged by a sterile game with a set of largely ad hoc features. The methodological flaws of the SPE are numerous. Among the major ones are its assumption of homogeneity of phonological behavior for the entire lexicon, its disregard of well-known phonetic facts in the selection of the feature set, its appeal to a simplistic notion of evaluation as the overriding theoretical constraint on competing analyses, etc.

There are some things in the SPE which are new proposals, such as the principle of cyclic rule ordering, the feature of heightened subglottal pressure, etc. These new proposals have been shown to be mostly in error or amenable to improved interpretation. There are, of course, many facts about English alternations gathered together in this volume. But by far the majority of these facts are the accomplishments of English scholars such as Jespersen, and structuralists such as Trager and Newman, and are certainly not new with the SPE. Indeed, given the severe methodological handicaps just mentioned, one would be hard put to find many results in the SPE that can be considered both true and new.

Since I have on several earlier occasions given detailed critiques of the SPE, in two lectures at the Linguistic Institute, Columbus 1970, and in a paper at the International Phonology Symposium, Vienna 1972, I will say no more about it at this time beyond noting again that generative phonology has strayed far from the sensible position that Halle himself took back in 1954 when he asked why and how do we study the sounds of speech. It is time that this fundamental question is seriously posed again. Indeed, there is a growing awareness of the intrinsic limitations of the direction that generative phonology has taken. It is heartening to read Kiparsky's suggestion (1972, 189) that phonology should 'return . . . to traditional functionalist questions: how phonological structure is grounded in the requirements of speech performances, in the broad sense of perception, production and acquisition.'

Of the two parts embedded in the question, the 'why' is the easier one to answer. There is surely no need to reiterate here all the arguments regarding the unique importance that language has for man's internal consciousness as well as for his interactions with the external world across time and space. And the sounds of language which we make our subject of study constitute one of the two major avenues one can take toward an understanding of how language emerged and how language works, the other being meaning.

The faculty of language can be broken down into three components: (a) the ability to acquire and manipulate a class of meanings or concepts; (b) the ability to acquire and manipulate a class of signals; and (c) the ability to associate strings of concepts with strings of signals. Obviously both the concept and the signal must exist in order for the association to develop. In the case of human language, the signals are primarily of a particular sort; the articulatory-auditory, or phonetic, ones.

In the traditional literature which deals with the emergence of language, the usual understanding is that language has not evolved in subhumans because they are incapable of developing (a), the conceptual component. The feeling that the conceptual component is the bottleneck to the emergence of language rather than the signal component is no doubt encouraged by casual observations of talking birds on the one hand, and of the dexterity in the control of facial and masticatory muscles in apes on the other.

Recent work on chimpanzees, however, suggests that the relative importance assigned to the conceptual component and to the signal component should be carefully re-evaluated. It seems that chimpanzees *can* be successfully taught a class of concepts, as well as a class of signals to associate with these concepts. But this success was achieved only by substituting for the phonetic signals of human language other types of signals.

I am referring, of course, to the experiments of the Gardners with Washoe and the Premacks with Sarah. The signals that Washoe uses are gestures based on the American Sign Language. Sarah, on the other hand, uses coloured plastic blocks placed on a board. The Premacks (1972) report that Sarah has a vocabulary of 'about 130 terms that she uses with a reliability of between 75 and 80 percent'.

Some of the ways in which those terms are used by Sarah are linguistically quite sophisticated, including rudimentary forms of interrogation, conditional relations, and even a small amount of conjunction reduction. There is no question that a chimpanzee has been taught to associate a class of concepts with a class of plastic blocks. Furthermore, it is likely that with improvements in the teaching method, future chimpanzee students may learn even more terms than 130, as well as more types of syntactic constructions.

After many decades of devoted efforts to teach language to animals, these breakthroughs with Washoe and Sarah have been achieved by replacing the medium of the signal from articulatory-auditory ones to gesticular-visual ones. Previous efforts failed because the experimentors did not realize that the significant bottleneck was not that in the conceptual component, but that subhumans are incapable of producing the sounds of speech. The visual signals have several obvious limitations which phonetic ones do not have: visual signals require the use of hands

and arms of the sender, they require the continuous visual monitoring of the receiver, they cannot be transmitted in the dark or across great distances, and they have a much lower ceiling as to the number of distinct signals and as to the rate at which these signals can be transmitted.

While it is true that a class of concepts can be associated with a class of signals of any medium or make, human language derives its tremendous wealth by having evolved along phonetic lines. It is difficult to conceive of any other system of bodily signals that could have been evolved that could function adequately as the carrier of man's rich stock of concepts.

In the light of these observations, it is not unreasonable to speculate that hundreds of millennia ago, whenever it was that apes first began bipedal walking and social living, communication systems among them evolved along distinct paths. The path that evolved with visual signals did not, for the limitations just mentioned, lead into sophisticated language. However, the path followed by our ancestors with the use of phonetic signals had a much greater potential for refinement and elaboration, and through the long mutually-supportive developments of speaking and thinking, ultimately led to human language as we know it today. Man's sounds, then, are a crucial ingredient in the emergence of his language, and should be studied in that perspective.

This capacity we have for controlling speech sounds is a more finely-tuned ability than that used in any other motor activity we engage in. Every time we utter a simple sentence, hundreds of muscles are called into play, coordinating with each other to a degree of precision that can only be measured in terms of milliseconds. Some of these muscles are large and massive, such as the diaphragm that regulates the air flow. Others contain just a few fibers, such as the vocalis muscle, which forms a part of the vocal folds and controls the mode of phonation. And the activities of these muscles are innervated by a complex network of nerve fibers, varying greatly in length and in cross-sectional area. At least seven of the twelve cranial nerves are directly involved in the production of speech sounds. Looked at strictly from the viewpoint of delicately tuned motor activities as they flow in time, the virtuoso performance of a Rubinstein at the keyboard is several magnitudes less demanding than a five-year-old child uttering a simple sentence.

In these considerations, we must not be too narrowly concerned with merely the observable aspects of the motor activity. Just as the ability to move one's fingers does not imply one can play the piano, physical control of the muscles used in articulation does not imply the ability to speak. If I may appropriate some terms from computer terminology, the 'peripheral hardware' here is surely the lesser part of the story, the critical part has to do with where the 'software' is stored and how it is organized. To answer these questions, we must look at not only the

movement of the tongue *vis-à-vis* the palate, but also into the brain, where the 'programs' for these movements are stored. Understanding of man's phonetic ability will ultimately come from research into both the hardware and the software of speech.

It is easy to see that the programs for vocalizing are stored in altogether different places for man and for the subhuman primates. Whereas speech can be systematically interfered with by electrical stimulation to the different portions of the cerebral cortex, monkeys do not vocalize when stimulated at similar places. Rather, they would vocalize when the electrodes are inserted deep into the limbic system, lying not on the surface but in the core of the brain. This is one way in which the different language capabilities of man and subhuman primates are reflected by corresponding differences in brain structure.

An important region in the brain structure is the angular gyrus, a portion of the brain which is well developed in man but minimally or not all developed in the other primates. The neurologist Geschwind has conjectured that in particular the angular gyrus region in man's brain has facilitated the acquisition of the ability to make cross-modal associations. It is this ability which underlies the process of object naming, the association of a visual object with an auditory event. Such an explanation would account for the fact that, at least so far, subhuman primates have not exhibited much ability for cross-modal association in learning experiments. Sarah and Washoe can learn to express the visual world around them only through visual signals, not through the articulatory-auditory signal produced by man.

For over a hundred years now, a steady pool of information has been accumulating which bears upon how language is coded in the brain. The bulk of this information comes from studies of people who have suffered injuries to the brain, from tumors or hemorrhage, from wounds, and from other causes. Such information is of vital interest to students of language in that it will help provide an organic basis for observed behaviour. And it is a very encouraging development in our field that more and more linguists are turning their attention to such information. This direction, I believe, will prove to be fertile and rewarding for the study of speech sounds.

Here are some samples of a few intriguing findings which bear on language in general. In the 1870s and '80s, H. Jackson conjectured that automatic utterances like greeting, apologies, etc., may be stored in both the left and the right hemispheres of the brain, whereas voluntary or propositional utterances may be in the left hemisphere only. The implications are that the creative use of language and the ritual use of language are controlled by different neural systems, and any theory that attempts to homogenize the two types of data would be going against behavioral evidence. (See also the cogent remarks in Van Lancker 1972.)

One also finds a consistent difference in how morphological categories are preserved in aphasic speech. Nouns are usually best preserved, in that the patient can repeat them when auditorily presented or read them when visually presented. Adjectives are better preserved than verbs. Morphologically complex forms are much more difficult than simple forms. In a study of receptive alexia in a German woman, Weigl and Bierwisch (1970) found that she had a 90 per cent success for nouns without prefixes, as opposed to 35 per cent for nouns with prefixes. The distinction held for verbs, too, though less strikingly: 57 per cent for prefixless verbs *vs.* 38 per cent for prefixed verbs.

These findings are clearly related to the results reported by Gazzaniga (1970) obtained from subjects with bisected brains. In flashing words to the right hemisphere via the left visual field, the subjects have no trouble with simple forms like *butter* and *letter*; suffixed forms like *locker* and *trooper* are more difficult. And 'in the extreme case when *fall* or *hit* or *jump* are used as nouns, all patients were unable to process the words meaningfully' (p. 120).

Also related is the observation that morphemes outside of the major classes are particularly difficult. Weigl's patient was unable to read *es* (it), saying 'one of those horrible little words again'; whereas she read the little word *ei* (egg) without any hesitation. Or, to take the words of Kurt Goldstein (1960) from a different context:

'Failure to understand these small words when spoken isolatedly may reveal itself in a very peculiar way. For example, when the patient hears the sound *for* that is similar to the sound of the word *four*, he may be able to understand the sound only in its numerical context, assuming this is appropriate to the situation in which it is presented. However, the patient will not be able to react in any way if the sound presented does not, for him, belong to an experienced, concrete situation. Therefore, the sound of the word *for* used by us as a preposition is totally without meaning for him and, as a consequence, he cannot do anything with it. He cannot copy it, he cannot read it, and he cannot speak it or repeat it' (p. 46).

There are many other interesting pieces of data of this sort. For instance, there are cases of paralexia reported where the subject is asked to write down from dictation or to read out loud from cards. Semantically-related concepts would be confused; so when the examiner dictates *cousin*, the patient writes *nephew*, or when the patient is presented with a word *liberty*, he reads it as *freedom*. The concepts are somehow short-circuited in the brain, and the wrong signal comes out.

Even more intriguing is the recent finding of some Japanese researchers (Sasanuma 1972). Many Japanese words have two written forms, one in a phonetic syllabary (*Kana*) and the other in Chinese characters (*Kanji*). It seems that these two modes of orthography are processed

neurally in independent ways, and some aphasics lose one mode without losing the other. A patient of Imura Tsuneo with damage to Broca's area was asked to write *inki*, a word borrowed from English into Japanese. He first wrote the complicated Chinese character for India ink, which is actually pronounced *boku* or *sumi*. When asked specifically to write it in *Kana*, he was unable to do it correctly, even though the *Kana* is graphically much simpler, and has a direct phonetic content.

The literature also contains numerous examples of cases more directly related to speech sounds. Thus Luria (1967, 1218) reports that lesions of the lower parts of the pre-motor area of the left hemisphere do not disturb the ability to articulate individual speech sounds but inhibit the 'fluent shifting' from one articulatory gesture to another. Jakobson (1966) recounts the case of the Czech who lost the length distinction in vowels, so that *drāha* (road) and *drahā* (dear) became homonyms. And the closely related case of a Norwegian woman who received a brain wound during an air attack. She lost the ability to distinguish the two tonal accents, both in speaking and in listening. According to Jakobson, 'When she shopped, the Norwegians did not want to sell her anything, suspecting her of being a German, although in fact she knew no German' (p. 88).

Yet another case that Jakobson (1966) recounts involves the loss of voicing in consonants by a Polish aphasic. It is significant, of course, for phonological theory, that in such cases of language dissolution it is invariably the marked member of the distinction that is affected; the voiced becomes unvoiced, not conversely. This direction conforms with that often observed in historical change, but goes counter to the order in which such distinctions are acquired by the child. The distinctions enter the language in a push-down storage, so to speak: they are undone by time or injury in a last-in first-out basis.

If the study of the software of language were completely restricted to observations and experiments on people with severe injuries, the participation of linguists would be much too limited. It is not easy to gain access to the patients outside medical channels; the syndrome that an accessible patient has may not be of the kind that interests the linguist at that time; and frequently the organic basis of the linguistic impairment cannot be examined until after a long delay. From a lesion at point A in the brain correlating with the loss of function B, we cannot conclude directly that A controls B, for A may be only one link in a chain of controls for B. While the literature that is accumulating appears to be full of promises, it is not an easy matter for the linguist to be directly involved in research in these contexts.

The ideal situation would be to work with normal people, over whom we can exercise selective control, and observe the neural consequences of their speech activity without the necessity of cutting into their brains.

One promising development along this line is to monitor the electro-chemical activity of the brain by electrodes placed over different portions of the head, over different cortical areas. The techniques for studying language in normal speakers, such as by means of EEG recordings, are quite new and, of course, very crude as yet. But there are already some interesting preliminary results.

One such result comes from two independent groups. If a subject is asked a question involving verbal or arithmetic analysis, there is a tendency for him to move his eyes to the right, indicating activation of the left hemisphere. If the question involves musical or spatial analysis, then the eyes tend to move to the left, indicating activation of the right hemisphere. The group at the Langley Porter Neuropsychiatric Institute also report a similar finding with EEG recordings, using four electrodes over each hemisphere. Again the power output of the particular hemisphere is shown to depend significantly on the nature of the task and the extent to which language is involved.

A study more directly related to speech production is reported by McAdam and Whitaker (1971) using EEG recordings. The motor tasks were to make a spitting gesture and a coughing gesture. The corresponding phonetic tasks were to pronounce a trisyllabic word beginning with P, and a trisyllabic word beginning with K. Presumably, the spitting gesture is similar in its requirements on the musculature to the articulation of P, and the coughing gesture to K. Their records show 'a clearly localized negativity (over the left inferior frontal area) prior to and peculiar to speech production'. Their enthusiasm for the finding is mirrored in their concluding sentence: 'These data provide the first direct physiological evidence for localization of language production functions in the intact, normal human brain'.

Novel as the implementation is, the idea itself was clearly enunciated almost half a century ago by Edward Sapir (1958). Recall that in that seminal article Sapir began by a painstaking comparison of the *wh* sound in English, and the sound made in blowing out a candle. At the end of the comparison, one finds these words, which early predicted the EEG findings of McAdam and Whitaker:

> 'In view of the utterly distinct psychological backgrounds of the two classes of sound production, it may even be seriously doubted whether the innervation of speech sound articulation is ever actually the same type of physiological fact as the innervation of *identical* articulations that have no linguistic context.'

This idea of Sapir's was written at about the same time that the very first recordings were made of brain waves, by the psychiatrist Hans Berger. Some forty years later, the idea and the techniques finally flowed together.

I have discussed this range of materials at some length because I feel

that a new vista is opening on how we can study the sounds of speech *vis-à-vis* the underlying neural activities. For many decades, Roman Jakobson was virtually alone among linguists to tap this rich resource— yet linguistic sophistication has much to contribute to the design and execution of experiments that will help us tease out the language that is coded in the brain.

The neural activities of interest taking place in the cortex are not accessible to direct probing. What makes the problem even more difficult is the fact that whatever signals we can record from the linguistic activities are complexly mixed in the multitude of other signals which are not language related. Nonetheless, results such as those reviewed above are sufficiently encouraging to warrant a significant effort toward developing a methodology that will be adequate for the task. We must not repeat the mistake of the little boy who after losing his coins in a dark corner of the room went outside to look for them because there is more light there. Clearly, many important keys in our understanding of language can be sought only by directly examining the neural activities of the brain.

The other approach that I will discuss here on how to study speech sounds is the historical one. Unlike the neural approach, the study of sound change has an long tradition in linguistics. Indeed, many would say that modern linguistics began as the study of sound change.

Surely one of the most exciting epochs in the history of linguistics must have been the several decades around 1870, when the neogrammarians propounded their well-known doctrine of the regularity of sound change. As with all grand issues, this doctrine has many variant forms deriving from the programmatic statements of Osthoff and Brugmann of 1878. Jespersen imagined the drift of articulatory gestures in time to be like the small errors that accumulate in sawing logs. Bloomfield crystallized the doctrine with two words: 'phonemes change'. And in generative phonology, the slogan is 'sound change is grammar change', and sound change is to be regarded as the addition, deletion or reordering of rules.

Common to all these variants is the basic theme which I have called 'lexical abruptness'. If phoneme X is to change into Y, then all the lexical items containing X will participate in the change according to exactly the same schedule. No word will lag behind; none will forge ahead. Or, in the current terminology of rule application, the rule $X \rightarrow Y$ will apply to all members of the lexicon in a homogeneous fashion.

An important consequence of the belief in lexical abruptness is the inference that the change must be phonetically gradual. For if it were not so, we would be claiming that dozens or hundreds of words could undergo metamorphosis overnight, a claim which goes against even the most superficial observations. There has been some uncertainty in recent

discussion as to what exactly is to be meant by 'phonetically gradual'. If an s turns into an r via an intermediate stage of z, clearly the z is not sufficient evidence for saying that the change $s \to r$ was phonetically gradual. The question is just what evidence is both necessary and sufficient for phonetic gradualness. That evidence, I believe, consists in the existence of a pair of states S_i and S_j in the chain of states leading from X to Y, satisfying the following conditions:

1. That the phonetic difference be consistently maintained at that stage of the language (to eliminate free variation), and

2. that this phonetic difference be not large enough to be contrastive in any language.

Although the issue of phonetic gradualness has been long debated, there is preciously little empirical work done to search for such evidence. A notable exception is Labov's research (1963) on vowel movement in Martha's Vineyard, which begins to give us one concrete case study of phonetic gradualness. It may very well be that for certain types of sounds, such as vowels and tones, the change tends to be phonetically gradual, whereas for other types, such as obstruent devoicing, or epenthesis or deletion, the change must be phonetically abrupt. (It can be, and frequently is, statistically gradual.) At any rate, this is an empirical question that can be answered by carefully documented phonetic evidence, and it is a line of inquiry that is well worth pursuing.

But notice that while lexical abruptness necessarily implies phonetic gradualness, and phonetic abruptness necessarily implies lexical gradualness, phonetic gradualness does *not* imply either lexical gradualness or lexical abruptness. Again, it is an empirical question in many cases whether sound changes indeed proceed in the lexically abrupt fashion discussed above. An alternative hypothesis would be that the implementation of the change is gradual across the lexicon, where most of the time, it is not possible to separate the changed items from the unchanged items by reference to a general condition. To give this latter concept a theoretical focus, it has been named 'lexical diffusion'.

In empirical investigations, the achievements are often limited by the power of the tools which are available. For the quantitative study of sound change, a team of us have developed a special tool: a large dictionary of computerized phonological information. This tool has been christened DOC (Dictionary on Computer), and has been operational for varying durations at the computer centers of Stanford, Stockholm, Urbana, and Berkeley.

With the help of DOC, a large number of studies have been concluded on Chinese dialects. They include obstruent devoicing in Shuangfeng; the development of homonyms from Middle Chinese, the spread of nasalization in Chinese dialects; tone splits in Chaozhou, in Meixian and in Changsha, and others. The results from these dozen or so colla-

borative studies have now been synthesized in an elegant report by
Matthew Chen (1972).

In each case where we find a significant number of exceptional items
in the lexicon, we subject these items to the most rigorous tests that we
can think of. We try to correlate the split with all of the conditions that
might conceivably be relevant—both synchronic and diachronic con-
ditions. We try to correlate the split not only with phonetic, but also with
morphological and semantic categories. When all these efforts fail, we
then entertain the possibility of dialect borrowing, by comparing the
lexicon in question with lexicons of other dialects, and by searching for
similar irregularities in other parts of the lexicon. Only after having
exhausted both internal and external factors which might have caused
the split, do we permit ourselves the conclusion that we have identified
a case of lexical diffusion, where the sound change has not been com-
pletely implemented. And many such cases have now been documented,
where the empirical evidence is incontrovertible. Since the DOC-
related work on Chinese dialects has been brought together in Chen's
article, some newer studies on lexical diffusion have been completed.
Here I will briefly mention two.

One concerns the development of the disyllabic diatones as a function
of time by Don Sherman (1972). A word like *insult*, for instance,
according to early dictionaries was accented on the second syllable
whether it was acting as a noun or as a verb. By the fourth edition of
Samuel Johnson's dictionary in 1775, however, the accent had shifted
to the first syllable when it was used as a noun, and a new diatone was
added to the English lexicon. Less usual is the case of *transfer* in that
it entered the diatone status via the other route. In the etymological
English dictionary of 1735 by Nathan Bailey, both the noun and the
verb were pronounced with initial stress. Again in 1775, the accent had
shifted to the second syllable for the verb, yielding another diatone.

By referring to some thirty old dictionaries dating back to the six-
teenth century, and by using a computerized dictionary of Modern
English prepared by Dolby and Resnikoff, Sherman was able to trace
the chronological profile of the 150 or so diatones that English now uses.
The earliest inventory, Sherman reports, dates back to 1586 and contains
nine diatones. 'By 1660, there were 24, by 1700 there were 35 attested.
By 1800 there was evidence for 70 in total, and by 1934 the total disyl-
labic diatone inventory stands at a core of 150.' If we plotted these
numbers against time on a linear scale, we would get a graph that is
remarkably close to a straight line for this particular phonological
development in English.

The significance of Sherman's study is that not only has he added to
the total evidence for lexical diffusion, but that he has exemplified a
line of investigation. He has tapped the resources of several centuries

of lexicographic scholarship, and applied those resources toward the solution of a central issue in the theory of sound change. Our ultimate understanding of the manner and rate of sound change will need to be built on such empirical results as the chronological profile of the English diatones that Sherman derived.

A related study that has just been completed has to do with the loss of final *d* in many words in Stockholm Swedish, reported by Tore Janson (1973). In words like *ved* (wood), *hund* (dog), *blad* (leaf) and *röd* (red), Stockholmers usually delete the *-d* in ordinary speech. This fact has been thoroughly checked out by Janson, both by sampling opinions from sophisticated informants, and by monitoring taped speech.

The point of special interest here, is that the class of words that can undergo optional *-d* deletion is now a much smaller class than it was, say, a half-century ago, as determined from earlier descriptions. It is believed that the final *d* was disappearing, in some Swedish dialects, as early as the fourteenth century. In Stockholm speech, the deletion used to be possible for many more words, across several more grammatical categories. However, since it has been kept in the orthography, the resurgence of *-d* probably came as a result of the rapid rise in literacy in Sweden in recent decades.

Here we have a case then, of lexical diffusion suddenly reversing its course, stimulated by social change. But in both the progressive and the regressive phase of the development of this change, the process appears to be lexically gradual.

Since the process is lexically gradual, it is not surprising that different subsets of the lexicon can be caught in other developments. Janson is able to report two stages of the split that result from the *-d* deletion. In the first stage, the morpheme appears to be splitting into two forms. The form that has an optional *-d* is found in more idiomatic constructions, such as:

Det var syn(d)	That's a shame
Jag har inte rå(d)	I have no means

On the other hand, in novel constructions the *-d* cannot be deleted, as in:

Han begick en synd	He committed a sin
Ge mig ett råd	Give me advice

In the next stage, however, the split is more complete. In one form the *-d* is always present, such as in *ett träd* (a tree) and *en skuld* (a debt). It is always absent, however, in the corresponding *ett trä* (a piece of wood) and *för min skull* (because of me). In this state, the lexical split is already mirrored in the orthography. The evidence here, then, is for a phonemic split, between *-d* and zero, where there is no general conditioning factor. It is of considerable interest for historical theory to know whether such unconditioned splits are restricted to cases where

one member of the pair is zero, or whether they have a wider range of member pairs.

Let us turn once again to the title of this discussion: why and how do we study the sounds of speech? It is clear that other animals besides man have at least the incipient capacity for the formation of concepts and for the manipulation of these concepts. Prominent in the literature are the apes and the dolphin, but there may well be other candidates whose intellectual resources we have not yet properly gauged. But in order for this capacity to have the opportunity to grow and blossom, through both internal and external communication, it is crucial that a suitable medium of signals be available to be matched with these concepts. This medium must have a great degree of flexibility and a high ceiling of complexity. Given the suitable medium, the set of concepts and the set of signals can provide each other with a symbiotic opportunity of explosive growth; without it language, in the full sense of the word that man has it, could not and did not develop. The success with Sarah and Washoe only serves to highlight this point.

Speech sounds are that medium, perhaps the only medium, that could have permitted the evolution of language. No more persuasive reason need be given as to *why* study them. Refined through numerous millennia of adaptation, the mechanisms for the production and perception of speech sounds perform one of the most finely-tuned activities that any animal engages in.

Underlying the vibration of the vocal folds and the movements of the tongue are the complex neural programs on the cerebral cortex that control all these activities. For a century now, we have been building up information on these neural programs, but only for cases in which they are malfunctioning. Nonetheless, this information gives us a valuable background to work with. Now, it seems, new possibilities are just dawning whereby external electrodes can give us direct readings on the normal brain, and offer us the hope of being able one day to correlate different types of linguistic tasks with different types of brain activities. This avenue of studying the sounds of speech is as new as it is promising, especially for young persons just entering the field. For theirs may be the generation that will be able to unravel in the brain the answer to the evolution of language.

The other avenue I explored in this paper is the traditional one of studying sound change. The pioneers in this area have given us a rich heritage of historical and phonetic observations. But in order to extrapolate the general principles underlying sound change, we need large quantities of controlled data to a degree of precision that only recent technology has made possible. Now that it is established that sound changes often, if not always, proceed by lexical diffusion, the need arises for tracing the actual chronological profile for a variety of changes.

We must search for correlations between the phonetic strength of a change and the manner and rate with which the change diffuses across the lexicon. We want to be able to determine if particular sectors of the lexicon are more vulnerable than others, and which grammatical category will win over which other in situations of a homonym clash. Is the present tense always more stable than the past, and the past more stable than the future, as Lyovin (1971) has found for Tibetan, or is this hierarchy language specific?

Lexical diffusion leads us to reconsider some of the central tenets of the methods of reconstruction. Whereas unconditioned phonemic splits were inconceivable within a framework where sound changes were considered lexically abrupt, they are certainly possible within lexical diffusion—since it is only when the change has completed its course that a split is prevented from occurring. This possibility goes against one of the cherished assumptions of the comparative method. On the other hand, the same possibility offers a perhaps more sensitive technique for the genetic grouping of language, based on the sharing of new and old lexical forms instead of entire sound changes. The exploration of this technique has been begun by Hsieh (1970) and extended by Baron (1974). It has crucial importance for our understanding of the process of language change and differentiation.

These are but two roads to take in current phonology. No less significant are the search for phonetic explanations, such as discussed recently by John Ohala and Bjorn Lindblom; the testing for psycholinguistic responses to alternations and surface phonetic constraints, of the sort done by Zimmer (1969) and Hsieh (1970); the study of phonology acquisition exemplified in the dissertation of Arlene Moskowitz (1971) and the important study of Ferguson and Farwell (1973); and many others. These investigations are indeed embedded in the 'physical and social context' within which, as Halle noted in 1954, phonology should be studied. This sensitivity to context, we can expect, will increase the probability that our collective results will converge and reinforce each other in a cumulative way.

Acknowledgements

This paper is based on a lecture delivered to the Berkeley Linguistic Group (January 1973), and in part on a presentation to the Linguistic Institute (Ann Arbor, July 1973). I am indebted to many colleagues for their helpful comments, especially William Labov, Peter Maher, and Harry Whitaker. The work of the Phonology Laboratory is supported in part by a grant from the National Research Foundation (GS2386). I am also indebted to Dr Roger Fouts of the University of Oklahoma for discussions on teaching language to chimpanzees and for the opportunity to visit Lucy and Washoe.

REFERENCES

Baron, S. (1974) On Hsieh's method of dialect subgrouping. *J. Chinese Linguistics*, **2**, no. 1.

Chen, M. (1972) The time dimension: contribution toward a theory of sound change. *Foundations of Language*, **8**, 457–98.

Chomsky, N. & Halle, M. (1968) *The Sound Pattern of English*. New York: Harper and Row.

Ferguson, C. A. & Farewell, C. B. (1973) Words and sounds in early language acquisition. *Papers and Reports on Child Language Development 5/6*.

Gazzaniga, M. S. (1970) The bisected brain. *Neuroscience Series* (ed Towe, A.)

Goldstein, K. (1960) Thinking and speaking. *Annals of the New York Academy of Sciences*, **91**, art. 1.

Halle, M. (1954) Why and how do we study the sounds of speech? *Report of the Fifth Annual Round Table Meeting on Linguistics and Language Teaching* (ed Mueller, H. J.). Georgetown University Press.

Hsieh, H-I. (1970) The psychological reality of tone Sandhi in Taiwanese. *Papers of the Sixth Regional Meeting of the Chicago Linguistic Society*, 489–503.

Hsieh, H-I. (1973) A new method of dialect subgrouping. *J. Chinese Linguistics*, **1**, 64–92.

Jakobson, R. (1966) Linguistic types of aphasia. *Brain Function*, vol. III (ed Carterette, E. C.). University of California Press.

Janson, T. (1973) Reversed lexical diffusion: the loss of *d* in Stockholm Swedish. *Papers from the Institute of Linguistics, University of Stockholm.*

Kiparsky, P. (1972) Explanation in phonology. *Goals of Linguistic Theory* (ed Peters, S.). Prentice-Hall Inc.

Labov, W. (1963) The social motivation of a sound change. *Word*, **19**, 273–309.

Luria, A. R. (1967) Problems and facts of neurolinguistics. *To Honor Roman Jakobson*, 1213–27. Mouton.

Lyovin, A. (1971) Sound change, homophony and lexical diffusion. *POLA 15*. Berkeley.

McAdam, D. W. & Whitaker, H. A. (1971) Language production: electro-encephalographic localization in the normal human brain. *Science*, **172**, 499–502.

Moskowitz, Arlene I. (1971) The acquisition of phonology. PHD dissertation, University of California, Berkeley.

Premack, A. J. & Premack, D. (1972) Teaching language to an ape. *Scientific American*, **227**, no. 4.

Sapir, E. (1958) Sound patterns in language. *Selected Writings of Edward Sapir* (ed Mandelbaum, D. G.). University of California Press.

Sasanuma, S. (1972) Selective processing of Kana and Kanji in Japanese aphasics. *Annual Bulletin of the Institute of Logopedics and Phoniatrics.* Tokyo.

Sherman, D. (1973) Noun-verb stress alternation: an example of the lexical diffusion of sound change in English. *POLA 17*, 46–81.

Van Lancker, D. (1972) Language processing in the brain. *Paper presented at the Annual Convention, American Speech and Hearing Association.*

Weigl, E. & Bierwisch, M. (1970) Neuropsychology and linguistics: topics of common research. *Foundations of Language*, **6**, no. 1, 1–18.

Zimmer, K. (1969) Psychological correlates of some Turkish morpheme structure conditions. *Language*, **45**, 309–21.

Literary Stylistics

C. MARTINDALE

The semantic significance of spatial movement in narrative verse : patterns of regressive imagery in the *Divine Comedy*

One of the salient characteristics of narrative poetry is its characters' traversal or immense distances, whether these be horizontal as in Virgil's *Aeneid* or vertical as in Dante's *Divine Comedy* or Milton's *Paradise Lost*. In comparison, lyric poetry tends toward introversion and internal movement, toward travel through Shelley's 'caverns of the mind', that 'thought can with difficulty visit'. This paper reports on some data concerning the possibility that the spatial movements in epic poetry may be read as a sort of exteriorization of the mental explorations which are more explicitly undertaken in lyric poetry.

The method employed might be termed quantitative psychoanalysis. By this is meant not a statistical quest for Oedipus complexes and libidinal cathexes, but a return with better tools to some of Freud's earliest ideas. It would seem that psychoanalytic theory has come to suggest a pile of Procrustean beds because one qualitatively or clinically 'verified' hypothesis has served as the foundation for another. Thus, the return to the earliest theories of Freud advocated by Lacan (1968) seems in order. In calling for this return, Lacan has argued that psychoanalysis should be a science of language, one concerned with the rules of transformation which govern the 'translation' of mental contents from one to another level of psychic language. Laffal's (1965) fruitful work has shown that Freudian notions are amenable to quantitative investigation so long as one stays on the level of language.

The dimension of interest in this research has been the continuum from secondary process to primary process thought. Freud (1938a) construed the former as logical, reality-oriented, goal-directed thought and the latter as more primitive free-associative, sensation- and drive-oriented thinking. Werner's (1948) differentiated *vs.* undifferentiated and Goldstein's (1939) abstract *vs.* concrete thinking refer to essentially the same continuum. In modern psychoanalytic theory (Rapaport 1957), regression from secondary to primary process thought is seen as paralleling movement through the continuum of states of consciousness from alert, waking thought through fantasy and reverie to dreaming or, to perpetuate an unfortunate metaphor, from consciousness toward the 'unconscious'.

Movement along the vertical dimension seems to bear a certain latent affinity with 'movement' along the conscious-unconscious or secondary process-primary process dimension, at least in Western cultures. We

speak of depth psychology and the subconscious when we think of regressive thought or unconscious motives (Thass-Thienemann 1967). On the other hand, psychoanalytically oriented theorists have argued that ascent symbolizes sublimation (Jung 1953, Bachelard 1943) or spiritualization (Neumann 1954); that is, movement away from regression toward rational, abstract consciousness. Here, however, there is less consensus. Eliade (1960) argues convincingly that ascent—especially effortless floating upwards—may have a latent symbolic meaning of what we would call regression or dedifferentiation.

Dante's *Divine Comedy* provides an excellent arena for exploring such ideas. The *Divine Comedy* is a poem of one hundred cantos, each about 1100 words in length, which are divided into three books: Inferno, Purgatorio, and Paradiso. The first narrates the journey of Dante, conducted by the shade of Virgil, down through the nine levels of Hell. Purgatorio continues with a journey through ante-Purgatory and up the seven terraces of the mountain of Purgatory. The last seven cantos concern Dante's reunion with his long-lost Beatrice in the Garden of Eden. Here there is no vertical movement. Beatrice conducts Dante—whether mentally or physically is not made clear—in the Paradiso on a journey up through the ten heavens. Paradiso ends with a vision of the mystic rose of heaven with God at its centre.

In broad outlines, the *Divine Comedy* follows the pattern of a typical 'night journey' or quest myth. A depth psychological translation (cf. Neumann 1954, Slochower 1970) would be that frustration in life (the Inferno begins with Dante lost in a dark wood) leads to an introversion, regression, or descent into the unconscious as symbolized by the journey to Hell. The presence of Virgil, symbolizing reason, suggests that it is a 'regression in the service of the ego' (Kris 1952). The negative or pathological aspects of the unconscious, as symbolized by Medea and, of course, Satan, are overcome or evaded. Thus, Satan is seen to be powerless since he is frozen eternally in ice. Then, following the resultant strengthening and enrichment of the conscious aspect of the personality (the ascent of the mountain of Purgatory), the ego (as symbolized by Dante) and beneficent aspects of the unconscious (as symbolized by Beatrice) meet in Eden and are metaphorically joined together (in the Paradiso) to form a more total personality. We have a pattern of regression symbolized by descent, return toward the secondary process symbolized by ascent, and regression again, but this time connected with ascent.

The *Divine Comedy*, then, may be seen as mirroring a number of cycles of regression and progression: the sleep-waking cycle (Rapaport 1957), the cycle of regression and elaboration which occurs in artistic creation (Kris 1952) and the analogous life-long cycle which Jung (1939) termed individuation. Jung (1953) has interpreted alchemical

experimentation as symbolically rendering this cycle of personal growth, often in terms of ascent and descent imagery. Ehrenzweig (1967) argues that the minimal content of any work of art is this 'poemagogic' mirroring of its own creation. The depth psychological interpretation gains some credibility by virtue of the fact that Dante did apparently intend his poem to be interpreted on one level as signifying the soul's journey toward God (Singleton 1958), a journey which may be equated with the process of individuation (Jung 1938).

The traditional method of validating such an hypothesis concerning the meaning of the Divine Comedy would be a qualitative one: The psychoanalyst, just as the literary critic, would attempt to prove by example. Thus, oral references would be cited as suggesting deeper regression than anal ones, and the latter, deeper regression than sexual ones (Freud 1938b). It is true that sexual sins are punished at a shallow level in Hell and expurgated at a high level in Purgatory, that anal references seem to peak in the middle of Hell, and that oral imagery, culminating in the image of Ugolino perpetually gnawing Ruggieri's skull, occur deep in Hell. The example should make clear that the psychoanalyst, just as the literary critic, tends to support his hypotheses with a very imprecise sort of content analysis. But the sceptic would require more than three or four examples; he would ask for a more complete count and one less subject to convenient lapses of memory. This, of course, is where the computer is useful.

The Regressive Imagery Dictionary (RID) is a content analysis dictionary presently containing 3647 words divided into thirty-six categories designed to tap primary process and secondary process thinking. It was originally designed for use with the General Inquirer (Stone, Dunphy, Smith and Ogilvie 1966) but is presently implemented with COUNT (Martindale 1973b) a PL/1 (D level) content analysis program for smaller computers. The RID categories are listed in Martindale (1973a). For this study, the variable primary process was defined as the percentage of words in a canto categorized into any of the twenty-nine primary process categories; secondary process was defined as the percentage of words in a canto categorized into any of the seven secondary process categories.

Evidence for the validity of the RID as an index of regressive cognition comes from a variety of sources. Martindale (1969, 1973a, 1973c) found that regressive imagery varies as theoretically predicted across both the courses of eighteenth century English and nineteenth-century French poetry and of experimentally simulated series of poetic texts. Further, poets exhibiting signs of psychopathology were found to exhibit more regressive imagery than those showing no such signs (Martindale 1972). Martindale (1973d) in a cross-cultural study found, as predicted from the primitive mentality hypotheses of Lévy-Bruhl (1966), Cassirer

(1955), and Werner (1948) that amount of regressive imagery in folk-tales is negatively correlated with degree of sociocultural complexity in preliterate societies. Reynes (1973) found that regressive imagery as measured by the RID varies as theoretically predicted across the course of psychoanalytic therapy sessions. Factor analyses of the categories in these studies as well as in the present study have consistently yielded a bipolar first factor accounting for about thirty per cent of the variance which may be labelled primary process *vs.* secondary process.

The hypotheses were also investigated by examining the mean value of the words in each canto on the concrete-abstract dimension. This was done with a program, SEMIS, which operates in a manner somewhat similar to COUNT. It looks up each word in a document in a dictionary which contains a list of words, each of which may be assigned a value of up to four dimensions. Thus, instead of only categorizing words, the dictionary allows weighting of the words indicating each category. The program produces as output the mean value on each of the dimensions of the words found in the dictionary The concreteness dictionary used with SEMIS was adopted from the norms for 925 nouns rated on a seven-point concreteness scale which were gathered by Paivio, Yuille, and Madigan (1968).

Sinclair's (1939) translation of the *Divine Comedy* was keypunched onto IBM cards for this study. (See Martindale 1973a for a comment on the validity of use of translations for the sort of content analysis reported here.) Coding was added to the text to indicate four speakers and re-cipients (Dante, Virgil, Beatrice, and others). For each canto, COUNT yielded tallies for each of the twelve possible combinations of speakers as well as for residual or unspoken contexts and for the total document.

Figure 1 presents the percent of total number of words in each canto categorized as primary process. Primary process decreases across the three books of the *Divine Comedy* from an average of 12·35% in the Inferno to 12·31% in the Purgatorio to 10·92% in the Paradiso. If we analyse these differences using a one-way analysis of variance, we find that $F = 4·34$ ($p < 0·05$, $df = 2, 97$), suggesting that the three books differ appreciably in amount of primary process imagery. With the exception of sensation, all of the component categories of primary process decrease as we move from the Inferno to the Paradiso. Con-creteness, as measured by SEMIS, decreases from 4·87 to 4·63 to 4·23 ($F = 17·42$, $p < 0·001$, $df = 2, 97$).

(It should be noted that in discussing the data, the results of several statistical tests are presented for the purely descriptive purpose of giving some idea of how significant (in the logical rather than the statisti-cal sense) the trends and differences are. Strictly speaking, such tests are designed for making inferences from a sample to a larger population. Since in this case we are dealing with the entire population, all of the

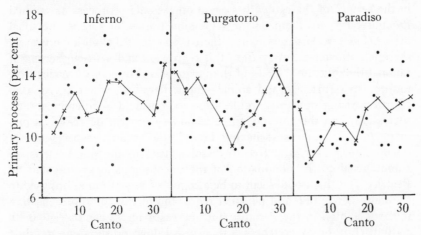

Figure 1. Primary process percentages by cantos in the *Divine Comedy*. Means of each successive set of three cantos are plotted

differences found are 'real' ones. Further, such tests require that each case (canto in this instance) be independent. Since all of the cantos were written by one person and since they follow each other in a logical order, this requirement is not unambiguously met.)

Thus, on this gross level, higher does seem to mean less regressed. However, if we look within cantos a somewhat different picture is presented. As may be seen in figure 1, primary process increases across the course of the Inferno—the Spearman correlation (r_s) between canto number and amount of primary process is 0.31 $(p < 0.05)$—and also across the course of the Paradiso $(r_s = 0.38, p < 0.01)$. If we examine the whole of the Purgatorio, primary process shows no trend $(r_s = -0.10,$ ns) but dividing into the ascent of Purgatory mountain segment (cantos 1–26, hereafter referred to as Purgatory proper) and the Garden of Eden segment (cantos 27–33), there are clear decreases across each $(r_s = -0.52, p < 0.01;$ and $r_s = -0.70, p < 0.05$ respectively). Concreteness increases across cantos in the Inferno $(r_s = 0.46, p < 0.01)$ and decreases in Purgatory proper $(r_s = -0.31, p < 0.10)$, but it shows no trend in the Paradiso $(r_s = 0.05,$ ns). Secondary process imagery is highest in Purgatorio $(X = 7.28)$ and somewhat lower in Inferno and Paradiso $(X = 6.97$ and 6.75 respectively). It shows no trend across the Inferno $(r_s = 0.04)$ but increases across the course of Purgatory proper $(r_s = 0.48, p < 0.01)$ and decreases across the course of the Paradiso $(r_s = -0.28, p < 0.10)$.

Putting together the results for primary process and secondary process, a coherent pattern seems to emerge. In the Inferno, where there is consistent downward movement, we have a tentative regression

in the service of the ego with a grasp on secondary process or rational thought being maintained; the regression purges or escapes personal drives. Then in Purgatory, where there is an effortful climbing upwards, there is a movement away from this regression and a strengthening of rational thought. At the end of the Purgatorio Dante and Beatrice—or, in Jungian terms, ego and anima—meet. Paradiso, where there is an effortless rising upwards, would seem to represent a different sort of regression than the Inferno, since secondary process decreases as primary process increases: having bound the negative aspects of the unconscious, the ego is free to dissolve itself in the unconscious, to submit itself to the domination of the unconscious as represented by Beatrice. But this would seem to be a cognitive regression as opposed to the more perceptual and personal regression of the Inferno. Sensation imagery is high in the Paradiso and increases across cantos ($r_s = 0.40$, $p < 0.01$) but the concreteness of the words is low and shows no trend. It is not concrete external events which are sensed but internal ones; there is a movement away from secondary process mental activity towards passive mental perception or 'enlightenment'.

That the *Divine Comedy* symbolizes regression and progression in the characters rather than a mere witnessing of these different states projected onto the external world is suggested if we examine the amounts of primary and secondary process imagery in the various contexts tallied by COUNT. Invariably, the residual contexts are the richest in primary process imagery and the lowest in secondary process imagery. However, there are no trends across cantos: for the three books the correlations between primary process and canto for residual contexts are $r_s = 0.10$, -0.16, and 0.16 (all *ns*) respectively. The trends, then, are in what the characters say to each other. For example, in the text spoken by Dante to others in the Inferno, the correlation between primary process and canto is $r_s = 0.71$ ($p < 0.01$). The other contexts yield analogous, if less extreme, correlations. Analysis of the various contexts promises to shed light on the symbolic meaning of the principal characters. At the very least, it raises questions concerning the traditional assumption that Virgil symbolizes natural reason: we find that the lines spoken by Virgil throughout the *Divine Comedy* contain much more primary process imagery than those emitted by the other characters (11·04% for Virgil as opposed to 8·76%, 9·17%, and 9·89% for Dante, Beatrice, and others respectively).

We have presented evidence which lends quantitative support to the notion that a 'translation' of the imagery of the *Divine Comedy* into the psychoanalytic 'language' of regression is possible. The question may remain, however, as to how profitable such an interpretation is for our understanding of the poem: to what extent does this reading penetrate to the heart of the poem's meaning? By way of a partial answer to

this question, let us examine briefly some empirical evidence bearing upon another possible 'translation'. Dante intended the *Divine Comedy* to be interpreted not only on the anagogic, or spiritual, level which we have been discussing but also on the moral level, as concerning good and evil (Singleton 1958). A semantic parallel of the vertical dimension which is more straightforward and universally accepted than the one we have been discussing is the evaluative or good-bad dimension (Bachelard 1943). If the journey to the depths of Hell is on one level a journey toward the unconscious, it would seem to be on another level even more clearly a journey towards evil. Can we offer a quantitative answer to the question of whether it is more one or the other?

A dictionary was prepared for SEMIS based on ratings gathered by Heise (1965) of 1000 frequent English words on seven-point scales tapping the good-bad dimension. When this dictionary is applied to the texts, we find that the mean evaluation rating of the words found in the Inferno is -0.22, while mean ratings are -0.14 for Purgatorio and -0.07 for Paradiso. As expected, the movement is from connotations of bad to those of good. Applying the analysis of variance test, we find $F = 34.14$ ($p < 0.001$, $df = 2, 97$), a much larger value than the F describing differences in primary process. However, if we examine changes in mean evaluation rating across cantos, we find $r_s = -0.59$ ($p < 0.01$) for the Inferno, $r_s = -0.03$ (*ns*) for Purgatory proper, and $r_s = 0.25$ ($p < 0.10$) for the Paradiso. In two out of the three cases the correlations between primary process and cantos are appreciably larger. Thus, for explaining changes in word choice across the three books the moral metaphor is more useful, while for explaining such changes across cantos within each book the regression metaphor in fact offers more explanatory power.

REFERENCES

Bachelard, G. (1943) *L'air et les songes*. Paris: Librarie Jose Corti.
Cassirer, E. (1955) *The philosophy of symbolic forms*, vol. 2. New Haven: Yale University Press.
Ehrenzweig, A. (1967) *The hidden order of art*. Berkeley: University of California Press.
Eliade, M. (1960) *Myths, dreams, and mysteries*. London: Haverill.
Freud, S. (1938a; orig. 1900) The interpretation of dreams. *Basic writings*, 179–549. New York: Random House.
Freud, S. (1938b; orig. 1905) Three contributions to the theory of sexuality. *Basic writings*, 553–629. New York: Random House.
Goldstein, K. (1939) *The organism*. Boston: Beacon.
Heise, D. R. (1965) Semantic differential profiles for 1000 most frequent English words. *Psychological monographs*, **79**, no. 8, 1–31.
Jung, C. G. (1938) *Psychology and religion*. New Haven: Yale University Press.
Jung, C. G. (1939) *The integration of the personality*. New York: Farrar and Rinehart.

Jung, C. G. (1953) Psychology and alchemy. *Collected works*, vol. 12. New York: Pantheon.

Kris, E. (1952) *Psychoanalytic explorations in art*. New York: International Universities Press.

Lacan, J. (1968) *The language of the self*. Baltimore: Johns Hopkins Press.

Laffal, J. (1965) *Pathological and normal language*. New York: Atherton.

Lévy-Bruhl, L. (1966; orig. 1910) *How natives think*. New York: Washington Square Press.

Martindale, C. (1969) *The psychology of literary change*. Unpublished PHD dissertation, Harvard University.

Martindale, C. (1972) Father's absence, psychopathology, and poetic eminence. *Psychological Reports*, **31**, 843–7.

Martindale, C. (1973a) An investigation of literary change: Incongruity, stylistic elaboration, and regressive imagery in two poetic traditions. Paper presented at International Conference on Computers in the Humanities, Minneapolis.

Martindale, C. (1973b) COUNT: A PL/1 program for content analysis of natural language (abstract). *Behavioral Science*, **18**, 148.

Martindale, C. (1973c) An experimental simulation of literary change. *Journal of Personality and Social Psychology*, **25**, 319–26.

Martindale, C. (1973d) Primitive mentality and the relationship between art and society. Paper presented at V International Colloquium on Empirical Aesthetics, Leuven, Belgium.

Neumann, E. (1954) *The origins and history of consciousness*. New York: Bolligen.

Paivio, A., Yuille, J. C. & Madigan, S. A. (1968) Concreteness, imagery, and meaningfulness values for 925 norms. *Journal of Experimental Psychology Monograph Supplement*, **76**, no. 1. part 2, 1–25.

Rapaport, D. (1957) Cognitive structures. *Contemporary approaches to cognition* (ed Bruner, J. E.), 157–200. Cambridge: Harvard University Press.

Reynes, R. (1973) *Variations in regressive imagery during psychoanalytic therapy*. Unpublished PHD dissertation, University of Maine.

Sinclair, J. D. (1939) *The Divine Comedy of Dante Alighieri*, 3 vols. London: The Bodley Head.

Singleton, C. S. (1958) Journey to Beatrice. *Dante studies*, 2. Cambridge: Harvard University Press.

Slochower, H. (1970) *Mythopoesis: Mythic patterns in the literary classics*. Detroit: Wayne State University Press.

Stone, P. J., Dunphy, D. C., Smith, M. S. & Ogilvie, D. M. (1966) *The general inquirer: A computer approach to content analysis*. Cambridge: MIT Press.

Thass-Thienemann, T. (1967) *The subconscious language*. New York: Washington Square Press.

Werner, H. (1948) *Comparative psychology of mental development*. New York: International Universities Press.

On the authenticity of the Baligant episode
in the *Chanson de Roland*

Ever since the discovery and publication, more than one hundred and forty years ago, of the Digby 23 (Oxford) manuscript, the oldest surviving version of the *Chanson de Roland* (Michel 1837), scholars have debated whether that eleventh-century epic was the work of a single genius or whether it is a *rifaccimento* from the hands of more than one poet. In particular, attention has been drawn to one section of the work, the so-called 'Baligant episode', which some have considered not to be a part of the original poem. It will be recalled that the *Chanson de Roland* can be divided roughly into four sections: the first describes how Ganelon, jealous of his step-son Roland, the nephew of Charlemagne, plots the death of Roland and 20000 other troops of the emperor's rearguard in the mountain pass at Roncevaux. The second part describes the battle, which actually did take place in the Pyrenees, 15 August 778, and which culminated in the death—but not defeat, at least in the poetic version—of Roland and his men at the hands of pagan forces. The third section, the controversial one, shows Charlemagne avenging that loss by vanquishing and killing the most powerful emir in all pagandom, Baligant, and the final part describes the trial and punishment of the man who started the sequence of events, Ganelon.

There are several arguments which justify the exclusion, or unauthenticity of the Baligant episode. In the first place, although much of the *Roland* contains foreshadowing of future events and recapitulation of action already described, Baligant is not mentioned prior to the start of his episode nor after it is finished. Moreover, half of the surviving versions of the *Roland* do not have it. It is not seen in the Latin versions, the *Nota Emilianense*, the *Pseudo-Turpin Chronicle* and the *Carmen de prodicione Guenonis*, nor in the Norse version, the *Karlamagnússaga*. The 'Lyon' rhymed version omits it, as do also the recapitulations of the legend found in the prose works *Garin de Monglane* and *Galiens li Restorés*. Perhaps the most compelling reason for not considering the Baligant episode to be a part of the original poem, however, is aesthetic. There is something pleasing about seeing the epic as a tripartite structure in which each section logically develops from what has passed, while preparing what is to come, with the whole united by a single theme: the plotting, committing, and punishment for a crime. The Baligant episode may then be seen as a strange addition to the original poem, an accretion which destroys the unity of the earlier epic and which

can hardly be attributed to the master poet who created the other sections.

While those arguments flourished during the nineteenth century, scholars of today generally believe the Baligant episode is indeed a part of the original *Roland*, for several reasons. First of all, while half of the manuscripts of the poem do not include that section, those that do include the oldest surviving version, the Digby 23 (Oxford) manuscript, and most of the versions in which it does not appear have vestiges of it: references to the emir, dreams which prefigure it, and elements of the plot which cannot be explained without it (Horrent 1951, 120–34). Rather than agree with the nineteenth-century argument that the manuscripts without the episode reflect an earlier tradition, one can just as easily say the reverse: those later manuscripts which do not include the episode are witnesses to a change in the original legend.

There seems, moreover, to be no stylistic variance between the different parts of the Oxford *Roland*, a view reaffirmed recently in a detailed analysis by Delbouille (1954). A linguistic analysis of the text to determine which *laisses* (strophes based on assonance) are the oldest reveals nothing which would suggest the Baligant episode was composed at a later date than the rest of the poem (Hall 1959). While, as mentioned above, the name 'Baligant' does not appear outside of that episode in the Oxford manuscript, the episode as a whole is prefigured in a dream so closely linked to other events it would be difficult not to attribute it to the original poet. The most powerful argument in favor of the authenticity of the Baligant, however, is the same one critics have used to refute it: aesthetically the epic is a greater work of art with the episode than without. If one takes the nineteenth-century view that the *Roland* is simply the story of a family quarrel in which an evil man is punished for plotting the death of his step-son, then, of course, the Baligant episode is incomprehensible. But if one sees the epic as dealing with much broader questions, the triumph of Christianity over paganism, of good over evil, then the Baligant episode is not only comprehensible but absolutely necessary for the unity of the poem. In such an interpretation, part two, the loss of Roland and 20 000 other Christians, is balanced by part three, the defeat of the greatest army in pagandom and the death of its leader at the hands of Charlemagne. Without the Baligant episode, there is no clear triumph of Christianity nor is the murder of Roland and his men properly avenged. Of course those who killed the French at Roncevaux die, but that is a small loss for the pagans. Charlemagne, the greatest emperor of Christianity, has not proven his superiority until he vanquishes his counterpart, Baligant, the greatest pagan ruler. This balance between parts two and three is then reflected and framed by parts one and four, dealing with the treason and punishment of Ganelon, so that here again one sees a triumph of justice. The whole of the

epic, with the Baligant episode, can thus be seen to present a harmonious unity of thought which is difficult to see as a product of more than one author. In the words of Gautier (1878, i, 426n): '. . . il faut n'avoir pas l'esprit littéraire pour contester une aussi belle et profonde unité', a statement which, however strong, none the less reflects the opinion of most students of the poem today, including the present writer.

The problem is, however, important enough to bear further examination. Certainly if aesthetic reasons can be cited both for and against the inclusion of the Baligant episode, then some other criteria ought to be used to determine, if possible, which of the conflicting modern interpretations most closely resembles that of the middle ages. During the past few years I have been attempting to shed light on this problem through a computational stylistic analysis. The rest of this paper will be devoted to describing the preliminary procedures used in that effort, the initial results obtained and the conclusions one can draw from those results.

There are certain problems which arise when attempting to use methods of modern stylometry to examine the *Chanson de Roland*. The poem is fortunately long enough (4002 lines) so that there is no difficulty in measuring only frequently occurring events independent of subject matter, but more problematical is the fact that, while the work was originally oral, what survives is a written record with highly inconsistent spelling. One example, out of hundreds, is seen in line 33 where the copyist spelled the word for a cart as *carre* whereas in lines 131 and 186 he spelled it *care*. Both would be pronounced the same and the poet obviously thought of them as the same word, but any computational analysis made directly on the text would treat them differently. Modern misprints in whatever edition of the poem is used for analysis complicate the matter even further, not to mention difficulties raised by homographs and polysemy.

To avoid those problems and to ensure having as accurate a text as possible, a number of initial steps were taken in the present study. A transcription of the poem in machine-readable form, based on the edition by Mortier (1940), was generously loaned to me by Joseph J. Duggan of the University of California at Berkeley. That copy served as a check against another transcription of the poem, based on the edition by Whitehead (1947), which I made at Dartmouth College in the course of about fifteen hours of typing. With the help of some subroutines for checking spelling without punctuation, previously developed for CAI language drills (see Allen 1971), it was a simple matter to compare the two texts and, where they differed, determine from the original manuscript where Mortier and Whitehead—not to mention Duggan or I— had made typographical mistakes. The resultant list of errors provided diversion by showing where a recent editor of the *Roland* had copied

certain sections of the poem including errors directly from Mortier, but the major goal was to create an accurate copy of the Digby 23 manuscript in machine-readable form.

The next step was to create another version of the poem for analysis, in which all 29 352 words of the *Roland* were replaced by their lemmas (dictionary forms), so that inconsistencies of spelling could be avoided and singular and plural forms of the same word would be treated alike. A grammatical analysis was also made on each word according to forty-five different classifications, to help in separating homographs. In the few cases where that would not make a distinction or where polyseminal differences were important, homographs were separated by adding a digit to the end of each individual form. Those steps took a fair amount of time but were not as difficult as might be imagined. Rather than replace the words individually, a procedure that would risk inconsistent decisions, each word was broken out of its context, given an address (its line number and position in that line), alphabetized, and stored in the interactive Dartmouth Time-Sharing System. Several of the words then could be assigned lemmas automatically, leaving only something less than fourteen thousand homographs which required individual decisions. Once the lemmas were assigned, it was relatively easy to determine grammatical classifications, sort the words according to those classifications to check for consistency, realphabetize according to the lemma to check the text against what has been considered the standard glossary up to now (Foulet 1927), and then put the lemmas back into the order they have in the poem itself, based on the addresses assigned as the words were first broken out of the text. Work could then begin on the analysis itself. Secondary results which were also derived from this reconstruction of the poem included a lemmatized concordance, a frequency list of the lemmas, and a list of new words and forms in order of appearance, to be used when teaching the poem.

Previous unpublished tests I had made on the unlemmatized text had tended to confirm the current opinion of critics that the style of the poem is remarkably consistent, for the distribution of words according to the number of letters in them remains quite constant throughout the poem, including the Baligant episode. The results of those tests, however, are open to question since they could indicate a general tendency of the language rather than of the individual, and since word length in letters is dependent on scribal tendencies. The same test could not be applied to the newly reconstituted text, for lemmas are arbitrarily chosen forms and bear little relationship to the spoken words (especially verbs) other than unifying variant forms. The first test that was used on the reconstituted text was a vocabulary distribution and since here positive results were achieved, the rest of this paper will be devoted to describing that test.

For purposes of comparison, the text was first divided into four roughly equal parts: the Baligant episode (lines 2525–2844; 2974–3681), and three other sections, arbitrarily named x, y, and z. A frequency list of the lemmas was then made up for each section, along with the percentage of usage. To ensure that only high-frequency function words would serve as a basis for comparison, only words that constituted at least one per cent of the vocabulary in at least two sections were considered. This gave a total of sixteen lemmas which made up just under thirty per cent of the 29 352 individual word-tokens in the text. While it was apparent that the high-frequency vocabulary was the same for all four sections of the poem, there was variation in the percentage of usage of those sixteen lemmas. For example, the most frequent lemma, the definite article *li* (which could also be represented in the text by *le*, *la*, *lo*, *lu*, *les*, and the contractions *al*, *as*, *del*, *des*, *el*, and *es*) comprised 5·459% of the word tokens in section x, 6·085% of those in section y, 5·766% in section z, and 7·216% in the Baligant episode. An arbitrary standard was chosen to determine whether any of those figures showed a significant deviation for any one section: if the greatest variance in percentage between any three sections was still less than the smallest difference between those sections and the remaining one, the word was considered to discriminate significantly. To use the example cited above, the four percentages were ranked in order, from the lowest to the highest: 5·459% (section x), 5·766% (section z) 6·085% (section y), and 7·216% (Baligant). For the usage in section x to have been considered significantly lower than the others, the difference between it and its nearest rival, section z, 5·62% (5·766 × 100/5·459 = 105·62; z is then 5·62% greater than x), would have to be greater than the difference between z and the Baligant, a 25·15% jump (7·216 × 100/5·766 = 125·15). But since 5·62 is less than 25·15, x is not significant. On the other hand, when the Baligant episode alone is compared to sections x, z and y, it is significant. The maximum variance between x, z and y is 11·47% (between x and y: 6·085 × 100/5·459 − 100), whereas the minimum difference between those sections and the Baligant is 18·59% (7·216 × 100/6·085 − 100). In other words, the definite article in the *Chanson de Roland* has a fairly constant usage in the non-Baligant sections but is significantly more frequent in the Baligant episode.

Not all of the lemmas used in this study were able to distinguish one or another of the sections according to that criterion. For example, the second most frequent lemma is the conjunction *e*, whose frequency of usage in x, y, z and the Baligant episode is, respectively, 3·129%, 3·302%, 3·968% and 3·579%, none of which differs significantly from its neighbours. Six other lemmas of the original sixteen showed similar non-significant consistency in usage, leaving nine which discriminate one or another section, as shown in tables 1 and 2.

6

lemma	category	section distinguished
li	definite article	Baligant
de	preposition	Baligant
estre	verb*	Baligant
aveir	verb*	Y
aveir	auxiliary verb	Z

* Any form of the verb except auxiliary, present or past participle, infinitive.

Table 1. Lemmas that have a significantly higher frequency in one section.

lemma	category	section distinguished
a	preposition	Baligant
en	preposition	Y
qui	relative pronoun (including *que*)	Baligant
que	subordinate conjunction	Baligant

Table 2. Lemmas that have a significantly lower frequency in one section.

In six out of the nine cases, then, the Baligant episode is the 'odd' section. Since the probability that any of the four divisions, X, Y, Z or Baligant, would be chosen is one out of four, it is easy to calculate the probability that any section will be chosen in at least six out of nine cases. While the chi-square test could be used here, it is only an approximation, whereas in a problem with as few figures as this the figure can be calculated more exactly. It is one out of a hundred. Statisticians usually consider a probability of 0·05 as significant and a probability of 0·01, as is seen here, very significant.

The test described above is not a very sophisticated one, but has the merit of distinguishing, on a purely numerical basis, the style of a part of the *Roland* which, for other reasons, critics have also distinguished. Further work on the analysis of vocabulary distribution and other traits of the poem is now being done, the results of which will be published elsewhere, but what has been obtained so far indicates that future investigation will discover other differences between the Baligant and the rest of the epic. We must be very careful before concluding, however, that those differences indicate different authorship. In the first place, no statistical study of this sort of problem can produce probabilities of 100 per cent: that is mathematics, not statistics. The evidence obtained so far simply indicates there is a one out of a hundred

chance that the stylistic differences noted in the *Roland* occurred simply at random and that further tests would be unable to distinguish the Baligant any more than any other section. But even if further tests confirm these initial results, the stylistic difference might be attributable not to a different poet but to the same man composing at different points in his life. The difference could probably not be attributed to a change in one man's style, however, because what is measured are unconscious traits and there is not enough of a difference in the events described to justify an unconscious change in tone.

If the change in style is due to a difference in authorship or in time of writing, it is quite possible that the tripartite structure revolving around the family quarrel between Ganelon and Roland had an early origin, perhaps in the ninth or tenth century when, with the breakup of the Carolingian empire and the advent of the Norse invasions, a centralized society no longer existed in what is now France. In this connection, it is interesting to recall the observation of anthropologists that when any society undergoes a severe strain, when the family becomes the dominant force for security, there is a tendency to emphasize the avuncular relationship. Literary critics have often noted the close bonds between Charlemagne and his nephew, a relationship duplicated in several French and pagan families described in the *Roland*, but the critics have usually failed to note that the vast majority of those cases do not appear in the Baligant section, where the dominant relationship is paternal/filial. It is only conjecture, but perhaps the nucleus of the legend of Roland, the tripartite story of treason and enmity between step-father and step-son, dates from those troubled times and it was only in the more stable period which led to the twelfth century renaissance that a version was created which emphasized the larger questions about which society or religion would triumph over the others.

A major cause of the debate over the authenticity of the Baligant episode was the unwritten assumption of nineteenth-century romanticists that the earliest version of any medieval work had to be the purest and therefore best version. Yet taste is so dependent on age, such subjective criteria should not be used in attempting to trace the development of the legend of Roland. If the initial results suggesting the Baligant episode is separate from the rest of the *Roland* are confirmed in further experimentation, it will have no bearing on which version is the 'best' one. It will, however, shed new light on the variety of medieval aesthetics.

REFERENCES

Allen, J.R. (1971) Two routines for CAI language programs. *Computers and the Humanities*, VI, 2.

Delbouille, M. (1954) *Sur la Genèse de la Chanson de Roland (Travaux récents, Propositions nouvelles), Essai critique*. Bruxelles: Acad. roy. de Langue et litt. franç. de Belgique.

Foulet, L. ed (1927) *Glossaire de la Chanson de Roland* in Joseph Bédier, *La Chanson de Roland, commentée par Joseph Bédier*. Paris: Piazza.

Gautier, L. (1878, 2nd ed) *Les Epopées françaises*. Paris: Palme.

Hall Jr, R. A. (1959) Linguistic strata in the *Chanson de Roland. Romance Philology*, XIII, 156–61.

Horrent, J. (1951) *La Chanson de Roland dans les littératures française et espagnole au moyen âge*. Bibliothèque de la Faculté de Philosophie et Lettres de l'Université de Liège, CXX. Paris: Société d'Edition 'Les Belles Lettres'.

Michel, F., ed (1837) *La Chanson de Roland ou de Roncevaux publiée pour la première fois d'après le manuscrit de la Bibliothèque Bodléienne à Oxford*. Paris: Silvestre.

Mortier, R., ed (1940) *Les Textes de la Chanson de Roland*. I, *La Version d'Oxford*. Paris.

Whitehead, F., ed (1947) *La Chanson de Roland*. Blackwell's French Texts, 3. Oxford: Blackwell.

W. M. BAILLIE

Authorship attribution in Jacobean dramatic texts

Despite the great advances in recent years in the methodology for solving authorship problems, there have been relatively few studies yet published applying computer-aided techniques to play texts of unknown or uncertain authorship. This lag is surprising in view of the intense effort in the past to develop a methodology for solving problems of dramatic authorship, particularly of Shakespeare's period. The central difficulty lies in two conflicting assumptions underlying authorship studies of plays. On the one hand, one must assume that each of the dramatists in question has an identifiable, coherent verbal style, a normal pattern of expression which can be isolated in such text features as lexicon, metrics, and image patterns; further, it is usually taken for granted that the better the dramatist, the more strongly marked and distinctive will be his style. On the other hand, one assumes that as a rule a good dramatist consistently distinguishes his characters from one another by individualized speech patterns. To the extent that the latter assumption is true, of course, authorship attribution is made increasingly difficult, at least if one searches for verbal and structural constants. In fact, however, little is known about the range of stylistic variation among the characters in typical plays or from scene to scene involving different groups of characters. Only when we have some idea of this range can large-scale stylistic studies of plays proceed from a really solid base. There are other difficulties peculiar to plays as well. A dramatic text represents spoken, rather than written, language, hence often presents looser syntactic patterns and a much wider range of verbal structures than other literary forms. Further, for the Jacobean era surviving play texts are much less likely than other literary texts to represent closely what the authors originally wrote.

There are problems as well in choosing a methodology. In recent important studies of dramatic authorship the chief tests used have included function word classes, semantic clusters, and image patterns; however, these three tests, in varying degrees, involve the critical disadvantages of low frequencies, conscious choice by the artist, or overt pattern imposition by the investigator. A method which can avoid all three of these disadvantages is to measure grammatical categories and syntactic patterns of high frequency. Unfortunately, as Louis Milic found in his large-scale study of Swift's style, most grammatical categories and the most-used syntactic patterns show frequencies within

a relatively narrow range in most written English (Milic 1967, 166–7). Hence it is probably unrealistic to expect to find in analysis of morphology and syntax any single discriminant which can consistently differentiate the writing of two or more authors. However, measurements of the interrelation among several categories may provide a sufficient power of discrimination.

It is essential, then, to clear the ground of some of these prior questions of methodology and of the variability in dramatic dialogue before tackling directly the questions of authorship in particular plays. Such a study should, nonetheless, be focused on a particular instance of questioned authorship so as to provide necessary constraints on procedure; perhaps the best available instance is Shakespeare's late history play, *Henry VIII*. Since James Spedding in 1850 first advanced the case for Fletcher's hand in the play, the prevailing opinion has been that Fletcher was responsible for the majority of its composition, including the penning of most of the memorable speeches. Spedding's claim has been buttressed by a long succession of scholars using numerous kinds of stylistic tests, especially metrics and imagery along with impressionistic assessments of such elements as crabbed syntax, vigor, and elegance. On the whole, the internal evidence for Fletcher is probably more impressive than similar evidence in any other case of doubtful authorship in a Jacobean play. Nonetheless, several recent editors of the play have cautioned against too easy an acceptance of the evidence and have provisionally or implicitly claimed the whole play for Shakespeare. At present the question seems to be entirely open. Since there are several similar plays extant by each author, *Henry VIII* offers a prime test case for the methodology.

This paper, then, presents the results of an intensive analysis of the range of verbal style in two plays each of Shakespeare and Fletcher chosen for their approximation in date and style to *Henry VIII*: for Shakespeare, *Cymbeline* (1609) and *The Winter's Tale* (1611), and for Fletcher, *The Woman's Prize* (1611) and *Valentinian* (1614). Texts used were, for Shakespeare, from the New Arden editions: *Cymbeline*, ed James Nosworthy, 1955; *King Henry VIII*, ed R.A.Foakes, 1957; *The Winter's Tale*, ed J. H. P. Pafford, 1963. For Fletcher: *Valentinian*, ed Robert G.Martin in *Works of Francis Beaumont and John Fletcher*, IV, 209–321 (London: G.Bell, 1912); *The Woman's Prize*, ed George Ferguson (The Hague: Mouton, 1966). Shakespeare's play closest to the date of *Henry VIII*, *The Tempest*, was not chosen for this preliminary study because of its stylistic peculiarities.

Samples were drawn from each play in three categories: standard-size units, whole scenes, and individual characters. The basic data for analysis was a set of ten 500-word samples from each of the four plays. Because of the requirement of obtaining values for whole scenes and for

individual characters, random sampling was impossible; instead, analysis proceeded from the beginning of each play until enough samples were obtained both for the standard sets and for individual characters. In addition, samples were chosen from the latter half of two plays as a check on the variability within each work. In all, over 30000 words of text have been processed.

The text analysis was carried out using the sophisticated EYEBALL program for stylistic analysis developed by Donald Ross and Robert Rasche (Ross and Rasche 1972). EYEBALL has two inherent advantages over previous similar text analysis programs such as those of Milic (1967) and Warren Austin (1969); EYEBALL begins from raw text without premarking, and it labels each word for both class and function. These features increase both the discriminating power and the reliability of the program. After processing, EYEBALL produces an 'augmented' text in which each word of the original is labelled with codes for location, part of speech, function, number of syllables, position in phrases and clauses, and following punctuation. From the 'augmented' text for each sample the final routine derives a set of sixty-five figures; twenty part-of-speech and fifteen function categories expressed as the proportion of the total sample, twenty combined groupings of categories and ratios among these, and ten means of word, phrase, and clause lengths. A great deal of other data produced by EYEBALL (particularly lexical frequencies) has not been utilized in the statistical analyses (though much of it is potentially of great value) so as to concentrate on syntactic features.

One major aim of this project was to find stylistic factors which consistently discriminate Shakespeare's late dramatic writing from Fletcher's of the same period. Of the sixty-five variables produced by the EYEBALL statistical routines, several proved capable of differentiating samples of the two writers with a success rate above 70 per cent; in few cases, however, were single discriminants able to achieve results significant at the 0·95 level (that is, the level at which the result would occur by chance in five per cent of cases in a random distribution). Among the twenty-three categories for parts of speech, the four high-frequency classes (nouns, verbs, pronouns, determiners) show proportions for the two authors which are closely similar and quite stable. Of the two remaining classes, the best discriminant is the percentage of descriptive adverbs; the mean value for Shakespeare samples is 3·4% (s.d. 1·0) versus 4·6% (s.d. 0·7) for Fletcher. Although the proportions are relatively low, the mean value for the class (4·1%) will serve to divide Shakespeare from Fletcher correctly for twenty-eight of the forty standard-size samples. Among the fifteen categories of word functions, one high-frequency group, complements, is a markedly better discriminant than others. The proportion of words in complement structures averages

18·4% (s.d. 1·3) for Shakespeare, 19·9% (s.d. 1·8) for Fletcher. The overall mean in this class (19·0%) will correctly classify twenty-nine of the forty samples, a proportion which is significant above the 0·99 level. Other high-frequency function categories show mean values nearly identical for the two writers.

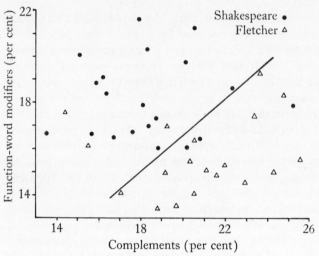

Figure 1. Percentage of function-word modifiers and complements in 500-word samples

The third set of statistics produced by EYEBALL for each sample are combined groupings and ratios among the word-class and function categories. Of these twenty variables six are potentially valuable discriminators. Four of these are combined word-class proportions: all content words, nominal phrase heads, function-word modifiers, and noun modifiers; the two others are ratios: function-word to content-word modifiers, coordinators to subordinators. The best of the six and the best single discriminant found is the class termed noun modifiers, comprising adjectives, determiners and intensifiers. Shakespeare's mean for the class is 22% (s.d. 2·3), Fletcher's is 19% (s.d. 1·6); the overall mean (21·0%) differentiates Shakespeare from Fletcher correctly in thirty-one of the forty samples.

Although no single discriminants were found to be entirely satisfactory in distinguishing the two writers, when two or more variables are combined the power of discrimination rises substantially. Figure 1 shows the interrelation of the percentages of complements (on the horizontal axis) and function-word modifiers (the vertical axis) for forty standard-size samples of the two writers. The sloping boundary correctly differentiates thirty-four of the forty samples, a proportion which would occur by chance in a random distribution less than one time in a

thousand. Note that each of the two variables averages nearly 20 per cent of the total sample size. Note also that the two variables are largely independent of one another: only a small proportion of words classed as function-word modifiers function in complement structures. Figure 2

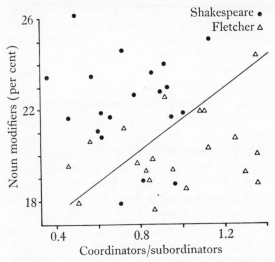

Figure 2. Percentage of noun modifiers, ratio of coordinators to subordinators in 500-word samples

plots the combined percentage of noun modifiers against the values for the ratio of coordinators to subordinators. These two variables are entirely independent; they are derived from word classes which together constitute an average 27 per cent of the total words in the samples. The slope in this case correctly separates all but eight samples. Comparing the results of the two graphs, we find that only one sample by each writer fails both tests (that is, is classified with the wrong group on both graphs). As a negative test, at least, this pair of graphs is able to achieve 95 per cent accuracy. Under these limited conditions, then, it is possible to tell Fletcher's writing from Shakespeare's with considerable confidence.

Are the results reliable? How far can we generalize from them? The study provides some indication of the answers in three ways. First, numerous other pairs of variables when plotted prove to be about as accurate in separating samples of the two writers as the two examples cited. These pairs include cross-plotting of the four variables used on the first two graphs, for example function-word modifiers against noun modifiers (this pair is highly correlated in the samples, of course). Or one of the four may be plotted against a new variable such as the proportion of adverbs or of nominal phrase heads (nouns and pronouns). The important result is that the same samples tend to fail the test (i.e.,

are on the wrong side of the slope) repeatedly, even on graphs involving four different and entirely independent variables. In a set of eight graphs using eight variables in various combinations there were a total of fifty-five failures to classify the forty samples correctly out of 320 tries. But just six samples of the forty account for more than half of the failures; these six in turn are drawn from only four of the twenty-six different scenes in the plays: Shakespeare's *Winter's Tale* I. ii, and Fletcher's *Valentinian* I. iii and *Woman's Prize* I. iii, III. iii. That is, a few scenes resemble the norms of the opposite playwright on a variety of kinds of stylistic measures. We will return to that point in a moment; for now, the converse is important: the various stylistic discriminants correlate well in assigning samples to authors even when the variables are entirely independent of one another.

A second way of assessing the generalizing power of the variables as discriminants is to test the values for whole scenes and for individual speakers. In these tests the problem of sample size becomes dominant. The twenty-six whole scenes processed range from 270 to over 3800 words; the means are 1120 for Shakespeare, 1130 for Fletcher. The graph tests score well on all but the smaller scenes; five different graphs correctly classify at least twenty-one of the twenty-six scenes, while the three others are right in eighteen of nineteen cases. As with standard-size samples, the results are fairly consistent from graph to graph and failures are concentrated in a few scenes. For Shakespeare, one short scene of 340 words (*Cymbeline* I. iv) causes six of the eleven failures; for Fletcher, four scenes, two from each play, account for two-thirds of the failures.

The graphs have a somewhat lower success rate in classifying individual speakers. As might be expected, it is difficult to find samples of individual characters within a single scene which are of the desired size; hence fully half of the character samples analyzed were smaller than 300 words. The mean sample size was about 460 words for Shakespeare's characters, about 415 for Fletcher's. A few of the samples above the mean size were drawn from two or three successive scenes in which the given character speaks. The eight graphs averaged thirteen correct assignments for Shakespeare's twenty characters, thirteen of eighteen for Fletcher's. As anticipated the failures were chiefly in the smallest samples, very few failures occurring in the ten samples larger than 500 words.

One other means of testing the discriminating power of the variables is to submit the values to multivariate discriminant analysis. The routine chosen was the BMD 07M Stepwise Discriminant Analysis produced at UCLA (Dixon 1959). This computer program for up to sixty variables weights the values in relation to their covariance, choosing for inclusion one by one in successive steps the variables which will maxi-

mize its ability to separate the data cases submitted into a predetermined number of groups. The program does not originally classify unknowns; rather, receiving as input two sets of samples already labeled as Shakespeare and Fletcher, it attempts to find a statistical basis for separating the two sets and then proceeds to classify further samples on the basis of the matrix thus established. With the forty standard-size samples as a basis and nine preselected variables to choose among, the BMD routine in three steps (entering three variables) was able to classify correctly thirty-one of the basic set, then among unlabelled samples was successful on twenty-one of twenty-six whole scenes and twenty-nine of thirty-eight character samples. The analysis was even more successful when whole scene values were submitted as the basis for the classification; in the third step the program correctly classified all twenty-six scenes. In a third run, with half the whole-scene samples (every other scene) for each author entered as the matrix basis, the program in two steps achieved perfect separation of these thirteen samples and then on this matrix correctly classified ten of the thirteen remaining samples. One further observation drawn from ten runs in various permutations is important: the samples which the multivariate analysis repeatedly classified incorrectly correlate highly with those samples failing several graph separations. In some measure this overlap results from the choice of some of the same variables in both procedures. However, there are enough variables which do not overlap in the two kinds of tests to permit us to say with confidence that both geometric and algebraic methods of discrimination of the samples arrive at similar results.

At this point we are able to draw several conclusions concerning the reliability of EYEBALL statistics as authorship discriminants, the necessary minimal sample size, and the range of stylistic variance among whole scenes and individual speakers. On the basis of a separation of forty standard-size samples, the BMD multivariate analysis using three variables was able to classify correctly twenty-one of twenty-six whole scenes and twenty-nine of thirty-eight character samples (half of which were less than 300 words in length). In a second kind of test, eight graphs were constructed plotting pairs of variables with a slope drawn by hand to maximize separation of standard-size samples. When applied to the other kinds of samples, these eight graphs were successful in 160 of 208 scene classifications and in 154 of 228 tries on character samples. All of these ratios are well above the 0·95 significance level. In both kinds of tests the failures were concentrated in a small number of samples, especially in those with a sample size under 500 words. Now in a typical Jacobean play the number of words is about 25 000, the number of scenes about twenty, both figures with wide ranges. Most Jacobean plays have two or more groups of characters who tend to appear onstage

in alternate scenes, only occasionally mixing the groups. In cases of joint authorship, it was often the case that each writer was responsible for writing all the scenes involving one group of characters. For these reasons it is imperative for studies in stylistic description and/or authorship attribution to choose for comparison samples which do not cross scene boundaries. A sample size much larger than 500 words will often overrun scene boundaries in most plays. On the other hand, it is clear in the present study that there is a considerable loss in discriminatory power when samples fall below 500 words, enough of a loss to produce results in classifying which are below the 0·95 significance level.

The key finding of this study is that the range of grammatical variance among different scenes and different speakers within single plays, and between two plays by the same writer, is not so wide as to preclude us from distinguishing one writer from another. Of course, the four plays were deliberately chosen in part because they seem to be similar in style. Three of the four are serious dramas on the grand scale involving royal personages in sweeping passions. The fourth play, Fletcher's *Woman's Prize*, is quite different in kind—a bourgeois city comedy— yet in the opening scenes it features a series of set speeches in a mock- heroic manner which resembles in many respects the verbal style of the other plays. Given this similarity of language in the four plays, it would not be surprising if their linguistic features overlapped to such a degree as to make differentiation of the authors impossible; such, however, is not the case. Indeed, the two plays which might be judged to resemble one another most closely in language, *Cymbeline* and *Valentinian*, are by far the easiest of the four pairs to tell apart. On the other hand, while all three kinds of samples from Fletcher's comedy failed the graph separa- tions and the multivariate analysis much more often than samples from the other plays, still the tests were able to distinguish that play's style from that of Shakespeare samples at a significant level. In fact, the overall variance among samples is much less for Fletcher than for Shakespeare, even though Shakespeare's two tragicomedies might be supposed to be much more alike than Fletcher's tragedy and comedy.

It was noted earlier that the discriminant values for the samples of individual speakers varied over a much wider range than with the standard-size or whole-scene samples. Nonetheless, to some extent the discriminants are sufficient not only to tell Shakespeare's characters from Fletcher's, but one Shakespeare character from another in the same play. There is a strong tendency for samples of the same speaker drawn from different scenes to show closely similar discriminant values. For example, the title character of *Valentinian* has speeches totalling between 300 and 450 words in each of three scenes of the play that were analyzed. In these samples the percentage for prepositional adjuncts (words in pre-

positional phrases) is 14% in all three cases compared with a mean for all samples of 21% (s.d. 3·5). Similarly, the values for this character's three samples are consistently variant from the overall means in eight of the ten most important variables. On this basis Valentinian's language is easily differentiated from that of the two other characters with prominent parts in the same scenes. Yet all three speakers are distinguishable from most of the individual characters of Shakespeare's two plays and are always identified as Fletcher's in two-way tests.

In several cases the failures to discriminate individual speakers are also significant. Of particular interest is the pattern of the four major characters in the long second scene of *The Winter's Tale*. In this scene both the obsessed jealous husband Leontes (1503 words) and his shocked spouse Hermione (521 words) fail all eight graphs and the BMD multivariate analysis, while the less disturbed characters in the scene, Polixenes and Camillo, are correctly identified as Shakespeare's by all the graphs and the BMD routine. At certain highly emotional moments, it seems, Shakespeare's characters resemble much more the norms for Fletcher's speakers than their own speech in saner episodes, or the general Shakespearean pattern.

It was noted at the outset of this paper that the specific problem in view all along was that of assigning Shakespeare's and Fletcher's shares in *Henry VIII*. A detailed study of that play can now proceed with the confidence that EYEBALL 'augmented' texts produce statistics which consistently discriminate Fletcher from Shakespeare at a high level of significance. The program generates valid stylistic descriptors for whole scenes and even for individual speakers of the two writers. While *Henry VIII* offers an ideal case because of the available control plays, it seems likely that the methodology may prove useful as well in other long-standing cases of disputed authorship in Jacobean drama.

Acknowledgements
This study was conducted with the aid of the OSU Instruction and Research Computer Center, especially the Center's consultant in humanities, Thomas G. Whitney.

REFERENCES

Austin, W. (1969) *A computer-aided technique for stylistic discrimination; the authorship of Greene's* Groatsworth of Wit. Nacogdoches, Texas: US Office of Education.

Dixon, W. J., ed (1967) BMD *Biomedical computer programs.* (Univ. of California Publications in automatic computation, 2.) Berkeley: Univ. of California Press.

Milic, L. (1967) *A quantitative approach to the style of Jonathan Swift.* The Hague: Mouton.

Ross Jr, D. & Rasche, R. (1972) EYEBALL: A computer program for description of style. *CHum,* **6,** 213–21.

Measuring alliteration : a study in method

The tendency of language elements to co-occur and cluster has received attention from numerous scholars working on a variety of linguistic fronts. Semanticists and psycholinguists have long been interested in the tendency of words to occur in close proximity to each other as a measure of latent speech behavior (see especially Osgood 1959). In the field of automatic abstracting, Doyle (1963) has demonstrated that statistical analysis of text can aid in identifying lexical strings which form a conceptual unit such as *black market* and *information retrieval system*. In phonetics, Königova (1967) has shown the use of both probability statistics and entropy measures in investigating the co-occurrence of Czech phonemes. More recently, Bailey (1971) has illustrated the use of various statistical measures, including entropy, on poetry.

In the field of literary stylistics, primary emphasis has been on the lexical level. The identification of frequently-occurring word clusters is obviously important as an index to thematic content. Gustav Herdan in his monolithic *Advanced Theory of Language as Choice and Chance* describes a method which he calls the random partitioning of text which can be used in tests of disputed authorship. The method involves finding significant differences in word-use statistics among the sections of such partitioned text. Statistical models similar to this, using both random and non-random partitioning have been used in many studies of theme and style.

B. F. Skinner in 1939 was probably the first to use the model, later described by Herdan, on the level of phonemes. Skinner was interested in alliteration as a literary manifestation of latent speech and its relationship to the more general problem of word association in the psychological sense. Rather than randomly dividing the text, Skinner used the line as the natural unit of poetry. Scanning 1400 lines from the sonnets of Shakespeare, he had the stressed syllables determined and a count made of the number of appearances of each consonant sound in initial position. Assuming that the consonants are randomly distributed throughout the 1400 lines, he could then calculate their probabilistic distribution. The process is much like assigning probabilities to the sequence of cards in a shuffled (random) deck. We know that the probability of any spade and any club occurring together is rather high, and we can calculate the number of times such a sequence may be expected to occur. The

probability of an ace followed by another ace is somewhat lower and it may be expected to occur much less frequently. In much the same manner, Skinner calculated the number of lines in which each initial consonant could be expected to occur once, twice, three times, and not at all. In this model what we would expect to find is that at least some of the consonants are not distributed randomly but tend to cluster together, giving a greater than probable number of lines with high occurrence rates. Skinner found that this did not happen, at least to any statistically significant degree, and blithely concluded that:

'In spite of the seeming richness of alliteration in the sonnets there is no significant evidence of a process of alliteration in the behavior of the poet to which any serious attention should be given. So far as this aspect of poetry is concerned, Shakespeare might as well have drawn his words out of a hat . . .' (Skinner 1939, 191)

In defense of the non-random nature of Shakespeare's poetry, several initial difficulties with the study could be cited. To begin with, Skinner limited his definition of alliteration to the repetition of initial consonant sounds. While this is indeed the traditional definition, it is only with a great deal of reluctance that we should allow alliteration to be quantified on this basis. Consider the line *Death's second self that seals up all in rest* (73, l.8). The strong sibilance of the line is due not only to the three initial *s*'s, but also to the two final *s*'s in *Death's* and *seals* and specially to the *s* in *rest*. To limit alliteration to the repetition of initial consonants only is to disregard the obvious alliterative effect of such phrases as *forebemoaned moan* (30, l.11) and the more subtle ones of *No longer weep for me / Than you shall hear the surly sullen bell* (71, l.2).

Skinner also felt curiously obliged to discard consonants that were due to repetitions of a word within a line. For his own example he cites the line *Suns of the world may stain when heaven's sun staineth*. Noting that there are four initial *s*'s in the line, Skinner attributes the two final *s*'s 'not only to formal strengthening but to some thematic source' (1939, 188). With some hesitance, he seems to have felt that repeated words have more to do with conveying theme than they do with actual alliteration. The introduction of such 'thematic' considerations into the study of alliteration seems to give rise to unnecessary complications. If we attribute certain repetitions to theme it would seem only right to begin considering other poetic and syntactic reasons for repetitions. It is obvious, for instance, that Shakespeare frequently uses rhetorical parallelisms as in the lines: *Then happy I, that love and am beloved, / Where I may not remove nor be removed* (25, ll. 13–14). It is difficult to say, let alone quantify, how much the repetitions of *love* and *remove* belong to a desire on the part of the poet for balanced sentence structure and how much to the impulse to make the lines flow with consonant repetition.

One further aspect of the study which appears suspect is Skinner's use of the line as the unit of alliteration. While this does seem to be a very natural way to divide up the sonnets for study, one can legitimately wonder how many of the high-frequency lines occur in close proximity to each other. Consider the line *If I lose thee, my loss is my love's gain*, (42, 1.9) which should yield a raw count of three *l*'s. It seems relevant to any quantification of alliteration, however, that the very next line is *And losing her, my friend hath found that loss*, with two more *l*'s. Furthermore these lines are found in a sonnet replete with high-frequency *l*-lines centering around various forms of the words *love* and *loss*. What we may call the domain of alliteration in many of Shakespeare's sonnets seems to go beyond the boundary of a single line and to lie somewhere inside the 'little room' of the sonnet itself.

In a later study (1941), Skinner attempted to take into account this problem of 'alliterative span' by counting the number of syllables intervening between initial consonant repetitions. These counts were then compared to the calculated expectancy from chance. For 500 lines of Swinburne's *Atalanta in Calydon* Skinner's calculations did show significant clustering of initial consonants in domains of up to five syllables. The Shakespeare sonnets, however, produced only one significant measure (for adjacent accented syllables), although the other measures did indicate a 'plausible trend' according to Skinner (1941, 72). But while this demonstrates some success in locating alliterative units other than the line, Skinner apparently saw no way of utilizing these units in an alliteration measure. His suggested overall measure, the 'coefficient of alliteration' uses the same formula for binomial expansion of probabilities and the line alliterative unit discussed above.

It would seem then, that a reasonable criterion for a statistical measure of alliteration would require that it be defined apart from any considerations of theme, rhetorical structure, or rhyme pattern, since looking at poetry from the vantage of alliteration seems to cut across these bounds. Ideally it would also include embedded as well as initial consonants and would not arbitrarily confine the domain of consonant repetition. In the present study, two of Shakespeare's sonnets were chosen; 18, the familiar *Shall I compare thee to a summer's day* and 30, *When to the sessions of sweet silent thought*. The two sonnets were encoded onto computer punched cards in modern spelling. Modern spelling was used primarily for ease of encoding. It is unlikely that the choice of spelling systems would have a significant effect inasmuch as the present study concentrates on consonants. No special weights were attached to initial or stressed letters, nor were the various idiosyncracies of orthography such as double letters eliminated. The sonnets then became 'data' for input to an open-ended computer program, written by the author in PL/1. The purpose of the program was to experiment

with various proposed methods of statistically measuring co-occurrence, contingency, and clustering in linguistic phenomena. Alliteration was thus viewed as a specialized subset of the more general problem of linguistic clustering on all levels. The problem then was to locate the areas of high concentration of consonants and, if possible, to arrive at a measure of such concentration.

| | Sonnet 18 | | Sonnet 30 | |
letter	occurrences	P(I)	occurrences	P(I)
A	40	·0825	37	·0786
B	5	·0103	4	·0085
C	9	·0186	12	·0255
D	20	·0412	22	·0467
E	61	·1258	62	·1316
F	10	·0206	16	·0340
G	10	·0206	11	·0233
H	31	·0639	27	·0573
I	28	·0577	33	·0701
K	1	·0021	2	·0042
L	23	·0474	17	·0361
M	23	·0474	12	·0255
N	33	·0680	42	·0892
O	44	·0907	39	·0828
P	4	·0082	7	·0148
R	29	·0598	22	·0467
S	42	·0866	35	·0743
T	40	·0825	33	·0701
U	13	·0268	9	·0191
V	5	·0103	5	·0106
W	5	·0103	17	·0361
X	1	·0021	1	·0021
Y	8	·0165	6	·0127
Total	485		471	

Table 1. Letter frequencies and probabilities for Shakespeare's sonnets 18 and 30

A more rigorous procedure would, of course, demand that the sonnets be phonetically coded before analysis is done on them. This approach would have the added power that clusters of consonant distinctive features could be located. The scope of the present study, however, was to investigate various methods of locating and measuring the clustered consonants rather than to produce any exact alliterative measures. While I was prepared for a good deal of 'noise' from the orthography, I felt that in most cases it did provide at least a rough index to what we traditionally call alliteration.

In table 1, I have presented the raw letter counts of each sonnet and the probability of occurrence for each letter. Table 2 presents the results

of a random partitioning of the text of sonnet 30 into fourteen equal segments, not necessarily consistent with line divisions. The concentration of a letter in any particular segment is expressed as a percentage of its total occurrence in the text. An examination of this table seems to sustain the objection that a good deal of information is lost because of the partitioning itself. While clusters of the consonants *l, m, r* and *s* are evident by an examination of contiguous percentages, this contiguity itself is lost when a measure such as Skinner's multiplication of probabilities is applied.

letter	occurrences	1	2	3	4	5	6	7	8	9	10	11	12	13	14
A	37	0	2	10	8	8	5	5	8	13	8	5	13	0	10
B	4	0	25	0	0	0	0	0	0	0	0	0	25	50	0
C	12	0	8	8	0	8	8	0	25	8	8	16	8	0	0
D	22	0	0	0	13	9	18	4	9	4	4	4	4	4	18
E	62	9	4	1	6	6	4	9	9	4	8	9	4	9	8
F	16	6	6	6	0	6	12	6	6	0	12	12	6	12	6
G	11	0	18	27	0	0	0	18	0	18	18	0	0	0	0
H	27	11	7	14	3	3	7	7	3	11	3	3	7	14	0
I	33	6	6	12	9	3	12	3	3	12	6	0	9	15	3
L	17	5	0	5	11	5	0	17	11	0	5	11	0	5	17
M	12	0	33	8	16	0	0	0	8	8	8	0	16	0	0
N	42	7	7	4	4	11	4	7	11	9	7	2	9	4	4
O	39	10	5	5	5	7	5	5	7	0	7	17	7	5	5
P	7	0	28	0	0	0	14	14	14	0	0	0	28	0	0
R	22	0	9	0	4	4	13	4	0	4	13	9	0	4	22
S	35	17	5	8	5	5	8	14	2	5	2	2	2	0	14
T	33	15	6	9	9	9	6	3	3	9	0	12	3	12	3
U	9	0	33	11	0	22	11	0	0	0	0	11	0	11	0
V	5	0	0	0	0	0	0	20	0	40	40	0	0	0	0
W	17	11	0	0	23	11	5	5	5	0	5	5	11	5	0
Y	6	0	0	16	16	16	0	0	0	16	16	0	16	0	0

text interval appears as the heading spanning columns 1–14.

Table 2. Percentages of each letter occurring in fourteen equal text intervals for Shakespeare's sonnet 30. Letters occurring fewer than four times omitted.

One promising means of avoiding this difficulty seemed to be to consider the text as a series of gaps or slots, each occupied by a letter. Spang-Hanssen (1956) used such a scheme in his study of lexical dispersions in a Danish novel, graphing the cumulative frequency of occurrence of a word against the text space. A somewhat different use of gap distributions in conjunction with the multiplication of probabilities

is discussed by Herdan (1962) who used it to demonstrate the pattern of
initial consonants in Vergil's *Georgics*. But the most generalized method
of utilizing this concept was suggested by Hildum (1963). Hildum was
interested in word associations and describes his 'association measure'
thus:

> 'Suppose that we are finding the association from a center word A
> to a target word B, forward in the text. . . . Assuming that A and B
> are not related in this direction, that is, that B is randomly distri-
> buted with respect to A, we should be able to calculate probabilities
> of occurrence and nonoccurrence at any location in the text using
> only the relative frequency of B. Thus the probability that word B
> will NOT occur in the first position following A is equal to $1 - p(B)$,
> the probability that it will not occur in either of the two following
> positions is $[1 - p(B)]^2$, and the probability that it will not occur
> in any of the n following positions is $[1 - p(B)]^n$. When probabili-
> ties are raised to successively higher powers, they become steadily
> smaller, and assuming that we start with rather high probabilities
> of nonoccurrence (that is, low relative frequencies of words), the
> probability will at some point cross the value ·5. This point, viewed
> in terms of a statistical distribution, is the median distance from
> word A at which an instance of word B will be found' (Hildum 1963,
> 650–1).

Hildum goes on to propose that we substitute into the formula $[1 -
p(B)]^n$, for n the empirical or actual median number of positions (gaps)
observed to occur between two words (or, in our case, letters) and for
$p(B)$ the actual probability of occurrence of the word. The value of this
formula will become ·5 for letters not particularly clustered or associated
and greater than ·5 for letters that are associated with each other more
than would be expected if they were randomly distributed. Thus as a
final refinement to the formula we can subtract ·5, making the range
zero for no association and greater than zero for higher associations, with
a maximum of ·5 being only theoretically possible if $n = 0$. The final
formula is thus $[1 - p(B)]^n - 0·5$.

Using this formula, association measures were calculated for all
letter pairs in both sonnets. The results are summarized in tables 3 and
4. Association measures for each consonant with itself are presented for
all consonants, since this is of primary interest to us in measuring alli-
teration. I have also presented other association measures which show a
significant associational or disassociational tendency between two letters.
All letters occurring fewer than four times were eliminated because of
the distorted measures which they could be expected to produce. The
tables present values for vowels only for the sake of completeness;
wide variations between vocalic phonology and orthography makes these
measures virtually useless for our present purposes.

target	base NCNT	A 40	B 5	C 9	D 20	E 61	F 10	G 10	H 31	I 28
A	−·05	+·21	+·21				+·31		+·21	
B		+·03	+·26				+·23	+·34		+·21
C			+·27	−·21						
D				−·03						
E						+·01		−·21		
F							+·06			
G								−·06		
H		+·22							−·06	
I		−·26								+·03
L				−·21						
M		−·33	−·27			−·22			−·25	
N			+·31							
O										
P								−·50		
R										
S										
T		+·21								
U		+·34	+·20							
V			−·28							
W										
Y		+·3 8								

Table 3. Letter association measures for Shakespeare's sonnet 18. Letters occurring fewer than four times have been eliminated; association values in the range −·19 to +·19 are omitted as nonsignificant, except for each letter with itself.

The alliteration measures produced may be examined by scanning the diagonal formed by associating each consonant with itself. In only three cases, *v* with *v* in sonnet 30, and *w* with *w* and *c* with *c* in sonnet 18, do the measures along the diagonal show any significant association. The fact that these measures are all based on a distribution of only a few cases immediately makes them suspect. An examination of sonnet 30, however, shows that all five *v*'s are found in lines 7–10 (*love, heavily,* etc.) centering around *grieve at grievances forgone.* Similarly, in sonnet 18 the high *c* association can be pinpointed in the lines *By chance or natures changing course untrimm'd* and *So long as men can breathe or eyes can see.* The high *w* association measure is due to the words *ow'st, wandrest, when,* and *grow'st* in lines 10–13 and may be considered spurious; a phonetic coding would have differentiated between the *ow, wh* and *w* sounds.

An examination of the other association measures in the table shows

N 33	O 44	P 4	R 29	S 42	T 40	U 13	V 5	W 5	Y 8	target
									+·24	A
+·21		+·20	+·24				+·34			B
		−·34	−·22	−·22	−·21	−·34	−·39			C
										D
		+·21					+·37	−·26		E
							+·27	−·35		F
										G
				+·30						H
							+·25		−·21	I
		−·26								L
		−·26					−·23	−·24		M
+·00								+·31	+·21	N
	−·02									O
		−·13					−·50			P
			−·04			+·29	−·44			R
				−·01			+·26			S
					+·02					T
						+·05	−·38			U
	+·21						−·09			V
		+·22			−·21		−·25	+·28		W
									−·07	Y

that the highs and lows frequently involve a low frequency letter as either target or base. Thus the columns under B, P, and V seem to produce a cascade of 'significant' measures, many of which are probably best discarded. In the present study, I used a very low arbitrary value (three occurrences) to eliminate such distorted measures. A thorough investigation of the relationships between frequency and the resultant association measure would seem to be requisite to its more exact use. Many of the measures, however, do prove interesting, if not revealing. Reassuringly, *t* associates highly with *h* in both sonnets (*thee, thou, then, this*, etc.). The high association of *m* with *n* in sonnet 30 is a reflection of such sonorous nasals as *summon, remembrance, moan*, and *many*. Surprisingly, *p* does associate highly with *f*, in spite of the low NCNT, with the word pairs *precious friends, weep afresh*, and *pay as if not paid before*, although the measure is biased slightly upward by the spurious *expense of*.

In light of these successes, how can we explain the insensitivity of the measure to associate *s* with itself given such lines as *When to the sessions of sweet silent thought* and *All losses are restored and sorrows end?* The answer, of course, lies in the distribution of the letter within the text.

target	base NCNT	A 37	B 4	C 12	D 22	E 62	F 16	G 11	H 27	I 33
A		−·01	−·21							
B			−·24		−·25				−·20	−·25
C			−·50	+·00						
D			−·20		−·02					
E						−·06				
F			+·33	+·23			−·08			
G			−·50		−·32			+·17		
H								+·21	−·01	
I										−·03
L										
M			−·50		−·24					
N										
O							+·21			
P			−·50	+·20						
R							+·39			
S			−·41	−·27						
T								+·21		
U					−·32					
V			−·50				−·26	+·23		
W										
Y		+·21	−·50					+·20		

Table 4. Letter association measures for Shakespeare's sonnet 30. Letters occurring fewer than four times have been eliminated; association values in the range −·19 to +·19 are omitted as nonsignificant, except for each letter with itself.

Taking the example of *s* with itself above, table 5 reproduces the data involved in the calculation of this association measure. The *unranked gap values* are simply a running count of the number of letters (gaps) between each *s* and the nearest *s* following it. Thus from the first *s* to the second there were 2 gaps, from second to third 1 gap, etc.

I have presented this data exactly as the computations were made on the computer, without adjusting for double *s*'s etc. An examination of the sonnet in question will show that, while *s*'s would be eliminated from *sessions*, *losses*, and *dateless*, a phonetic coding would also pick up the *s*-sounds in *remembrance*, *since*, and *cancell'd*. The 'infinite' gap represents the last *s* in the text and its sole purpose is to bias the distribution (hence the median of the distribution) upwards. These gap counts are then ranked into a frequency distribution and the median is substituted into Hildum's formula.

Hildum himself does not elaborate on his use of the median as a

N 42	O 39	P 7	R 22	S 35	T 33	U 9	V 5	W 17	Y 6	target
		+·42			−·23	+·34			+·34	A
			−·28	−·21	−·23	−·27		−·28		B
						+·27				C
										D
		+·25							−·24	E
		+·32								F
	−·34	−·50					+·33	−·32	−·23	G
					+·34		−·24			H
										I
										L
		−·33								M
−·09										N
	−·03									O
+·21		+·08			+·34					P
		+·20	+·00				+·20			R
			+·08		−·23					S
				+·00		+·31				T
						−·05				U
	−·30	−·21	−·50		−·25	+·32				V
	−·24							−·01		W
								+·25	+·00	Y

measure of central tendency, but it is probably due to the problem of infinite gaps. It should be noted that in almost all cases the median will be much lower than the mean of the gap data; in statistical terms, the gap frequency distribution has a characteristic positive skew. Using the mean number of gaps between letters would tend always to produce very low association measures. By using the median we have managed to eliminate the bias of very high gap distances between letters. However, for a letter which is distributed in a text at very irregular intervals, unexpectedly high or low values might be produced.

One cannot really quarrel with the use of the median as a measure of central tendency in the present example. In fact, the point at which the most information, from the standpoint of alliteration, seems to have been lost is in the distribution grouping itself. After the data has been ranked we have lost the fact that distances of 2, 4, 3, and 5 gaps between s's occur in succession; that these are followed closely by distances of 3 and 3; that the poem ends with gap distances of 2, 6, 8, 6, etc. One can see that by using the median of the frequency distribution in our association or alliteration measure, a high value will be produced only when short gap distances are not counterbalanced by larger ones. Such seems

unranked gap values
2, 1, 4, 3, 5, 14, 26, 3, 3, 24, 19,
18, 3, 24, 18, 7, 11, 7, 1, 17, 6,
5, 30, 13, 3, 30, 41, 41, 56, 1, 2,
6, 8, 6, infinite.

frequency distribution

gap length	frequency
1	3
2	2
3	5
4	1
5	2
6	3
7	2
8	1
..	
11	1
..	
13	1
14	1
..	
17	1
18	2
19	1
..	
24	2
..	
26	1
..	
30	2
..	
41	2
..	
56	1
..	
infinite	1
	35

median = 7
mean (of 34 finite) = 13·5
probability of s = 0·0743

Table 5. Raw data for calculating
the association measure of s
taken as base and target in
sonnet 30

to be the case with v noted above (*grieve at grievances*); but the reason
that it is not counterbalanced seems to be due to the distribution of the
letter in English rather than to any real success of the formula to measure

alliteration. In the example of s presented in table 5 we had no such fortuitous circumstances working in our favor. S is both a frequently occurring sound in English and one which Shakespeare has favored in the sonnet. Thus when the central tendency measure is applied the two effects cancel each other. We should note in passing that Hildum's association measure would have similar difficulties on the lexical level. For example, a word which is frequently mentioned in one section of a text would have a very high association with itself for that section taken alone; but in following sections this might be nullified by a more widely dispersed use of the word.

It thus becomes evident that the phenomenon of alliteration is one of domain or locale which cannot necessarily be captured by the measurement of median gap distances alone. It is in the more exact quantification of such locale or domain phenomena that the search for a more exact measure of alliteration should be concentrated.

REFERENCES

Bailey, R. W. (1971) Statistics and the sounds of poetry. *Poetics*, **1**, 16–37.
Doyle, L. B. (1963) The micro-statistics of text. *Information Storage and Retrieval*, **1**, 189–214.
Herdan, G. (1962). *The Calculus of Linguistic Observations*. The Hague: Mouton.
Herdan, G. (1966) *The Advanced Theory of Language as Choice and Chance*. New York: Springer-Verlag.
Hildum, D. C. (1963) Semantic analysis of texts by computer. *Language*, **39**, 649–53.
Königova, M. (1967) Measuring dependence of linguistic elements. *Prague studies in Mathematical Linguistics*, **2**, 141–53.
Osgood, C. E. (1959) The representational model and relevant research methods, in *Trends in Content Analysis* (ed Ithiel de Sola Pool), 33–88. Urbana: U. of Illinois Press.
Spang-Hanssen, H. (1956) The study of gaps between repetitions. *For Roman Jakobson* (ed Halle, M.), 497–502. The Hague: Mouton.
Skinner, B. F. (1939) The alliteration in Shakespeare's sonnets: A study in literary behavior. *The Psychological Record*, **3**, 186–92.
Skinner, B. F. (1941) A quantitative analysis of certain types of sound patterning in poetry. *The American Journal of Psychology*, **54**, 64–79.

D.ROSS

An EYEBALL view of Blake's *Songs of Innocence and of Experience*

In 1970, Robert Rasche and I began development of a procedure for the description of style named EYEBALL (documented in Ross and Rasche 1972, 1973; Ross 1973a). Starting with a text in natural language, PHASE 1 provides statistics of vocabulary distribution, automatically marks the number of syllables per word, and prepares for an accurate parsing. Intermediate states update computer files using a set of programs called SYNTAX. An 'augmented text', the final result, contains annotations for each word which indicate syllable length, grammatical category and function, location in clause, sentence, and in the text. The augmented text is then analyzed for a variety of measures, such as word and clause lengths, distributions of word-classes, and proportions of combined word-classes (e.g., all modifiers). This report will describe recent developments in the EYEBALL programs and present some techniques being used to formulate generalizations about coherent sets of augmented texts. The focus of the discussion is the style of Blake's *Songs of Innocence and of Experience*.

The most famous early poems of William Blake are contained in two illustrated sequences published, in 1794, under the title *Songs of Innocence and Of Experience Shewing the Two Contrary States of the Human Soul*. Aside from recognition that these are excellent poems, there has been sustained interest in the ironic contrast between their 'simple' or 'childlike' style, and their subtle and philosophical content. Analysis of the poems by many critics over the years has resulted in something like a consensus that 'two contrary states' are not totally exclusive categories, and that the pastoral settings and characters of *Innocence* frequently join the religious and social themes of *Experience*. The chief link between these two worlds seems to be the ambiguous pastoral language of Christianity, where 'Lamb', and 'Father', and 'Child', and 'Tree' imply both the objects of this world and of God's province. A typical poem, 'The Human Abstract', from the *Songs of Experience* should serve to remind the reader of the style which will be analyzed:

> Pity would be no more
> If we did not make somebody Poor;
> And Mercy no more could be
> If all were as happy as we.

And mutual fear brings peace,
Till the selfish loves increase:
Then Cruelty knits a snare,
And spreads his baits with care.

He sits down with holy fears,
And waters the ground with tears;
Then Humility takes its root
Underneath his foot.

Soon spreads the dismal shade
Of Mystery over his head;
And the Catterpiller and Fly
Feed on the Mystery.

And it bears the fruit of Deceit,
Ruddy and sweet to eat;
And the Raven his nest has made
In its thickest shade.

The Gods of the earth and sea
Sought thro' Nature to find this Tree;
But their search was all in vain:
There grows one in the Human Brain.

The *Songs of Innocence and Songs of Experience* are coherent works. Once each series was assembled, a special 'Introduction' was written, and the poems along with related illustrations were etched in copper and used to print copies. Blake consciously reaffirmed the coherence of the series since each copy he sold over some twenty years was printed, for the occasion, from the plates. While the order of poems varies considerably from copy to copy, the contents of each set are nearly invariant (Erdman 1965, 712–23). It was initially hoped that rigorous analysis would reveal well-defined contrasts in the styles of these two sets. Although a few significant differences have been found, most measures indicate that the style of *Innocence* is nearly the same as the style of *Experience*. Even though this approach has not solved the critical problems, the data which are presented should prove to be useful in the future. Blake's style has such pronounced features of what might be termed 'simplicity', that precise definition of his features can provide a standard against which other poets can be judged.

When the style of a number of poems (or of samples of a long prose work) is to be generalized about, different ways of compressing and of comparing the data are needed. Variability measures, means and medians help solve the first problem. Statistical procedures are available which compare sets of observations, but their application is severely limited

	Innocence				Experience		
	all words	func-tion	con-tent		all words	func-tion	con-tent
Introduction	1·83	2·61	1·42	Introduction	1·37	2·00	1·11
Shepherd	1·42	2·21	1·20	Earth's Ans.	1·33	1·95	1·12
Ecch. Green	1·57	2·21	1·20	Clod & Pebble	1·43	1·89	1·16
Lamb	2·22	2·71	1·87	Holy Thursday	1·59	2·33	1·18
Lit. Black Boy	1·94	2·84	1·38	Lit. Girl Lost	1·61	2·18	1·36
Blossom	1·68	1·75	1·65	Lit. Girl Found	1·45	2·42	1·13
Chim. Sweeper	1·65	2·55	1·16	Chim. Sweeper	1·73	2·50	1·22
Lit. Boy Lost	1·32	1·38	1·26	Nurse's Song	1·64	2·83	1·11
Lit. Boy Found	1·39	1·92	1·15	Sick Rose	1·13	1·31	1·00
Laugh. Song	1·84	2·94	1·34	Fly	1·47	1·78	1·17
Cradle Song	1·80	1·94	1·72	Angel	1·51	2·12	1·18
The Div. Image	2·12	2·14	2·10	Tyger	1·96	3·13	1·39
Holy Thursday	1·36	1·94	1·06	Pret. Rose T.	1·47	1·74	1·21
Night	1·57	2·42	1·16	Sun-Flower	1·22	1·53	1·04
Spring	1·48	1·82	1·33	Lilly	1·29	1·86	1·06
Nurse's Song	1·73	2·50	1·29	Garden of Love	1·53	1·96	1·16
Infant Joy	1·92	1·73	2·18	Lit. Vagabond	1·58	1·93	1·27
A Dream	1·22	1·56	1·03	London	1·55	2·73	1·16
Anoth. Sorrow	2·26	3·18	1·66	Hum. Abstract	1·42	2·00	1·05
				Infant Sorrow	1·18	1·64	1·00
Average	1·70	2·22	1·42	Poison Tree	1·91	2·95	1·27
s.d.	0·30	0·51	0·35	A Lit. Boy Lost	1·48	1·75	1·22
No. > median	13	10	13	A Lit. Girl Lost	1·48	2·23	1·19
				Tirzah	1·58	2·48	1·16
				Voice Anc. Bard	1·19	1·55	1·00
				School Boy	1·63	2·47	1·21
				Average	1·49	2·13	1·16
				s.d.	0·20	0·46	0·10
				No. > median	8	11	8

Table 1. Type averages for both sets. The medians for combined sets: all words 1·55, function words 2·00, content words 1·20. *F*-test (comparison of variances) and *t*-test (comparison of means): the means for all words are significantly different at the 0·01 level ($t = 3·02$; $F = 2·1$ for df 25, 18); there are insignificant differences for function words ($t = 0·4$; $F = 1·2$). Variance differences for content words are sufficiently large that the *t*-test is useless ($F = 6·8$).

because almost no data have been collected and published, especially data from English poetry. We are often left with little but intuition to guide us when we judge Blake's words 'short' or his clauses 'simple', or when we sense that his style includes conventions which imitate children's language or songs.

In the absence of this data for comparison, Blake's *Songs* have to be

treated as a statistical population. Ultimately their style will need to be evaluated in terms of a representative sample of appropriate texts, particularly English Romantic and Augustan verse. Such a sample is unlikely to exist in the near future; therefore, studies of this sort will necessarily be weighted toward description *per se*, and valid interpretations will be difficult to obtain. One way to circumvent the lack of background data is illustrated by the new features of EYEBALL which analyze observed data for word lengths in terms of mathematical-statistical models which have been built to simulate events in language. The 'contingency-table' approach which is also briefly discussed may be the start of a model for word-class distributions. Given these limitations, the discussion of Blake's *Songs* can begin with the output of PHASE 1, the repetition of vocabulary items.

Table 1 gives the vocabulary statistics for each poem in the *Songs*, listed as the 'type averages', or the rate each type is repeated for all words, for function words, and for content words. On all three counts, *The Songs of Innocence* shows more repetition than does *The Songs of Experience*, as reflected in the averages at the bottom of the columns. Medians for the two combined sets are given, since thirteen of nineteen *Innocence* poems have ratios above the medians both for all words and for content words. Standard deviations (s.d. in the table), a normalized measure of variability, indicate that type averages are more alike from poem to poem in *Experience* than in *Innocence*. When data are assembled from other sources it seems likely that a relationship between text length and these rates of repetition in lyric poetry will be able to be specified. The great variability of the data from Blake does not allow any generalization. The division between statistics for content and function words is important to preserve in future studies. Not only is the repetition of function words likely to be higher, it will inevitably increase with the size of the text (the 175 function words in the EYEBALL dictionary comprise about half of all tokens in the million-word corpus gathered at Brown University). However, the stability of content-word repetition in *Experience* (1·16 average repetition of types; s.d. 0·10) suggests that a low rate, and perhaps a nearly constant rate, may be a component of the style of certain groups or genres of lyric poetry.

Most of the statistics, not just those for vocabulary repetition, exhibit greater relative variability in *The Songs of Innocence*. One explanation of this difference is that the earlier set reflects Blake's search for an appropriate style, and that he had more or less decided on a style by the time he composed the companion series of poems. Further study of the development of Blake's style after 1793 will be needed before this hypothesis can be evaluated.

Since words are classified in EYEBALL both by category (e.g., noun, auxiliary verb) and function (e.g. prepositional adjunct, subject), two

category	*Innocence* % of words	*Experience* % of words	all poems % of words
noun	22·5	23·3	22·9
verb	16·9	15·5	16·2
adj	9·9	10·8	10·4
advb	2·9	2·1	2·4
pron	8·3	5·9	7·0
determ	13·3	15·5	14·5
prep	9·8	10·4	10·1
aux vb	3·8	3·6 .	3·7
sub conj	4·0	3·9	3·9
coor conj	6·2	6·6	6·4
misc	2·6	2·5	2·5
function			
subject	20·3	22·3	21·3
complement	15·0	16·5	15·8
predicate	22·2	20·3	21·2
adjunct	8·3	6·4	7·3
prep adjt	25·5	27·9	26·8
misc	8·8	6·5	7·6

Table 2. Word-class data for each set and for all poems.
A distinction should be made between *composite*
and *averaged* descriptive data for the sets. The
composite description is calculated by adding all words
which have a certain component and dividing by the
the number of words. The latter are generalizations
made by adding the percentages or proportions for
each poem and then dividing by the number of poems.
This table is based on composite statistics; there
are 2404 words in *Innocence* and 2729 in *Experience*.
Both methods were tried on a number of components
and the differences were not significant, although
with prose or poetry less uniform than Blake's *Songs*
the method of generalization might become a crucial
issue.

sets of data are available and are summarized on table 2. The function-
distributions show little difference, a fact which reflects the basic
similarity of Blake's syntax at the ranks of clause and sentence. Greater
variability and possible experimentation in the earlier *Songs of Innocence*
is indicated by the fact that medians and means are consistently further
apart in that set than in the later one, and by higher variability measures.
One example is the percentage of nouns: the average for *Innocence* poems
is 22·5%, the median is 20·8%, the range is from 16·6 to 41·7%, and
the standard deviation is 5·5. The poems of *Experience* average 23·3%
nouns, their median is nearly the same (23·1%), their range is con-
siderably less (17·5% to 29·7%), and the standard deviation is 3·5.

The largest proportional differences between the two series of poems are in the category of pronouns (*Innocence*, 8·3%; *Experience* 5·9%), and the function-class of prepositional adjuncts ('Prep. Adjt.' in table 2, which is 25·5% in *Innocence* and 27·9% in *Experience*). When prepositional adjuncts are added to the other words which function as adjuncts (mostly adverbs), there is but a small difference (0·5%) between the sets; roughly one third of Blake's words are some kind of adjunct while the remaining portion is in the main elements of clauses: subjects, predicates and complements.

item	brief description		Innocence	Experience
1	Content words		54·0	51·0
2	Modifiers:	all	29·9	30·3
3		content-word	14·3	12·5
4		function-word	15·6	17·8
5		content-to-function ratio	1·09:1	1·42:1
6	Verbs:	all	20·2	19·3
7		auxiliary-to-main ratio	0·21:1	0·25:1
8		participles+infinitives/main vb	0·13:1	0·03:1
9		'not'-to-verb ratio	0·02:1	0·03:1
10	Nominals:	modifiers of nouns	25·6	26·4
11		determiner-to-adjective ratio	1·47:1	1·94:1
12		adjective-to-noun ratio	0·51:1	0·46:1
13		pronoun-to-noun ratio	0·43:1	0·31:1
14		pronouns+nouns (heads)	31·6	29·7
15	Nominal-to-verbal categories: ratio		2·6:1	2·7:1
16		nominal	65·4	66·6
17		verbal	25·1	23·8
18	Adjective-verb ratio (AVR)		75:100	65:100
19	Conjunctions: all		9·1	10·6
		coordinator-to-subordinator ratio	1·7:1	1·9:1

Table 3. Aggregate word-category measures for both sets. Ratios are given ':1' and the other statistics are percentages. These are *averaged* rather than *composite* statistics (see the comment for table 2, above).

As noted, there are relatively more pronouns in *Innocence* than in *Experience*. The ratio of pronouns to nouns is also higher: 0·43 to 1 in *Innocence* compared to 0·31 to 1 (see table 3, item 13); eleven of the nineteen *Songs of Innocence* have this ratio above the median of all poems. Despite the proportional difference in pronouns, the averaged percentage of nominal phrase heads (item 14) is slightly higher for *Innocence*, which indicates no tendency to 'substitute' nouns for pronouns, or vice versa. The proportional difference in pronouns may be partially explained because more than half of the *Innocence* poems have a first-person narrator, compared to eleven of the twenty-six *Songs of*

		subj & comp	in prep phrases	total
Innocence	Noun	14·5	8·0	22·5
	Adjective	7·5	2·4	9·9
	Determiner	8·6	4·7	13·3
	Pronoun	7·1	1·1	8·3
Prepositions are 9·1%				
Experience	Noun	14·2	9·1	23·3
	Adjective	4·8	3·9	8·7
	Determiner	10·3	5·2	15·5
	Pronoun	4·6	0·5	5·1
Prepositions are 11·0%				

Table 4(a). Matrix of cross-referenced word-classes. The data are *composite* percentages; functions are the columns and categories are the rows. 'Contingency table' analysis of these data shows that the joint effect of category and function is significantly different at the 0·001 level ($\chi^2 = 40·8$, $df = 7$). The cross-referenced 'cells' with the largest standardized residuals are (in descending order): pronoun/subj-comp, adjective/subj-comp, pronoun/prep, determiner/subj-comp. In both sets the hierarchy of residuals is the same, but the values for *Innocence* are slightly larger than those for *Experience*.

Experience. First-person narration intrinsically requires more pronouns, although it is impossible to quantify the difference for so few poems.

Other components of nominal and verbal phrases are illustrated in table 3. The ratios of adjectives to nouns (item 12) differ but slightly. However, determiner percentages differ by over 2%, and the ratio of determiners to adjectives (item 11) is about one third higher in *Experience* (about 2:1) than in *Innocence* (about 1·5:1). I have proposed elsewhere (Ross 1973b) that the relatively high ratio of a function-word category (e.g., determiner) to its content-word analogue (adjective) is a mark of what might be termed 'syntactic complexity' at the rank of the phrase. There are proportionally fewer auxiliary verbs in *Innocence* than in *Experience* and proportionally more main verbs, infinitives and participles. As a result the ratios of auxiliary to main verbs differ: one verb in four from *Experience* compared to one in five from *Innocence* (item 7). The greater complexity of the verbal phrases of *Experience* is parallel to the case of nominal phrases. Overall, verbs play a lesser role in *Experience* as shown most clearly by the higher ratio of nominal to verbal classes (items 15 to 17), and the lower adjective-to-verb ratio (item 18).

The relationships among the word classes which form nominal phrases can be specified more precisely. All classes are displayed by the

		Innocence	Experience
proportion of class in			
prepositional phrase	class		
	Noun	0·356	0·392
	Adj	0·238	0·448
	Det	0·352	0·338
	Pron	0·135	0·094
Aggregate ratios (agg)			
and ratios in preposi-			
tional phrases (prep)			
pronoun: noun	agg	0·37:1	0·22:1
	prep	0·14:1	0·05:1
adjective: noun	agg	0·44:1	0·37:1
	prep	0·29:1	0·43:1
determiner: noun	agg	0·59:1	0·67:1
	prep	0·59:1	0·57:1
determiner: adjective	agg	1·35:1	1·92:1
	prep	1·78:1	1·33:1

Table 4(b). Proportions and ratios derived from the
cross-referenced word-class matrix. 'Aggregate
ratios' are calculated by dividing all words of the first
class by all the words of the second class in the set.
These ratios might be compared with the averaged
ratios in table 3, items 13, 12, and 11.

STYLE 1 program on a matrix, with categories in rows and functions in
columns; summaries are printed at the right and along the bottom.
Table 4(a) presents a selected part of the proportion-matrices for the
two sets of poems, and allows a closer look at the differences. Pre-
positional phrases with pronoun heads are quite rare: from table 4(b),
we see that 13·5% of the pronouns in *Innocence* are in prepositional
phrases, as contrasted to 36% of the nouns; 9·4% of the pronouns and
39% of the nouns of *Experience* are in such phrases. The pronoun to
noun ratios also reflect these differences. Since most pronoun-headed
phrases answer an implied 'to whom' question, while noun-headed
phrases can serve a variety of adverbial functions (time, manner, place),
the contrast may be a feature of English, rather than of Blake's style.

There are proportionally more adjectives in the prepositional phrases
of the *Experience* set (3·9% of all words; 45% of all adjectives), and
fewer in *Innocence* (2·4% of all words, 23·8% of adjectives). The deter-
miner to adjective ratio (the index of nominal-phrase 'complexity'),
although higher overall for *The Songs of Experience*, is lower if we
consider only prepositional phrases (1·78:1 in *Innocence* and 1·33:1 in
Experience). This difference in the construction of nominal phrases
which form the subjects and complements of the clauses in *Songs of
Innocence* is related, of course, to the smaller proportion of adjectives in
such phrases. Detailed and systematic analysis of the word-classes which

8

Innocence	mono. words (%)	*monosyllabic strings*			av. word length	words in poem
		av. length	% one-word	longest		
Introduction	82·6	4·76	19·0	14	1·17	121
Shepherd	83·6	5·67	0	10	1·20	61
Ecch. Green	82·9	5·52	19·0	32	1·18	140
Lamb	83·5	6·40	20·0	26	1·17	115
Lit. Black Boy	86·3	7·26	14·7	36	1·14	249
Blossom	47·6	2·86	0	4	1·52	42
Chim. Sweeper	87·1	6·73	13·3	18	1·13	232
Lit. Boy Lost	84·9	6·43	28·6	18	1·15	53
Lit. Boy Found	77·4	3·15	38·5	14	1·23	53
Laugh. Song	85·1	5·38	18·8	13	1·16	101
Cradle Song	77·7	4·16	22·6	16	1·25	166
The Div. Image	71·3	2·85	33·3	10	1·29	108
Holy Thursday	72·9	3·48	25·9	9	1·36	129
Night	77·7	4·24	17·4	16	1·25	251
Spring	79·5	4·71	35·7	22	1·30	83
Nurse's Song	85·4	6·18	41·2	15	1·15	123
Infant Joy	92·0	14·40	22·2	21	1·08	50
A Dream	76·4	3·82	22·7	12	1·28	110
Anoth. Sorrow	84·3	5·72	6·3	15	1·17	217
						2404
average	79·9	5·46	21·0	17	1·22	
s.d.	9·4	2·55	11·5	7·8	0·10	
no. > median	11	12	8	11	7	

Table 5. Word-length measures for both sets. The medians for combined sets: percentage of monosyllable words 80·9, average length of monosyllable string 4·50, percentage of one-word strings 20·0, longest string 15, average word length 1·23. Using *F*-test and *t*-test methods, no significant differences are revealed.

constitute the nominal phrases of Blake's *Songs* has pointed up a significant contrast in the syntax and style of the two sets of poems.

The data concerning word lengths have been explored in detail. Table 5 lists the measures involved: (1) per cent of monosyllable words, (2) average length of unbroken strings of monosyllable words, (3) percent of isolated monosyllable words (one-word strings), (4) longest string of monosyllable words, and (5) average word length. The distribution of values above and below the medians is not 'symmetrical'; there is a tendency for shorter words and longer monosyllable strings to be in *The Songs of Innocence*. Because it was observed that extremes for these components tended to occur in the same poems, an effort was made to explain the relationships. With the aid of S. Keith Lee a model was constructed on the analogy of card shuffling. The complete pro-

Experience	mono. words (%)	monosyllabic strings			av. word length	words in poem
		av. length	% one-word	longest		
Introduction	75·8	3·29	23·8	9	1·26	92
Earth's Ans.	75·0	3·52	26·1	9	1·27	108
Clod & Pebble	72·6	2·94	16·7	8	1·32	73
Holy Thursday	80·9	5·07	6·7	17	1·29	94
Lit. Girl Lost	73·7	3·28	28·3	8	1·29	205
Lit. Girl Found	74·8	3·62	28·9	10	1·27	218
Chim. Sweeper	84·5	5·86	21·4	19	1·18	97
Nurse's Song	87·5	8·56	11·1	24	1·13	64
Sick Rose	85·3	5·30	0	8	1·21	34
Fly	92·8	12·80	0	49	1·07	69
Angel	88·6	7·75	25·0	21	1·11	105
Tyger	81·8	6·88	0	18	1·21	143
Pret. Rose T.	75·4	3·91	27·3	12	1·30	57
Sun-Flower	66·0	2·75	16·7	5	1·40	50
Lilly	80·6	3·57	28·6	8	1·23	31
Garden of Love	82·2	4·93	20·0	18	1·13	90
Lit. Vagabond	80·4	4·41	33·3	15	1·22	148
London	74·2	3·45	15·0	6	1·22	93
Hum. Abstract	83·1	5·38	14·3	16	1·24	136
Infant Sorrow	68·9	2·21	57·1	8	1·33	45
Poison Tree	87·1	6·77	7·7	13	1·14	101
A Lit. Boy Lost	80·0	4·43	25·0	12	1·24	155
A Lit. Girl Lost	75·8	3·21	21·1	15	1·25	161
Tirzah	82·7	4·78	5·6	11	1·21	104
Voice Anc. Bard	75·4	3·25	43·8	16	1·26	69
School Boy	77·0	4·00	22·2	21	1·24	187
						2729
average	79·3	4·84	20·2	14	1·23	
s.d.	6·3	2·27	13·3	8·7	0·07	
no. > median	11	11	14	12	16	

Table 5 (*contd.*)

cedure is described elsewhere (Ross and Lee 1973), but, in brief, the computer simulates a situation where a 'deck' of fixed length (100) with two 'suits' in set proportions (e.g., 80 monosyllables and 20 poly-syllables) is rearranged by picking numbers from a stored list of random numbers. Three parameters have been estimated, all as functions of the monosyllable proportion: average length of monosyllable string, pro-portion of one-word strings, and longest string. Exponential curves for the means and ± 1 standard deviation are plotted in figure 1, and the observed values for the two sets of *Songs* are given as discrete points on the graphs. Of the 135 observations (three each from 45 poems), 52% fall within one standard deviation of the model's mean, and 88% fall

within two standard deviations. It should be clear upon inspection that Blake's average-string-length values increase at a more rapid rate than the model for monosyllable proportions above 0·85, while the values for one-word strings and longest strings are quite close. The linear regressions on the latter two parameters can be regarded as the same as those of the model (with the confidence interval set at 0·90), and Blake's behaviour can be called random. Primarily because the observed average-string-length values exhibit less variance than does the model, the regressions are not exactly the same. This evidence of stylistic control may be peculiar to Blake, or it may be related to the ballad-like form of the poems.

Figure 1. Card-shuffling model values. The means and standard deviations for the three parameters, average string length, percentages of one-word strings, and longest string, are graphed along with the observed values from Blake's *Songs: Innocence* with points, *Experience* with crosses.

Another procedure called a 'geometric model' estimates the number of words of two and more syllables and the average word length from a known proportion of monosyllable words. This technique seems to give more reliable estimated values than others which start with average word length as the given parameter, primarily, it seems, because it is very difficult to determine monosyllable proportion from average word length (see Brainerd 1971 and the appendix to this paper). The formula for calculating the proportion of words of n syllables ($prop_n$), using the monosyllable proportion ($mono$) is $prop_n = (1\text{-}mono)^{n-1} \times mono$. The estimated average word length is the inverse of the monosyllable proportion ($1/mono$). Table 6 gives the estimates and the observed values for both sets of poems, which are compared using the standard χ^2 test. For both sets the probability is less than one in a thousand that Blake's deviation from the model can be laid to chance; the major source of the difference is his high use of two-syllable words. This tendency to use shorter polysyllable words than expected from the model also accounts

no. of syllables	Innocence		Experience	
	proportions		proportions	
	model	observed	model	observed
1	0·812	0·812	0·791	0·791
2	0·153	0·171	0·166	0·186
3	0·029	0·018	0·035	0·020
4	0·005	0·001	0·007	0·003
χ^2 value	26·75		30·60	
av. word length	1·23	1·20	1·26	1·23

Table 6. Geometric model and observed data for word lengths. The data are *composite* proportions. The proportion of monosyllables for the model is derived from the observed value. χ^2 for $a = 0·001$ at $df = 3$ is 16·27.

for differences between predicted and observed average word lengths; the tendency is more pronounced in *Experience* than in *Innocence*.

The five word-length measures which are described by EYEBALL are detailed enough to specify differences among various styles. Further, the models which are suggested are sufficiently powerful to serve as simulations of random behavior against which the performance of a given author can be judged.

Data on the lengths of subordinated and independent clauses are given in table 7. The average length of a prepositional phrase in *Innocence* is 2·93 words, in *Experience*, 2·95 words. Although no marked difference between the two groups of poems is revealed, the data should prove useful for comparison with other poets. The similarity of these observations supports a general conclusion that the syntax at grammatical ranks above the phrase is rather uniform. Other very general measures tend to confirm this conclusion: the ratio of words functioning as subject to those as complement is 1·35:1 for both sets; ratios of predicates to subjects is about one to one (1·09 for *Innocence*, 0·95 for *Experience*). One component in Blake's syntax deserves final mention, namely his frequent use of coordinating conjunctions at the start of independent clauses ('He is meek, *and* he is mild'). These comprise 36% of all coordinators in *Innocence* and 33% of those in *Experience*, and they begin 29% of all independent clauses in the poems.

As noted at the start of this discussion the EYEBALL program yields an 'augmented text' which is annotated in several ways. The existence of such information in a form which is accessible allows the critic to obtain information and to answer questions which are tedious (if not impossible) to confront without computer assistance. For example, it seems likely that a line in a poem will start with a function word and

	subordinated		independent	
	Innocence	*Experience*	*Innocence*	*Experience*
number of clauses	115	136	182	208
average length (words)	7·01	7·15	8·29	8·49
lengths by quartiles				
first quartile (Q1)	3·2	3·2	4·5	4·3
median (Q2)	5·2	6·6	6·9	6·7
third quartile (Q3)	8·2	7·9	9·4	10·6
ninth decile (D9)	13·5	15·0	16·0	15·7
'middle half' (Q3-Q1)	5·0	4·7	4·9	6·3
longest clause	38	32	52	37
% of words in subord. clauses	34·6%	34·6%		

Table 7. Clause lengths for both sets

end with a content word, since the poetic line is likely to be a syntactically coherent phrase, clause or sentence. A simple search program was written to test this hypothesis and 92% of all final words were found to be content words (including 55% nouns). Function words begin 71·5% of the lines in both sets, including 21·4% of the lines which start with coordinators, a trait which may be peculiar to Blake. During the search another general question was asked, based on a marked contrast in the word classes of the second words of the lines of the 'Introduction' poems. Of the twenty lines in the 'Introduction' to *Innocence*, twelve have personal pronouns or pronominal determiners ('thy,' 'his'); none of the lines in the companion *Experience* poem have words of the two classes in second position. The search program found that, of the 393 lines in *Innocence*, 18·6% have pronominal words second, as was in the case with 14·2% of the 493 lines in *Experience*. Even though there are relatively more pronouns in *Innocence*, they tend to be second in the lines more often than expected. These data, while confirming intuitions, illustrate the facility with which questions of literary importance can be readily answered.

This discussion of augmented texts, even for the few thousand words and few hundred clauses of Blake's *Songs*, illustrates something of the present state of stylistic analysis using the EYEBALL programs. Description of a style, although intrinsically valuable as a record of information, becomes an interesting and useful tool of literary criticism and literary analysis only when the description is put into perspective. Evaluation and even valid interpretation are possible only when one style is set next to others. Statistical models such as the ones described, both for comparing sets of observations, and for comparing observations with simulations of language, will allow us to arrive at standards of measurement even in the absence of sufficient background data. Perhaps more important, the testing of such models will give us a progressively

better notion of what to do with the new data which is gathered in the future.

Acknowledgements
This research has been supported by grants from the Graduate School and Computer Center of the University of Minnesota. The development of EYEBALL was begun at the University of Pennsylvania. The aid of Jeanine Budnicki, S. Keith Lee, Donald Berry and Robert Rasche has proven invaluable for various aspects of this project. The EYEBALL programs in IBM and CDC FORTRAN, and a User's Manual, are available from the author.

REFERENCES

Brainerd, B. (1971) On the distribution of syllables per word in English texts. *Mathematical Linguistics*, no. 57, 1–17.

Elderton, W. P. (1949) A few statistics on the length of English words. *Journal of the Royal Statistical Society*, A, **112**, 436–45.

Erdman, D. V. (1965) *The Poetry and Prose of William Blake*. Garden City, N.Y.: Doubleday.

Ross, D. & Rasche, R. H. (1972) EYEBALL: a computer program for description of style. *CHum*, **6**, 213–21.

Ross, D. (1973a) Beyond the concordance: algorithms for the description of English clauses and phrases. *The Computer and Literary Studies* (ed Aitken et al.), 85–99. Edinburgh: Edinburgh University Press.

Ross, D. (1973b) Emerson and Thoreau: a comparison of prose styles. *LangS*, **6**, 185–95.

Ross, D. & Lee, S. K. (1973) *A card-shuffling model for the distribution of monosyllabic and polysyllabic words*. Mimeograph, Department of English, University of Minnesota.

Ross, D. & Rasche, R. H. (1973) *Description and user's instructions for EYEBALL, revised version*. Mimeograph, Department of English, University of Minnesota.

APPENDIX

In order to test the 'geometric model' as a means of estimating the proportions of polysyllabic words, published and unpublished data were tested. The word-length counts are from Brainerd 1971 (B in the table) and Elderton 1949 (E); other counts are my own. The relevant χ^2 statistic and appropriate significance levels are given in the final columns. For the purpose of stylistics, knowledge that the model does not fit (and for which syllable-lengths it does not fit) is just as valuable as discovering no significant differences.

data and source	no. words	observed values						estimated values					χ^2	df	signif. level
		1	2	3	4	5	av. w. len.	2	3	4	5	av. w. len.			
Bible (E) *	3533	·832	·147	·017	·003	·001	1·19	·140	·024	·004	·001	1·20	7·90	4	·01
Bible (E)	3613	·815	·160	·021	·003	·001	1·22	·151	·028	·005	·001	1·23	10·89	4	ns
Blake, Songs *I & E*	5132	·801	·179	·019	·002		1·22	·160	·032	·006		1·25	16·27	3	·001
Hen. iv-prose (E)	13698	·800	·159	·031	·007	·002	1·25	·160	·032	·006	·001	1·25	7·11	4	ns
Hen. iv-both sets (E)	25280	·793	·162	·036	·008	·001	1·26	·164	·034	·007	·002	1·25	8·76	4	ns
As You Like It (B)	500	·786	·162	·046	·006		1·27	·168	·036	·008		1·26	1·69	3	ns
Hen. iv-verse (E)	11582	·784	·166	·041	·009	·000	1·28	·170	·037	·008		1·27	22·71	3	·001
Julius Caesar (B)	500	·776	·168	·046	·010		1·29	·174	·039	·009	·002	1·28	0·83	3	ns
Lady of Lake-Scott (B)	500	·764	·214	·022			1·26	·180	·043	·009		1·29	8·11	2	ns
Gray-prose (E)	5237	·761	·159	·054	·023	·003	1·35	·182	·043	·010	·003	1·31	111·60	4	·001
Thoreau-Walden	4672	·753	·172	·049	·023	·003	1·35	·186	·046	·011	·003	1·31	58·29	4	·001
Keats-Sonnets	5113	·747	·197	·048	·008		1·32	·189	·048	·012		1·33	6·25	3	ns
Conrad-L. Jim (B)	3500	·733	·173	·063	·023	·007	1·40	·196	·052	·014	·004	1·34	50·08	4	·001
Bacon (E)	6352	·730	·170	·066	·026	·007	1·41	·197	·053	·014	·004	1·36	124·71	4	·001
Conrad-3 samp. (B)	6500	·728	·183	·063	·019	·007	1·40	·198	·054	·015	·004	1·37	43·02	4	·001
Conrad-Victory (B)	1000	·724	·182	·071	·014	·010	1·41	·200	·055	·015	·004	1·37	14·25	4	·01
Gray-verse (E)	2448	·723	·239	·029	·009	·000	1·33	·200	·056	·015	·004	1·38	64·56	4	·001
Conrad-Nig of Nar (B)	2000	·720	·200	·060	·014	·006	1·38	·201	·056	·016	·004	1·38	1·94	4	ns
T. S. Eliot (B)	500	·714	·186	·060	·040		1·43	·204	·058	·017		1·39	17·08	3	·001
Cheever (B)	1007	·708	·220	·054	·015	·004	1·39	·207	·060	·018	·005	1·40	2·24	4	ns
Patrick White (B)	1000	·701	·213	·066	·018	·002	1·41	·210	·063	·019	·006	1·41	2·57	4	ns
James Joyce (B)	539	·696	·230	·067	·007		1·39	·212	·064	·020		1·43	4·98	3	ns
Carlyle (E)	3185	·696	·182	·079	·033	·009	1·48	·212	·064	·020	·006	1·44	59·53	4	·001
Emerson	2253	·677	·210	·074	·030	·009	1·48	·218	·071	·023	·007	1·44	7·82	4	ns
Macaulay (E)	2991	·663	·189	·099	·037	·013	1·55	·223	·075	·025	·009	1·48	59·99	4	·001
S. Johnson (E)	2000	·634	·212	·098	·039	·019	1·60	·232	·085	·031	·011	1·51	19·82	4	·001
Gibbon (E)	3000	·620	·205	·114	·051	·010	1·63	·236	·090	·034	·013	1·58	59·24	4	·001
Time magazine (B)	1500	·594	·211	·135	·048	·015	1·69	·241	·098	·040	·016	1·61	28·99	4	·001

Table 8. Tests of the 'geometric model' for word lengths. The first Bible sample (*) has proper names removed.

Lexicography and Language

M. SPEVACK
H. J. NEUHAUS
T. FINKENSTAEDT

SHAD : a Shakespeare dictionary

SHAD, a complete, systematic, and analytic Shakespeare dictionary, attempts to provide a basic and modern research instrument for literary and linguistic scholars. It attempts, furthermore, to present a model for the interaction between man and computer in the fields of literature and language, as well as to exemplify a new concept in the construction and arrangement of a dictionary.

The first question is, naturally: Why do we need a new Shakespeare dictionary? Is it worth the money and effort to start on a new and expensive project instead of concentrating on improving existing works? It might be tempting to say that the question will answer itself in this case just as it does if Spevack's *Concordance* (1968–70) is compared with Bartlett's (1894). There is, however, a strong case for a dictionary based on a firm foundation of linguistic theory. The lack of such a theory for dictionary-making is a fact, and it is probably only with the help of the computer that dictionaries and concordances which satisfy the rigorous demands of scientific investigation can be produced.

A concordance is, in the words of the *OED*, 'an alphabetical arrangement of the principal words contained in a book . . . with the citations of the passages in which they occur', and the tradition of biblical concordances, the prototypes of later concordances, has persisted right up to now for literary texts turned into concordances: the alphabetical arrangement of 'principal' or 'meaningful' words helps us find half-forgotten passages and enables the scholar and the critic to use these 'meaningful' words as the starting-point of, or illustration for his particular theme. Yet an attempt to define such 'meaningful' words from the point of view of linguistics—or, to put it another way, from a point of view other than that of a rather specialized kind of literary analysis—has hardly, if ever, been made. Spevack's *Complete and Systematic Concordance to Shakespeare* (SHAC) is, however, exhaustive and really does give us systematic access to all 'gates and alleys' of the entire corpus of Shakespeare. This concordance—as well as its *Urwesen*, the magnetic tapes which contain the works of Shakespeare—clearly reflects a new and more sophisticated way of dealing with a text and can be used as a starting-point for linguistic research. Reworked into a complete dictionary of Shakespeare, it will become useful in a novel way for both literary and linguistic research.

There are in existence a number of Shakespeare dictionaries, but they

stem from the same kind of tradition as the literary concordances: they primarily contain and 'explain' (whatever that may mean) difficult words and passages. But 'difficult', like 'meaningful', is a highly subjective and as yet undefined concept. It is, in fact, impossible to find an acceptable statement about what *should* be in a dictionary; this basic question has only rarely been asked. Nor, surprisingly, is it known what exactly is contained in existing dictionaries like the *OED* or *Webster's Third*. Dictionaries, or so it seems, are to be used and obeyed, not analyzed.

Dictionary criticism and reviewing is then an underdeveloped or, at best, a developing area of English Studies. A number of reasons can be mentioned for this state of affairs, among them the difficulty of dealing with vast masses of verbal material. This difficulty is probably as important for an explanation of the present situation as the almost complete lack of interest in lexicography and lexicology shown by modern linguistics. The computer has helped to change the scene by enabling us, first, to cope with large amounts of data and, secondly, by enabling us to test hypotheses about language in a genuinely scientific way. Thus far computers in lexicography have, however, mainly been used to speed up production and to improve collecting and sorting processes. It is hoped that computer linguistics will lead to more comprehensive linguistic models of language which can explain both the grammar *and* lexicon of a language as well as their relationship.

In 1965 work was started at the University of the Saarland on aspects of the development of the English vocabulary as represented in dictionaries. The question: 'What is the English lexicon like?'—lexicon being defined as the totality of recorded and possible words—was approached through a close analysis of existing dictionaries of English, especially the *Shorter Oxford English Dictionary* (*SOED*). The 80096 heavy-type entries of this dictionary were stored as a Computer Dictionary (CD); the information for each entry is given in figure 3. The CD was subjected to a number of statistical, mainly distributional, experiments with the aim of testing its reliability and of discovering structural features of the English lexicon. The main result of the investigation is evidence that the vocabulary contained in the *SOED* and the CD mirrors within definable limits the structure and development of English, and can therefore be used as a yardstick to measure texts of different periods in the history of the English language. The entries of the CD were also rearranged according to the year of first occurrence as given in the *SOED* and published in Finkenstaedt *et al.* (1970) as *A Chronological English Dictionary* (CED). This dictionary enables us to 'stop' the development of the recorded English vocabulary at any desired moment and to compare, for instance, Shakespeare with the corpus of English words recorded up to 1623, when the *First Folio* appeared (figure 1).

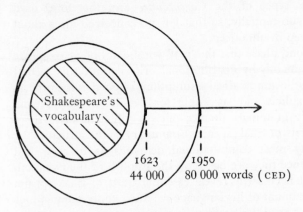

Figure 1. Comparison of recorded English vocabularies

The position of the two projects SHAC and CD in the context of present-day English studies may be characterized as follows:
1. Both projects make use of the computer in order to achieve completeness and scientific accuracy.
2. Both are influenced by modern linguistic ideas about text and corpus and try to avoid uncontrolled decisions about content and meaning. SHAC is based not on a hypothetical poet Shakespeare, but 'simply' on the text of a specific edition; CD does not ask: 'What *is* a dialect?', but: 'What are the principles of the *SOED* in marking words as dialectal?'
3. Both projects pay particular attention to the historical dimension of their material. SHAC will make available old spellings and variants and mark editorial emendations. CD includes chronological information. Several studies have already shown that such information is relevant for an understanding of the structure of the English lexicon. In this respect the philosophy of the CD goes beyond that of a modern and purely synchronic approach.

The merging of SHAC, a concordance, and CD, a dictionary, is a complicated linguistic operation. The first phase, the process of reducing the linguistic *types* of the concordance to basic units, the *lemmata*, by the systematic stripping away of inflections etc., cannot be based on an existing model grammar or automatic parser (even if it were available). This is due to the fact that we do not yet know which system is adequate for a description of Shakespeare's language. A dictionary presupposes a definition of what constitutes a 'word', and any definition of 'word' implies a specific type of grammar. The grammar implied in the CD and the *OED* is the traditional Latin-based grammar of nineteenth-century philology, as is obvious in an analysis of the word classes, especially of nouns and adjectives. The CD entries used for the sorting

of the Shakespeare types of the *Concordance* are, therefore, used 'operationally', not substantially, so that few preconceived ideas about Shakespeare can creep in unnoticed.

It is only in a second phase that the 'real' vocabulary of Shakespeare can be determined, mainly by distributional criteria, and this second phase will also make the grammatical assumptions implied in the process of lemmatization explicit and accessible for detailed treatment and correction. Available grammars do not offer a sufficient basis for a computational analysis of Shakespeare. Grammars of the structural or generative type may meet computational demands as to rigor and formalization, but since they are based on the English of the twentieth century they do not necessarily reveal essential traits of Shakespeare. For a systematic treatment of his language we must apply the methods of modern linguistics to describe Shakespeare's language structurally. This can be done by using a simplified modern grammar as a starting-point and refining it afterwards, again chiefly by distributional criteria. The method used may be described as a machine-aided dialogue between researcher and text, a dialogue starting from an imperfect dictionary (of which the degree of imperfection is known) and from a primitive grammar (of which the degree of primitiveness is also known). By controlling each step, by testing and refining all steps as we proceed, we can optimize both grammar and dictionary simultaneously. For SHAD the corpus called Shakespeare could thus be an almost perfect informant.

THE LEMMATIZATION PROCESS

A concordance may be said to list in alphabetical order classes of identically-coded segments of a text. Conventionally these segments are given in a certain context, and with additional information about their respective position in the text. Thus there is an equivalence class or type-token relationship as organizing principle. This principle is not particularly helpful from the point of view of a grammatical description when we are looking for linguistically motivated classifications.

A concordance offers merely a formal classification. Nevertheless concordances seem to be a far better starting-point for a linguistic analysis than the running text itself. This is not only a question of economy—there are almost 900000 tokens of text in the Shakespeare corpus but only some 30000 different types in Spevack's *Concordance*—but even more a question of consistency and reliability in the linguistic analysis itself, since grammatical descriptions are made with most of the occurrences of a particular wordform readily available. Actually there hardly seems to be an alternative to some kind of distributional analysis of this type. Elizabethan English cannot be studied intuitively. Perhaps nativeness in Modern English may even be harmful, and not only in the more subtle areas of semantic structure.

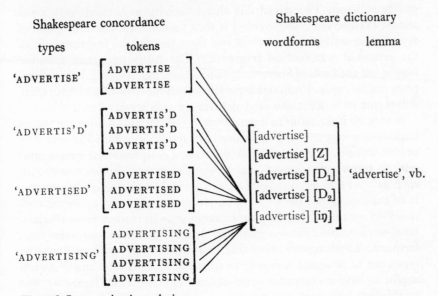

Figure 2. Lemmatization relations

This is not to say that lemmatization as the first step towards a linguistic description should bypass the analysis of tokens altogether. On the contrary, only tokens and not types correspond to linguistically meaningful units, and only tokens may be assigned to wordforms and subsumed under a certain lemma. Thus there are in Shakespeare three occurrences of the type ADVERTISED (figure 2). Only an analysis of each token shows that all three have to be interpreted as inflected wordforms with a past participle suffix. The inflected form with a preterit suffix would be equiform, but it happens not to be realized in the Shakespeare corpus. In principle it may be the case that a morphological analysis will call for a separation of tokens and their assignment to different wordforms although they all belong to the same type. A single wordform, on the other hand, may correspond to various tokens of different types. This aspect becomes even more important with the lack of a normalized orthography as in Shakespeare.

Sensible lemmatization procedures can be devised despite the potential complexity of these lemmatization relations and in a situation where we cannot rely on previous explicit descriptions. Since lemmatization has to be accomplished by an analysis of tokens it is reasonable to begin analyzing types with relatively few tokens. After some trials we chose a frequency of fifty occurrences as our preliminary limit during the first phase of lemmatization. The aim was to gather enough structural information from these types to be able to do the rest with a set of hypothetical rules—a more or less explicit grammar—as a predictive

device at hand. The trivial fact that creativity in natural language is almost exclusively rule-governed is thus used both for a description of actually occurring constructions and for a testing and improvement of the proposed grammatical framework. The really important question here is, on the basis of how much material sensible structural generalizations can be made. From our experience with the fifty-tokens limit there still seems to be a margin of structural redundancy involved.

It may be interesting to have a look at the relevant figures for tokens beginning with the letter M. Of the 1612 types there are 1533 with fifty or fewer tokens. Of these, only 102 types show morphological homonymy: only six types have tokens that correspond to more than two wordforms, such as MUTE as noun, adjective, and verb. Morphological homonymy is of various kinds: MAN'S may be possessive case or a syntactic contraction: *man is*. Types may be homonymous in respect to word class: noun-verb conversions—cases like MASK or MATCHES—are most frequent. These figures show that more than 90 per cent of the SHAC types can be assigned uniquely to wordforms. This ratio made it quite useful to have a computer print-out, a Matching List (figure 3), that established lemmatization relations which prove valid for over 90 per cent of all types. Even in the first phase the task of lemmatization was thus mainly one of proof-reading with special marking conventions for ambiguous types. Punched cards were used to store this type of information in order to have it available as input for another print-out, the Lemmatization List (figure 4). Whereas the Matching List uses a more formal criterion in making the tentative matching of classes of equiform tokens as listed in Spevack's *Concordance* and classes of wordforms as listed as entries in the CD, the Lemmatization List is organized exclusively according to linguistic criteria.

A conventional dictionary like the CD can only roughly be identified with a list of lemmata in this strict sense. Certain adjustments have to be made in order to make the exemplification of lemmata as dictionary entries a workable one. Work with the CD soon revealed that the set of lemmata as we defined it linguistically and the set of dictionary entries do have a large common core, but that both additions and subtractions have to be made. Extra lemmata were called for, mainly for proper names, but also for various word-formations and foreign elements (e.g. GARSOON) not included in the CD (figure 4).

The Lemmatization List as it evolves out of phase I of the project can be seen as a skeleton dictionary to Shakespeare. Completion in phase II has two aims: first, and quite naturally, it has to be completed in the sense that it will include all lemmata, also those with a higher frequency of occurrence; second, additional information for each lemma has to be prepared and integrated in a proper way. (In the following I will only deal with the first aspect.) From the outset we consciously

The upper matrix (read by word column) records the following SOED attributes:

running number SOED	word	word class	status	field	first occurrence	native/denizen/alien	rough etymology	specific etymology	number of meanings	number of homographs	SOED/ALD/GSL
30492	GASP	03	00	000	1577	2	1	061	001	-	1
30493	GASP	04	00	000	RRRR	2	1	061	002	2	1
30499	GAST	04	14	000	9999	1	1	019	001	0	0
30500	GASTER	04	14	000	1593	-	1	019	001	0	0
30504	GASTNESS	03	14	000	RRRR	-	1	019	001	0	0
30515	GASTROMANCY	03	11	042	1610	3	3	032	001	0	0
30524	GASTRURAN	01	00	000	6666	2	2	042	001	0	0
30540	GAT-TOOTHED	01	14	000	6666	2	2	061	001	0	0
30526	GATE	03	00	000	9999	-	1	019	007	-	2
30527	GATE	03	25	000	RRRR	1	1	061	005	1	0
30530	GATE-HOUSE	03	00	000	RRRR	2	1	019	002	-	0
30531	GATE-KEEPER	03	00	000	1572	-	1	019	002	2	0
30533	GATE-POST	03	00	000	1522	-	1	019	002	0	0
30532	GATELESS	01	00	000	160R	-	1	019	001	0	0
30535	GATHER	03	00	000	1555	-	1	019	003	-	0
30536	GATHER	04	00	000	9999	-	1	019	014	2	2
30537	GATHERER	03	00	000	RRRR	-	1	019	002	-	0
30538	GATHERING	03	00	000	9999	-	1	019	006	1	1

The lower section gives the SHAC running numbers, the token forms, and the number of tokens:

running number SHAC	number of tokens	token
11493	1	GASKINS
11494	8	GASP
11495	1	GASPING
11496	2	GASPING
11497	1	GASTED
11498	1	GASTNESS
11499	2	GAT
11500	55	GATE
11501	86	GATES
11502	2	GATHERED
11503	25	GATHER
11504	6	GATHERED
11505	4	GATHERED
11506	2	GATHERING
11507	1	GATHERS

Figure 3. Matching List (SHAC-CD 1623)

avoided making an arbitrary distinction between a dictionary of Shakespeare and a grammar of his language. For us a dictionary is nothing more and hopefully nothing less than a mode of presentation of grammatical structure. This view made it easy to switch from the Lemmatization List to a grammatical analysis of the running text itself, at that moment when it seemed to be promising from the point of view of an effective methodology. Perhaps this change in perspective can best be explained by describing it as a change from the paradigmatic towards the syntagmatic: lemmatization is achieved by an analysis of a token in its particular context. The Shakespeare text is thus taken as a sequence of sentence strings, some being elliptical, some even asyntactical, but most still well formed.

The automatic lemmatization of tokens not analyzed during phase I is made possible by a systematic use of information previously gathered and stored on magnetic tape. Some examples may elucidate this strategy. In *The Tempest* 1.1.9 we have the following string (figure 5.1): GOOD

Top table (running number CD section)

Row label	GARNER	GARNISH	GARNISH	GARNISH	GARNISH	GARNISH	GARRET	GARRISON	GARRISON	GARRISON	GARTER	GARTER	GARTER	GARTER	GARTER	GARTER	GASH	GASH	GASH	GASKIN	GASP	GASP	GASP	GAST	GASTNESS
number of homographs	1	2	1	2	2	2	1	1	1	2	1	1	1	1	2	2	1	1	4	1	2	2	2	0	0
number of meanings	001	002	005	007	007	003	004	004	003		005	005	005	002	002	002	001	002	002	002	002	001	019	001	001
specific etymology	056	056	056	056	056	056	056	056	056	056	056	056	056	056	056	061	061	061	061	061	061	061	019	019	
rough etymology	2	2	2	2	2	2	2	2	2	2	2	2	2	2	2	2	1	1	1						
native/denizen/alien	2	2	2	2	2	2	2	2	2	2	2	2	2	2	2	2	2	1	1	1	1	1	1	1	
first occurrence	RRRR	RRRR	RRRR	RRRR	RRRR	RRRR	RRRR	RRRR	RRRR	1569	RRRR	RRRR	RRRR	RRRR	RRRR	154R	154R	1562	1573	1577	RRRR	RRRR	9999	RRRR	
field	000	000	000	000	000	000	000	000	000	000	000	000	000	000	000	000	000	000	000	000	000	000	000	000	
status	00	00	00	00	00	00	00	00	00	00	00	00	00	00	00	00	00	00	00	00	00	00	14	14	
word class	03	04	04	04	04	04	03	03	04		03	03	04	04	03	04	03	04	03	04	04	04	04	03	
running number CD	030497	030498	030503	030504	030504	030504	030512	030516	030516	030517	030525	030525	030525	030525	030526	030526	030545	030545	030548	030555	030561	030562	030562	030567	030572
number of tokens	00002	00001	00002	00002	00002	00002	00001	00001	00001	00001	00001	00001	00013	00013	00011	00005	00006	00001	00001	00008	00002	00001	00001	00001	

Bottom table (running number SHAC section)

Row label	GARNERS	GARNERED	GARNISH	GARNISH	GARNISHED	GARNISHED	GARRET	GARRISON	GARRISONS	GARRISONED	GARSON	GARTERS	GARTER	GARTER	GARTER	GARTERED	GASH	GASHES	GASHED	GASKIN	GASP	GASP	GASPING	GASPING	GASTED	GASTNESS
remarks	0	0	0	0	0	0	0	0	0	0	0	0	0	0	0	0	0	0	0	0	0	0	0	0		
variant classification	20	11	02	00	11	00	00	00	00	00	00	00	00	90	11	00	11	00	00	00	00	00				
syntactic functions	02	04	02	16	04	00	02	04	02	31	02	0R	0R	1C	2C	01	02	0R	00	20	52	04				
inflectional morphology	51	00	00	00	51	00	31	51	00	00	31	00	00	00	51	00	31	51	00	00	52	51				
morphological structure	10	10	10	10	10	10	10	10	00	10	10	10	10	10	10	10	10	10	10	10	10	11				
grammatical ambiguities																										
number of tokens assigned to lemma	00002	00001	00001	00001	00002	00001	00001	00001	00002	00003	00001	00016	00002	00001	00005	00001	00006	00001	00006	00002	00001	00001				
extralemma																										
running number SOED	030428	030429	030434	030435	030435	030444	030448	030449	0304601	030457	030457	030457	030458	030475	030475	030478	030485	030492	030493	030493	030499	030504				
running number SHAC	11477	11476	11478	11479	11480	11481	11482	11483	11484	11485	11489	11487	11487	11490	11491	11492	11494	11494	11496	11495	11497	11498				

Figure 4. Lemmatization List (LEMCA-SHAC-CD 1623)

BOATSWAIN, HAVE CARE. Of these four tokens, only BOATSWAIN is already available as a lemmatized wordform. GOOD and CARE belong to types with 2960 and 227 tokens respectively; the type HAVE occurs 6229 times. All three forms appear in the CD. All are morphologically ambiguous. GOOD may be adjective or noun; CARE may be noun or verb. The token GOOD in front of BOATSWAIN, an identified noun, makes it an acceptable occurrence of the adjective lemma. The identification of CARE works in a similar way. CARE follows HAVE, a token that is not lemmatized but nevertheless identified in a finite list of function words. If CARE is assigned to the verb lemma, HAVE would call for the inflected form CARED. Since CARE is given, it is interpreted as a noun,

and HAVE consequently as a main verb. The comma that separates the noun phrase from the verb phrase, the lack of an article (*a good boatswain . . .*), as well as the lack of congruence (*. . . has care*), make possible a further automatic identification of an imperative construction.

5.1	Good boatswain, have care.	TMP	1.01.	9
5.2	That makes him gasp, and stare, and catch the air.	2H6	3.02.371	
5.3	What cares these roarers for the name of king.	TMP	1.01.	16
5.4	Are we all met?	MND	3.01.	1

Figure 5. Lemmatization, phase II

Sometimes automatic lemmatization only succeeds with a long context, such as (figure 5.2): THAT MAKES HIM GASP, AND STARE, AND CATCH THE AIR (2H6 3.2.371). Here the verbal interpretation of GASP is chosen because of the verb phrase CATCH THE AIR and the coordinating conjunctions. Morphologically GASP, STARE, and CATCH could be both noun or verb. A similar strategy succeeds with strings like the following (figure 5.3): WHAT CARES THESE ROARERS FOR THE NAME OF KING? (TMP 1.1.16). Here only ROARERS has already been lemmatized in phase I. There are five function words. CARES, NAME, and KING are morphologically ambiguous. They all correspond either to a noun or a verb lemma. The latter interpretation is exluded for NAME because of the definite article, for KING because of the preceding preposition. With KING and NAME as nouns there is only one token in the string to function as a verb, namely CARES. In an additional cycle the -*s* suffix is marked as being congruent with a plural noun phrase (THESE ROARERS).

Information of this type is eventually available for a complete inflectional morphology. All strings with peculiar phenomena, like the -*s* suffix as a plural verb ending, are easily retrievable from the text for further linguistic analysis. Again, the main use we make of the computer is not in automatization but in retrieval. Grammatical descriptions are made with the help of various print-outs that bring together all relevant material. All automatic decisions are specially marked so that they may be checked if necessary. Of course, there are strings that resist our apparatus and cannot be disambiguated automatically. One example is the question of Bottom the Weaver in *A Midsummer Night's Dream* (figure 5.4): ARE WE ALL MET? (MND 3.1.1). The CD has both a noun (*a met of coals*) and an adjective entry (*met* as past participle for *measured*). A list of irregular verb inflections leads to *meet*, but it seems hardly possible to expect an automatic identification even if some semantic feature apparatus had been integrated in our procedure. Here only the situational context (the beginning of a new scene) can be used to decide. Cases like this one that have to be dealt with separately are

quite rare. On the whole the lemmatization procedure works with an optimizing effect. Every string that is completed in the sense that all tokens appearing in it are uniquely assigned to lemmata can be used as an abstract syntactical pattern in lemmatizing strings that still contain blanks or unanalyzed items. These string patterns are, of course, also the basis for more detailed work in Shakespearean syntax and style.

THE SCOPE OF SHAD

It should be apparent that SHAD is different from conventional dictionaries. What has been related about the construction of SHAD is possible because we have on tape the largest sample of the written language of an English-speaking communicator. It is almost as large as the sample used by Kučera and Francis for their *Computational Analysis of Present-Day American English*, and it is certainly more amenable to statistical investigation and scientific generalization. Unlike Kučera and Francis (1967), which consists of 500 samples of approximately 2000 words each, the Shakespeare corpus is a more or less coherent body of material —this is a hypothesis we hope to prove—indeed an idiolect, which we are attempting to describe and define. What we have, in short, is a context: not the skeletal 'English language' as presented alphabetically in a conventional dictionary, with a negligible quantitative and qualitative perspective, but rather a complete context which is accessible and which can be systematically and thoroughly analyzed. And it is context, we must agree, which can help provide 'meaning'—that most difficult concern of linguistic and literary scholars. Since we have already touched, in this regard, on the viewpoints and needs of the philologist and on the those of the linguist, it might be opportune to deal with those of the Shakespearean scholar.

Like all scholars, the Shakespearean is an interpreter, be he critic or philologist or editor. He is interested in the 'meaning' of a word or passage; he spends most of his time trying to discover what 'makes sense'. His tools, however, are limited: there is neither a complete, definitive dictionary (despite the impressiveness of Schmidt 1923), nor grammar of Shakespeare (despite the excellence of Franz 1939), or of Early Modern English. Even the *OED* has become, for Shakespeareans, a crutch rather than a cure. Most unsatisfactory because most practiced is the glossing of words and phrases which is to be found in most editions of Shakespeare: here a circular definition, there a paraphrase, here a modern synonym, there a citation of a parallel usage, here and there— perhaps the result of frustration—a compilation of all circular, paraphrastic, synonymic, and parallel glosses. What these attempts at 'meaning' have in common is their unevenness, their fragmenting attention to isolated instances—in short, their inability to grasp the total

linguistic and so dramatic-stylistic context. It is exactly a systematic command of all the elements of the corpus which SHAD can provide. If the customary brief 'definition' is not, for the moment, pithily presented, then at least SHAD can assemble and organize for each dictionary entry those ingredients which together render or may be equated with 'meaning'.

The information upon which SHAD draws consists of material retrievable from the tapes of the *Concordance* and the CD. Thus, in addition to the host of morphological, syntactical, and other such material in the matching list, there is from the *Concordance* tapes, for example, supplementary information for each type: play, act-scene-line reference, speaker, context, prose-verse distinction, a mass of statistical and distributional data, and the like. The word GASP will provide an appropriate illustration.

A. LEMCA Information (semi-automatic lemmatization: figure 4).

1. GASP is running number 11 494 in the *Concordance*.
2. It corresponds to running number 30492 in the *SOED* and requires no extra-lemma assignment.
3. It occurs six times.
4. It contains no grammatical ambiguity.
5. It is composed of one free morpheme.
6. It is uninflected.
7. It functions as a nominal.
8. It is not a variant spelling.
9. It elicits no questions in this phase.
10. It, as type, has a total of eight tokens in Shakespeare (i.e. also twice as verb, as the next LEMCA entry indicates).

B. Computer Dictionary Information (drawn from the *SOED* as additional information and/or for purposes of comparison and control: (figure 4).

11. It corresponds to running number 30561 in the CD.
12. It is classified as a noun in the *SOED*.
13. Its status is 'common'.
14. It is assigned no specialized field.
15. It first appeared in print in 1577.
16. It is considered 'denizen' in broad origin.
17. It is Germanic in rough etymology.
18. It is assigned to Old Norse in a more specific etymology.
19. It is given one meaning.
20. It is a homograph—i.e. it is the first of two thus spelled in the *SOED*.
21. It is to be found also in *The Advanced Learner's Dictionary* (Gatenby, Hornby and Wakefield 1963) but not in *A General Service List of English Words* (West 1953). (Cf. figure 3.)

C. Shakespeare Concordance Information.

22. Its six occurrences are distributed among four plays: AYL (1 ×), 1H6 (2 ×), 3H6 (2 ×), CYM (1 ×).

23. It occurs twice in a first act (1H6 1.2.127; CYM 1.5.53), three times in a second act (AYL 2.3.70; 1H6 2.5.38; 3H6 2.1.108), and once in a fifth act (3H6 5.2.41).

24. It occurs four times in history plays.

25. It occurs five times in plays of the 1590s.

26. It is spoken by men (Adam, Mortimer, Warwick, Somerset) and women (Joan la Pucelle, Queen of Cymbeline).

27. It is spoken by major and minor characters (using length of speaking parts as a criterion).

28. It is spoken by persons of all social levels.

29. It occurs only in verse passages.

30. It occurs only at the caesura (4 ×) or at the end of the verse line (2 ×).

31. It occurs, with the exception of CYM (the only instance of a figurative application), only with the definite article or possessive pronoun.

32. It is always directly preceded by an adjective; the adjective is always *last, latter, latest*.

All this information is by no means exhaustive or even digested. There has been only a slight attempt to set this information in the 'widening gyre' of contexts: of the single speaking parts, or the single plays, or the complete corpus, or the vocabulary of the period (retrievable from the *Chronological English Dictionary*), or the total English vocabulary (retrievable from the CD). Nor has much been made of the extent of the information which may be derived from various kinds of *analyses*—'string' or otherwise—of the material available singly or in combination or in combinations of combinations. And one can only mention but a few of the further paths of investigation into different areas of Shakespearean research:

1. The apparent synonymity of *last, latter, latest*.

2. The metrical implications of the set phrases 'to the last gasp', 'till the last gasp', 'at last gasp'.

3. The interaction between meaning and recurring clusters: since the gasp is always the 'last', a word like *greenly* in Henry V's 'I cannot look greenly, nor gasp out my eloquence' (H5 5.2.143) must in this context be granted the possibility of meaning 'sickly' rather than being glossed, as is quite customary, as 'inexperienced, foolish'.

The many-faceted, snow-balling mass of information brings up the question of arrangement. For both practical and economic reasons a tabular presentation would appear most feasible: that is, an extensive framework would be constructed and the information filled in where possible. Naturally, the amount of information would differ for different

lemmata but, from a distributional point of view, even the blanks would convey certain and immediate data. This arrangement would be designed to meet the needs of the broadest spectrum of users, those, say, who have a text of Shakespeare and for the present an *SOED*.

Considering the fact, however, that SHAD can provide more information than conventional dictionaries, that it has almost unlimited possibilities for presenting questions and so eliciting still more information, that the variegated and specialized needs of literary and linguistic scholars must also be met, and that the Shakespeare corpus fills—if only in size—a noteworthy place in the development of the English language, it should be obvious that there will have to be more than one work, and that supplementary productions may well have to take forms other than the conventional alphabetical. In many ways SHAD is a work which can never be finished; like another product made in Germany, it can run and run and run.

REFERENCES

Bartlett, J. (1894) *A New and Complete Concordance or Verbal Index to Words, Phrases and Passages in the Dramatic Works of Shakespeare, with a Supplementary Concordance to the Poems*. London: Macmillan.

Finkenstaedt, T., Leisi, E. & Wolff, D., eds (1970) *A Chronological English Dictionary: Listing 80,000 Words in Order of their Earliest Known Occurrence*. Heidelberg: C. Winter.

Franz, W. (1939) *Die Sprache Shakespeares in Vers und Prosa, unter Berücksichrigung des Amerikanischen entwicklungsgeschichtlich dargestellt*. Halle/Salle: Max Niemayer Verlag.

Gatenby, E. V., Hornby, A. S. & Wakefield, H. (1963) *The Advanced Learner's Dictionary of Current English* (2nd ed). London: Oxford University Press.

Kučera, H. & Francis, W. N. (1967) *Computational Analysis of Present-Day American English*. Providence: Brown University Press.

Onions, C. T., ed (1964) *The Shorter Oxford English Dictionary on Historical Principles* (3rd ed). Oxford: The Clarendon Press.

Schmidt, A. (1923) *Shakespeare-Lexicon: A Complete Dictionary of all the English Words, Phrases and Constructions in the Works of the Poet* (4th ed). Berlin and Leipzig: W. de Gruyter & Co.

Spevack, M. (1968–70) *A Complete and Systematic Concordance to the Works of Shakespeare*, 6 vols. Hildesheim: Georg Olms.

West, M. P. (1953) *A General Service List of English Words, with Semantic Frequencies and a Supplementary Word-List for the Writing of Popular Science and Technology* (2nd ed). London: Longmans.

E. R. MAXWELL
R. N. SMITH

A computerized lexicon of English

Examining the literature involving the processing of words by a computer we find four basic types of computer dictionaries in use: the machine translation (MT) dictionary whose function it is to provide a word in language X that is equivalent to some word in language Y; the concept dictionary (used in information retrieval systems) which searches through texts and using statistical methods groups words according to topic; the linked-list dictionary (used in artificial intelligence systems) uses standard dictionaries as a source and links the words of a definition together; and feature dictionaries (used in transformational grammar systems) which list in a binary fashion the syntactic (and semantic) features of the words. These dictionaries are more or less sophisticated depending on the particular desires of those constructing them and the importance the designers have given to the dictionary in their particular systems.

Computerized dictionaries in general seem to suffer from the fact that they are not considered to be autonomous entities but rather small parts in a larger system: a parsing system, a textual search system, or a transformational grammar system. That is, there has been little work done in developing a lexical theory, a theory of lexical systems.

We propose here a theory of lexical systems which we call Semantic Field theory. The concept of semantic fields is not new, but we have integrated it with a theory of information structures and the field of mathematical study called graph theory, and have developed an autonomous theory of lexical structure.

Using this theoretical framework, we are in the process of building a lexicon of 20000 of the most frequent words as contained in the Brown English Corpus. We call this a 'core dictionary' since it accounts for 98 per cent of the words found in most texts, but does not include, in general, specialized vocabulary. The dictionary, when finished, can be interfaced with special purpose dictionaries (like the SNOP medical dictionary) which tend to be less problematic since they contain less ambiguity.

INFORMATION
The first problem that we faced was that dictionaries do not contain one type of information, but many types: historical, scientific, cultural, experiential, evaluative, grammatical, etc. And the second problem we confronted was the circularity of standard dictionaries, a fact which

many have noted. However, we did discover that Webster's Dictionary, for example, is not as circular as we thought: a relatively small number of words are used in the definitions. But the fact that this is not done systematically virtually neutralizes the effect.

Feature dictionaries attempt to overcome the circularity problem by using a subset of words as components in defining other words. However, this has been quite unsuccessful because it seems that in choosing features the principle has been *chacun a son goût*, resulting in dictionaries that are as theoretically uninteresting as standard dictionaries. The feature system is also based on the assumption that 'word' is to 'semantic component' (or 'feature') as 'phoneme' is to 'distinctive feature'. This theoretical assumption is easily disputed since the production of a sound can be analyzed as the combined effect of lips, tongue, air, vocal cords, etc. But the production of a word cannot by any stretch of the imagination be analyzed this way. That is, components cannot be discovered by any type of concrete, physical analysis. However, feature dictionaries are popular because they work, albeit roughly, within the systems they are developed for.

The problem of information types is dealt with interestingly in both linked-list and concept dictionaries. However, despite the ability to do quick searches that grouping information types gives one, without an interesting theory of meaning the information is practically worthless. A typical entry in a linked-list dictionary would define 'lightning' as 'flash (of) light followed (by) thunder', with pointers from the location containing 'lightning' to the one containing 'flash' (which in turn would be pointed to words which define it), and so on. The dictionary is then a large interlinked and circular network or ring, each word being defined by other words with the pointers being defined as primitive relations like 'is a', 'has a', 'or', 'and', etc.

We need, then, a comprehensive theory of meaning. This, of course, has been a problem for some time and our solution is of necessity more heuristic than algorithmic. We begin with a very small set (perhaps twenty) of undefined concepts called primitives: for example, sameness, difference, events, rest, motion, space, emotion, etc. At the next level we have what we call 'neutral' concepts which are defined in terms of their relations to the primitives; a set of primitive relations (like 'cause', 'change', etc.) which are also defined in relation to the primitives; and finally the lexical system which is defined in terms of the neutral terms and the primitive relations.

It is very important to understand that at this point we are not talking of the lexical system in terms of 'words' but in terms of independent cognitive concepts that are for the most part universal. Individual language-specific lexical systems are mapped onto this universal system; it is this mapping process that gives us 'words'.

Let us take as an example of how a lexical item would be defined within this theoretical system, the item *slap*. At the lowest, most complex level, *slap* is placed within a field of words (we call the 'semantic field') which includes such things as *punch*, *jab*, *spank*, *cuff*, etc. It is defined taxonomically, in an 'is a' relationship, in terms of the word *hit* which is the head-word in the semantic field (all the words in the field are taxonomically related to *hit*). It is differentiated from the other words in the field because of its *instrumental* relationship to the *hand* (which is a member of the body-part semantic field). (*Spank* also has an instrumental relationship to the 'hand' but it also has a *goal* relationship to another body part: the buttocks.)

This information is part of the presuppositional structure of the word: i.e. the information is incorporated into the meaning of the word. The word *hit* can be seen as the head word in the semantic field because it carries no information about instrument and goal, whereas all of the others do.

We must now proceed up to the next level and define the item *hit*. At this level a lexical entry may be a member of another semantic field or may be defined directly in terms of its relationship to the primitives. In this case *hit* would be defined by primitives: an *event* involving a *motion* against an *object* (*object* being defined as *experiencer's body* or *experiencer's environment*) by another *object*, the two objects being *different*.

Actually the situation is slightly more complex since the *hit* semantic field contains several subfields involving words whose meanings incorporate other types of relationships (for example, the word *bump* incorporates the whole body as instrument).

STRUCTURES

After setting up the system of primitives, relations, and semantic fields our problem was to relate this organization interestingly to computer implementation. The way that we have accomplished this is to relate the structuring of information discussed above to various types of graphical structures (called 'trees'). It should be noted that the graphical structures used by transformationalists (commonly known as 'trees') are one type of structure involving a rather complex set of relationships among the nodes (i.e. relationships of linear and hierarchical ordering).

Rather than limit ourselves to one type of graphical structure for all types of information (syntactic and semantic) as the generative semanticists have done, and rather than developing a formalism that does not lend itself to computer implementation very readily (as the interpretive semanticists have done with their projection rules), we have decided to relate the different types of information contained in the dictionary as discussed above to different types of graphical structures and then

develop algorithms to translate this information into structures which the computer can process (in the manner discussed in Knuth 1968).

The three types of trees that we use to represent information are: (a) free trees; (b) oriented trees; and (c) ordered trees. As graphs, any of these trees can be directed or undirected; that is, directionality may or may not be indicated. A discussion of this and its implication for linguistic theory can be found in Maxwell (1973). Briefly, free trees represent information that has no hierarchical or linear structure; for example the relationship between the members of a semantic field (like *slap, punch, jab,* etc.) or the set of prepositions. Oriented trees represent hierarchical information; for example, 'has a' or 'is a' relationships (taxonomies). Ordered trees represent information that is both hierarchical and linear; for example, certain lexical relationships like 'I did*n't* go out *because* of the rain' and 'the rain *kept* me *from* going out' where the hierarchical and linear relationship between *neg* and *cause* is necessary information to interpret the sentence semantically.

The Dictionary

Let us now look at some examples of how the dictionary is to be physically structured in the computer, incorporating the theoretical constructs discussed above.

First, there are a couple of problems that we will not be considering at this point: (a) the problem of programming the computer to understand the primitives like 'sameness', 'difference', etc.; (b) the problem that certain polysemous words are not polysemous in certain contexts: e.g. 'can you see that?' could be either viewing or understanding, but 'do you see?' can only refer to understanding; (c) a particular polysemous word can have one meaning that is stronger than another (i.e. excitation values must be assigned to meanings), or one meaning that is used only by a particular cultural group (a possible solution is discussed in Smith and Maxwell 1973); e.g. *sea* in the sense of water or in the sense of domain, or *cool* in the sense of color or in the slang sense of attitude.

A graphical representation of the structure of the dictionary would look like figure 1. The relationships among the lexical entries in the semantic fields (sf) to each other and to other words in other fields will be represented by tree structures (described above). The shape that these structures will take in the computer will be doubly or triply linked list structures. Along with this information, certain deductive procedures will be built in: e.g. the transitivity relation that states that if w_1 is a member of sf_1 and sf_1 is a member of sf_2, then w_1 is a member of sf_2. The purpose of constructing it in this way is to eliminate as far as possible all redundant information and to decrease circularity.

Each lexical word will have two or more computer words or locations

Figure 1

(where P = PRIMITIVE and R = primitive RELATION)

Figure 2

Figure 3

which will structurally be nodes in the lexical system (e.g. w_1 in the tree above). The structure of the nodes will be as follows: first, the NEUTRALS (like *hit*) will be defined in terms of the PRIMITIVES (see figure 2). Then, all the words in the semantic field headed by the word *hit* will contain in their definitions only that information which differentiates them (figure 3). Another set of computer words that will hold the meaning of a lexical word will include information about the

syntactic and case potentials of a word. For example, there will be a link from the definition of *hit* (as given above) to the set of computer words containing the following information:

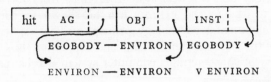

Notice that the definition of a NEUTRAL does not contain case and syntactic potential within its meaning, whereas the definitions of lexical items within semantic fields do; that is, *punch* already contains the information that the instrument is the fist as part of its meaning, whereas for *hit* the instrument must be stated. For this reason we include the instrument as part of the meaning of *punch* but as part of the syntactic potential (or case frame) of *hit*.

Notice also that a speaker has the opportunity to choose either the fully specified statement: (a) John hit Mary with his fist; or, if he wants to delete the instrument, the speaker can say (b) John punched Mary. However, this is not always the case. For example, we can say: (c) Harriet boiled the water. But there is no expression using *cook* that parallels (a) above. This is understandable since *cook* is both the NEUTRAL expressing the notion of an EVENT in which HEAT is applied to some OBJECT that is EDIBLE or POTABLE and is also a non-neutral member of the semantic field expressing the particular notion of applying heat in the absence of water, while *boil* refers to the application of heat to some object in the presence of water. Since *cook* is both the neutral term and a member of the SF (which is not the case with *hit*), then our theory would predict that no parallel construction could exist.

The approach that we have been discussing in this paper has the following advantages:

1. The construction of the dictionary can be done in sections (constructed like a computer program would be constructed). That is, we can work on the meanings of words, semantic field by semantic field—thus decreasing the problems of polysemy. Further, we can assign a subset of the computer words used in the definition of a lexical word to the description of the lexical meaning and another subset to the case frames and syntactic potential. In other words, our lexical theory lends itself readily to a 'divide and conquer' principle.

2. We eliminate the problem of redundancy since only necessary information is given and rules of deduction permit us to retrieve information that is 'implicit'.

3. Our lexical theory corresponds to current linguistic theories and our partitioning of the definitions will allow us to keep the dictionary

up to date easily. Further elaboration (discussed in Smith and Maxwell 1973) will allow the dictionary to function in performance as well as competence systems.

4. The theory that a lexical system develops from PRIMITIVES to NEUTRALS to SEMANTIC FIELDS can be shown to correspond to Piaget's developmental psychology principles. That is, we can relate our theory of the lexical system to language acquisition thus allowing for the possibility of constructing a computer system that learns the meanings of words.

CONCLUSION

Just about every computer program that involves man-machine interaction, and some that do not, could benefit by having a dictionary. A simple example would be a computer-assisted instruction program in which some verbal response is expected. Instead of having the teacher who makes up the program try to guess all of the possible responses and to have replies appropriate to them, the dictionary itself could decide the appropriateness of the response in terms of the distance (the number of paths separating the nodes) that the answer given is away from the correct answer. We are in the process of constructing a 20 000 word core dictionary that will possess both the flexibility necessary to deal with such problems and the theoretical sophistication which will allow it to be useful in many types of systems: artificial intelligence, machine translation, CAI, etc.

REFERENCES

Apresjan, Y. D., Mel'čuk, I. A. & Žolkovsky, A. D. (1969) Semantics anp lexicography: toward a new type of unilingual dictionary. *Studies in syntax and semantics* (ed Kiefer, F.), 1–33. Foundations of language, Supplementary Series no. 10.

Castelfranchi, C. (1973) *Un mente enciclopedia.* Mimeograph, Istituto di Psicologia, CNR, Rome.

Fillmore, C. J. (1968) The case for case. *Universals in linguistic theory* (eds Bach, E. & Harms, R. T.). New York: Holt, Rinehart and Winston, Inc.

Friedman, J. (1971) *A computer model of transformational grammar.* New York: American Elsevier.

Gove, P. B. (1972) English dictionaries of the future. *New aspects of lexicography* (ed Weinbrot, H. D.). Carbondale, Ill.: Southern Illinois University Press.

Kiss, G. (1967) Networks as models of word storage. *Machine intelligence 1* (eds Collins, N. L. & Michie, D.), 155–68. New York: American Elsevier.

Lakoff, G. (1970) On generative semantics. *Semantics: an interdisciplinary reader in philosophy, linguistics, and psychology* (eds Steinberg, D. & Jakobovits, L.). New York: Cambridge University Press.

Marx, S. (1972) *Deductive question-answering with natural language inputs.* Unpublished doctoral dissertation, Northwestern University.

Maxwell, E. R. (1972) *Semantic structures.* Unpublished doctoral dissertation, Northwestern University.

Maxwell, E. R. (1973) Graphical representation of semantic fields. National Conference of the Association for Computational Linguistics, Ann Arbor, Michigan.

Maxwell, E. R. (forthcoming) Possible lexical items.

McCawley, J. (1968) The role of semantics in a grammar. *Universals of linguistic theory* (eds Bach, E. & Harms, R. T.). New York: Holt, Rinehart and Winston, Inc.

Minsky, M., ed (1968) *Semantic information processing*. Cambridge, Mass.: MIT Press.

Pacak, M. & Pratt, A. W. (1971) The function of semantics in automated language processing. Reprint from *Symposium on information storage and retrieval*, April 1–2, 1971.

Quillian, M. R. (1968) The teachable language comprehender. *Semantic information processing* (ed Minsky, M.). Cambridge, Massachusetts: MIT Press.

Salton, G. (1971) The performance of interactive information retrieval. *Information processing letter 1*.

Simmons, R. F. (1970) Natural language question answering systems. *Communication of the ACM*, **13**, 15–30.

Smith, R. N. (1972) Interactive lexicon updating, *Computers and the Humanities*, **6**, no. 3.

Smith, R. N. & Maxwell, E. R. (1973) An English dictionary for computerized syntactic and semantic processing. International conference on computational linguistics, Pisa, Italy.

Weinreich, U. (1963) Lexicology. *Current trends in linguistics*, vol. I (ed Sebeok, T.). The Hague: Mouton and Co.

Werner, O. (1972) *Ethnoscience*. Mimeograph, Northwestern University.

Woods, W. A. (1972) *The lunar sciences natural language information system*. Cambridge, Mass.: Bolt, Bernak and Newman.

Žolkovsky, A. K. & Mel'čuk, I. A. (1970) Semantic synthesis. *Systems theory research*, **19**, 170–243.

The language of the *Peterborough Chronicle*

My study of the Peterborough Chronicle (PC) was initially motivated
by an interest in syntactic typology. I was specifically interested in
gathering further evidence (see Mitchell 1972) concerning the surface
order patterning of the constituents of VP in Old English, i.e. Aux and
MV, in order to refute the claim made by Closs (1965) that MV Aux order
'will automatically account for most coordinate and subordinate clauses'
(p. 407). I would assert, however, that no worthwhile syntactic analysis
of a medieval language can proceed without prior study of the manuscript
itself. It is particularly important that the establishment of major
syntactic units be based upon manuscript and not modern, editorial,
punctuation. Unfortunately it is by no means clear what punctuation
marks in Old English, if any, correlate with syntactic units; nor is there
any general agreement among scholars about what should be considered
the major syntactic unit in Old English. Carlton (1970), for instance,
assumes that there are sentences in Old English 'for the sake of clarity,
convenience and efficiency' (p. 28), whilst Shannon (1964) finds the
clause to be 'the largest convenient unit for the description of Old
English syntax' (p. 87). Most scholars are content to label Old English
'paratactic' and leave it at that.

As we all know, however, computer-aided textual analysis demands
unambiguous decisions. While this is in many ways a virtue, there are
inherent dangers not least of which is the temptation to make the most
convenient rather than the best motivated decision. The work of
Carlton on the Old English charters, though not computer-aided,
provides an appropriate example. In his attempt to produce a rigorous,
formal syntactic analysis of the charters, Carlton falls into the classic
structuralist trap of claiming that he has established a formal 'procedure
for isolating sentences' when in fact his procedure crucially depends
upon semantic criteria, i.e. recognizing 'larger word-groups which can
stand alone and give an intelligible idea, fact or piece of information . . .'
(p. 28). The problem, of course, is that Carlton's procedure is unscienti-
fic in that it cannot be replicated by anyone else. Thus Carlton's results
are practically impossible to verify, and cannot be compared with the
analyses made of other texts by other researchers. Clearly such a pro-
cedure cannot be incorporated into a computer program.

How then can one initially approach the analysis of a medieval manu-
script without dependence on meaning on the one hand, or on punctua-

tion on the other? I suggest the following: keypunch the text from the manuscript, faithfully recording the scribal punctuation, but write the computer program in such a way that it ignores, for the purposes of syntactic-unit determination, such punctuation. Then incorporate into the program recognition of tentative editorial punctuation. The procedure is best illustrated by reference to what was done with the PC. Scrutiny of the manuscript suggested that a formal working definition of sentence-boundary was possible. A sentence-boundary marker (/) was inserted whenever a manuscript point or *punctus* was followed by a word beginning with a capital letter. This definition is supported by Whitelock's (1954) observations, based on semantic criteria, that 'the usual mark of punctuation is the *punctus*, marking minor pauses as well as the end of sentences. New sentences fairly often begin with a small capital' (p.18). A 'sentence' thus became any sequence occurring between two boundary markers. This procedure, then, assumes no commitment to preconceived, and perhaps inappropriate, notions of what sentences should be in Old English, or whether indeed we can define such constructs for Old English as a whole. At the same time it avoids obscuring any correlation between the manuscript punctuation and syntactic units that might be demonstrated to exist after analysis has been completed.

Perusal of the PC itself and of the few relevant studies done upon it convinced me that nothing less than an exhaustive linguistic analysis of the whole corpus would be necessary before any syntactic analysis should be attempted. Sampling would have been inappropriate given our lack of knowledge of the distribution characteristics of linguistic data—here, the text. Furthermore, there are perfectly normal linguistic phenomena which occur quite infrequently (see Chomsky 1956). Another difficulty was the complexity of the text itself—a complexity I will endeavour to explain briefly.

The Peterborough MS (Laud misc., 636) is but one, albeit an important one, of seven manuscripts containing different versions of the *Anglo-Saxon Chronicle*. Its relationship to the other six is not altogether clear, but we do know that it is an early twelfth-century version of a Northern recension which probably originated either in York (Whitelock 1954) or Ripon (Plummer 1892). Our manuscript seems to be a copy of one lost in the Peterborough fire of 1116 (ref. Whitelock 1954, 31), and was, therefore, written in its entirety in the Peterborough scriptorium. But the burned exemplar may well have resided for a time at Canterbury, on the evidence of the annals from 1023 to at least 1061. Only two scribes, it is now generally agreed, worked on the Laud MS. The first scribe copied the annals up to 1121, adding some twenty insertions of local interest. He then wrote new entries at intervals from 1122 to 1131. The second scribe did his work in one block, some time in 1155, and thus

completed the annals from 1132 through 1154. To complicate matters, not all of the annals are in Old English. There are thirty-four distinct entries in Latin, and numerous sporadic occurrences of Latin names and phrases. Furthermore, there are thirteenth-, fourteenth-, and even six-teenth-century additions to the manuscript—marginalia and underlinings for the most part.

TEXT ENCODING SYSTEM

The encoding system finally adopted is basically that suggested for Old English by Venezky (1970), with such additions as were necessary to handle certain manuscript features for which no provision had been made, e.g. additions above or below the manuscript line, scribal errors and marks of correction. (For a full listing, see Mitchell 1973, table I). The only significant variations from Venezky's system are: the ⟨æ⟩ is represented by AE, not ($) which is used as a word-boundary marker; a single slash (/) is used to indicate sentence-boundaries rather than restorations for which square brackets are employed; a double slash (//) is used to indicate the end of a year entry, rather than runic charac-ters, of which there are none.

The operation of the text encoding system is detailed in Mitchell (1973), but the following points should be noted with regard to table 1. Some words abbreviated in the manuscript have been expanded in the encoding process and are marked by (=) followed by a code letter indicating the form of abbreviation and by a numeral locating the ex-pansion. For example, the encoded word NAM = B3 shows that the manuscript reads *nã*. Words not expanded are marked by (≠) followed by a code letter indicating the superscript and by a numeral locating the superscript. Thus, the encoded word KL ≠ C1,2 tells the reader that the manuscript shows *kł*. The not-equals sign is also used for such common non-segmental features as dots over letters (D) and accent marks (J), so that *Y ≠ D2 allows reconstruction of a manuscript form *þẏ* and IULII ≠ J4,5 a manuscript form *iulíí*.

With the decision to preserve the manuscript-line format so that the punched card reflected only what was in a given line in the manu-script, problems could have arisen. In order to prevent a word like GEHATEN in table 1 from being broken at the end of one line as GEHA and continued on the next as TEN and treated as two separate words, the numeral 1 was punched in column 80 of the card, blocking the insertion of a word-boundary marker after GEHA. The numeral 2 in column 80 indicates that the manuscript line was too long for in-clusion on one card.

Here I have included the corresponding extract from Plummer's edition to demonstrate the unreliability of what is usually considered an authoritative text. It is hard to believe that '[his] work aims at re-

[Facsimile manuscript text in Old English insular script]

> Her cynepulf ɟ offa ge flyton
> ymb benesing tun. ɟ offa ge nã þone tun. ɟ þy ilcan
> geaþe man ge halgode ædelbeþht to biþcope to hpiteþn
> ne in eofeþpic on. xvii. kł iulii. On þaþ kinigeþ dæi
> offa þæþ an abbot on medeþhamþtæde Beonne gehi
> ten. þe ilca beonne þuþh ealle þa muneke þed oþ þeþe
> minþtþe þa let he cuþhbþuht ealdoþima: x · bondeland

777. Her Cynewulf ꝺ Offa ge flyton ymb Benesing tun. ꝺ
Offa genam þone tun. ꝺ þy ilcan geare man gehalgode Æðel-
berht to biscope to Hwiterne in Eoferwic on ·xvii· kł Iulii.

On þas kinges dæi Offa. wæs an abbot on Medeshamstede
Beonne gehaten. se ilca Beonne þurh ealle þa muneke red of
þere minstre þa let he Cuðbriht ealdorma[n] ·x· bonde land |

```
777Y
HER CYNEWULF≠D2 7 OFFA GE FLYTON≠D3
YMB≠D1 BENESING TUN. 7 OFFA GE NAM=B3 *ONE TUN. 7 *Y≠D2 ILCAN
GEARE MAN GE HALGODE AE+ELBERHT TO BISCOPE TO HWITER                    1
NE IN EOFERWIC ON XVII KL≠C1,2 IULII≠J4,5./ ON)) *AS KINGES DAEI
OFFA WAES AN ABBOT ON MEDESHAMSTEDE BEONNE)) GEHA                       1
TEN, SE ILCA BEONNE *URH EALLE *A MUNEKE RED OF *ERE
MINSTRE *A LET HE CUTHBRIHT EALDORMA X BONDELAND
F24A
```

```
Here Cynewulf and Offa fought
around Bensington and Offa took the town and in the same
year someone ordained Aethelberht bishop of Whithorn
in York on June 15th.  In the days of King
Offa (there) was an abbot in Peterborough called Beonna
this same Beonna on the advice of all the monks of the
monastery then let he to Alderman Cuthbriht ten bondlands
```

Table 1

producing the MSS as nearly as possible . . .' or that he has 'endeavoured
to mark the peculiarities of the MSS' (Plummer 1892, Preface pp. viii,
ix), when one compares his work with the manuscript and the encoded
text. One can point to Plummer's arbitrary failure to observe morpheme
boundaries (we find *ge halgode* in 762, but *gehalgode* in 777), to his
unwarranted insertion of capitals (thus obscuring, for example, the fact
that the first instance of *Beonne* is capitalized in the manuscript but the
second is not), and to his neglect of the accent marks over *iulii* (though
he includes one over *Ii* in 729). Errors of commission include an un-
motivated point after the third instance of *offa*, though we are assured
in the Preface that 'stops not in the MSS are represented by commas and

semicolons,' (p. lx), and the puzzling substitution of ⟨ð⟩ for manuscript ⟨th⟩ in *Cuthbriht*. This extract was chosen at random, and I would judge it typical.

Some errors certainly remain as yet undetected in the keypunched text of the PC. Specific steps were taken, however, to eliminate errors. Each batch of work was proofed immediately after keypunching, and the whole text upon completion of the work. Smith observes in his Preface to *A Concordance to Beowulf* (Bessinger and Smith 1969, xxii) that errors remain in the text even though the 17306 words were proofed six times by four different people—and in the PC we are, after all, dealing with a text of 51037 words.

PROGRAMMING: STAGE I

Some of the early programs were originally written in SNOBOL 4, a higher-level language designed for string-manipulation. But trial runs soon proved that SNOBOL in the form available was excessively slow, and so eventually all the programming was done in FORTRAN IV by John Larson of the University Computer Center. Our experience with SNOBOL bears out the comments of Day (1971, 245) that the programming burden is greater with FORTRAN than with SNOBOL, but the resulting programs employ more efficient techniques.

```
STORAGE FILE 1
FOR+FERDE, 7 WAES BE BYRGED≠D2 BE AUGUSTINE IN DIE IIII≠N3 NONARUM≠B7
Process 1 :
Insert word-boundary markers ($), calculate ULR (ED/LOC)
STORAGE FILE 2
FOR+FERDE$,   7$      WAES$    BE$    BYRGED$≠D2  BE$   AUGUSTINE$ IN$    DIE$   IIII$≠N3 NONARUM$≠B7
6164117      6164118 6164119 6164120  616121    6164122  6164123  6164124 6164125 6164126  6164127
Process 2 :
Delete Latin (except proper names), poetry,     (ED/LOC)
STORAGE FILE 3
FOR+FERDE$,   7$      WAES$    BE$    BYRGED$≠D2  BE$   AUGUSTINE$ XXXXX   XXXXX   XXXXX    XXXXX
6164117      6164118 6164119 6164120  6164121   6164122  6164123  6164124 6164125 6164126  6164127
Process 3 :
Normalize special characters (*, +, 7)   (ED/LOC)
STORAGE FILE 4
FORTHPFERDE$,  AND$   WAES$    BE$    BYRGED$≠D2  BE$   AUGUSTINE$ XXXXX   XXXXX   XXXXX    XXXXX
6164117      6164118 6164119 6164120  6164121   6164122  6164123  6164124 6164125 6164126  6164127
Process 4 :
Alphabetize word-list (SORT/MRG), count frequencies (STATS)
```

Figure 1. Sample from the PC (616 AD) to illustrate the sequence of operations necessary to produce stage I output.

Three major programming phases produced the output for stage I (the sequence of operations is illustrated in figure 1). The first phase, called ED/LOC (EDITING/LOCATION), inserts word-boundary markers ($) whenever it encounters an illegal character (i.e. one outside the set: A-Z, 7, +, *, 1, [,]), merges words broken at the end of a line and

calculates the unique location-reference (ULR) for every word. The only difference between the two programs involved is that the second is insensitive to dummy words (XXXXX) for all purposes but location-reference. Thus every word in Latin or from a poem is assigned a ULR, but is otherwise ignored. A third program prepares the text for the next phase by normalizing all instances of (*) and (+) as TH, a step which facilitates alphabetizing. (See further Venezky 1970, 71–2.)

word	year	sen.	word no.	CF
LIG+$	796	1	26	3
LIHT$	1122	7	266	1*
LIHTEDE$	1140	2	46	1*
LIHTINGE$.	1117	3	103	1*
LIHTINGE$.	1118	4	124	2
LIII$	565	1	9	1*
LILLAN$	626	1	21	1*
LIMAN$.	1125	1	34	1*
LIMENE$	892	1	46	1*
LIMES$./	1137	13	337	1*
LIMU$	1086	42	*53	1*
LIN$.	963	8	356	1*
LIN$	963	13	488	2
LINCOL$=B5,6	1132	1	59	1*
LINCOL$	1137	3	91	2
LINCOL$	1140	5	130	3
LINCO]L$	1154	4	169	4
LINCOLLAN$.	627	1	64	1*
LINCOLNA$	1064	1	84	1*

Table 2. Word location list

The second phase consists of two programs. The first is a CDC library program, SORT/MRG version 3.0, the output of which is an alphabetized list of every word in the corpus. This list in turn becomes input to a second program that records the cumulative frequency of each occurrence of every word and collates the data which appear in the word location list (table 2). This program is also the source of the alphabetized frequency list (table 3).

The third phase of stage I is the program STATS. By reference to the alphabetized frequency list, it calculates the rank of every word and the cumulative absolute frequency (CAF) of every group of words as well as the percentage and cumulative percentage of the text represented by each word and group of words (table 5). Although not a part of the STATS phase, the last program of stage I uses the alphabetized list as input to produce a reverse alphabetical list (table 4). The letters in each word are transposed and the resultant list is run through SORT/MRG.

word	AF
OFSLOH	7
OFT	13
OFTAR	1
OFTOR	4
OFTORFOD	1
OFTRAEDLICE	3
OINNAN	1
OLAF	2
OLAN	1
ON	1392
ONBRYTENE	1
ONFANGEN	1
ONFENG	21
ONFENGON	4
ONFON	1
ONFRANG	1
ONFUHTON	1
ONFUNDON	1

Table 3. Alphabetized frequency list

SONE	OTHERNE	GEORNE
SONE	NORTHERNE	BURNE
SONE	NORTHERNE	WAETELLEBURNE
TONE	SLAEPPERNE	GYRNE
UTONE	MAETERNE	HYRNE
DEARNE	MAETERNE	STYRNE
DEARNE	WITERNE	TRYWLEASNE
DEARNE	HWITERNE	GAESNE
UNDERNE	HWITERNE	THISNE
SEOLFERNE	HWITERNE	THISNE
WYRTGERNE	HWITERNE	THISNE
OTHERNE	QUARTERNE	THISNE
OTHERNE	AESTERNE	THISNE
OTHERNE	CORNE	THISNE
OTHERNE	CORNE	THISNE
OTHERNE	CORNE	ORMAETNE
OTHERNE	CORNE	RIHTNE

Table 4. Reverse alphabetical list

The accompanying tables are merely representative samples chosen at random, and no attempt has been made to delete inevitable errors. In table 3, for example, OINNAN is a keypunching error, and ON-BRYTENE is the result of a programming error which merged a few words under rare conditions. OLAN, however, is not an error but part of the place-name OLANIGE (modern Olney) which was written OLAN IGE in the manuscript and therefore keypunched in the same way. Not surprisingly, many such errors and peculiar forms can be

	word	AF	%	CAF	%
1	AND	4131	8·3291	4131	8·3291
2	TO	1487	2·9982	5618	11·3273
3	ON	1392	2·8066	7010	14·1339
4	THA	1232	2·4840	8242	16·6179
5	GE	1229	2·4780	9471	19·0959
6	SE	817	1·6473	10288	20·7432
7	HE	726	1·4638	11014	22·2070
8	OF	705	1·4215	11719	23·6284
9	HIS	680	1·3711	12399	24·9995
10	WAES	674	1·3590	13073	26·3584
11	THE	640	1·2904	13713	27·6488
12	TH	618	1·2460	14331	28·8949
13	HIM	490	·9880	14821	29·8829
14	THAER	484	·9759	15305	30·8587
15	HI	473	·9537	15778	31·8124
16	MID	466	·9396	16244	32·7520
17	HER	442	·8912	16686	33·6432
18	THAM	423	·8529	17109	34·4960
19	SWA	370	·7460	17479	35·2421
20	CYNG	336	·6775	17815	35·9195
21	FOR	292	·5887	18107	36·5083
22	THONE	289	·5827	18396	37·0910
23	BE	280	·5646	18676	37·6655
24	MAN	258	·5202	18934	38·1757
25	NE	240	·4839	19174	38·6596
26	GEARE	227	·4577	19401	39·1173
27	EALLE	216	·4355	19617	39·5528

Table 5. Ranking list

detected by scrutiny of the *hapax legomena* (word-types of frequency one).

PROGRAMMING: STAGE II

Since there was little advantage in creating yet another concordance program, the PC was automatically reformatted for input into an already existing program, CONCORD. As table 6 shows, the program EXPAND converted the special characters (*) and (+) into TH, merged broken words (e.g. HWITER-NE) and removed all manuscript coding and punctuation together with year entries and folio markers.

The next operation—compilation of a look-up dictionary—proved time-consuming, since the vital step of determining the grammatical category of each word could not be programmed. The input to the look-up dictionary was the alphabetized frequency list (table 3) which was run through SORT/MRG to produce a set of punched cards listing each word-type in descending order of frequency. The words on this frequency list had already been expanded for input to SORT/MRG. At this

HER CYNEWULF AND OFFA GE FLYTON
YMB BENESING TUN AND OFFA GE NAM THONE TUNE AND THY ILCAN
GEARE MAN GE HALGODE AETHELBERHT TO BISCOPE TO HWITERNE
IN EOFORWIC ON XVII KL IULII/ON THAS KINGES DAEI
OFFA WAES AN ABBOT ON MEDESHAMSTEDE BEONNE GE HATEN
SE ILCA BEONNE THURH EALLE THA MUNEKE RED OF THERE
MINSTRE THA LET HE CUTHBRIHT EALDOR MA X BONDELAND

Table 6

rank	category	symbol	frequency
1	noun	—	12028
2	prep)	6568
3	conj	+	4645
4	verb	.	4364
5	advb	(4323
6	det	=	3762
7	pron	$	3746
8	adj	/	2814
9	aux	*	1657
10	part	,	1340
11	interj	≡	13

Table 7

point, categories were determined only for those word-types of frequency greater than one. Initially defining the dictionary in this way worked well since the ranking list showed that the 2735 word-types thus categorized represented nearly 92 per cent of the text.

In all, eleven grammatical categories have been recognized. With the exception of the terms 'determiner' and 'particle' all of the category names are unambiguous and theoretically neutral. Table 7 is both a category ranking list and a key to the symbols used in the look-up dictionary. These categories could be refined along the lines of Pillsbury (1970), but only at the cost of considerable pre-editing of the text. For instance, Pillsbury distinguished between prepositions whose objects were postposed (P1) and those whose objects were preposed (P2). But the decision as to whether a given preposition was a P1 or a P2 had to be made for every preposition in the corpus. Such massive pre-editing is patently uneconomical. The category-insertion system outlined below is far more efficient, in spite of inherent problems.

CATEGORY-INSERTION
After the word-types of frequency greater than one had been categorized, the entire dictionary of 6723 word-types was run through SORT/MRG yet again in order to produce the alphabetized version necessary for the binary search routine. The category-insertion program (CT/INSRT) checked every token in the 49597 word text (i.e. the corpus minus the

Latin entries) against the 6723 types in the look-up dictionary. When a specific text-word was matched in the dictionary, any accompanying category was linked to the text-word and stored in another file to be output later in the format shown in table 8. In this sample, only FLYTON remains uncategorized, and the rest gives every appearance of having been accurately, though superficially, parsed.

HER	CYNEWULF	AND	OFFA	GE
(ADV	−N	+CONJ	−N	,PART
FLYTON	YMB	BENESING	TUN	AND
)PREP	−N	−N	+CONJ
OFFA	GE	NAN	THONE	TUN
−N	,PART	.V	=DET	−N
AND	THY	ILCAN	GEARE	MAN
+CONJ	=DET	/ADJ	−N	−N
GE	HALGODE	AETHELBERHT	TO	BISCOPE
,PART	.V	−N)PREP	−N

Table 8

Study of the category-marked text itself makes it clear why *hapax legomena* were not initially categorized in the look-up dictionary: the majority of them are easily identifiable in context. Although no complete breakdown by category is yet available, nouns clearly seem to predominate among word-types of frequency one—especially personal and place names. A sample of ten pages of output turned up 91 unmarked nouns, 21 verbs, 7 adjectives, 2 adverbs and 1 auxiliary.

The *hapax legomena* in the PC have now all been categorized manually, but for future texts it should be possible to develop a series of rules which would label some of them automatically. For example, *ge* is a morpheme of high frequency in the PC. Sometimes bound, sometimes free, it is fifth on the ranking-list with 1229 occurrences. But it is also a homonym, functioning primarily as a particle (479 of the first 500), infrequently as a correlative conjunction (19 of the first 500), and rarely as a pronoun (none of the first 500). In the look-up dictionary, *ge* was, of course, categorized as a particle. Obviously, what we know about the distribution of *ge* could help us categorize some of the *hapax legomena*. We might, for instance, try incorporating context-sensitive rules like (i) and (ii) into the category-insertion program:

(i) uncategorized⇒.V(ERB)/#HER GE—
 word

(ii) uncategorized⇒-N(OUN)/)PREP⎫
 word /ADJ ⎬GE—

At the moment it is difficult to evaluate the relative merit of manual versus rule-based categorization of *hapax legomena*. The former costs nothing in computer time, but the latter is of far more theoretical interest. However, such rules necessarily depend upon just the kind of

information that results from the category-insertion program here
described.

SOME PROBLEMS

Homonyms (or homographs) are a perennial problem for anyone
attempting to perform an analysis of a natural language. It is largely
because of such homonymity in Old English that the figures cited in
table 7 must be regarded as no more than tentative. The number of
prepositions, for instance, will diminish after some occurrences of high
frequency words like *for, to, on*, etc., have been recategorized as particles.
Here predictive rules might be utilized to decide between categories. As
an example, *to* followed by a form already marked as a verb (e.g. *to
dældon*) would be marked 'particle', but *to* followed by a determiner or
a noun (e.g. *to ðe mynstre, to Normandi*) would be marked 'preposition'.
The mis-marking of some words in the process of category-insertion,
because of homonymity, was not, however, altogether unproductive. It
will allow for the compilation of a checklist of homonyms such as that
found in Bessinger (1969)—a valuable by-product of the correction
process.

The numerical system is a good example of a group of words that is
not amenable to category-insertion. A sub-concordance program run
shows that there appear to be some 341 numerical constructions in the
PC, representing 151 different number forms. But, of course, the same
number may occur as a Roman numeral (e.g. V, LX) or as a word (e.g.
fif, sixtiga). I chose to categorize numerals as adjectives in the look-up
dictionary, though I was aware they also occur as nouns. My decision
was motivated, at least in part, by the impression that the adjectival
construction was the more frequent. Examination of the evidence from
the PC for the word *gear* seemed to confirm this impression. Examples
(iii) and (iv) are illustrative:

 (iii) *he was þær iii gear* . . . (658 AD)
 (iv) *se wæs biscop xxxiii geara* . . . (721 AD).

In (iii) the numeral must be an adjective, but in (iv) it must be a noun
because it is followed by a noun (*geara*) in the genitive case. Both
numerals were marked as adjectives by the program. There were 45
adjectival constructions in the PC and only two nominal ones. Unfor-
tunately this pattern did not hold for all lexical items. An examination of
numerical constructions with *winter* yields only 15 adjectival, but 54
nominal constructions. Although handling such constructional varia-
bility is clearly beyond the scope of the category-insertion program
described, it is important to note that the identification of the differences
in construction that occur with *gear* and *winter* is itself a contribution to
Old English studies.

SOME EXAMPLES

The data now available from the PC will facilitate more detailed studies of specific aspects (e.g. phonological, syntactic, onomastic, etc.) of the work and will prepare the groundwork for a projected definitive edition. A better idea of some of the possibilities can be obtained by consideration of the following examples.

There are many instances of lexical variation that might fruitfully be studied in a large corpus of Old English: *beo*/*eom*, *was*/*wæs*/*wes*, *here*/*fyrd*, agentive *mid*/*fram*/*þurh*, etc. Since the traditional handbooks have little or nothing to say about the relative distribution of such variants either in a specific text or in Old English in general, almost no guidance is available to the student. As an example of lexical variation, consider the prepositional variants *on*/*in*. In his glossary, Plummer (1892) comments that 'MS A [Parker] shows a tendency to use *in* for *on* e.g. 626, 635, 666, 709 (bis) where B, C, D, E have *on*.' (p.365). The note is suggestive, though inaccurate. In fact, D shows *in* in 626 and E (Peterborough MS) has no parallel entry for that year. Nor is there any entry in any manuscript for 666. But from the ranking list we determine that *on* ranks third with an AF of 1392, and *in* thirty-third with an AF of 202 (keeping in mind that the list is unlemmatized and therefore contains verb particles as well as prepositions). Next we look at the word location list to discover the total number of occurrences of *on* in PC up to 1070, the year in which the Parker MS breaks off: there are 739. Of these 97 occur in constructions with parallels in the Parker manuscript. And in fourteen cases (35, 455, 456, 495, 527, 552, 568, 584, 601, 635, 636, 661, 709(2)) the Parker shows *in* where the Peterborough MS has *on*. At times the Parker shows other variants too—for example, *æt* (755, 855) and *in on* (934). What we have here are the raw data needed to ask other more interesting questions such as: Which prepositions alternate with one another? Are there any conditioning factors such as case, pronoun/noun, locative/temporal? And it will now not be too difficult to map the distribution of all prepositions in the PC—an undertaking hitherto unlikely except as a dissertation project.

Using a program called STX, it has also been possible to construct what amounts to a 'lexicostatistical' profile of the PC. This program outputs some sixteen values by means of information derived from earlier programs such as the number of types and tokens, and figures from a frequency distribution table. All of the values refer to characteristics of the (abnormal) curve which might be plotted if one used classes of words as points on the horizontal axis and numbers in a given class as points along the vertical axis. Unfortunately, there exist to the best of my knowledge no similar data for a different corpus of Old English with which these results could be compared. I will, therefore, confine

myself for the moment to a few cautious remarks about Yule's *K* or characteristic—perhaps the measure of most interest here because it has been shown to distinguish writers.

Yule's *K* is usually described as a measure of vocabulary diversity or 'richness'. It measures, in effect, the probability for a given corpus of picking, as it were, the same word out of the hat twice. As Williams (1970) points out: 'it is . . . a better measure of uniformity than of diversity' since 'Yule's characteristic increases as the diversity decreases' (p. 99). That Yule's *K* is 126·20 (i.e. there are 1·26 chances in 100 of picking the same word) for the PC suggests, then, a relatively high degree of repetitiveness compared to that deducible from the Brown-Kučera figures: not surprising, for a record that confines itself for the most part to accounts of the birth, reign and death of various ecclesiastics and monarchs. I need only cite a few examples: 934 references to *king*, 290 references to *bishop* or *archbishop* and 270 references to *earl*. But the claims that the repetitiveness of the vocabulary of the PC is reflected in such words will have to wait upon the tabulation of separate scores for content words and for function words. One would predict, after all, that function words would characteristically show less diversity than content words.

The next stage of the program will bring us closer to the syntax of the PC. Once the category-marked text has been corrected (now under way on an interactive terminal), we will be able to determine every category string configuration in the text, e.g. the number of occurrences of DET N or DET ADJ N. This information will, in turn, facilitate the design of rules for the merger of such category strings into higher categories—a necessary step in the path toward syntactic analysis.

Acknowledgements
This study has been supported by University of Minnesota Graduate School and Computer Center Grants. I would like to thank Robert Wachal for the use of his STX program and David Hacker for rewriting it in FORTRAN. I would also like to acknowledge the invaluable aid of my research assistants, Esme Evans and Veronica Guarnera, as well as the many rewarding discussions with my colleagues in the department.

REFERENCES

Bessinger, J. B., ed (1969) *A Concordance to Beowulf*. Ithaca: Cornell University Press.

Cameron, A. *et al.*, eds (1970) *Computers and Old English Concordances*. Toronto: University of Toronto Press.

Carlton, C. (1970) *Descriptive Syntax of the Old English Charters*. The Hague: Mouton.

Chomsky, N. (1956) Three models for the description of language. *IRE Trans. Inform. Theor.*, IT-2, 113–24. Reprinted in *Readings in Mathematical*

Psychology (eds Luce, R. D., Bush & Galanter), vol. 2, 105–24. New York: John Wiley and Sons, Inc. 1965.

Clark, Cecily (1970) *The Peterborough Chronicle 1070–1154.* London: Oxford University Press.

Closs, E. (1965). Diachronic syntax and generative grammar. *Language,* **41,** 402–15.

Day, A. C. (1971) FORTRAN as a language for linguists. *The Computer in Literary and Linguistic Research* (ed Wisbey, R. A.), 245–57. Cambridge: Cambridge University Press.

Doložel, L. (1969) A framework for the statistical analysis of style. *Statistics and Style* (eds Doložel, Lubomir & Bailey, R. W.), 10–25. New York: American Elsevier.

Mitchell, J. L. (1972) Old English as an SVO language: evidence from the auxiliary. *Papers in Linguistics,* **5:2,** 183–201.

Mitchell, J. L. (1973) A computer-based analysis of an Old English manuscript: the first stages. *Mid America Linguistics Conference Papers,* 1972. Stillwater: Oklahoma State University Press.

Pillsbury, P. W. (1970) A concordance to the West Saxon gospels. *Computers and Old English Concordances* (eds Cameron, A. *et al.*), 48–56. Toronto: University of Toronto Press.

Plummer, C. (1892) *Two of the Saxon Chronicles.* London: Oxford University Press.

Shannon, Ann (1964) *A Descriptive Syntax of the Parker Manuscript of the Anglo-Saxon Chronicle from 734 to 891.* The Hague: Mouton.

Venezky, R. (1970) The computer processing of Old English texts. *Computers and Old English Concordances* (eds Cameron, A. *et al.*), 65–75. Toronto: University of Toronto Press.

Whitelock, D. (1954) *Peterborough Chronicle, Bodleian Manuscript Laud Misc. 636.* Copenhagen: Rosenkilde and Bager.

Williams, C. B. (1970) *Literary Style and Vocabulary: Numerical Studies.* London: Charles Griffin & Co.

Information Retrieval

R. L. FRAUTSCHI

A list of French prose fiction, 1751–1800 : a progress report

Historians of literature tend to concur that the eighteenth century marks the coming of age of the novel. Likewise students of francophone literature are increasingly aware that prose fiction exhibited significant growth within the period. When one compares, quantitatively, the production of the seventeenth century in France (Williams 1931) with the first half of the eighteenth century (Jones 1939) approximately 1000 titles are encountered for each period. The average annual rate of production has in fact doubled. A list of French prose fiction generated between 1751 and 1800 is presently being compiled by Professor Angus Martin of Macquarie University, New South Wales, Professor Vivienne Mylne of the University of Kent at Canterbury and myself. According to material to be included in the forthcoming *Bibliographie du genre romanesque français* it is already apparent that the rate of accelerating production is sustained to the end of the century, approximately 2000 separate titles and over 5000 re-editions having been identified within the fifty-year period.

If this escalation appears at first overwhelming to the humanist accustomed to thinking of French Enlightenment fiction as limited to a few tales by Voltaire, a novel or so by Diderot, Rousseau's *La Nouvelle Héloise* and Prévost's *Manon Lescaut*, it would be useful to establish parameters capable of measuring the behavior of internal and external elements. Do descriptors such as titles and putative places of publication change significantly within a half-century span? In the case of internal descriptors, such as preferences in narrative locale, or the names and social station of characters, can we observe patterns of stability or of change? And thirdly, are there incidences of cofrequency between internal and external data? Answers, even partial answers to these questions can provide us with insight into authorial and public taste during the second half of the Enlightenment in France.

Using two five-year segments of the *Bibliographie . . .*, the production of 1751–55 and 1771–75, a preliminary *modus operandi* was developed using the Computerized Language Analysis System (CLAS) written in PL/1, developed by Professor George Borden of The Pennyslvania State University (1971). A report based on the preliminary samplings was presented at the Second Symposium on the Uses of Computers in Literary Research in Edinburgh (1972). The present report adds two more five-year periods: 1761–65 and 1791–95. The four populations

11

Figure 1. Title word lengths *Figure* 2. Character word lengths

were selected because they exhibited remarkably similar raw quantities:
196 titles observed in the 1751–55 group; 205 in the 1761–65 lists; 200
in the 1771–75 period and again 190 during the revolutionary period
1791–95. The title words in the four periods generate in turn the
following types and tokens:

	types	tokens
1751–55	749	1861
1761–65	833	2173
1771–75	759	2038
1791–95	829	2092

The verbal material was prepared for input with the following parsing
descriptors: nouns, proper nouns and names, adjectives, determiners
(articles, possessives), pronouns, verbs (including participles used

	total	15+ words no/%	−6 words no/%	6–14 words no/%
1751	41	4/10	9/22	28/68
1752	44	4/09	7/16	30/75
1753	34	4/11	10/29	20/60
1754	35	4/11	3/08	28/81
1755	42	6/14	9/21	27/65
	196	22/11 /9%–14%/ ±5%	38/19 /08%–29%/ ±21%	136/69 /60%–81%/ ±21%
1761	26	5/20	8/31	13/46
1762	38	6/16	10/26	22/57
1763	43	6/14	10/23	27/62
1764	46	9/20	7/15	30/65
1765	52	10/19	11/21	31/59
	205	36/18 /14%–20%/ ±6%	46/23 /15%–31%/ ±16%	123/57 /46%–65%/ ±19%
1771	49	5/10	7/14	37/76
1772	36	7/19	5/14	24/67
1773	36	7/19	4/14	24/67
1774	33	6/18	7/21	20/61
1775	46	12/25	1/02	33/73
	200	37/18 /10%–25%/ ±15	24/12 /02%–21%/ ±19	139/69 /61%–76%/ ±15
1791	52	14/26	12/23	26/50
1792	43	10/23	15/34	18/41
1793	25	6/24	6/24	13/52
1794	21	2/09	7/33	12/57
1795	49	12/24	12/24	25/51
	190	44/21 /09%–26%/ ±17	52/27 /24%–34%/ ±10	94/50 /41%–57%/ ±16

Table 1. Title lengths

adjectively), connectives (in compound titles), plus symbols for omissions and subtitles. French diacritics were retained.

The basic output of the CLAS program has provided (a) a profile of word lengths; (b) a concordance in ascending alphabetical order; (c) a list of decreasing word frequencies. The three types of output have been applied to titles, stated places of publication and to names of

	+15 words	−6 words	6–14 words
1751	4	9	28
1752	4	7	30
1753	4	10	20
1754	4	3	28
1755	6	9	27
	observed $\chi^2 = 6.5$		
1761	5	8	13
1762	6	10	22
1763	6	10	27
1764	9	7	30
1765	10	11	31
	observed $\chi^2 = 3.52$		
1771	5	7	37
1772	7	5	24
1773	7	4	25
1774	6	7	20
1775	12	1	33
	observed $\chi^2 = 10.4$		
1791	14	12	26
1792	10	15	18
1793	6	6	13
1794	2	7	12
1795	12	12	25
	observed $\chi^2 = 4.62$		
totals			
1751–55	22	38	136
1761–65	36	46	123
1771–75	37	24	139
1791–95	44	52	94
	observed $\chi^2 = 28.46$		

Table 2. Chi-square test of title lengths

characters and locales of narrative action. A comparative description of the four periods is presented herewith.

Beginning with word length of title vocabulary the four populations appear virtually identical (figure 1). Two-letter words account for 33–37 per cent of the totals, with a second peak occurring among the seven- to nine-letter words. The 1760 and 1770 groups show a higher incidence of length types, four of which run from seventeen to over twenty letters. Upon examination these have turned out to be names of characters, usually coupled with a noble or religious tag: for example, *L'Impératrice Catherine*.

Within each period titles have been manually classified into three

	total	compound titles with ou no/%	multiple titles (also subtitles— et, suivi de) no/%
1751	41	14/34	3/07
1752	44	7/16	6/13
1753	34	9/26	4/10
1754	35	15/42	2/06
1755	42	15/35	1/02
	196	60/30 /16%–42%/	16/08 /02%–13%/
1761	26	6/23	6/23
1762	38	14/36	3/08
1763	43	19/44	3/06
1764	46	15/32	11/24
1765	52	19/36	11/21
	205	73/34 /23%–44%/	34/16 /06%–24%/
1771	⸍9	20/40	12/24
1772	36	15/41	6/16
1773	36	13/36	3/08
1774	33	10/30	6/18
1775	46	18/39	8/19
	200	76/38 /30%–40%/	35/17 /08%–24%/
1791	52	22/42	6/11
1792	43	19/44	7/16
1793	25	8/36	2/08
1794	21	14/66	3/14
1795	49	19/38	10/20
	190	82/49 /36%–66%/	28/14 /08%–20%/

Table 3. Compound and multiple titles

groups: titles of fifteen or more words, titles containing between six and fourteen words, titles of five words or less (table 1). The moderate six-fourteen word group appears most popular in all populations. However, short titles appear to have flashes of popularity in all periods except the 70s. Long titles rise in preference in the 70s and 90s, although never exceeding the middle group. Application of a chi-square test to title lengths within each period has not produced a level of significant

1751	1752	1753	1754	1755
3/03	3/06	4/03	2/04	3/05
3/12	1/02	4/27	5/04	7/04
3/15	2/03	3/09	3/03	3/08
3/04	4/05	8/05	3/05	10/06
5/06	1/03	4/05	1/06	2/12
3/05	3/04	3/09	2/05	3/05
4/03	3/08	4/05	4/07	5/05
3/04	———	6/06	1/06	7/05
1/03	17/31	1/04	3/13	1/03
3/15	48 total	———	4/04	3/01
3/05	6·8 aver.	37/73	5/05	5/06
2/05		110 total	4/19	3/06
3/04		12 aver.	3/ > 39 part omitted	3/09
7/03			2/09	3/04
———			1/10	3/09
52/90			———	———
142 total			43/139	61/88
10 aver.			182 total	149 total
			12 aver.	9·9 aver.

1761	1762	1763	1764	1765
2/4	2/8	2/18	3/5	3/5
4/3	4/4	4/5	1/3	2/9
6/7	3/4	3/5	4/3	3/8
2/3	2/4	3/5	3/5	3/12
4/3	4/6	2/6	3/6	1/6
3/4	2/4	4/11	2/4	1/5
———	2/3	4/3	4/4	4/7
21/24	1/5	1/3	1/3	1/12
45 total	4/5	3/3	2/5	1/3
7·5 aver.	1/5	4/11	4/5	1/7
	2/5	2/4	3/16	2/3
	3/7	4/4	5/5	4/3
	1/2	4/6	5/7	1/9
	4/7	3/5	1/5	1/4
	———	2/4	4/5	8/3
	35/69	5/7	———	2/4
	104 total	4/5	45/81	4/2
	7·4 aver.	6/8	126 total	3/3
		3/7	8·4 aver.	2/6
		———		
		63/120		47/111
		183 total		158 total
		8·8 aver.		8·3 aver.

Table 4. Comparison of first and second parts of compound titles containing *ou*. (N.B. Phrases such as *conte allégorique* or *traduit de l'anglais*, which apply to both parts of the compound, have not been included in the following counts.)

1771	1772	1773	1774	1775
3/04	1/09	2/04	3/02	5/05
3/14	4/18	1/09	3/03	2/03
4/05	1/05	5/06	3/10	6/08
2/15	2/20	3/03	2/05	3/04
2/08	1/03	4/07	4/16	1/06
4/03	5/11	11/10	4/05	4/16
4/06	4/02	4/05	3/14	7/05
2/06	1/04	2/04	3/07	3/19
2/05	4/05	3/05	3/05	7/01
5/11	4/29	4/05	4/12	1/02
1/05	2/02	3/03	————	1/06
4/03	7/04	2/04	35/79	4/01
2/05	3/07	4/04	114 total	1/05
2/11	3/03	————	11 aver.	4/03
6/04	3/05	48/69		1/06
6/08	————	117 total		1/02
4/19	45/127	9 aver.		6/13
1/03	172 total			3/05
1/07	11 aver.			————
3/03				60/110
————				170 total
61/145				9 aver.
206 total				
10 aver.				

1791	1792	1793	1794	1795
4/6	1/2	8/3	2/4	2/6
7/4	1/4	3/4	1/4	1/11
2/3	4/5	7/9	1/5	3/4
4/5	2/5	4/4	1/3	2/3
4/3	2/5	2/9	3/7	1/3
4/3	3/5	1/5	1/4	1/3
4/4	6/10	1/3	1/7	3/3
3/8	7/3	5/2	4/11	5/3
2/7	1/5	————	5/5	5/5
2/2	3/4	31/39	2/4	4/4
2/6	1/12	70 total	5/4	5/5
1/3	9/4	8·7 aver.	4/3	1/2
3/4	4/5		2/4	1/7
5/9	2/4		5/4	2/6
2/9	1/4		————	3/3
4/5	3/15		37/68	1/5
1/4	1/2		105 total	1/4
4/4	1/3		7·4 aver.	3/4
2/19	1/5			2/5
5/9	————			————
1/5	53/102			46/86
————	155 total			132 total
66/122	8·1 aver.			6·9 aver.
188 total				
8·9 aver.				

Table 4 (*contd.*)

		first part						*second part*		
50s	9	6	26	9	11		11	10	14	24
60s	13	17	16	20	6		17	13	18	24
70s	14	13	17	19	12		18	9	17	32
90s	25	16	11	13	15		21	23	17	19

$$\chi^2 = 29 \cdot 01 \qquad\qquad \chi^2 = 11 \cdot 91$$
$$df = 12 \qquad\qquad df = 9$$
$$\phi < 0 \cdot 005 \qquad\qquad \phi > 0 \cdot 05$$

Table 4 (contd.)

difference on a 0·05 scale. However, a chi-square application to the four title populations does indicate significant change (table 2).

Compound titles (for example, *Zaide ou la comédienne parvenue*) and multiple titles (titles with more than one narrative or with subtitles) display a general increase in use, especially the former (table 3). In the 50s compound titles range between 16 and 42 per cent, whereas in the 90s they peak between 36 and 66 per cent of the total production. Multiple titles, on the contrary, exhibit a greater stability of use: 2 to 13 per cent in the 50s and 8 to 20 per cent in the 90s. The 60s and 70s, however, produce percentages of 24. The definite rise in popularity of compound titles and the more moderate and shorter lived increments in multiple titles help to account for the rise in title lengths noted in the 60s and 70s. The 90s, on the other hand, while favouring compounds, also favour shorter compounds.

Another quantifiable aspect of compound titles is the distribution of words between the first and second parts. Normally the second part of a compound title contains the greater number of words (table 4). Seven exceptions, however, are observed in the early 50s, four in the 60s, eight in the 70s and eleven in the 90s. When a chi-square test is applied to word counts in the first part of compound titles, no significance is noted (table 5). In the second half of compounds, on the other hand, a significant difference at the 0·005 level is observed.

From the CLAS printout of decreasing frequencies single title words and lemmas have been compiled manually according to a minimal rate of frequency in each period. In this study the rate has been set at four or more occurrences per lexical unit per period (tables 6–9). The lemmatized words group morphological variants such as plurals, feminine or irregular endings as well as words having a common core of meaning (for example, *vengeance, venger*). Only seven words (*auteur, avec, écrit, galant, nouveau, oeuvre, qui*) meet the requirements of a 'high'-frequency stable vocabulary list (table 6), stable being defined as a variance of no more than two occurrences between chronological groups. The largest group of 'high'-frequency vocabulary is found in table 7 where 38 words occur four or more times in two or more of the

first part	1	2	3	4	5 or more
1751–55	9	8	26	9	11
1761–65	13	17	16	20	6
1771–75	14	13	17	19	12
1791–95	25	15	11	13	14

$$\chi^2 = 26 \cdot 74 \quad df = 12 \quad \phi = 0 \cdot 005$$

second part	less than 4	4	5	6 or more
1751–55	11	10	14	24
1761–65	16	13	16	25
1771–75	18	9	17	32
1791–95	19	23	16	17

$$\chi^2 = 12 \cdot 93 \quad df = 9 \quad \phi = 0 \cdot 25$$

Table 5. Length of compound titles containing *ou*

	1751–55	1761–65	1771–75	1791–95
auteur	6	6	5	7
avec	7	6	5	5
écrit	4	5	4	3
galant	4	5	3	4
nouveau (adj.)	11	12	10	10
oeuvre	4	3	3	3
qui	7	7	6	5

Table 6. High-frequency stable title vocabulary

chronological periods but with considerable fluctuation in frequency. Table 8 presents eight lexical items which demonstrate a consistently rising rate of occurrence from the 1750s to the 1790s (*allemand, et, français, nouvelle, ou, roman, suite, sur*) and five lexical units which show a concurrent decline (*fille, histoire indien, marquis, monsieur*). The last table in this group, table 9, displays twenty-six 'high'-frequency items which occur four or more times in only one chronological period and infrequently, if at all, in the others. We have, then, isolated high-frequency stable, variable, rising, declining and non-recurring function words and lemmatized forms in order to obtain a pattern of authorial preference in each of the four periods under review. Although a perusal of the words individually suggests certain patterns of usage and taste, I have grouped the lemmatized forms in five rubrics (literary terms, terms of address, nationality, other nouns, other adjectives). These arrays place in sharper focus the interests, preferences and concerns of each five-year period (table 10).

	1751–55	1761–65	1771–75	1791–95
amant	2	8	1	5
ami	4	5	7	3
amour	9	11	17	11
anecdote	6	7	26	8
anglais	19	21	11	12
aventure	11	21	11	12
chevalier	11	8	23	2
conte	14	19	22	19
dans	8	11	7	11
de	268	325	275	293
elle	0	2	5	4
en	12	13	16	8
femme	8	5	10	2
grec	4	6	2	2
homme	3	5	10	2
jeune	0	9	10	6
le	235	284	254	281
lettre	14	31	23	4
madame	6	4	0	4
mademoiselle	5	6	0	2
mémoires	0	231	13	7
monde	4	5	3	0
moral	1	11	18	9
par	18	21	16	19
poésie	1	9	9	7
pour	7	12	10	5
philosophe	5	12	11	7
plaisir	4	2	0	4
recueil	1	7	5	8
sans	1	4	4	0
sentiment	2	0	6	7
tiré	3	0	5	3
traduit	26	40	40	35
un	26	37	28	34
vertu	0	3	8	2
vie	3	6	4	6
voyage	8	4	7	10

Table 7. Variable high-frequency title vocabulary

For example, the literary vocabulary (*histoire conte, lettre aventures, anecdote auteur*, etc.) generates 150 tokens in the 50s, 234 in the 60s, 223 in the 70s and a decline to 159 in the 90s. References to people follow a similar curve: 68 tokens in the 50s, 71 in the 60s, 74 in the 70s and a mere 20 in the 90s. References to nationality show 30 tokens in the 50s, a high of 45 in the 60s, followed by a levelling off in the 70s and 90s with 38 and 39 tokens, respectively. If we merge the rubrics 'other nouns' and 'other adjectives' we obtain a collective token count of 52

	1751–55	1761–65	1771–75	1791–95
rising vocabulary				
allemand	0	8	14	13
et	61	70	70	93
français	6	6	13	14
nouvelle (n.)	5	4	14	12
ou	64	74	77	84
roman	4	6	6	8
suite/suivi	1	8	9	14
sur	5	6	4	12
declining vocabulary				
fille	6	5	3	2
histoire	61	51	45	17
indien	5	1	2	1
marquis	7	2	1	0
monsieur	10	13	4	2

Table 8. High-frequency rising and declining vocabulary

	1751–55	1761–65	1771–75	1791–95
amusant	3	3	5	0
autre	1	1	2	5
chinois	1	4	2	0
choix	0	1	6	1
comtesse	4	2	0	0
curieux	0	2	4	0
deux	1	8	1	3
divers	1	4	1	0
épreuve	0	0	8	0
fait	4	0	2	0
folie	4	1	2	3
jolie	0	1	4	2
jour	4	1	1	3
leur	0	2	3	5
malheur	0	1	3	5
moderne	0	6	1	0
nature	1	7	2	0
nuits	2	0	0	4
Paris	2	1	5	2
petit	2	2	3	8
prince	0	0	4	1
que	3	1	7	0
raison	1	3	4	0
siècle	4	1	1	3
tout	0	3	2	6
triomphe	0	1	4	0
veillée	0	1	0	5
vraisemblance	4	1	0	0

Table 9. High-frequency vocabulary (one occurrence
of four or more)

Content Words

literary terms

1751–55			1761–65	
histoire	61		histoire	51
traduit	26		traduit	40
conte	14		lettre	31
lettre	14		aventure	21
aventures	11		mémoires	21
anecdote	6		conte	19
auteur	6		poésie	8
écrit	4		suite/suivi	8
roman	4		anecdote	7
oeuvre	4		recueil	7
			auteur	6
10 types	150 tokens		roman	6
			écrit	5
			nouvelle (n.)	4
			14 types	234 tokens

1771–75			1791–95	
histoire	45		traduit	35
traduit	40		conte	19
anecdote	26		histoire	17
lettre	23		suite	14
conte	22		aventures	12
nouvelle	14		nouvelle	12
mémoires	13		anecdote	8
aventures	11		recueil	8
poésie	9		roman	8
suite	9		auteur	7
roman	6		mémoires	7
tiré	5		poésie	7
			veillée	5
12 types	223 tokens		13 types	159 tokens

people

1751–55			1761–65	
chevalier	11		monsieur	13
monsieur	10		philosophe	12
marquis	9		amant	8
femme	8		chevalier	8
madame	6		mademoiselle	6
fille	6		ami	5
mademoiselle	5		femme	5
philosophe	5		fille	5
ami	4		homme	5
comtesse	4		madame	4
10 types	69 tokens		10 types	71 tokens

Table 10. High-frequency title words by categories

1771–75		1791–95	
chevalier	23	philosophe	7
philosophe	11	amant	5
femme	10	elle	4
homme	10	madame	4
ami	7		
elle	5	4 types	20 tokens
monsieur	4		
prince	4		
8 types	74 tokens		

nationality

1751–55		1761–65	
anglais	19	anglais	21
français	6	allemand	8
indien	5	français	6
		grec	6
3 types	30 tokens	chinois	4
		5 types	45 tokens

1771–75		1791–95	
allemand	14	français	14
français	13	allemand	13
anglais	11	anglais	12
3 types	38 tokens	3 types	39 tokens

other nouns

1751–55		1761–65	
amour	9	amour	11
voyage	8	nature	7
plaisir	4	vie	6
folie	4	monde	5
jour	4	voyage	4
siècle	4	5 types	33 tokens
6 types	33 tokens		

1771–75		1791–95	
amour	17	amour	11
épreuve	8	voyage	10
vertu	8	sentiment	7
voyage	7	malheur	5
sentiment	6	vie	6
choix	6	nuits	4
Paris	5	plaisir	4
recueil	5		
raison	4	7 types	36 tokens
triomphe	4		
vie	4		
11 types	74 tokens		

Table 10 (*contd.*)

other adjectives

1751–55			*1761–65*	
nouveau	11		nouveau	12
fait	4		moral	11
galant	4		jeune	9
			deux	8
3 types	19 tokens		moderne	6
			galant	5
			6 types	51 tokens

1771–75			*1791–95*	
moral	18		nouveau	10
nouveau	10		moral	9
jeune	10		petit	8
amusant	5		jeune	6
curieux	4			
jolie	4		4 types	33 tokens
6 types	51 tokens			

Function Words

1751–55			*1761–65*	
de	268		de	325
le	235		le	284
ou	64		ou	74
et	61		et	70
un	26		un	37
par	18		par	21
en	12		en	13
dans	8		pour	12
avec	7		dans	11
pour	7		qui	7
qui	7		avec	6
sur	5		sur	6
que	4		sans	4
13 types	722 tokens		13 types	870 tokens

1771–75			*1791–95*	
de	275		de	293
le	254		le	281
ou	77		et	93
et	70		ou	84
un	28		un	34
en	16		par	19
par	16		sur	12
pour	10		dans	11
dans	7		en	8
que	7		tout	6
qui	6		autre	5
avec	5		avec	5
sans	4		qui	5
sur	4		13 types	856 tokens
14 types	779 tokens			

Table 10 (*contd.*)

in the 50s, 84 in the 60s, a high of 125 in the 70s and a declining count of 69 in the 90s. When the behaviour of the above-lemmatized groups is compared we note that in general the 60s and 70s are characterized by a marked increase in high-frequency types and tokens. Also, the high-frequency preferences of the 50s are not those of the 90s.

	1751–55	1761–65	1771–75	1791–95
France				
Paris	11	27	40	97
Paris-another town	23	28	90	13
Provinces	13	8	14	11
	47	63	144	121
		$\chi^2 = 100 \cdot 68$	$df = 6$	$\phi < 0 \cdot 05$
Western Europe				
Dutch Provinces	62	55	57	1
Belgian Provinces	3	5	6	3
Swiss Cantons	5	9	12	19
German Provinces	15	9	11	7
Italian Provinces	4	2	3	4
Great Britain	43	40	41	8
	132	120	120	42
		$\chi^2 = 86 \cdot 13$	$df = 15$	$\phi < 0 \cdot 05$
Non-Western Europe				
Orient and Africa	11	3	2	—
Fanciful	7	2	3	2
Central European	2	3	3	2
No Place	23	36	9	41
	43	44	17	45
Grand totals	222	227	281	208
		$\chi^2 = 29 \cdot 28$	$df = 9$	$\phi = < 0 \cdot 05$
France	47	63	144	121
Western Europe	132	120	120	42
Non-Western Europe	43	44	17	45
		$\chi^2 = 122 \cdot 04$	$df = 6$	$\phi < 0 \cdot 05$

Table 11. Stated places of publication

A final category of external data, putative places of publication, has been arrayed in three rubrics—France, Other Western European, Non-European (table 11). We note a dramatic increase in the attributions to Paris through the four periods. A curious variation within the data is the rise in attributions to Paris and another city (usually a non-French locale) which peaks in the 70s. During the revolutionary period this category drops to its lowest point. Concurrently the Revolution brings

an end to the acknowledged activities of Dutch and British printers of French fiction. In contrast, Belgian, German and Italian attributions remain more or less constant in each period, whereas a moderately rising activity is observed among the Swiss. The third category in table 11 indicates a steady decline in fanciful attributions (for example, the moon) and in exotic locales. The anonymous locales, however, describe a declining curve from the 50s to the 70s, a phenomenon which is reversed by the Revolution when secrecy again becomes the order of the day. In sum, the preferences in declared places of publication confirm the cosmopolitan characteristics witnessed in title word preferences in the 60s and 70s. The Revolution, on the contrary, brings once more an abrupt decline to these qualities.

If we pass to some internal data, for instance names of characters and locales of action, some provocative shifts in authorial preference are suggested. But first, a word of caution. Content descriptions have not been recorded for 32 titles in the 50s, 22 in the 60s, 54 in the 70s and 71 in the 90s, primarily because we are still searching for hard copies of the items. The problem is particularly acute in the revolutionary period where brief 'penny' novels proliferated in makeshift circumstances. With this caveat in mind I have processed 207 character types and 569 character tokens for the 50s, 484 character types and 586 tokens for the 60s, 230 character types and 565 tokens for the 70s and 398 types and 493 tokens in the 90s. Although the data is limited, there is a strong suggestion that the novelists of the 50s and 70s relied on recurring character names much more than say the novelists of the 60s and 90s. A profile of the four populations (figure 2) shows a general trend to longer names of characters in the 70s and 90s, a phenomenon parallel to the profiles in title word length in figure 1.

Among the most popular single names of heroines we find the following favourites:

> 1750s—Julie Rosalie, Sophie (4 occurrences)
> 1760s—Julie (9), Sophie (8), Emilie (5)
> 1770s—Sophie (9), Adélaide (5). Henriette (4)
> 1790s—Eugénie (4).

High-frequency masculine names appear to be cloaked in titles of nobility. The following list shows the relative decline, however, in aristocratic titles, a trend which predates the revolutionary period. It is significant, also, that there appear to be no high-frequency male characters who do not have patrician attributes. The title of *comte* occurs sixteen times in the 50s, declining to six in the 90s. A similar behaviour is observed for *chevalier* and *marquis*. The title of *baron* is conspicuously absent in the 50s, but occurs in the 60s and 70s, partly through the influence of German translations. I do not find it in the 90s, however. Reference to *prince* and *roi* are modest in the 50s and 70s, non-existent

	1751–55	1761–65	1771–75	1791–95
France				
Paris	42	27	24	21
Provinces	33	10	22	17
General	16	29	29	9
	91	66	75	47
		$\chi^2 = 21\cdot76$	$df = 6$	$\phi < 0\cdot05$
Western Europe				
Dutch Provinces	4	5	1	4
Belgian Provinces	3	3	1	0
Swiss Cantons	2	2	0	4
Italian Provinces	6	16	11	2
British Isles	20	33	24	19
German Provinces	8	6	8	8
	43	65	45	38
		$\chi^2 = 20\cdot64$	$df = 15$	$\phi > 0\cdot05$
Other				
Orient and Africa	35	31	22	18
Fanciful	45	11	15	8
East European	10	16	5	7
Americas	4	6	9	10
	94	64	51	43
		$\chi^2 = 33\cdot49$	$df = 9$	$\phi < 0\cdot05$
France	91	66	75	47
Western Europe	43	65	45	38
Other	94	64	51	43
		$\chi^2 = 15\cdot73$	$df = 6$	$\phi < 0\cdot05$

Table 12. Locales of narrative action. (N.B. In this table locales of action are recorded for 165 titles in the 1751–55 period, 126 in the 1761–65 period, 139 in the 1771–75 period, and 89 in the 1791–95 period.)

in the 60s and 90s (although royalty is mentioned in several titles of each period). Also of interest is the relative importance of the title *Monsieur* designating either patrician or plebian status. In the 50s, 60s and 70s the occurrences of the term appear more or less divided between the two social groups with the balance tipped in favour of the aristocrats. In the 90s, not unsurprisingly, the number of *roturiers* is double the number of noble family names. Female titles of nobility (*comtesse, baronne, marquise, milady, princesse, reine, mademoiselle de XXX, madame de XXX*) exhibit a similar attrition during the 90s, although the trend to fewer aristocratic stereotypes is evident already in the 70s. The data suggest that characters in novels of the 70s are increasingly described as individuals, a development which predicates an increase in more realistic and sentimental types of fiction.

The locale of narrative action undergoes a number of significant shifts according to the novels which have been machine-processed to date. For example, one finds a decline in Parisian locales from the 50s to the 90s and a corresponding rise in provincial attributions (table 12). In Western European locales, Britain and Italy appear to rise during the 60s and 70s. The popularity of the English novel in translation (or the pseudo-English novel in translation) is also most evident. In non-European locales there is a sustained attrition in Oriental/African locales as well as an incisive drop in fanciful locations. A chi-square test comparing locales of action in the 50s with those in the 70s produces a significant level of difference: $\chi^2 = 9 \cdot 4$ with a significance level of $0 \cdot 01$.

Finally, it is useful to attempt correlations between the external and internal data. We have already noted the parallel behaviour of word title lengths and character word lengths. But does there appear to be a statistical likeness between stated places of publication and locale? A chi-square test applied to the stated locales of narrative action and putative places of publication in the 50s does not generate a significant difference ($\chi^2 = 3 \cdot 16$). The correlation of rates of occurrence, then, is close—a clue to the rather homogeneous profile of the 1750 material as a whole. On the other hand, the relationship between place of publication and narrative locale in the 70s generates a high level of difference ($\chi^2 = 35$). This confirms the growing divergence between Paris as a preferred place of publication and the rising style for provincial locales of action. In light of the Revolution to come, such tensions may seem provocative.

In conclusion, the quantification of external and internal data taken from the *Bibliographie du genre romanesque français* suggests a need for further research. From the evidence presented herewith one begins to acquire a greater awareness of the parameters within which a specific work of fiction can be evaluated. As such, a novel appearing in the 50s or 90s may appear to be quite typical of the behavioural preferences of the day. Or again, the work may stand out as a maverick or strikingly original piece of literature. When the entire half-century has been machine-processed we will have a sensitive source of measurement which can lend itself to many applications, both within the literary domain and without. The comparisons and correlations in the present paper, then, are but a hint of information which remains to be gleaned.

Acknowledgements
Input preparation and some manual classifications were supervised by Mrs Geoffrey Wilson, State College, Pa. Professor Thomas Hettmansperger, Department of Statistics, The Pennsylvania State University, performed all chi-square calculations. Funds for input preparation

were provided by an in-house grant from funds allocated by the National Science Foundation and by the Department of French.

REFERENCES

Borden, G. (1971) A computerized language analysis system. *Computers and the Humanities*, **5**: 3, 129–41.

Frautschi, R. (1973) A project for computer-assisted analysis of French prose fiction, 1751–1800. *The Computer and Literary Studies* (eds Aitken, A. J. et al.), 183–95. Edinburgh: Edinburgh University Press.

Jones, S. P. (1939) *A List of French Prose Fiction from 1700 to 1750*. New York: H. W. Wilson.

Martin, A., Mylne, V. & Frautschi, R. (in press) *Bibliographie du genre romanesque français*. London: Mansell.

Williams, R. C. (1931) *Bibliography of the Seventeenth-Century Novel*. New York: Century.

G. R. ROY
R. L. OAKMAN
A. C. GILLON

A computerized bibliography of Scottish poetry

Several years ago, with the aid of major research and provincial libraries in Scotland, Professor G. Ross Roy began compiling materials at the University of South Carolina for the first complete scholarly bibliography of Scottish poetry. Although he originally had planned to produce a conventional literary bibliography by hand, he eventually decided to store all the information in a permanent computerized data file. With this data bank not only could he publish his printed bibliography, but also he would have all of the information in a format suitable for selective information retrieval. In 1968 Robert L. Oakman came to South Carolina with a joint appointment in English and Computer Science; and as part of his duties helping scholars in the humanities with computer applications, he has been in recent years a consultant during the development of the SPINS project (Scottish Poetry Indexing System). The computer programming has been done mainly by A. C. Gillon, with assistance from the staff of the Computer Services Division of the University. Granted our project, now in progress, is not the first computerized bibliography; yet perhaps a discussion of some of our practical and editorial decisions, made necessary by the complicated nature of the data and the equipment available to use at this time, may be helpful to others contemplating the development of large computerized files of bibliographical data.

As in most literary data processing applications, the sheer bulk of the information itself has posed input problems. When completed, the data file will consist of all known volumes of Scottish poetry, beginning with the first books printed in Scotland—the Chepman and Myllar chapbooks of Scottish verse, published in Edinburgh in 1508. Initially we intend to publish in book form a bibliography of items printed before 1900—over 12 000 in all. When twentieth-century editions are added, the total number of bibliographical entries will exceed 15 000. These entries will will be all the volumes of Scottish poetry uncovered, with the exception of anonymous chapbooks published in the eighteenth and nineteenth centuries, estimated to be between 10 000 and 15 000 titles alone. Not surprisingly the largest number of entries—more than 1 200—are for Robert Burns, Scotland's national poet.

In addition to the large number of entries, the extensive information to be stored for each one required careful consideration in the design of a suitable data structure. A good literary bibliography includes a much

more detailed description of each book and other ancillary material than a typical library information retrieval system contains. In our case, there are fourteen possible significant kinds of information for each volume of poetry, divided into two types: facts pertaining to the author or editor and an accurate description of the book itself. Of course, not every book will require a complete analysis into all categories.

Included in the authorial information are author's epithet; author's dates, if known; and notation of appropriate biographical and bibliographical references, for authors noteworthy enough to have any. In the published bibliography, this authorial data will be printed only once for each poet, preceding his first book citation. For instance, the first entry for William Edmondstoune Aytoun would note his professorship at the University of Edinburgh; give the dates of his life (1813–65); and mention his inclusion in the *Dictionary of National Biography*, the standard biographical reference for famous Britons. For less well-known poets, any information that can be included may be helpful in identifying a particular author. For example, during the short period between 1825 and 1834 were born four poets named James Thomson who wrote in the later nineteenth century. To identify the work of one of them, an epithet might be the only clue. To gather this kind of biographical data for minor authors, we have relied on notes in two collections of Scottish verse (D. H. Edwards' *Modern Scottish Poets*, 16 vols., 1880–97; Charles Rogers' *Modern Scottish Minstrel*, 6 vols., 1855–57) and Hew Scott's exhaustive listing of clergyman in the Church of Scotland since the Reformation (*Fasti Ecclesiae Scoticanae*, 7 vols., 1915–28), as well as the standard British Museum and Library of Congress catalogues. Several regional anthologies exist and were consulted when appropriate—for example, George Eyre-Todd's *The Glasgow Poets: Their Lives and Poems* (2nd edn., Paisley, 1906).

There are ten possible fields of information that can be included about the book itself, most of them established from the title page. In addition to the usual citation of title, publisher, and place and date of publication are added the editor's name, if appropriate; the number of pages or volumes; and the name of at least one library which has a copy of the book, normally in the United Kingdom. Also included is a final 'catch all' category for other information which will note unique features of a particular volume, such as the format of books printed before 1800 (folio, octavo, duodecimo, etc.) or the author of a preface or introduction. This kind of bibliographical and scholarly material is needed in a literary bibliography which will serve as a standard reference work, and thus must be included in the computerized record.

The need to preserve all of this detail about each book in standard bibliographical form affected the choice of available input devices. Most of the conventional bibliographical symbols and all upper and lower case

letters must be encoded. At least two special characters, the square brackets [] and the temperature degrees symbol (°), are needed, as well as the usual punctuation marks. Square brackets enclose information about an entry not shown on the title page (for instance, J[ames] Sibbald), and the degrees symbol is conventionally used in bibliographies to denote book format (i.e. 8° denotes an octavo volume).

After some experimentation, input was done in four stages—from original preparation to final, corrected computerized file. Initially the record was produced as paper tape on a Dura 1041 device. This machine incorporates a standard typewriter keyboard with a paper-tape punch. The typewriter has all of the characters required for bibliographical entries, and the machine can be operated with ease by anyone who can use an electric typewriter.

We decided on two simple error codes to be inserted by the operator of the Dura machine whenever she noticed a mistake made in punching. The symbols for cents (¢) and per cent (%), not significant for any bibliographical purpose, were available to denote, respectively, one or more consecutive erroneous characters or an entire faulty record. For instance, if the typist misspells the word *Smith* as *Smmith* and notes it immediately, she types four cent signs after the word, followed by the correction (the paper tape would contain the following set of characters: Smmith¢¢¢¢ith). The four cent signs indicate that the four characters immediately preceding them are in error. On the other hand, if the typist does not discover a mistake until she has typed a full line of characters following it, she may insert a per cent sign in the entry to mean that the whole entry is in error and should be deleted. She then types the entire record again as a new entry. Thus, the system has two error correction techniques that can be activated by the operator in the initial phase of data preparation for both minor and gross mistakes.

In the second stage of data input, the paper tape records were put onto magnetic tape, still in uncorrected form. For this purpose we used a Mohawk Data Science 6415 device, which reads the characters on Dura paper tape and transfers them without alteration into magnetic tape binary codes. At this point we had an unedited version of the original data on magnetic tape and are ready for the third phase of the input process—initial correction of the magnetic tape file. For the first time, the University's IBM 360/65 computer system was used to read the magnetic tape and create a corrected magnetic tape file. Essentially the computer program does two tasks: it corrects or deletes erroneous records based on the conventions described for the cent and per cent symbols, and it translates the Dura character codes to their equivalent standard EBCDIC codes. The computer then produces a new magnetic tape, free of the mistakes noted in the creation of the paper tape, and writes out an inspection copy of the edited records on a printer equipped

with the full range of upper and lower case letters and special characters.

At present, these first three stages of the input process are operational. Biographical and bibliographical information is collected and verified before any machine records are produced. Then student assistants prepare the original Dura tapes. To date approximately 5000 bibliographical entries have been produced on paper tape, and it is estimated that the full 12000 entries for books printed before 1900 will be prepared within another eighteen months. As records are produced, they are collected on an updated magnetic tape including the programmed correction of paper tape errors.

Final updating and correction of each bibliographical citation will be carried out at a CRT (cathode ray tube) terminal, a convenient input/output device just being added to the University's computer system. This final phase of the input process is scheduled to be functioning by the fall of 1973. When the CRT terminal becomes available, we will stop using the Dura machine and do all input and correction of information directly at the terminal. Professor Roy will be personally responsible for the final checking of each entry. At a terminal installed in the English department, items will be called up from magnetic tape one at a time for inspection and updating. By means of an interactive editing program, each entry will be doublechecked for errors in spelling or punctuation and appropriate corrections made. At this time any information not originally included in the preparation of the data will be added, including any new biographical information discovered about an author. For example, to the general information field for important editions of Robert Burns will be added their entry number in the standard Burns bibliography compiled by Joel W. Egerer. Also recorded for early books will be their bibliographical entry number in either the *Short Title Catalogue*, edited by A. W. Pollard and G. R. Redgrave for books printed from 1475 to 1640; the supplement to the *STC* compiled by Donald Wing for imprints from 1641 to 1700; or the *List of Books Printed in Scotland before 1700*, compiled by H. D. Aldis in 1904 and revised by Robert Donaldson in 1970. This cross-referencing of materials to standard bibliographies will be a helpful scholarly aid for users of the Scottish poetry bibliography.

When a particular entry has been updated at the terminal, it will be entered in a permanent file of magnetic tape or disc storage that will contain all the final edited information. Gradually this file will grow to contain the largest compendium of information ever assembled on Scottish poetry. This massive machine-readable data bank will be the basis for the published bibliography of books printed before 1900. Computer programs in preparation will merge the author file with the file of book information and then alphabetize the merged file preceding the actual production of the printed bibliography. There will be

procedures to allow cross-references for variant spellings of author's names or pseudonyms. These additions can be merged into the output data file via the CRT terminal before final printout.

At present it has not been decided whether the printed book will be prepared by photocomposition or by photo-offset printing of computer output produced on a printer with the upper and lower case character set. In either case, the full repertory of bibliography symbols will be necessary. The following sample of entries for James Beattie will serve to illustrate the proposed output format. Note that the author's name and biographical data will appear only once, preceding the first book entry:

BEATTIE, James (1735–1803) See DNB.

————. THE JUDGEMENT OF PARIS. A POEM. London: T. Becket & P. A. De Hondt; Edinburgh: J. Balfour. 1765. 34 pp. 4°. M.

————. THE MINSTREL; OR, THE PROGRESS OF GENIUS. A POEM. THE FIRST BOOK. 4th edn. London: Edward & Charles Dilly; Edinburgh: A. Kincaid; W. Creech, 1774. 32 pp. 4°. NLS.

————. ————, IN TWO BOOKS: WITH SOME OTHER POEMS. London: Charles Dilly; Edinburgh: W. Creech. 1784. 108 pp. 8°. M.

————. ————TO WHICH ARE NOW ADDED, MISCELLANIES. By James Hay Beattie. London: C. Dilly; Aberdeen: A. Brown. Ptd. by T. Gillet, London, 1799. 2 vols. 8°. Vol. I contains the poems of James Beattie, Vol. II those of James Hay Beattie (his son), consisting of poems in English & Latin & prose, as well as a 54-page life by the father. M.

In addition to being used to produce the bibliography in book form, the computerized file of bibliographical information has been designed for information retrieval. Throughout the development of the data file, we have always planned to make it a permanent repository of Scottish poetry information and plan to allow scholars to request specialized bibliographical searches and printout. We have already completed and tested a prototype sorting procedure based on the data fields included in the input that allows for considerable flexibility and complexity in searching. Up to eleven different fields can be queried; the complete list of possibilities is as follows: (1) author, (2) title of book, (3) publisher, (4) place of publication, (5) printer, (6) place of printing, (7) editor,

(8) epithet, (9) comment, (10) library that has the book, (11) date of publication.

To retrieve a particular kind of information, a 'search specification' punch card is prepared and run with the sorting program to query the entire bibliographical data file. The 'search specification' card defines the fields and the specific information within the fields that is to be used in searching through the data. For example, only one request card is needed to ask for a complete listing of the poetical works of Robert Burns. After the sorting is completed, the entries found are written out on the upper and lower case printer. The one search with Burns specified in the author field would find and list over 1200 items. As another example, a scholar concerned with the history of Scottish poetic publication might want to request all the poetical volumes published by Blackwood in Edinburgh; he would request a search of the publisher field.

The use of at least three search fields—epithet, comment, and dates— needs further explanation. In general, epithets can be either occupations or names of geographical locations with which authors are generally associated. For example, the word *minister* in this field would find all authors whose epithets identified them as ministers, whereas listing the town of Dumfries in this field would retrieve books written by authors whose epithets include the name of the town. The comment field is used to search for names of persons appearing in other fields than those for author, editor, publisher, or printer. For instance, a person looking for poetical works with prefaces by a specific person would set up his search request in this category, which looks for the name in the 'catch all' field. Similarly the comment field allows flexibility of possible searching for information other than peoples' names that may appear in this same data field of other information. The date field allows for multiple search possibilities. Listing one date in that field causes the program to extract all the books published in that year. On the other hand, if someone wanted to see all entries of Scottish poetry published in the 1820s, he could use the date field to implement an inclusive search for all books published from 1820 through 1829.

Not only do the individual fields of search specification permit many possibilities for detailed queries of the data file, but also a search specification can combine several categories to delimit, or specify more closely, the books desired. As an illustration, the sorting program could find all editions of Burns' poetry printed in London between 1800 and 1835. This complicated request requires multiple sorting in three data fields as follows: Robert Burns as author; London as place of printing; and the inclusive years 1800–35 as the date. Only those books meeting all three of these criteria would be matched. Also entries containing the same name in different fields can be recorded together; for example,

in order to do a complete search for the works of William Edmondstoune Aytoun, the requester would specify that the program pick up Aytoun's name in any of the author, editor, publisher, or comment fields. As a result, an anthology of Scottish verse edited by Aytoun would be picked up along with Aytoun's own poetry. It is also possible to list multiple entries within one category, such as looking for books published by both T. Cadell in Edinburgh and T. Cox in London. Indeed, the search procedure has been designed to permit a maximum of flexibility and complexity in the specification of search requests.

In conclusion, the originators of the SPINS system have tried, by careful advance planning, to make sure that the completed data file of bibliographical information can be used in several ways. We have chosen a data structure of sufficient detail and generality to include all the information useful in scholarly bibliographies. The input format makes no compromise on characters or symbols that need to be included. We have designed the sorting procedure in order to be able to query the data file for a wide variety of bibliographical and biographical information. At present, about one half of the entries for books published prior to 1900 have been input into the data bank and await final updating and correction via a CRT terminal equipped with a text editing program. A prototype retrieval procedure is currently operational with a limited data file.

When the full 12 000 entries for authors writing before 1900 become part of the permanent file, they will be alphabetized, cross-referenced, and printed in book form, probably within three years. Once this bibliography receives wide circulation, scholars will no doubt find Scottish poetry materials that have not been included. As they appear, these newly discovered items and twentieth-century materials up to about 1970 will be added to the master computerized field and eventually published as a revised and expanded edition of the original bibliography. Meanwhile, the data file itself will constitute the most complete repository anywhere of information on Scottish poetry, from which interested scholars will be able to request a variety of sophisticated and specialized bibliographical searches relevant to their research.

Computer-output microfiche
in the Catalog of American Portraits

The National Portrait Gallery is a branch of the Smithsonian Institution, responsible for collecting and displaying to the public portraits of people who have made significant contributions to the history and culture of the United States. As an adjunct to this function, the Gallery also collects information about American portraiture, its artists, and its sitters. This information is available to the staff and public in the form of exhibits, publications, educational programs, a research library and the files of the Catalog of American Portraits (CAP).

The CAP is a reference center, whose files contain photographs and documentation on thousands of portraits of Americans, from public and private collections. The CAP has served users in many fields: collectors and curators have compared their own holdings with similar portraits in other collections; art historians and social historians have been aided in iconographical studies and in tracing the development of artists' careers; writers and publishers have been led to sources of illustrations. New applications appear in other fields, such as interior architecture and cross-cultural studies, as the files grow.

ORGANIZATION
The sources of the CAP's information range from surveys made by staff and volunteers, through published and unpublished bibliographic materials, to letters, phone calls, and visits from the general public. There are three main divisions of activity in the CAP: the CATALOG, the MINIFILE, and the GRAPHICS STUDY COLLECTION. Each deals with a different type of source material, but all attempt to make information available to users approaching the files from a number of points of view.
THE CATALOG
The CATALOG is the CAP's principal file, where users may access some 25000 file folders, each containing information on a portrait of an American, or by an American artist. The folders result from our survey of collections, our incoming mail from the public, a systematic search made some years ago at the Frick Art Reference Library, and the results of curatorial and cataloging research. The ideal, complete folder contains a photograph of its portrait, standard art cataloging data (medium, size, date, history of ownership, color notes, for example), photocopies of pertinent documentation, citations to pertinent literature, and copies of any Gallery correspondence dealing with the portrait. Not all of the

folders are this complete, depending on how much cataloging time has been available and on how much our sources could tell us.

The CATALOG folders are filed by sitter name, with a typed card index to artist names. Since the CATALOG is where users can find the most information about any portrait known through the CAP system, our goal is to give access to these folders from many other points of inquiry. We are frequently enough asked about particular artists or sitters to make indexing by these two factors an obvious necessity. There is also a need, however, for indexing by collections past and present, sitter occupations, ethnic minority groups, regions in which sitters and artists lived, and connections with historic events. In all, there are usually between ten and thirty indexing points for a typical portrait, when the basic biographical and art-historical information exists.

Preparation of this more extensive indexing is a long process, and has been completed for only about 3000 portraits. Cataloging data and indexes for these portraits are managed by computer. The remainder of the CATALOG folders are accessible only through artist and sitter names, and constitute a backlog for catalogers.

On a roughly bi-weekly schedule, we update the information in the computer's CATALOG file, adding new records and amplifying existing ones. This produces a new set of transaction and editing records, updated file dumps, and updated indexes with each update cycle.

THE MINIFILE

Our method for controlling portrait references in the art and historical literature is the MINIFILE. This is a simple indexing system, with a one-line entry for each reference to a portrait. Each entry contains fields for source of entry, volume, page number, year of publication, sitter name, artist name, medium, collection and location, and whether the portrait is illustrated in the source. Each field, excepting volume, page, year, and illustration, is the basis for an index to the MINIFILE.

The MINIFILE method is currently being applied to indexing references in *Antiques Magazine*, an abundant source of information over the last five decades, which is inadequately indexed for our purposes. A recent update, after which there were approximately 11000 entries on file, brought the project near the half-way mark after some seven months of work by our indexer. When work on *Antiques* is completed, other sources will be indexed, such as MA and PhD theses, exhibition and auction catalogs, collection and *oeuvre* checklists, and the like.

THE GRAPHICS STUDY COLLECTION INDEX

The third automated system in the CAP is the GRAPHICS STUDY COLLECTION INDEX, based on the CAP's own study collection of some 30000 portrait prints and photographs. In this index, we cross-reference names of artists, sitters, engravers, printers, publishers, publications, and names of collections in which original works of art were when en-

graved. This information is noted whenever it appears on the print or photograph, along with medium and dimensions, but is not researched. Therefore, indexing moves along quickly. Almost 14000 items from the GRAPHICS STUDY COLLECTION have been indexed in this way over a period of approximately three years.

OTHER FILES

The CAP is also responsible for four auxiliary files, all maintained by computer. An EXHIBIT INDEX lists portraits currently on view in the Gallery, by sitter, artist, and location, and is updated every one or two weeks. A copy is placed at each entrance to the Gallery, and in each departmental office, for public and staff reference. The CORRESPON-DENCE INDEX is a subject and personal name index to outgoing Gallery correspondence, for in-house use. A CUMULATIVE BIOGRAPHICAL INDEX, which awaits funding, has been developed and tested, and will merge the personal name entries from an unlimited number of existing back-of-book indexes. Its purpose is to speed access to biographical information in widely scattered library source materials for our bio-graphical and historical researchers. It is possible that this index could be published or otherwise made available to libraries and historical agencies as it is compiled. Our WORKFILE is a stopgap method of managing elementary data about portraits in the process of being cata-loged, and is used as an aid within the CAP office.

USAGE PATTERN

In all of these files, the information that researchers really want to see is in some form of manual file, in the library, or hanging on the Gallery walls. The point of the CAP is to direct the users to the points in the files or collections that best match their needs for information. If we were operating in an environment where we could have terminals in the office, we could make inquiries of the extracted information in computer stor-age, and provide timely replies to guide the users through the manual files. Since this is not possible in our situation, we rely on indexes, constructed to anticipate the most common classes of inquiries, and kept up-to-date by the computer. When the indexes cannot conveniently handle an inquiry, as in complex questions combining a number of factors, or questions regarding factors that we have not indexed, searches can be run on the extracted information in the computer. This is always a difficult procedure, however, due to the lack of an easy and flexible search utility, and usually requires a turnaround time on the order of three or four days. This inconvenience puts an extra burden on the design of indexes.

THE OUTPUT PROBLEM

As the manual and computer files grow larger, the volume of output for file dumps and indexes increases. Computer-time costs for processing

and reporting also increase. For example, at the point where the CATALOG system had indexed 3 000 portraits, the file dumps and indexes took up the equivalent of some 2 200 pages. At an average cost of seven cents per page, we would be spending $150·00 every two weeks for the output of this system alone. This figure is approximately double the output costs six months earlier, when the file size was approximately 2 000 portraits. At the end of June 1973, the output of the MINIFILE and GRAPHICS STUDY COLLECTION INDEX were of approximately the same volume. In each of these systems, input and processing costs prior to output were less than or approximately equal to output costs.

Cost is not the only output problem that the CAP has encountered. There are nine researchers and catalogers on the CAP staff. In the process of cataloging and indexing they make frequent, regular use of the existing computer files and indexes. In the past, this has meant a continual scramble in the office as staff members checked each other's desks to find who had which copy of which report. It would have been prohibitively expensive to give each cataloger a personal copy of each report and index, and would have created an intolerable bulk of paper to collate, bind, label, distribute, and keep orderly on the desks, even when the files were half their present size. In short, when we relied on the computer printer for output, the necessity of having at hand both file dumps and indexes for all systems, frequently updated and replaced, presented us with burdens of cost and inconvenience, and indicated that radical changes in method were needed.

The problem is not unique to the CAP. Business and government have been plagued by the same problem, since even before the 'paper explosion' of the 1960s. By adopting a solution developed for much larger applications than ours, we have been able to reduce our output costs by at least 30 per cent (in some cases 60 per cent), and at the same time reduce or eliminate preparation, distribution, handling, and access problems, all for quite modest initial costs.

THE SOLUTION

Each researcher and cataloger now has a complete set of files and indexes pertaining to his or her work, on the desk and within reach, taking up negligible storage space. The newly adopted medium for this information is computer-output microfiche (COM-fiche). As far as we have been able to determine, ours is the first application of the computer-output microfiche technique in a museum situation, possibly the first in the area of the humanities. The same techniques should be useful in many other situations where computers are used to store and maintain reference information, where on-line file access is not available or is too expensive, where frequent updates make files obsolete, and where there is a high usage rate for the computer output.

COM is a method for by-passing paper output altogether, with some form of microfilm as the output product. Details of the method vary widely among applications, but the overall scheme is common to all. The computer prepares its output in the form of magnetic tapes, containing the data that would otherwise be printed by the computer, along with certain control codes. These tapes are input to a COM 'generator', which is controlled by operator settings and codes on the tapes. Data from the tapes is converted to character images on a TV-like screen, which are exposed in 'frames' on microfilm, simulating what would have been printout pages previously. The film is developed, reproduced in sufficient quantities for the application, and distributed to users, who must have microfilm readers to use it. Reader-printers are used to make hard copy, when necessary, of selected frames.

Initially, COM work began with roll film, 16 mm film being the most common form. While archival operations continue to use roll film, users who need more frequent and convenient access to files have generally found that microfiche produced by COM are faster and easier to use than roll film. Our own experience was that roll film, with which we experimented in 1971, was too difficult to handle in continual use, and that the equipment needed to read it was too expensive, unreliable, and inconvenient for desk-top use.

COM-fiche are made to many size and format standards, depending on generating equipment, and the requirements of each application. Our COM-fiche are plastic sheets, 4×6 in, each containing 224 'frames' (equivalent to page images) arranged in sixteen columns of fourteen frames each. Compared to conventional computer printing, the linear reduction ratio is $1:48$. Each cataloger has a desk-top reader, which projects the image at a $32:1$ ratio, 25 per cent smaller than the linear size of normal printouts. This is quite legible, but readers may be obtained with larger or smaller enlargement ratios, and in more portable or more stylish forms.

Our data is prepared on the Smithsonian Institution's Honeywell 2150 computer, then tapes are sent to a service bureau where the fiche are made. We have been able to obtain reliable turnaround within thirty-six hours (often within twenty-four hours) for the fiche-making process.

In the spring of 1971, when we began to experiment with COM, the Smithsonian had had no prior applications with the medium. The CAP's programmer, Ralph Walker, has now converted the CATALOG, MINIFILE, GRAPHICS, CORRESPONDENCE, and WORKFILE systems from paper to COM-fiche output. All have been in full use since November 1972. In the process of conversion, his approach was tailored to our application, but its overall form, and many details, are directly applicable or easily adapted to other applications. For example, Mr Walker is

himself using COM for program listings, to simplify documentation of his programs.

CAP MICROFICHE

As we use it, the data in each frame on a fiche simulates the format that the same data would have on paper. There are, however, considerations unique to the new output medium. A file of several fiche, each frame filled with data, provides no guides to help the user pick the correct fiche and locate the correct data frame within it.

CAP's method, which is characteristic of COM-fiche systems, is to assign the top row of frames on each fiche, sixteen in all, to a title written in characters readable by the naked eye. The fiche title is automatically composed from the first line of data on the fiche and certain running title information. The following elements are always included in CAP fiche titles:

Name of file (CATALOG, MINIFILE, etc.)

Issue number (sequential, advanced for each update cycle)

Sequence number (within each edition of a file, advanced for each successive fiche, to keep them in order)

Type of report (file dump, index)

Beginning data (first 20 or 25 characters of data from the first frame on the fiche).

The fiche are stored in each desk in flat plastic frames clipped inside three-ring binders, so that the fiche title line for each fiche is visible. A user may easily scan the fiche titles, and pick out the fiche containing the desired section of the report application to his problem.

Having located the correct fiche, the user still must bring to the screen the frame of information needed. To save him from having to scan all 208 frames remaining after the fiche title is written, one of these frames on each fiche is assigned to an internal index to the contents of the fiche. The computer stores the beginning data from the first line of each frame, along with an automatically generated frame number. This information is accumulated, and placed in the last frame on the fiche, the 'index frame', which acts as a pointer to the contents of each frame on the fiche in much the same way as a table of contents points to chapters in a book. The frame numbers displayed in the index frame correspond to a grid card on the reader. Moving a pointer to the correct number on the grid shifts the fiche to display the desired frame on the screen.

In our experience, locating the correct file, fiche, and frame, takes about one-half the time needed to locate the correct page in a 2000 page printout, assuming that one has the printout on the desk to begin with. Our staff members feel that the fiche are easier to read than paper copy, and much more convenient to handle. This means that the dozen copies of each file that we produce are not only cheaper than the four printed copies we formerly made, but also more acceptable to their users.

In addition to a reader on each desk, there is a reader-printer in the main office and in our field office. When information from the manual files must be sent to a user, we use the usual electrostatic photocopying method. When data from the automated files or indexes must be sent, hard copy from the reader-printer is fast and inexpensive to make. The machine is also useful in the editorial process. When the indexes indicate to the editor inconsistencies of spelling or coding, for example, the reader-printer produces a sheet that shows exactly what the editor saw. This can be handed to the original cataloger, who then fixes the problem, and returns the sheet to the editor. The sheet may later be used to check that the repair worked properly, and that the problem has disappeared. We 'clean the file' in a systematic way every six months in the CATALOG, irregularly in the GRAPHICS system, and with every new edition of the MINIFILE.

TECHNICAL INFORMATION
Detailed technical information on making COM-fiche may be obtained from the author or the programmer, and visitors are welcome at the CAP office. A brief scenario will, however, give a general idea of the method we use for making fiche. The reader should note that each computer-stored file has a different format, record length and blocking factor, but that each is of a fixed-length, fixed-format type, stored on tape or disk, and arranged sequentially by some form of record number. Indexes are formatted line-by-line on a preliminary output tape, roughly in the same form that would be used for a print tape. The indexes are completely re-written from the file dumps at the end of each update cycle.

The file dump and index tapes, which otherwise would be input to a report-printing program, are processed by a program called FICHE, which organizes the text into frames of a certain number of lines, assigns frame numbers, composes running fiche titles and sequence numbers for the fiche, and extracts selected data from the text of each fiche for titling and internal indexing. The result is a 'fiche tape', which will operate a COM generator, to make it produce readable, self-indexed microfiche automatically.

A dump of a fiche tape would show that it is organized in records, each record corresponding to a line of data on the fiche. Each record is preceded by a one-digit code, instructing the fiche generator how to handle the line. The FICHE program may tell the fiche generator to write a line after advancing one line (or 0, 2, or 3 lines), write a line after advancing to the beginning of a new frame, expose a line after advancing to the top of a new column, write an overall title for the next fiche, write a line in an index frame, or reset the sequence number in the fiche title. In order to give all these instructions, FICHE must count

13

the lines of data that it receives, to know when a frame is filled. It must count the frames to know when a column of fiche is filled and when to write an index frame, and must count fiche to provide correct sequence numbers.

	COM *fiche*		*printed output*	
	per frame	per fiche	per page	224 pages*
original	1.75 ¢	$3·92	4–7 ¢	$8–15
duplicates	0·08–0·1 ¢	$0·20–0·25	**	**

* 224 pages of printed output are equivalent to one COM fiche.
** Duplicate printed copies from manifold sets at no extra charge;
further copies require reprinting at original cost, or other
duplication methods.

Table 1. Comparison of fiche and page printing costs.

FICHE must also store the first twenty-seven characters of data from the first data line in each frame, so that after writing sixteen title frames and 207 data frames, it can compose an index frame in the last frame position. Finally, FICHE carries the necessary matrices to form the eye-readable fiche titles in the top row of frames of each fiche, using a method invented by Mr Walker for reducing all of the alphabetic, numeric characters, and ten special characters to four matrices, in order to conserve the limited memory available on our computer.

COSTS

Programming, equipment, and production costs will not be entirely comparable from project to project, but our expenses appear to be in line with those encountered in other projects. In adapting the CAP's file systems to COM, our programmer spent approximately four months of working time spread over one year, including programming, testing, debugging, and revisions. As a regular staff member, his time on the COM project was not separately accounted for. Our purchased equipment includes a reader for each researcher's desk, a reader-printer for the office, and a portable reader for use away from the main office. We pay for use of a COM generator at a service bureau, eliminating the high cost of its purchase or rental.

Charges for making the fiche at the service bureau, using fiche tapes produced at the Smithsonian, are 1·75 cents per frame of original fiche (i.e., $3·92 per original fiche), and 20–25 cents per duplicate fiche. Both charges are reduced somewhat for very large orders. Table 1 compares these fiche costs with the charges we have been paying for page printing at $63 per hour of computer time.

SAVINGS

Savings in output costs due to COM-fiche stem from reduction in computer time needed for output, and from low costs for duplicate sets of fiche. Writing the fiche tape is much faster than printing pages, so that our saving in computer time is on the order of 30 per cent where considerable 'computing' is done during the output process, regardless of medium, to 60 per cent where only printing was done in the output process. Savings in duplication begin when multiple printing runs must be made to provide duplicate sets of information, or when other duplication methods cost more than 0·8 cents per page.

Savings to other operations may be greater or smaller than ours, depending on whether low-cost, off-line printing has been in use, time charges for the computer, local fiche-making charges, and the efficiency of output programs.

CONCLUSION

To profit in other settings from the CAP's experience with COM-fiche, one must consider that certain of the constraints of our situation will not apply to others. For example, we are limited in computer size and speed, and have highly specialized data that requires difficult formatting of reports. On the other hand, we do have a staff programmer and a sufficient computer budget for experimentation.

With this in mind, our experience leads us to recommend consideration of COM-fiche in applications where any of the following factors are present:

1. The essence of the operation is access to information on file, rather than calculation based on the filed data.

2. Data is frequently consulted by users; the operation is not basically archival or dead storage.

3. Distribution is desired to a number of points greater than the number of printout copies available from a single printing run (usually four or six).

4. Output costs are high in proportion to other computer costs.

5. Output costs have reached, or are increasing toward, an intolerably high level.

6. Maintenance and handling of conventional printouts is burdensome.

7. On-line, interactive computer service, which could preclude the need for hard copy or microfilm, is not available, or is too inconvenient or expensive.

8. Publication of computer output is being considered e.g. thesauri, concordances, massive bibliographies or indexes.

E. J. JORY

New approaches to epigraphic problems
in Roman history

The Romans had the same general interests, the same bureaucratic processes that we have but no television, no radio, no proper newspapers and few books. Yet they needed to make public their treaties with foreign powers, their 'summit meetings', the laws by which they governed both their own country and their foreign subjects, the dates and details of their religious festivals, and the achievements of sportsmen, athletes, charioteers, gladiators, etc. All this was part of public life, but luckily for future historians it was balanced by a private desire on the part of the individual to proclaim his own merit. On their tombstones, for example, the Romans recorded in detail the progressive steps in their careers, the public offices held, their achievements, the honours paid to them, in short, those things which accounted for their standing in the community—that standing which the Romans called *dignitas*. On the lighter side we frequently find on women's tombstones the familiar, endearing, and totally unrealistic dedication: 'To my dear wife with whom I lived for 40 years *sine ulla querella*—'without a cross word'—sometimes varied with the formula *sine stomacho*, perhaps best translated as 'without bellyaching'. All this they made known by inscribing such records on stone, bronze, marble or other durable materials. For our purposes Epigraphy can be defined as the study of matter inscribed on such materials.

What can be said about this epigraphical evidence from a historian's point of view? For the student of the Roman world the value of evidence as diverse in scope as this is obvious. However, three general points can be made. First and most important, the epigraphic evidence is contemporary or nearly contemporary with the events it records. Secondly, unlike the literary sources which survive as a result of copies, the epigraphical evidence consists of original documents. Thirdly, what we now have is a 'random sample', 'selected' only because of its survival and not with any purpose, political, moral or literary, in view. In this sense it can perhaps claim to be unprejudiced.

Unfortunately, although semi-permanent in nature the inscriptions did not survive intact. Often in later generations the blocks of marble or tufa were cut up and incorporated into buildings, or formed into pavements for the roads of Italy. Even more frequently those written on bronze were melted down because of the value of the metal itself. Accidental breakage and deliberate vandalism have also taken their toll. Thus many of the remnants are fragmentary and enigmatic.

THE COLLECTIONS

The question now arises—how does the student gain access to this information? Fortunately, from the tenth century on, a few scholars and antiquarians, recognizing the importance and interest of epigraphic evidence, started compiling their own written records of the monuments.

However, it was not until the nineteenth century that any systematic compilation was undertaken. At that time a team of scholars led by Theodor Mommsen and working under the auspices of what was then called the Royal Prussian Academy—known now as the Democratic German Academy of Sciences—embarked on the task of collecting and publishing a record of all the Latin inscriptions from the Roman world. The collection, still being completed, is known as the *Corpus Inscriptionum Latinarum*—CIL for short. It is in sixteen volumes, each of which (with three exceptions: 1, 15, 16), contains the inscriptions from one geographical area; Africa, Spain, Rome, etc. The first volume appeared in 1869, the latest supplement in 1970, and in all over 160000 inscriptions are included. The records in the MSS of the Mediaeval and Renaissance collectors were compared one with another and, where the stone was still intact, the readings were checked against those on the stone, and the best reading—that is the one which was once on the stone—was established as firmly as possible. Within the volumes the inscriptions have been arranged by the editors in rough groupings under headings such as sacred inscriptions, calendars, inscriptions referring to the Emperor and his family, to Senators, to the army, etc., with little or no cross-referencing between these diverse sections. But to aid students, classified indexes of varied quality and comprehensiveness have been added. These present, in carefully arranged lists, proper names, imperial records, kings, consuls, records of imperial and public administration, etc. The classifications in the indexes reflect the nineteenth-century preoccupation with political history, and end with a section called *notabilia varia* which includes whatever unclassifiable information each individual editor thought interesting in that selection with which he was dealing. The very existence of such a label points to the inadequacy of the system of classified indexes. However, these indexes, although inadequate, are invaluable, provided only that the scholar limits his enquiries to the type of investigation envisaged by the original editors. But what of the student who is interested in other features than those which are represented in the classified indexes? In social questions? In the lives and careers of slaves and freedmen rather than Emperors and Senators; in family connections among the lower classes, the age at death perhaps, or in specific trades rather than imperial administration? What about those interested in the formulae and the language of the inscriptions themselves? All such enquiries entail years of reading

through all the inscriptions before analysis can start. And this despite the provision of classified indexes for fifteen of the sixteen volumes. In the case of volume VI, which contains the inscriptions from the city of Rome itself, the situation is even worse. This volume contains about 40000 inscriptions ranging in length from a fragment of a single letter to documents of more than 1200 words. In bulk it makes up approximately 25 per cent of all the records published in CIL. The site on which these particular records were found, Rome itself, guarantees that not only is this collection the largest single volume in the *Corpus* but also the most important. Yet in this volume the only aid to the researcher is an index of *gentilicia* (family names) published in 1926, fifty years after the first fascicule appeared. The solution to the problem of how to make the information in this volume readily accessible to scholars seemed to me to lie in the computer.

THE WORD-INDEX
In 1961 I started to interest myself in the problem of producing a computer-compiled index by learning first the AUTOCODE language designed for the Mercury computer, then FORTRAN. By 1964 I knew the possibilities and difficulties, had some idea of costs, had aroused the interest of the Director of the Computing Centre in the University of Western Australia, himself a keen Latinist, and got him to agree to write the necessary programs. We then had to ensure that we gained optimum benefits from the financial outlay involved. Since the immediate aim was to produce an index to CIL VI, given the possibilities provided by the computer we were faced with perhaps the hardest decision of all: 'What sort of index should we produce?' In favour of the traditional classified indexes were the following factors: first, they have remained largely unchanged in form for well over one hundred years; secondly, classical scholars, a conservative group, are used to them and might well resist innovation; thirdly, we would eventually have to find a publisher for the completed work and any publisher could be excused for hesitating to invest in a work of seven or eight thousand pages which was presented in a totally new format.

On the other hand was the consideration that the traditional type of classified index had already proved an inadequate aid to much modern research, and that since a complete word-index was invariably added to the classified indexes in modern papyrological publications there was a precedent for taking such a step with inscriptions.

Financial considerations made production of both classified indexes and a word-index out of the question. We compromised by settling for a complete word-index of the KWIC type. We felt that in this way, by providing *en passant* much of the information found in the classified indexes we might blunt criticism from the ultra-conservative, while

```
1. VOCABVLA                              5407                      STEPHANEPHORO
  )

FAVEN"+[T] /+F ANI VITALIS V"+ /+T" F    STE TERTIV+ /+AVG+ /+F" SEP+ :           32641-(9)
            : L COHANVS /L F             STE VALENS /DOMU GRAVISCIS /MIL COH =XIII= 2928-(2)
       IND =LIII= /SCRIBAE /VALERIVS     STE+ /VALERIVS KARICVS + /TVCEIVS HERMES + 33858LD=1060LD-(19)
            : C CALPVRNI /C F            STE /VIBIANI :                           14224-(2)
C+---+TOR /FRATER CE+---+ARVM /FILIVS    STE+--- ++ISTORIS /MATER ANTI+--- ++AMITUSA 7908-(4)
       : +D + /CHIC IACET EJ+X"ANIMIS    STE.+ /+T"HIASIS DECORA+ /[TA]+V"RINO    32476U-(2)
                   : +D M"+ /+           STEFAN"+ :                               26836-(2)
            : INSTEI TERTV/LLI V C ET    STEFA/NILLAE AEMILI/ANAE C F :           37126-(3)
  : D M /L NOBIVS EVTHYC@ES ET IVLIA /   STEFANIS ET HORVM LIBERORVM /ET LIBERTIS 23036-(3)  —
            : +M /[FL]+AVIO /[           STJ+E"FANO :                             18214-(3)
 ET /[FIL]+IS NATVRALIBVS /CAELJ+IO      STEFANO AELIAE /[EVTJ+YCHIAE :           10737+A-(7)
            : D M /II CLAVDIO            STEFANO /BENEMERENTI FECIT /CARA CONIVNX : 15270-(2)
            : D M /Q VERANIO /           STEFANO /ET VERANIAE /HELIADI /CASTRESIS 28532-(3)
            : DIS MANIBVS /A FABIO       STEFANO /FABIA AGATHANGELIS /PATRONO SVO 17555-(2)
                   : D M /               STEFAN/O FECIT :                         26842-(3)
            : D M /A CORMELIO /          STEFANO /FECIT POMPE/IA EVTHOPIL/LA TATAL 16316-(3)
                        :                STEFANO /FILIO /B M /QVI VIXIT /ANN =V=   26840-(1)
            : D M /IVLIQ' TIBERIO' /     STEFANO' IVLIA /+D"IONYSIAS LIBER/[T]+O' 20275-(3)
  /P TVTICANIO HERMETI B- PH P AELIO     STEFANO LIBR I D /L CORNELIO HONORATO VEX 7 220-(27)
V+ C' QVI /[LOCVS COMPARATVS] +E"ST AB   STEFANO PRAEPST /[BASILICAE SCI L]+A"VRENTI 8565-(8)
 ET RV/BRIA MARCIANE L HOS/+TILIVS+ +    S"T"E"FANVS :                            25551-(8)
       : +@M"I".M" R"+--- +CONPARAVIT    S+[TE]+FANV+[S] /CAPHINAR SE VIVO HIC REQ+ 9231-(1)
M /SAEVERIANAE PARAMYTHIADI /P MARCIVS   STEFANVS COIVGI /SANCTISSIMAE ET SIBI ET 26477-(3)
       /POMPEIAE /TYCHES /POMPEIVS /     STEFANVS /CONIVGI /B M :                 37351-(6)
            : D M /SEX IVLIVS            STEFANVS /ET ANNIA SABINA FECERVM /SIBI ET 20274-(2)
            : D M /M FVRIVS /            STEFANVS ET /MINVCIA SABINA /FVRIAE FILIAE 18790-(3)
       POSTERISQ EORVM /PVBLIVS AELIVS   STEFANVS /FECIT SIBI ET SVIS LIBERTIS    14347-(5)
            IN QVO RE++QVIESCENT IN PACE STEFANVS FILIVS EIVS QVI VIXIT+ /A"NN =XV= 9157-(3)
            : MICCINVS /ET /             STEFANVS /HIC :                          22490-(3)
 FILIAE /SVAE DVLCISSI/ME M AVRELIVS /   STEFANVS PATER /DVLCISSIMVS :            28891-(7)
 PVBLILIVS C L IAMBVS /C PVBLILIVS C L   STEFANVS /VIAE LATAE P =VI= :            6994-(9)
 P DECIM PRIMIANV /L CAELI VENVSTIAN /Q  STEI PRIMITIVVS /S+ T L TITI SATVRNINVS /C 31234R3=1057R3-(11)
```

Figure 1. Sample of KWIC concordance of CIL VI

serving the interests of all by providing complete listings of every word.
The resulting 7315 pages are now being published by de Gruyter in
Berlin under the auspices of the Democratic German Academy of
Sciences. The first fascicule is due to appear at the end of this year and
the remaining fascicules progressively through 1974. An example is
provided in figure 1.

DATING THE INSCRIPTIONS

Long before we started punching the data it became clear that we now
had for the first time the possibility of being able to establish some form
of dating criteria for undated inscriptions. It is of course this problem of
dating which causes most trouble to historians who attempt to use
epigraphical evidence. While some inscriptions are dated by references
to people or to events known from other sources, the vast majority give
no indication of their date in their content. In these cases it is necessary
to establish the date from a comparison of formulaic expressions, of
orthography, and of palaeography. Since all the inscriptions in volume
VI of CIL come from Rome, the geographical variable in comparisons
of this nature can be dismissed. Consequently we included on our tapes
information about irregularities in the form of the letters or the size of
the letters, types of decoration with palm or ivy leaves, types of abbrevia-
tions employed, the occurrence of ligatures, the frequency and type of
punctuation, in fact all the physical information available about the
monument. A good idea of what that entails may be had by studying

c. No. 316. De Rossi 4 (= Diehl, *ILCV* 1266 = Silvagni 8719). A.D. 338

Figure 2.

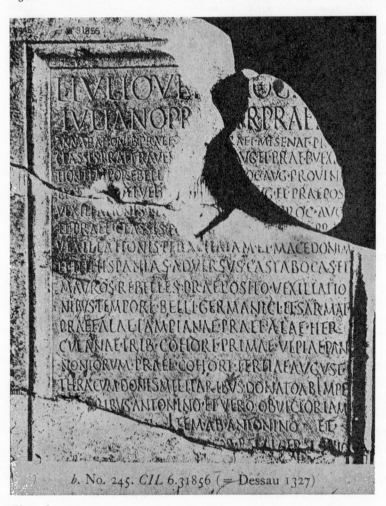

b. No. 245. *CIL* 6.31856 (= Dessau 1327)

Figure 3.

the examples in figures 2 and 3. Now that the Index has been completed
we are engaged in analysing this information in the hope that we may
discover, within the large sample of inscriptions we have processed,
some firm dating criteria.

SPECIAL PROBLEMS OF PREPARATION OF EPIGRAPHIC DATA

The main difference between coding literary data for computer analysis
and coding epigraphic data lies in the fragmentary nature of the latter.
Our problems were further complicated by the fact that many of the
records of the inscriptions were taken from ancient MSS, in which the
conventions for indicating physical details are often inconsistent. While
this causes little trouble to the epigraphist it cannot be detected by a
punch operator.

A few details will suffice to point to the type of complications involved.
First of all the teletype provided only 63 characters, all in upper case
typescript, while in the printed edition of the inscriptions several italic
fonts of different sizes are used to indicate restorations, readings on the
monument when first discovered which are no longer extant, supple-
ments and the like. This difference in fonts we overcame by using
various delimiters. For example, if there occurred in CIL the notation

 *imp. caes. m. au*RELLIO·ANTONINO (31349)

our coding would represent this as:

 [IMP,·CAES,·M,· AU[+RELLIO,·ANTONINO,/

where the left-hand square brackets signify that *imp. caes. m. au* are a
restoration, the + the break in the monument, the point the punctua-
tion, the comma the end of a word and the / the end of the line. This was
the simplest coding difficulty we encountered.

One slightly more complicated example. Let us assume that the
original letters on the monument have been erased, that ABCD was
written in the space made available by the erasure, that the A, B and D
were subsequently partly erased and the C completely erased and that
E, F, G were then inscribed in the same space. In the input code we
employ (...(to signify that the enclosed letters have been inscribed
in litura, + for a break, 3...3 for letters partly erased but still legible,
2...2 for letters added subsequently, and % for a missing letter. Thus
we obtain (ABCD,(for the first step, (3AB+%+D,3(for the second
step, and finally (3AB+%+D,32EFG,2(. Naturally this input is tidied
up by the substitution of regular left- and right-hand brackets in the
print out. In this particular example we have assumed that all the letters
on the monument are of uniform size and regular shape, which is rarely
the case.

PROSPECTS FOR THE FUTURE

I should like to finish by usggesting what I consider to be two important epigraphic projects which could and should be undertaken.

The number of Latin inscriptions is continually increasing as more and more are discovered each year. New discoveries are published in a wide variety of scholarly and unscholarly periodicals and places, ranging from local newspapers in Mediterranean country towns to the most learned academic journals. Despite the difficulties involved in collating such scattered information an annual publication, *L'Année Epigraphique*, attempts to give references to all new discoveries and comments briefly on the most important. A classified index of the traditional type, with all its good points and all its failings, is provided to each annual production. It seems to me that a complete word index to the inscriptions published each year in *L'Année Epigraphique* would be simple to produce and inexpensive to publish. At the same time all the physical details of the new inscriptions could be recorded in the same way as we have done for the inscriptions of CIL VI. A basic decision would have to be made on the type of index considered most useful, not only to epigraphists but to all scholars interested in the Ancient World. It is my belief that when scholars have had the opportunity of using the KWIC type of index they will find this type the most satisfactory all-purpose epigraphic index. It would also be in conformity with our CIL VI index and the data, added to that which we already have, could help confirm or destroy our dating criteria.

But this is a minor project, possibly in itself not justifying the use of a computer. What is really needed is a central data bank containing all the information about every single Latin inscription. This would be structured in such a way that enquiries would be dealt with in sequence at the centre, with programming services provided and the results communicated to the enquirer as soon as they became available. The benefits to classical scholars in general and to editors of inscriptions in particular resulting from a readily accessible comparative body of information need no stressing.

An information system for the Joint Caesarea Maritima (Israel) archaeological excavations

The application of computers to problems in anthropology and archaeology has been the subject of several conferences, published papers, and reports. A booklet published by International Business Machines Corporation covers a range of pertinent topics and includes a bibliography of us contributions to the subject. A review of the booklet (Chenhall 1971a) cites additional references. An international conference was held at the University of Arkansas (Chenhall 1971b) to consider the feasibility of storing large quantities of archaeological data in computers. Computer-based information systems of particular interest are those associated with the Museum Computer Network and the Arkansas Archaeological Survey. Reports of additional information systems of interest to those in the humanities were also presented at this conference.

Computer-based information systems vary in sophistication from little more than manual systems to highly interactive generalized systems that attempt to provide a broad spectrum of capabilities for a diverse group of users. The system under development for the Caesarea excavations is relatively simple. It consists of an artifact and pottery coding manual and directions for its use, specially prepared recording forms, an instruction set of sherds for training purposes, a data set or data base consisting of several thousand data cards, a set of FORTRAN and COBOL programs and linkages to sort routines in the operating system to generate various catalogs and listings, and the potential for embedding the data set into a commercially available generalized data base management system should the need arise.

There is concern over the amounts and types of data to collect, particularly if there is only one chance to do so. Experience with two large scale medical data base systems consisting of case histories, diagnoses, therapies, surgical repairs, progress reports, post-mortem findings, etc., for patients with heart disease and cancer has led to personal skepticism about large-scale data base efforts for a diverse group of investigators. The two medical registries were updated by staffs of several full-time people over an extended period of time and contained many thousands of entries; however, they were not used by the physicians and eventually were abandoned. Most large-scale data base efforts are likely to meet the same fate unless there is a group of interested investigators that make active use of the data. Rather than

attempting to gather data on a large number of parameters with expectations that some of it may be useful at a later date, it is more appropriate to gather limited data of definite current use. Such usage frequently stimulates additional requirements which help guide the development of the data base and the services it performs.

Shepard (1956) discusses significant pottery properties to be considered for an archaeological data base. She raises the important question: 'How can one make an intelligent record when one does not know how the data are to be used?' The primary uses of the Caesarea data base are: (a) to prepare detailed locus and stratum catalogs of artifacts and sherds; (b) to prepare locus and stratum summaries; (c) to investigate pottery chronology determinations; (d) to provide searches of the data base for specific sherd and/or artifact associations. The main thrust of this report deals with data recording and data reliability rather than manipulation and analysis of the data. It is essential that the properties of the individual data elements be ascertained before one arbitrarily accepts the results from a computer program, whether it be a library program or a specially prepared program.

The data base for the Caesarea excavations contains artifact information required for registry with the Department of Antiquities of Israel. In addition it contains detailed information on sherds. Most of the entries in the data base are associated with the Byzantine period (330–614); however, there are entries ranging from the Hellenistic period through the late Crusader period.

ARTIFACT AND POTTERY RECORDING

The artifact and pottery coding manual prepared for use at Caesarea by Fisher and Yates (1972) was based on earlier work by Toombs and Wagner (1971) of Waterloo Lutheran University. Toombs and Wagner applied their recording system to North American Indian pottery at New Dundee, Ontario and to Palestinian pottery at Ai and Hesi in Israel. Thus, the recording system had been subjected to considerable field use prior to its adoption for use at Caesarea. One important concept found in both recording systems was that of 'open-endedness', namely, a new recording category could be added whenever it became apparent that the existing categories were inadequate to describe a specific case.

In addition to open-endedness, the Caesarea recording system was designed to allow a recorder to use discursive descriptions whenever it was deemed necessary. In this way, as similar uncategorizable items appeared, they could be described discursively until it was decided to define an appropriate new category for the coding manual. Subsequently the items so described in prose could be identified easily and updated.

Thus a new category was included only after it was obvious that one was required. Chenhall (1967) states that: 'The storage, retrieval, and analysis of archaeological data on electronic computers requires that artifacts be described in the framework of models which are: (a) sufficiently analogous to the "real world" of the data to be meaningful; (b) sufficiently expandable or open-ended to be usable in situations as yet undefined; and (c) sufficiently specific to be convertible into machine language'.

The recording form designed for use at Caesarea separates the recording tasks into two distinct parts. For all artifacts and sherds the following items are recorded on a general data recording form:

identification

location (field, square, bucket, locus, elevation, stratum, and location on plan)

material (e.g., antler, bone, charcoal, glass, ivory, leather, metal, ceramic, etc.)

function (e.g., architectural feature, household utensil, personal article, ritual equipment, tools, weapons, etc.)

manufacturing technique (blown, burnished, carved, cast, fire hardened, etc.)

period (Hellenistic, Roman, Byzantine, Arabic, etc.)

Munsell color (interior clay color(s))

photo number

scale (of the artist's drawing of the item)

description

In addition to the above, the following are recorded for all sherds on a detailed recording form:

identification

location (field, square, bucket)

feature (rim, neck, shoulder, body, stem, base, handle, spout)

indication of completeness

stance (for all features except handles and spouts)

shape (edge, exterior, interior, bottom, cross-section)

measurements (width, height, radius—when appropriate)

grit size and frequency

production method

decorations (on interiors, exteriors, edges, etc.)

incisions (on interiors, exteriors, edges, etc.)

paints (on interiors, exteriors, edges, etc.)

colors (on interiors, exteriors, edges, etc.)

finish (on interiors, exteriors, edges, etc.)

A unique identifier with the format *s yy m dd nnn* is assigned to each artifact. The characters in the artifact identifier have the following meanings:

character	example	description
s	C	site (Caesarea)
yy	72	year (1972)
m	5	month (May . . . use A for Oct., . . ., C for Dec.)
dd	25	day of discovery
nnn	1	sequence number (assigned in increasing sequence beginning with 1 each new day)

Sherds retained for the sherd registry are also assigned unique identifiers, with the format *s yy f aa bbb nnn*. The characters in the sherd identifier have the following meanings:

character	example	description
s	C	site (Caesarea)
yy	72	year (1972)
f	B	field designator
aa	2	area or square designator
bbb	123	bucket number
nnn	17	sequence number (assigned in increasing sequence beginning with 1 for each bucket).

A SHERD RECORDING EXAMPLE

Vessel features considered in this study include base, stem, body, shoulder, neck, rim, handle, and spout. One or more of these features may be absent from a specific vessel. For consistent terminology and reference, all vessels are considered as constructed by a potter, from the base upward. The *stance* of any part of a vessel is defined with respect to this mode of construction. A portion of the vessel which goes outward from the center line, as one views it scanning from the base to the rim, is called *everted* or angled outward. A portion of the vessel which goes inward toward the center line, as one views it scanning from the base to the rim, is called *inverted* or angled inward.

Stance lines are determined for each of the features except for handles and spouts and are categorized as vertical, horizontal, inverted (slightly, moderately, or extremely), and everted (slightly, moderately, or extremely). 'Slightly' refers to nearly vertical, 'moderate' ranges from slightly to approximately 45° from the vertical, and 'extremely' is an angle greater than 45°. If one were to use sawn sherds, more refined stance angles could be defined. Figure 1(b) illustrates the stance lines of the base, body, shoulder, neck and rim of the vessel depicted in figure 1(a). All references to sherd cross-sections are oriented as in figure 1(a) with the cross-section on the right of the vessel center line

and the interior of the vessel between the center line and the cross-section.

One can think of the stance as a skeleton for a portion of the vessel. The shape about the stance line determines the shape of the vessel, and the finish placed on either the exterior or interior or both gives a final description of that portion of the vessel. The stance, shape and finish are recorded for all sherds retained.

(a) vessel (b) stance lines

Figure 1. A vessel and its associated stance lines

From the coded description of the sherd one can reconstruct a reasonable representation of the sherd; however, other coded descriptions may give rise to representations that are similar. This is true in particular for intricately shaped sherds and for sherds that appear to be broken near a rim to neck boundary, near a neck to shoulder boundary, etc. In these cases, the recorder should not attempt to make the recording appear more accurate than the sherd warrants.

To illustrate the types of entries recorded for pottery sherds, the description of a sherd from the C.72 dig as it appears in the data base is given below. This description requires three punched cards, one each for the general, rim and neck descriptions. No discursive description is given. Also since the sherd has no colors, glazes, incisions, decorations, etc., these characteristics are not recorded.

1. Artifact general card:

item recorded	description
C.72	Caesarea 1972
B.2.3	field B, square 2, bucket 3
2060	locus
3	sherd sequence number
3	material: ceramic
205	function: jar
7, 23	technique(s); firehardened, wheel made
11	period: Byzantine
2.5 YR 6/8	Munsell color of clay interior

2. Sherd detailed card (rim):

item recorded	description
B.2.3	location
3	sherd sequence number
1	feature: rim
3	completeness: can reconstruct entire rim from given sherd
6	stance: moderate eversion
14	edgeshape: slightly bevelled toward exterior
3	exterior shape: moderately convex
2	interior shape: slightly convex
8	width (mm)
13	height (mm)
45	radius (mm)

3. Sherd detailed card (neck):

item recorded	description
B.2.3	location
3	sherd sequence number
2	feature: neck
3	completeness: (see under rim above)
4	stance: vertical
23	exterior shape: pointed ridge low on neck
01	interior shape: straight
47	height (mm)
10	width (mm)

DATA CONSISTENCY

Over 186000 distinct rim shapes may be described by the categories given in the Artifact and Pottery Coding Manual. Similarly, numerous possibilities exist for the description of each of the other sherd features. Two questions which require answers before a major investment is made in recording characteristics of large sets of sherds are:

1. If a single individual records the characteristics of a given sherd during several independent recording sessions, how consistent are the results?

2. If several individuals record the characteristics of a single sherd during independent recording sessions, how consistent are the results? Other related questions are:

3. Given a coding system, how many different ways can one describe a given sherd so that the resulting descriptions represent the sherd reasonably?

4. How can the coding system be defined in order that a given sherd be described consistently, uniquely and easily?

In order to answer questions 1 and 2, a small sample set of sixteen

representative sherds was set up as a test set. Six different individuals participated in independent recording sessions in which the sherds were selected according to a latin square assignment procedure. The characteristics of four different sherds were recorded during such a session. Each individual participated in sixteen sessions, thus recording each sherd on four different occasions. Quantitative, subjective, and quantitative subjective parameters were recorded in the test sessions. Calipers graduated to one tenth of a millimeter were used to measure thicknesses and heights of rims, necks, etc. Plexiglass sheets scribed with concentric quarter circles at 5 mm increments were used to estimate sherd rim radii. The only purely quantitative parameter recorded was the thickness measurement. Quantitative subjective parameters included the height and radius measurements. Subjective parameters included the stance and shape descriptors.

As was expected the least variation occurred in the thickness measurements, the greatest in the shape descriptors. The rim height measurement required the definition of the point at which the rim merged into the neck. The definition of this point caused variations within individual rim height measurements as well as variations among the measurements recorded by different individuals. Similar variations occurred in the rim radius measurements, particularly for those sherds with small rim arc-segments relative to their radius measurements.

One should not attempt to make the data more precise than the source warrants. For example, one complete jug from the 1972 data set has a circular rim with a radius of approximately 50 mm that is flattened on one side. A radius measurement at the flattened part varies from a radius measurement elsewhere by over 15 mm or approximately 30 per cent. Consequently, radius measurements recorded to 5 mm increments for radii less than 40 mm and to 10 mm increments for radii between 50 and 100 mm should be adequate for most purposes. The limits and increments of precision should be determined from the specific corpus of pottery under consideration.

In order to select recorders for an excavation, training sessions should be conducted using representative sherds and artifacts from the dig. After the training session, a screening session should eliminate individuals who are inconsistent or who contribute to the extremes in the variations associated with different recorded parameters. A latin square selection procedure is recommended to provide independent data sets for the screening. A reasonable test set consists of 25 sherds arranged in 5 rows of 5 columns each. A single individual could record characteristics on the 25 sherds working with rows one day, with columns the next, lower left to upper right diagonals the next, and upper left to lower right diagonals the fourth day. The screening session also serves as a valuable advanced training session for those who are to participate as recorders.

14

Reinforcement training sessions should be conducted both periodically and whenever new or different classes of items are encountered during the dig.

If one is interested in reviewing the characteristics of all sherds with a given rim shape, say, that have been recorded in the data base, it is necessary to have a partial answer to question 3. The results obtained from screening tests help to define possible variations that might occur; however, there is no guarantee that these are the only variations. Considerable experience both with the sherd collection and with the descriptions of sherds according to the coding manual are required in order to obtain a reasonable empirical answer to this question. Figure 2(a) depicts a rim and neck of a sherd obtained from the 1971 dig.

(b) (c) (d)

(b,c,d) possible representations

(a) sherd

Figure 2. A rim sherd and possible representations

Figure 2(b), (c) and (d) illustrates three possible descriptions of the rim portion of the sherd. The leftmost and middle representations have a vertical stance and a pointed edge, the rightmost representation has a moderately everted stance and a flat edge perpendicular to the stance. The interior shapes are all the same. The exterior shapes are pointed, angled inward and parallel to the stance, respectively.

Such variations in sherd descriptions pose interesting data base search problems. They also give impetus to defining descriptive characteristics in such a way that the multiplicity of feasible descriptions is reduced.

SAMPLE SUMMARY OUTPUT

For each locus within a field and square, the following are printed: description and count of item(s), such as 5 bowls, 2 jars; the total artifact and sherd count associated with the locus; the item count for each period; bucket numbers associated with the locus. The total count is primarily for accounting purposes since only a representative sample of sherds is retained from a given locus. It becomes more useful if several loci are merged to form a single locus. A detailed description of each artifact or sherd is printed on a separate report.

A sample of the summary output follows:

Field B	Square 2		Locus 2126
	Item/Function	Number	
	bowl	1	
	jar	6	
	platter	1	
	fry pan	1	
	cook pot	1	
	undetermined	1	
	Total	11	

Periods (no/per): Mid Roman (1); Roman-Byz (1); Middle
 Byz (2); Late Byz (6).
Bucket Numbers: 195 196 202 228

Field C	Square 2		Locus 2283
	Item/Function	Number	
	jar	36	
	platter	2	
	amphora	3	
	cook pot	2	
	undetermined	1	
	Total	44	

Periods (no/per): Late Roman (1); Late Byz (43)
Bucket Numbers: 115 116 117 119

CONCLUSION

Much of the effort spent on the Caesarea Information System during the 1972 season was directed toward developing a consistent and useful working tool and in obtaining reliable data for subsequent computer processing. By selecting the Toombs-Wagner coding system as the basis for the Caesarea coding system, compatible data sets from two different Palestinian sites have been collected. Studies on sherd shape representations have been useful in searching the data base for sherds with specific shape characteristics. Attempts have been made to generate computer plots of sherd shapes as an aid to chronology studies. Detailed and summary catalogs have been printed. Additions to the data base are being made from the 1971 sherd collection and the remainder of the 1972 sherd collection.

REFERENCES

Chenhall, R.G. (1967) The description of archaeological data in computer language. *American Antiquity*, **33**, 161–7.

Chenhall, R.G. (1971a) *Computers in Anthropology and Archaeology*. International Business Machines Corporation technical publication GE 20–0382.

White Plains, New York. Review 23606 in *Computing Reviews*, **13** no.8 (1972).

Chenhall, R.G. (1971b) The archaeological data bank: a progress report. *Computers and the Humanities*, **5** no. 3, 159–69.

Fisher, D.D. & Yates Jr, K.M. (1972) *Artifact and Pottery Coding Manual.* Stillwater, Oklahoma: Oklahoma State University.

Lapp, P.W. (1961) *Palestinian Ceramic Chronology 200 B.C.–A.D. 70.* Cambridge, Mass.: American Schools of Oriental Research.

Shepard, A.O. (1956) *Ceramics for the Archaeologist.* Publication 609. Washington, DC: Carnegie Institution of Washington.

Toombs, L.E. & Wagner, N.E. (1971) *Pottery Coding Handbook.* Waterloo, Ontario: Waterloo Lutheran University.

APPENDIX: EXCERPTS FROM ARTIFACT AND POTTERY CODING MANUAL

(The number of categories for an item is enclosed in parentheses)

Function (8)

2. *Household utensil (27)*
 01. bowl
 02. cup
 03. flask
 04. goblet
 05. jar
 .
 .
 .

4. *Personal articles (25)*
 01. bead
 02. buckle
 03. button
 04. chain
 05. comb
 .
 .
 .

Stance (8)

\ 1. extr. inversion
\ 2. mod. inversion
\ 3. slight inversion
| 4. vertical

/ 5. slight eversion
/ 6. mod. eversion
/ 7. extr. eversion
— 8. horizontal

Rim shapes:

edge shape (19)	*interior shape (34)*	*exterior shape (36)*
01. —— (perpendicular)	\|	\| (parallel to stance)
02. ⌐	() slightly convex
03. ⌒	() mod. convex
04. ∩	() extr. convex
05. ∧	<	> pointed
06. ⌐	≷	≷
⋮	⋮	⋮

Systems for the Humanities

Sara R. Jordan

A computer program that learns
to understand natural language

A concern which has occupied many areas of artificial intelligence research in computer science is that of understanding natural language. Although we do not know exactly how the human brain understands (or even what 'understanding' really means), computer scientists have used various methods to model understanding by demonstrating certain types of language behaviour—usually question answering or paraphrasing the 'understood' information. The author has designed and written a large, interactive computer program (described in Jordan 1972) which tries to demonstrate understanding of natural language by handling a variety of language manipulation tasks. This artificial intelligence system is referred to as METQA, an acronym derived from two of the behaviour tasks of the program: mechanical translation and question answering. This article will describe METQA on a level aimed at the nonspecialist.

Almost all computer systems which attempt to understand natural language use built-in linguistic information and/or logical processing techniques. For example, input sentences may undergo syntactic analysis according to some built-in grammar, and at some later stage information may be processed by deductive routines to produce a final 'proof' or answer to a question. In a departure from this approach, the METQA system avoids using built-in linguistic or logical information. Instead, it uses learning and pattern recognition techniques; that is, the system observes 'correct' language behaviour and tries to discover underlying patterns or rules governing their behaviour. From observation over time, METQA draws conclusions on the organization of the language information it has experienced.

Another characteristic of most programs which seek to understand natural language is that the understanding is demonstrated by a single type of behaviour, often working with a narrow and specialized information set. Contrary to this approach, METQA attempts several types of language behaviour in a single program, including transformation or translation of language strings, information learning and organization, and question answering.

Overview of the Metqa System
METQA accepts as input unsegmented strings of natural language from a human trainer. In a general and uniform way, METQA processes

each string and outputs a natural language response. The processing of the string may involve transforming (or translating) it to some other form in the same or another language, or it may involve answering an input question based on information previously learned by the program. The system's operation is not dependent on the subject matter or the particular language in use.

The overall objective of the METQA system is to see how well an adaptive program can learn to produce 'intelligent' manipulation of language without any prior knowledge of it. In order to acquire an understanding of natural language which can be demonstrated in several ways, METQA learns and organizes information, storing it in a relational network so that the information can be used as necessary for whatever task is attempted later.

METQA has no built-in dictionaries or grammars, and no fact files or deduction routines. The reason for this is that the system must handle any language and any subject matter by trying to acquire the appropriate 'world view'. It must adapt its memory to reflect whatever experience it has had.

In order to achieve this level of generality, the only built-in knowledge given to the program is two general processes of action for the formation of its memory. The first is the ability to organize experienced language into a network of items of information (called nodes) which are freely connected by labeled links which show how the pieces of information are related. For example, the nodes containing 'wiener' and 'frankfurter' may be connected by a link which indicates equivalence. The second general process is the formation of different classes or categories of these memory nodes according to similarity of behaviour and usage; examples of such categories are the class of all feminine nouns or the class of all words showing negation. Given only these two processes, METQA must learn to understand the language information it is given and to handle tasks such as translation and answering questions.

Within this framework, METQA operates as follows. First, it learns to transform some input string to some other desired form which is shown to it by a human trainer. This might involve learning that several different external forms may correspond to a single internal language unit, and that each external form complies with a certain contextual situation. METQA must also learn any permutations of language segments necessary for correct transformation between different representations (to take care of word order differences, for example).

In addition to transformation of strings, METQA also tries to learn the information contained in the strings it processes, so that it can assemble related sets of learned facts and answer questions based on this information.

METQA decides what to learn by comparing its response with any

(specially marked) feedback string the human trainer may wish to give. A feedback string is taken to be the *correct* response which METQA should have given to the original input from the trainer. By comparing the feedback with its own response, METQA tries to determine which (if any) portions of the original input string were processed incorrectly so that it can learn memory modifications. The learned information and relationships are represented and stored in the node network which serves as the permanent memory of METQA.

THE MEMORY STRUCTURE

A basic problem in most areas of artificial intelligence is how to represent the knowledge, or 'memory', needed by a program to perform its duties. Various projects have used tables of information, or hierarchically structured 'trees' of information, but the most successful efforts have used some variation of relational networks. That is, each segment of information (a word or a procedure, perhaps) is stored as a *node* of the network, with links or pointers connecting it to other nodes containing information related to that node. With networks, information can easily be added or modified in the net. The basic form of a network is simple, but concepts can be freely associated with each other as more and more relationships are discovered, yielding what looks like a bewildering mass of interconnected nodes of information. However, it is just this feature of complexity grown from simple parts that makes network memories so suitable. Each of us has a supremely complicated internal store of knowledge which seems to consist of an unlimited number of concepts, connected by a myriad of relationship links. Only with networks can we even approach the versatility and power needed to imitate the human mind.

One well-known computer system which used a structure such as this was Quillian's semantic memory network (Quillian 1968). This memory model consisted basically of a mass of word nodes interconnected by different kinds of associative links. Quillian holds that his memory organization is useful for semantic tasks and provides a reasonable description of the general organization of human semantic memories.

As mentioned in the previous section, the METQA system has the ability to construct on its own a network to hold its knowledge, and to aid its learning by forming different categories of concepts (nodes) which seem to be used in similar ways. The system learns about language by observing the language usage of a human trainer, by drawing conclusions about the organizing rules of the language, and by representing these hypotheses in the memory network. All the permanent knowledge gained by METQA's experience is represented in this one semantic memory structure, which contains grammatical as well as factual information. Although METQA's semantic memory structure is

similar in many respects to Quillian's memory model mentioned above, an obvious major difference is that METQA's memory is learned, whereas humans (aided by their own semantic memories) encode the entries in Quillian's model.

Link relationships shown:

T—transforms to E—equivalence; can be replaced by
C—combines to form fact D—description
M/S—member/subset of this class i—marks 'idea' or concept nodes
CL—class membership in

Figure 1. Sample memory net

A sample memory net is shown in figure 1. This memory structure is fully described in Jordan (1972); in this paper we shall briefly review its basic features. Each node in the network is a list of information which represents some state of a word or phrase during its processing. The nodes are connected by directed links that represent various basic relationships indicating class structures, transformation possibilities, word usage in input facts, and so on.

The traversal of a link may be restricted by a context requirement which limits the use of this link to certain situations. The indicated context must be found in the input string before that link can be

followed. For example, context requirements can prohibit transforming to the French word 'la' unless the input has nearby a member of some usage class, say class C1, containing feminine words (see figure 1). Thus the program can learn to choose among multiple links at some node by discovering the disambiguating contextual word classes which typically appear for each situation.

The nodes in METQA's memory fall into conceptual layers as in an onion. Entry to the net can be made only at a terminal, or surface, node by matching its external string description. In figure 1, only the terminal node for 'the' shows its external description string. Once a surface node is entered, a transform link leads to the internal 'idea' node which connects all the external forms that this particular concept can assume. For example, the internal node representing the concept of a domesticated canine might be connected by transform links to the surface nodes representing 'dog', 'chien', and 'hund', if METQA has experienced and learned those external forms. In addition to these links, an idea node has combination links to nodes deeper in the net which represent all the known facts which involve that concept. Meanwhile, each fact has links out to the idea nodes whose surface words would externally state that fact. Because it links to the internal concept nodes instead of surface word nodes, a piece of factual information learned in some language is always accessible by way of any language METQA learns. Thus surface nodes link to idea nodes, and idea nodes are the entry points to the information part of the net—the facts which are used to answer questions.

The categories which METQA forms exist as class nodes connected to each node which seems to have similar usage in certain situations (for example, the class of all feminine words or the class of all adjectives which permute with French nouns). Typically, METQA forms a class to contain a word which elicits a special form of some other word or perhaps which causes a difference in the order of the language segments. Other words which behave in the same way will be put into the same class, and that distinctive behaviour is a characteristic of the *class*, not just of the particular word combinations seen. Having learned the pattern of a class's behaviour, METQA can generalize this behaviour to newly learned members of the class and correctly transform combinations of words which have not occurred together before. Thus by generalizing across classes, METQA can correctly handle situations it has not seen before.

The Transformation Process

Now that we have described METQA's memory structure, let us show that it can indeed be used to demonstrate understanding of natural language. The first task which can be attempted while a memory is

being constructed is transformation of one language string into another. This transformation might conceivably be from phonetic to orthographic strings, or from active to passive form, but for our discussion the transformation will be from one (source) language to another (target) language, say English to French.

For definition of link labels, see figure 1.

Figure 2. Sample memory net fragment

The trainer inputs the source string on a teletype in unsegmented form (that is, with no helpful spaces). METQA scans the string and finds all the patterns it knows. Then the system proceeds to transform these matched segments into the target language. Starting from each of the recognized segments, METQA forms a path through the nodes of the memory network. These paths grow toward the desired target language, following transform links. Whenever there is a choice of links to follow from a node, METQA chooses one whose contextual restrictions are satisfied by this input, if possible. When all the paths reach the surface again in the target language, METQA outputs its transformed response, along with any string segments it did not understand.

Consider the fragment of a memory net shown in figure 2. Given these nodes in memory, the input string 'thedog' would form two transform paths from the source language nodes through the internal idea nodes to the target nodes, as shown in figure 3. The output response would be 'le chien'. The second input string 'thewoman' would also form two paths through memory. This time, however, when faced with the choice of transform links to follow from the idea node (N2) for 'the', METQA will find that the input string context includes a member of the class (C1) of feminine words. Consequently, the path will select the restricted link and reach the target node 'la', which is the correct form for 'femme'.

Suppose METQA has processed an input and responded with a transformed string. If the trainer wishes, a specially marked feedback string (also unsegmented) may now be submitted to show METQA what the correct response should be. A feedback string is matched and processed

Input: 'thedog' Output: 'le chien'

 Path1 the→N1–N2–N3→le
 Path2 dog→N7–N6–N5→chien

Input: 'thewoman' Output: 'la femme'

 Path3 the→N1–N2–(C1)–N4→la
 Path4 woman→N8–N9–N10→femme, and femme \in C1

Figure 3. Sample transform paths through net

just as the original source string was, but the goal of each feedback path stepping back through the network is to quickly join or intersect a path from the source input. The reason for this is that METQA wants to know if it was correct in its processing of the source string. If it was, then the source input and the feedback paths should overlap immediately. It is these intersected paths that METQA uses to associate and learn string transformations.

In order to demonstrate METQA's learning behaviour, consider figure 4, which shows an input sequence which would cause the formation of the memory net shown in figure 2. Since METQA begins with an empty memory, it does not recognize the first string 'the' which is input from the trainer. However, when feedback shows it that the correct response should be 'le', METQA builds nodes N1, N2 and N3 to learn the correct transformation. In the second input, METQA recognizes and transforms 'the', but must use the feedback to learn that 'dog' transforms to 'chien' and to build nodes N5, N6 and N7. Similar learning occurs for 'femme' and 'woman'.

In the fourth input METQA recognizes and transforms the entire string to 'le femme', but the feedback shows a different, unknown form 'la' which should have been used. In order to learn the proper use of this special form of 'the', METQA builds a behaviour class C1 which initially contains only 'femme', and constructs a new node for 'la' which is reached from node N2 if and only if a member of class C1 is found in the string context.

When the sixth input is received, METQA recognizes the string and responds with the only transforms it knows, but feedback shows a new form 'petite'. Now when METQA tries to characterize this situation in order to learn what elicited this new form, it notices that the context 'femme' has already been put into a behaviour class. METQA hypothesizes that this new form 'petite' is also governed by that same behaviour class, so the transform link to the new form is restricted by the already existing class C1.

Now that METQA has broadened the use of the behaviour class C1, notice what happens when the eighth input is processed. The feedback shows that the 'petite' form should have been used with 'fille'. Newly learned 'fille' has no classification as yet, but METQA sees that 'petite'

input	response	feedback	learned structure
1. the	(the)?	le	the↔le
2. thedog	le (dog)?	lechien	dog↔chien
3. femme	(femme)?	woman	femme↔woman
4. thewoman	le femme	lafemme	femme ∈C1, the —(C1)→la
5. petit	(petit)?	small	petit↔small
6. smallwoman	petit femme	petitefemme	small —(C1)→petite
7. girl	(girl)?	fille	girl↔fille
8. smallgirl	petit fille	petitefille	fille ∈C1
9. thegirl	la fille		

Figure 4. Sample sequence showing how the net in figure 2 might have been learned

is used with members of class C1. So it reasons that 'fille' must be another member of class C1, and learns the appropriate class membership links.

Generalizing the use of class C1 to characterize the similar behaviour it observes in this manner, METQA learns to respond correctly with special forms even in new situations. Thus 'thegirl', which METQA has not seen before, is correctly transformed to 'la fille'.

Since there are often differences in word order between two languages or between two equivalent strings in the same language, METQA learns and uses rules which describe the conditions under which string segments should be permuted. These permutation rules are also stated in terms of behaviour classes, and the rules are modified and generalized by processes similar to those of the above example.

THE QUESTION ANSWERING PROCESS

After METQA has learned sufficient vocabulary to understand all the words in input sentences, then the trainer can set a system flag causing future input strings to be learned as factual information, forming fact nodes in memory. When sufficient facts are learned, the system can try to answer input questions by outputting a small set of related facts which hopefully contain the answer to the question.

When a question is input, METQA must recognize its words and enter the memory net as if for regular transformation. But the system begins at the internal idea nodes to form the answer to the question. Using the 'content words' (in the sense of Simmons *et al.* (1964); those words seen rarely enough to carry meaning, as opposed to 'common words' which indicate grammatical function) found in the question, METQA selects an initial set of facts from the memory net. The words in these initial facts suggest other nodes, and these in turn suggest other facts, and so on. The facts are thus linked together into 'chains' of related information which METQA assembles in an attempt to account for (with information) each content word in the question. When the content words

of the question are all 'covered', METQA outputs as its answer the re-
sulting chain of facts and class information used. In this manner,
METQA imitates the human process of putting together all the informa-
tion known about requested topics to get a resulting answer. There are
definite limitations to this method, but let us first use figure 5 to show
an example of its operation.

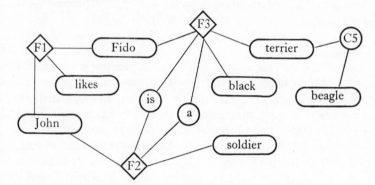

Facts in memory: F1. John likes Fido
 F2. John is a soldier.
 F3. Fido is a black terrier.
Also known: Class C5 has as members 'terrier', 'beagle'.
Question: Does a *soldier like* a *black dog*?
Resulting fact chain (showing fact links):
 F2—(John)—F1—(Fido)—F3—(terrier ϵ dog)⇒complete cover of
 requested information

Answer: John is a soldier.
 John likes Fido.
 Fido is a black terrier.
 'Terrier' is a member of class 'dog'.

Figure 5. Question answering example

In figure 5, the nodes of the simplified memory segment are shown
in streamlined form for clarity. When the question is input, METQA
determines that the content words to be accounted for are those words
which are shown in italics. The word 'soldier' indicates that fact F2
is relevant to the question; 'John', the other content word in F2, forms
a link to fact F1. With facts F2 and F1 in the chain, the content words
'soldier' and 'like' are covered in the question. The word 'Fido' links
the chain to fact F3, which adds 'black' to the words covered. Fact F3
contains the word 'terrier', which is a member of the class 'dog'. Since
METQA routinely uses such class information in order to enrich its selec-
tion of information, fact F3 is considered to cover 'dog' in the question
and the fact chain ends, having accounted for all the requested informa-
tion. The set of sentences in the chain is output as METQA's answer.

15

As indicated earlier, the simple chaining of facts without linguistic or logical information can lead to erroneous or nonsensical responses. Suppose fact F3 in figure 5 were replaced by 'Fido *bit* a black terrier'. Using the chaining technique with no other facts available, METQA would form exactly the same fact chain and would output as its answer this different set of facts, which by no means answers the question. Further tuning on the system could decrease this type of problem, but with simple chaining it would never be completely solved.

CONCLUSION

The purpose of the METQA system has been to produce a system for understanding natural language which can structure and adapt its own memory to reflect whatever experience it is given. METQA demonstrates its understanding by attempting a range of tasks on any subject matter in any language. The objective of the METQA system is not to produce outstanding skill in any particular language manipulation task, but to produce a breadth of ability. To accomplish this, METQA has only its learning mechanisms, the learned memory net structure, and a set of simple and general heuristics. By adapting its memory network from its experience over time, METQA tries to demonstrate understanding through intelligent manipulation of language.

Acknowledgements

The author acknowledges with gratitude the many helpful conversations with Leonard Uhr of the University of Wisconsin. This research was supported primarily by NIH grant number GJ-583, and in part by a University of Tennessee Faculty Research Grant.

REFERENCES

Jordan, S.R. (1972) Learning to use contextual patterns in language processing (PhD thesis). Technical Report No. 152, Computer Sciences Department, University of Wisconsin.

Quillian, M.R. (1968) Semantic memory (PhD thesis). *Semantic Information Processing* (ed Minsky, M.), 227–70. Cambridge, Mass.: MIT Press.

Simmons, R.F., Klein, S. & McConlogue, K. (1964) Indexing and dependency logic for answering English questions. *American Documentation*, **15** no.3, 196–204.

A common structure for lexicographic data

In recent years a great deal of textual and lexical material has been converted to machine form. Although many conversion projects in the humanities deal with historically or logically related corpora, there is as yet no simple way to exchange or to integrate different data bases. As a result it is difficult to correlate and compare matching lexical information, for example to use a dictionary file to help establish word concordance lemmata. Such difficulties are not inevitable, however, as shown by the work of the Centre National de la Recherche Scientifique which has carefully built a unified approach to the machine form materials of the French language. The materials themselves are not lacking for English, but at this time we enjoy neither the financial support nor the unified approach of the CNRS.

The suggestion I will make in this paper is that exchanging or integrating data bases can be made much easier by using a common, standard structure to define the record formats of different data bases. A standard data structure, if it can be found, will help to solve many of the problems of giving data to, and getting data from, other people. Some of these problems are: describing the content and the format of a data base; defining a data structure which is accessible to both research interests and retrieval methods; developing generalized software; and educating programmers and scholars to be able to communicate with and among each other.

It is not an easy matter to discover or decide just exactly what constitutes an acceptable standard, especially since there are so many different machines, languages, and systems, each with their own special capabilities and limitations. There is no way to avoid conflict and disagreement, but the benefits of standardization are so obvious that we should look carefully at any group which has developed and used a standard data structure to improve communication and data base exchange. The libraries in the United States and in England are one such group, and the standard which they have developed is called MARC (Machine Readable Catalog).

The MARC standard can best be described as a continuation of the long tradition of data sharing among libraries, and it is used operationally to define and exchange several bibliographic files including the current Library of Congress English language catalog cards (see Sherman 1972, 221–43). We can conclude from the success of MARC

that it is possible for a large group to design, propose, accept, and implement a standard structure for machine form data, and further that a single common structure can be used to define record formats which will represent entirely different kinds of data. It seems natural therefore to consider extending the principles of MARC to other and broader forms of data, and in fact to use the MARC structure itself as a possible medium to define formats for various kinds of textual and lexical records.

Recently I have experimented with defining MARC-based record formats for several different data bases. The largest of these is a new format for the existing machine form version of *Webster's Seventh Collegiate Dictionary* (W7) (see Olney 1969). My purpose in defining WEBMARC, a MARC structure format for the W7 data records, is to improve access to the data by creating records which can be processed by MARC program systems for editing, sorting, printing, and especially for data retrieval. The W7 data base has been converted to the WEBMARC format, and is available for distribution. Based on the reactions of those who choose to request and use the WEBMARC file, I hope to evaluate the usefulness and limitations of MARC as a potential standard for data exchange.

MARC DATA STRUCTURE

The structure and the format of a machine record are not necessarily identical. Structure can be defined as a set of general conventions, and the same structure can be used by many different formats. The conventions of the MARC structure apply to the physical organization of a machine record and to the means for identifying various levels of data elements. Based on these conventions, common MARC software can be (and has been) developed to accept any MARC format record regardless of content or format definition. For the designer or user of a data base, identifying data elements is a way to structure the material into the categories which will be most interesting for analysis and research.

The physical organization of MARC records is divided into three distinct areas, called respectively leader, directory and data. The leader is an initial fixed-length area, and contains general record status and control number information. Following the leader is the directory which functions as a table of contents and inventories all the data fields in the record. The final record area contains only data, with one data field corresponding to each directory entry. The first two characters of each data field are reserved for indicator codes; the remainder of the field contains the codes and texts which comprise the data base.

MARC has two levels of data element identification: field, and subfield. To start with the more detailed level, a subfield consists of an identifying code followed by a data string which is the text of the subfield. A special reserved character, represented here as $, serves both to

introduce the identifier code and also to mark the end of the previous subfield. For example: $aSamuel$bJohnson$cA.M.$cLL.D. The codes $a, $b and $c identify three independently accessible subfields (first name, last name, and academic degree); the $ symbol introduces the identifier codes and also terminates the preceding subfield. The meaning or interpretation of a subfield depends entirely upon the intention of the format designer. Thus a subfield may vary widely as to content, level of detail, and whether its presence is required or optional.

A MARC data field consists of a sequence of one or more subfields and is independently identified by a three-digit label or tag. All the field tags in a single record are listed in the record directory which also contains field lengths, and address pointers to the data section of the record. For programming purposes, the directory both summarizes and locates the contents of a record, thus making it possible for data fields to vary in length, to be present or absent, and to occur more than once within a single record.

Record formats defined within the MARC conventions have considerable freedom in organizing their subject matter and in identifying different levels of detail. In the WEBMARC format, which will be fully described subsequently, the scheme of fields and subfields is based on the traditional categories of lexicography, such as spelling, etymology, and definitions, and also on the interests of lexicographic research. Some fields contain no subfield structure at all because of the allocation of priorities during conversion programming. Other fields, most notably the W7 phonetic citations, have been fully analysed and as a result have a detailed subfield structure which is designed to provide direct access to research data.

WEBMARC

During 1967–69, a machine readable transcript of W7 was produced by the System Development Corporation. This transcript was subsequently 'parsed' (see Olney 1969) in order to identify various categories of lexicographic information, especially the components of lexical definitions. In 1972–73 I designed the WEBMARC format for the W7 data with the intention of creating a compact and MARC-compatible version of the data base with additional 'parsing' of its phonetic information.

In WEBMARC, lexicographic information is organized according to a field tag scheme which matches types of entries against categories of data. Three types of entries (main, variant, run-on word) and six categories of data (spelling, definitions, full and partial pronunciations, etymology, synonomy) are independently identified. Table 1 shows the field tag scheme. Not all combinations of type and category are valid; for example, run-on words do not have etymologies or definitions (see Gove 1963, 13a).

entry types	spelled form	definition	full phonetic	synonomy	etymology	partial phonetic	control
			data categories				
main	100	200	400	500	600	800	001
1st variant	101		401			801	
2nd variant	102		402			802	
.	.		.			.	
.	.		.			.	
.	.		.			.	
1st run-on	110	210	410			810	
2nd run-on	120	220	420			820	
.	
.	
.	

Table 1. WEBMARC field tag scheme

In order to eliminate any dependency on the order of data fields within a record, the second and third digits of the tag scheme act as serial control numbers for data fields within a given entry type: e.g. the spelling and pronunciation of a variant will have the same third tag digit (1 for the first variant, 2 for the second, etc), while for a run-on word these fields would share an identical second digit. When there are more than nine occurrences of a variant or run-on entry type, then the symbols A, B, C, ... are used to continue the sequence of control numbers. The tag scheme also separates full phonetic data from partial phonetic citations because the two will ultimately require different strategies for retrieval and analysis.

LEADER
'The leader is fixed in length for all records and contains 24 characters' (US Library of Congress 1969, 25).

Data elements	position
1. record length	0–4
2. status (F = full record)	5
3. source data (W7 = Webster's Seventh Collegiate)	6–7
4. homograph number (0 = non-homograph)	8
5. record extension number (0 = non-extended record; 1, 2, ..., 9 are used if a lexical entry needs to be extended across more than one physical record)	9
6. not used	10–11
7. address pointer to data area of record	12–16

8. record identification number (ID number has two
low-order zeroes to allow for interfiling) 17–23

CONTROL FIELD : TAG 001

'The control fields do not use indicators and subfield codes. Data
elements in these fields begin in a fixed location relative to the first
character position of the field' (US Library of Congress 1969, 30).

The first ten bytes of the 001 field contain a brief map of the contents
of the record directory, organized by blocks of tags. Each of the ten
bytes corresponds to a specific tag block, such as 0XX, 1XX, etc. A byte
contains a number (in binary form) which measures the displacement
from the beginning of the directory to the first directory entry of a tag
block. A displacement of zero means that the entire tag block is absent
from the directory (and from the record).

Data elements position
 1. displacement bytes (see above) 0–9
 2. capitalization indicator (C = main entry contains a
capital letter) 10

SPELLING FIELD : TAG 1XX

The two indicators are used as a general word class code for the entry;
the codes are taken from the original W7 tapes, and are as follows:

AJ adjective	N noun	VA verbal auxiliary
AS adverb suffix	NC noun comb. form	VB verb
AV adverb	NS noun suffix	VC verb comb. form
CF combining form	PF prefix	VI verb, intransitive
CJ conjunction	PN pronoun	VM verb, impersonal
DA definite art.	PP preposition	VP verb, imperative
IA indefinite art.	SF suffix	VS verb suffix
IJ interjection	TM trademark	VT verb, transitive
JS adjective suffix		bb run-on phrase

Subfields
$a spelled form of entry in upper case without diacritics.

$b hyphenation points, coded as a string of digits which count the
number of characters since the last hyphenation point. For example,
'dic.tio.nary' would be coded as $b33.

$c accent mark information, in the form of a two-digit code. The
first digit counts the number of characters since the last accent mark;
the second digit is a code for the accent mark (see Olney 1969, A-7).

$d status of alternate word class code. The possible values are: =
(e.g. 'n or adj') or 2 (e.g. 'n (or adj)').

$e alternate word class code (see indicator codes above).

$l status label attached to entry, e.g. slang, dial.

$i type of variant: a value of zero means that this is a spelling or
other form of variant, while a non-zero value (i.e. 1,2,3,...) means that
the entry field is an inflected variant.

$s status of variant: variant is either equal ($=1$) or secondary ($=2$).

DEFINITION FIELD : TAG 2XX

Each 2XX field represents a separate definition of the main entry or run-on phrase. A single sense or subsense may contain more than one definition. In the W7 printed text each definition is introduced by a 'symbolic colon' (see Gove 1963, 11a). The two indicator codes for this field are used to express the word class code which is in effect for a specific definition.

Subfields

$a sense number, subsense letter and subsense number of the definition, represented as a five position code, e.g. Ø1aØ1.

$d text of the definition.

$1 status label attached to the definition, e.g. slang, obs.

$s synonymous cross-reference (used as a definition). 'A cross-reference following a symbolic colon . . . means that the definitions at the entry cross-referenced to can be substituted as definitions for the entry sense or subsense' (Gove 1963, 13a). Each cross-reference word will be identified as a separate $s subfield.

$t homograph number and sense data for synonym cross-reference, if needed. The first digit is a homograph number; the remaining five digits are parallel to $a (see above).

$u usage note: 'a usage note may be a comment on idiom, syntax, semantic relationship, status, or various other matters' (Gove 1963, 13a).

$v verbal illustration, i.e. a sense-specific example of the entry word or phrase as it might appear in context. Verbal illustrations may be appended to or embedded in definitions, usage notes or synonym cross-references.

$w type of directional cross-reference. Directional cross-references 'explicitly direct one to look elsewhere for further information' (Gove 1963, 13a). The types of cross-reference are expressed as a one digit code with the following meanings:

 Ø,1 see x or see x table
 2,3 see x at y or see x at y table
 4,5 compare x or compare x table
 6 called also x
 7 compare x at y table

$x directional cross-reference entry word.

$y homograph number and sense data for directional cross-reference entry; see comments under $t.

$z second directional cross-reference word, e.g.—see kip at MONEY.

FULL PRONUNCIATION FIELD : TAG 4XX

Full phonetic citations which may occur in main, variant or run-on word entries are identified as 4XX fields. Where several pronunciations

are given, each citation is represented as a separate 4XX field. The first indicator position identifies the syllable marked for primary stress. The second indicator is a syllable count. The indicator values for *explain*, for example (ik-'splān), would be 22, meaning a disyllabic word with final stress.

Subfields. Separate subfield codes will identify the separate phonetic clusters which make up a word, according to the following scheme:

$a first consonant cluster.
$b first vowel cluster.
$c second consonant cluster.
$d second vowel cluster.
 etc.

The ordinal position of a phonetic cluster is expressed directly in its subfield code. Within a phonetic cluster individual phones are further identified by an index number which denotes position within a cluster. An example of the scheme is *strength*, with its canonical phonetic form $C_3V_1C_2$, which would have the subfield structure: $a1S $a2T $a3R $b1E $c1NG $c2TH. The actual phonetic data or text of each subfield is a digraphemic version of the W7 phonetic symbols.

In addition to the subfield structure outlined above, several additional subfields have been defined to represent other information given in the W7 pronunciations, or to simplify future retrieval problems.

$v optional phone segments, which are bracketed by parentheses in the W7 citations, are included in the WEBMARC phonetic data field; however the $v subfield notes the identification (in terms of cluster code plus index number) of the optional phone segment.

$w label information, e.g. chiefly dial., etc.

$x vowel nasalization, which is infrequently marked in W7, is represented in a manner similar to the $v subfield above; that is, the $x subfield notes the identification of the nasalized vowel phone.

$y syllable division information is not directly included in the 4XX data stream, but is represented instead by noting the identification of the phone segment immediately to the left of the syllable boundary.

$z canonical shape: a simple summary of the phonetic shape of each entry given by recording the highest index number of each phonetic cluster. Using the $C_3V_1C_2$ from of *strength* again as an example, the $z subfield would be $za3b1c2.

In contrast to syllable boundaries, optionality and nasalization, primary and secondary stress are included directly as part of the phonetic data stream. A stress symbol is identified as a part of the vowel cluster which it marks (although in the printed text of W7 stress is marked at a syllable boundary), and it is assigned an index number of zero. Thus the earlier example of strength should read: $b0@ $a1S $a2T $a3R $b1E...

SYNONYMY FIELD : TAG 500

This is an 'unparsed' field in the sense that its structure does not have as much detail as other WEBMARC data fields. The first indicator position will have a value of S if the field contains a synonym paragraph. The second indicator will have a value of X if the field contains a synonym cross-reference word.

Subfields

$a text of entire synonymy paragraph.

$w type of cross-references: the codes used in this field are identical with those used in the $w subfield of the definition field (tag 200), with the following two additions:

 8 syn see in addition x
 9 syn see x

In this case, x refers to a main entry which has a synonymy paragraph.

$x cross-reference entry word.

$y homograph number and sense data for cross-reference entry.

$z second cross-reference word, if any.

ETYMOLOGY FIELD : TAG 600

This is also an 'unparsed' field in the current format; however identifying the potential subfield components of this field would provide interesting historical information. The indicator positions are not used.

Subfields

$a text of etymology.

PARTIAL PRONUNCIATION FIELD : TAG 8XX

Partial phonetic citations are a common editorial device in the W7 text, and are used especially for alternate pronunciations and run-on words. The first indicator position is used to classify the ways in which the phonetic data can be abbreviated. The values are as follows:

 1 citation begins with a syllable boundary (word-initial data is omitted).

 2 citation ends with a syllable boundary (word-final data is omitted).

 3 citation begins and ends with a syllable boundary (both word-initial and word-final data have been omitted).

The second indicator is used as a syllable count. The subfields for the 8XX field are identical with the subfields defined for the 4XX field.

REFERENCES

Gove, P.B., editor in chief (1963) *Webster's seventh new collegiate dictionary.* Springfield, Mass.: G. & C. Merriam Co.

Olney, J., Paris, J. & Reichert, R. (1969) *Two dictionary transcripts* (*Technical Memo 3978; AD 691 098*). Santa Monica, Calif.: System Development Corp.

Sherman, D. (1972) Converting bibliographic data to machine form. *Advances in librarianship*, vol. 3 (ed Melvin Voigt), 221–43. New York: Seminar Press.

US Library of Congress, Information Systems Office (1969) MARC *manuals used by the Library of Congress.* Chicago, Ill.: American Library Association.

APPENDIX I : PHONETIC SYMBOL CODING SCHEME

The goal of this scheme is a readable character set
for the phonetic data in W7. Each W7
phonetic symbol is converted into
a computer-code digraph.

IPA	W7	MARC	IPA	W7	MARC	IPA	W7	MARC
p	P	P	m	M	M	i	Ē	IJ
b	B	B	n	N	N	I	I	I
t	T	T	n	Nʸ	NJ	e	Ā	EJ
d	D	D	ŋ	ŋ	NG	ɛ	E	E
k	K	K	1	L	L	æ	A	AE
g	G	G	r	R	R	ai	Ī	AɓIɓ (diphthong)
						ə	ə	*
f	F	F	y	Y	Y	a	Ä	A
v	V	V	w	W	W	ɑ	À	A2
θ	TH	TH				æu	AU̇	AEU̇ɓ (diphthong)
ð	*TH*	DH				u	Ü	UW
s	S	S				U	U̇	U
z	Z	Z				o	Ō	OW
š	SH	SH				ɔ	O̊	O
ž	ZH	ZH				ü	ŪE	IW
ç	*K*	CH				Ü	UE	IU
h	H	H						
tš	CH	TC				ø	ŌE	EW
dž	J	DZ				ɔ̃	OE	EU
ts	TS	TS		primary stress		'	@	
				secondary stress		,	.	
				syllabic consonant		ᵊ	+	

This sample record is a schematic representation
in that the leader is omitted and the
directory and data areas of the
record are not shown
as continuous areas.

slay/'slā/*vb* **slew**/'slü/**slain**/'slān/**slay·ing** [ME *slen*, fr. OE *slēan* to
strike, slay; akin to OHG *slahan* to strike, MIr *slacain* I beat] *vt* 1: to
put to death violently: KILL 2 slang: to affect overpoweringly:
OVERWHELM ⟨~s the girls⟩~*vi*: KILL, MURDER **syn** see
KILL—**slay·er** *n*

tag	size	addr	data fields
001	12	0	01 02 07 00 0C 0F 10 00 00 00 00 ♭F
100	9	12	VB$aSLAYF
101	15	21	VB$aSLEW$il$sl F
102	16	36	VB$aSLAIN$i2$s1 F
103	21	52	VB$aSLAYING$b4$i3$s1 F
110	14	73	N$aSLAYER$b4F
200	37	87	VT$a 1 $dTO PUT TO DEATH VIOLENTLYF
200	16	124	VT$s 1 $sKILLF
200	44	140	VT$a 2 $l&SLANG$dTO AFFECT OVERWHELMINGLYF
200	35	184	VT$a 2 $sOVERWHELM$v"S THE GIRLSF
200	24	219	VI$a 0 $sKILL$sMURDERF
400	29	243	11$b0@ $a1S $a2L $b1EJ$za2b1 F
401	29	272	11$b0@ $a1S $a2L $b1UW$za2b1 F
402	36	301	11$b0@ $a1S $a2L $b1EJ$c1N $za2b1c1 F
500	12	337	X$w9$xKILL F
600	107	348	$a¬M¬E&SLEN, FR. ¬O¬E&SLE?-AN TO STRIKE, SLAY; AKIN TO ¬O¬H¬G&SLAHAN TO STRIKE, ¬M¬IR&SLACAIN I BEATF

D. J. KOUBOURLIS

From a word-form concordance to
a dictionary-form concordance

The best examples of traditional computerized concordances (TCC's)
are word-form concordances. These have proven to be excellent tools
of research and teaching. (By teaching, I mean not only lecture pre-
paration but also language learning, as can be the case with a foreign
language concordance, especially of a representative sample of a given
language.)

Probably the leading publisher of TCC's in the US is Cornell Univer-
sity Press. They are to be commended for the tremendous service they
provide for the scholarly community. Other university presses in this
country have published TCC's, e.g. Alabama, North Carolina and the
University of Wisconsin Presses. Normally, there is no cost to the pub-
lisher for preparation of camera-ready copy. The computer printout,
as error-free as possible, serves as the copy for offset reproduction. As
concordances, however, are notoriously lengthy, and never become
bestsellers, whatever economy is achieved in the camera copy prepara-
tion tends to be offset by high production costs due to large size and the
small number of copies produced.

Reviewers from time to time, while hailing the value of TCC's, find
themselves compelled to lodge a few recurring criticisms. Two of these
I call *word-form diffusion* and *homoform insensitivity*. The former means
alphabetical separation of word-forms of the same word, e.g. English *see/
saw*; *is/are/were*; French *oeil* 'eye'/*yeux* 'eyes'; Russian *idti* 'to go'/*šel*
'went'; and the latter, i.e. homoform insensitivity, refers to the lumping
together of homographic forms on the basis of spelling identity alone,
without taking phonological and semantic differences into account. No
doubt pre-editing, effected either manually by discriminatory coding or,
to a large extent, by sophisticated programming relying on morphological
and syntactical constraints, can remedy the problem. Such remedies,
however, are time-consuming and it seems that the average concordance
maker is either unwilling or unable to invest in either approach.

The present paper is an outgrowth of the author's grappling with these
and other TCC shortcomings and presents one technique for dealing
efficiently with the problems of word-form diffusion and homoform
insensitivity. The accent is on minimal pre-editing and maximum
simplicity. Other approaches are also discussed in passing. In addition,
brief statements are presented on KWIC indexes and other concordance
types, and on the concepts of headword context and omitted words.

Tcc Structure

A TCC is an aggregate of word-form (WF) entries arranged in alphabetical order. Alphabetical order is tradition oriented and is a function of the source text language. A WF entry consists of a *headword*, the WF itself, WF_i, and *context*, i.e. source text material of arbitrary length co-occurring with WF_i. Context usually denotes a line of print for poetry TCC's and includes line-identifying information, such as source text page and line numbers. Optimally, if applicable, poem titles (instead of numbers referring to poem titles), and information on whether the line is a variant or not, may form part of the context. It can be easily seen that the TCC structure is quite simple. The layout is esthetically satisfying and is particularly suited to rapid scanning, although it requires more storage and printing space than actually needed.

The WF TCC is a significant formal improvement over the KWIC index format: word-form boundaries are always respected—this, of course, can be and occasionally is implemented in KWIC index runs. Tcc's are more flexible in that a headword can be followed by a frequency indicator—not that this feature could not be incorporated into a KWIC index. Also the KWIC index format does not readily translate into a dictionary-form concordance, especially when a linguistically-based context definition is adopted.

Whatever the actual relative merit of the TCC over the KWIC index, the fact remains that we are dealing basically with *a different arrangement of the same type of data*, and that there are actually more similarities between the two formats and variations thereof than there are differences. (Similarities include word-form diffusion and homoform insensitivity.)

Context Concept

The prevalent concept of context lacks theoretical foundations. It should be rather apparent that context delimitation, i.e. print-line of poetry for poetry concordances, is arbitrary and due to convenience. It makes good sense to pick such an arbitrary context length as the poetry line; it is convenient from a programming point of view as well as because of layout considerations. Yet, as is well-known, poetry lines and syntactical demarcations do not coincide.

However, when prose is concorded, the initial spurious appeal of print-lines as context decreases considerably. There rarely seems to be overlap of syntactic demarcation and prose print-lines; words are frequently truncated at the right end, and although ways can be devised to circumvent word truncation, still concordance context does not always constitute adequate linguistic context.

It seems to me that minimal requirements for concordance context should be coextensive with punctuational denotations, such as periods,

question marks, exclamation points, and semi-colons. These minimal requisites for concordance context appear to be a compromise between the established concordance context and a linguistically-viable context concept. Optimally, it should be possible for the concordance user to access as much context as he desires in a given search: on-line computing can offer that possibility, of course, but it is far from being practical. True, the user's source text can adequately simulate on-line accessing.

The concept of context which I am proposing has some other advantages: as free-form coding is understood to be operative, concomitantly greater coding flexibility and simplification of keypunching complexity result. More importantly, though, this context concept introduces a uniform means for both prose and poetry and circumvents the glaring artificiality of the print-line as context. (After all, print-lines, especially those of a prose text, can contain more or fewer characters depending on the particular font and setting: should such considerations determine context length?)

OMITTED WORDS

The problem of what to do with high frequency words is usually solved in TCC's by what may be styled a 'gambit' type solution. A gambit, of course, involves the sacrifice of some possibly valuable material.

In order to reduce the concordance volume (usually) certain function words are arbitrarily omitted from the concordance, and a list of such words is included in the introduction. It is informative to note that as much as one-third of the body of a Russian language concordance can be eliminated by introducing stop words. It would not be unfair, therefore, to suggest that sound business considerations have played a role in this regard.

In my introduction to *A concordance to the poems of Osip Mandelstam* (1974), I took issue with the tradition of omitted words. I argued that completeness and exhaustiveness are indisputably scholarly desiderata and should not be compromised, for there is no way to determine in advance what a particular user might be looking for in a concordance. The concordance maker must adhere to a design that satisfies the needs of as wide a spectrum of users as possible. If a concordance is to be a means of study of an author's language it must include function words, simply because an author had to use them and could not do without them. A concordance, I submit, can hardly afford to ignore them either.

THE DICTIONARY FORM CONCORDANCE

Word-form diffusion becomes an acute problem when one deals with data in a language which possesses a high degree of desinential variation. Russian is such a language. In compiling a concordance to the poems of Osip Mandelstam, it soon became apparent that the TCC format would

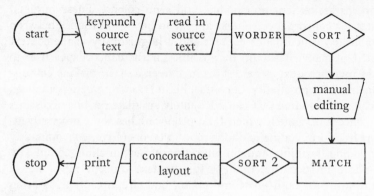

Figure 1

have to be enhanced. Of course, using the KWIC index format was out of the question. Consequently, once the decision to eliminate WF diffusion was made, or rather forced upon me by the nature of the data, my attention was turned towards optimal ways of implementing this decision. I thought it advisable to deal with the related problem of homoform separation at the same time. I wanted maximum retrievability with as little editing (manual or otherwise) as possible. I decided to keep the TCC format, as it was based on the well-tested dictionary retrieval approach and had become rather well established in its own right. The usual guiding principle to relegate as much work to the computer as possible would be operative.

In the background of such considerations, I proceeded to devise ways to deal with the aforementioned problems. A crystallization of my efforts is shown in the synoptic flowchart (see figure 1).

It was obvious from the start that the dictionary form (DF) should be the unifying reference point for all occurring WF's in a given concordance application. This was clearly a matter of practical convenience that made a great deal of sense. A DF is, of course, the 'initial' form, e.g. the infinitive for verbs, the nominative singular for nouns, adjectives, etc.

Both DF's and WF's are optionally followed by frequency designation. Frequency equals the number of contexts in which a given WF occurs. The grand total of all related WF frequencies may be appended to the DF.

Clearly, there was nothing novel in the DF concept—nor are concordances (manual) that fit this model lacking (see, e.g. the *Dictionary of Pushkin's Language*). But, to my knowledge, there was not a method which utilized hardware to accomplish a mightily time-consuming and decidedly tedious but essential task. It was my intention to eliminate as much of the tedium and retain as many of the creative aspects of concordance-making as possible. It has also been my intention to create a concordance which reflects the concorded author's language and

respects linguistic desiderata, such as content rather than merely ex-
pression. It was such convictions against which the adopted approach
was cast.

I believe that, because the resulting model turned out to be inherently
flexible, predictive, and extremely simple, one can reasonably expect to
see an increase in the number of dictionary-form concordances (DFC's)
produced in years to come.

DESCRIPTION OF DFC PROCEDURE

After concordance data are keypunched and proofread, a program
named WORDER (see figure 1) extracts each WF occurring in each
context record and places it immediately adjacent to the context record,
so that a longer record results (see figure 2):

1. $context_i \rightarrow context_i + WF_i$ (WORDER record)

WF_i serves as the sort-key. Note that for non-Roman alphabet con-
cordances, WF_i generates WF_i', a sort-key substitute, so that the WORDER
record might look like this:

1'. $context_i + WF_i (+ WF_i')$

After SORT 1 is completed, all WF's with their 'context' are listed in
alphabetical order with a serial number associated with each record.
Thus, records output by SORT 1 have the following structure:

2. $context_i + WF_i (+ WF_i') + serial number$

A certain modicum of manual editing cannot be bypassed. Of course, a
lot of programming can go into efforts towards language-specific
automated editing based on formal and/or syntactical criteria (see
Other Approaches, below).

Whereas the TCC editor usually concludes his task with formatting
the results of SORT 1, the DFC editor's job really begins at this point.
Next to the serial number, the editor writes the DF under which a given
WF is to appear. To save time and energy for the computer, the key-
punching personnel and himself, however, the editor indicates a DF
only *if different from the one immediately preceding*. Because any author's
vocabulary is finite, the amount of editing is minimized, and is a func-
tion of the language concorded. The fact that the more a language
varies desinentially, the greater the number of WF's, has no effect on the
number of written-in DF's. (In Osip Mandelstam's poetry, I found
about 16000 WF's.) Yet, the number of different DF's will be controlled
by other than fluctuations in the number of different WF's or their
frequency of occurrence.

Because WF's of the same word in the main occur alphabetically either
together or very close, a DF will have to be written only when WF's of a
different word group appear so that although the number of word forms
may be high, the number of actually written DF's is considerably
smaller.

16

*KAK PELA TIXAH VODA.	2 7911424 *VODA	16440 VODA	
*VO RVU -- PROZRA4NAH VODA...	2 8011516 *VODA	16441 _____	
*I SKOVANA L'DAMI ZLAH VODA.	2 14721211 *VODA	16442 _____	
*TIXIJ PAR STRUIT VODA,	2 172249 6 *VODA	16443 _____	
*S KOTOROGO RU4'EM LILAS' VODA,	2 20729737 *VODA	16444 _____	
*LIS' VOZDUX -- HSNYJ, KAK VODA...	3 18 3316 *VODA	16445 _____	
*TAM -- LIS' 4ERNAH VODA,	3 23 3815 *VODA	16446 _____	
*KAK SVINEC, 4ERNA VODA.	3 23 3911 *VODA	16447 _____	
*SPALA ZELENAH VODA,	3 111136 2 *VODA	16448 _____	
*I POD MOSTOM POET VODA:	3 12715810 *VODA	16449 _____	
*VODA GOLUBYX OZER		3 32341020 *VODA	16450 _____
*LIS' NEBO I VODA.	3 38349316 *VODA	16451 _____	
*A LUNA U# BLESTIT NA VODE.	1 26 29 2 *VODE	16452 _____	
*BLEDNYJ MESHC BLESTIT NA VODE...	1 26 29 8 *VODE	16453 _____	
*KAK OPROKINULSH V VODE	1 20620923 *VODE	16454 _____	
*V 4ERNOJ VODE OTRA#EN'E NESLOS'.	1 302310 8 *VODE	16455 _____	
*V 4ISTOJ ZERKAL'NOJ VODE	1 420388 5 *VODE	16456 _____	
*V NEBE, V TRAVE I V VODE	1 433395 5 *VODE	16457 _____	
*ODINOKO BOHRIN POD#EXAL K VODE...	1 48541718 *VODE	16458 _____	
*V STAL'NOJ, GLUXOJ VODE MERCAWT TENI,	1V651673 1 *VODE	16459 _____	
*V STAL'NOJ GLUXOJ VODE MERCAWT TENI,	1V651674 1 *VODE	16460 _____	
*V VODE, DA SKOL'KO VYPIL?	2 207298 9 *VODE	16461 _____	
*KAK RAZ NA SAMOJ ROZOVOJ VODE.	2 20829917 *VODE	16462 _____	
*BEGUT V VODE ZA NAMI. *V'ETSH BYSTRYJ SLED,	2 209304 6 *VODE	16463 _____	
*V VODE, KAK PLOSKAH SPINA MORSKOGO	2 20930414 *VODE	16464 _____	
*PO VODE STUPAT'		2 22932420 *VODE	16465 _____
*I NA ZEMLE, I NA VODE --	2 24633514 *VODE	16466 _____	
*VIDIT LAN' -- V VODE	3 308396 5 *VODE	16467 _____	
*I LESTNICA KRUTAH V T*MU VODILA.	1 189192 2 *VODILA	16468 VODIT?	
*NAS VODILA PAGUBNAH STRAST',	3 12215118 *VODILA	16469 _____	
	*KAK, VPRO4EM, VODITSH IZDAVNA	3 24432020 *VODITSH	16470 _____
*DAJ-KA NAM VODICY		2 21531512 *VODICY	16471 VODICA
*PRIDET I NAGLO SPROSIT VODKI,	3 244315 5 *VODKI	16472 VODKA	
*PROSIL NA VODKU U GOSTEJ...	1 74454717 *VODKU	16473 _____	
*BESSTRA$NAH, NA VODNOJ BYSTRINE.	1 186189 6 *VODNOJ	16474 VODNYT	
*TOGDA, ALEH NAC VODNOJ BEZDNOJ,	2 12417613 *VODNOJ	16475 _____	
*A *ON -- PROSTERT NAD BEZDNOJ VCONOJ	2 149215 3 *VODNOJ .	16476 _____	
*IX KORABLI V PU4INE VODNOJ	3 68 87 9 *VODNOJ	16477 _____	
*I KORABLI IX V BEZDNE VODNOJ	3V 68522 2 *VODNOJ	16478 _____	
*ZA4EM ISTO4NIK VODNYJ NE ISSHK?	1V 857410 *VODNYJ	16479 _____	
*U# S BO4KOJ VODOVOZ PROEXAL,	3 24431013 *VODOVOZ	16480 VODOVOZ	
*V VODCVOROT...	3 43 5614 *VODOVOROT	16481 VODOVOROT	
*TAM -- V OKEANE -- V ZEMNOM VODOEME --	20 36 56 7 *VODOEME	16482 VODOEM	
*A VVERXU, V VODOEME TVOEM,	3 13716624 *VODOEME	16483 VODA	
*NAD STOH4EJ I R#AVOJ VODCJ	2 15 2732 *VODOJ	16484 _____	
*I NAD VODOJ, ZA MGLOJ TUMANNOJ,--	2 60 85 7 *VODOJ	16485 _____	
*S P'HNO-ALCW VODOJ,	2 10614914 *VODOJ	16486 _____	
*ZALIT SINEJ VODOJ.	2 23733020 *VODOJ	16487 _____	
*NAD VODOJ POD#EMNYJ KRAN,	3 7 19 6 *VODOJ	16488 _____	
*TOQIJ KUST I SKALU NAC VODOJ...	3 20924424 *VODOJ	16489 _____	
*4EJ BREG, VSTAWQIJ NAD VODOJ,	3 31840316 *VODOJ	16490 _____	
*POKROPIL VODOJ STRU4OK,	3 325412 6 *VODOJ	16491 _____	
*NAD VODOJ VSTAWT I REWT.	3 37849014 *VODOJ	16492 _____	
*4UT' VIDNY POD VYSOKCJ VODOJ...	3V20958226 *VODOJ	16493 _____	
*S DU$OJ VODOLAZOV, S OTVAGCJ BOJCOV		2V 3339330 *VODOLAZOV	16494 VODOLAZ
*GROZHQIJ BELYJ VODOPAD.	1 422389 8 *VODOPAD	16495 VODOPAD	

Figure 2. From *A Concordance to the Poems of
Alexander Blok* by Demetrius J. Koubourlis

Homoforms are separated in the same step by appending Roman numerals or other discriminatory tags immediately after the DF, e.g.

> English: plane I 'airplane'
>
> plane II 'carpenter's tool'
>
> Russian: *mex* I 'fur'
>
> *mex* II 'bellows'

The next step after manual editing has been completed consists of keypunching only the written-in DF *plus* its corresponding serial number.

MATCH attaches the DF to the correct record by matching serial numbers and generates the most recent DF for all records until another DF appears and so on. The MATCH record has the following form:

3. $\text{context}_i + \text{WF}_i (+\text{non-Roman alphabetic adjustment}) +$

$\text{serial no.} + \text{DF}_i (+\text{non-Roman alphabetic adjustment})$

Note that the above record format is extremely flexible as it permits sorting in Roman and non-Roman alphabetical order as well as effecting inter-DF and intra-DF sequencing.

Finally, SORT 2, a variation of SORT 1, takes over. The result is a

concordance which, in addition to homoform differentiation and elimination of word form diffusion, features minimization of manual editing and maximization of retrievability.

The author is now converting his completed, but unpublished, *A Concordance to the Poems of Alexander Blok* from a TCC to a DFC. The same procedure is being applied to a *Concordance to the Poetry and Drama of Nikolai Gumilev*, as well as to a *Concordance to the Tapisseries* of the French poet, Charles Péguy, and to a Latin concordance of the works of Corripus.

OTHER APPROACHES

In an attempt to concord the poetry of Thomas Traherne, I experimented with attaching part-of-speech tags to each WF before the text was keypunched. I found, after examining part-of-speech/WF overlap, that not all parts-of-speech needed tagging. This tagging procedure proved extremely laborious. The possibility of error in part-of-speech determination was intensified by instances of idiosyncratic poetic licence. Several times structural ambiguity led to a dead end. Needless to say, the part-of-speech approach has been abandoned; the DF approach, in my opinion, shares none of its shortcomings and is not only infinitely faster but a great deal more dependable.

Another general approach, the 'brute-force' method (which I cannot recommend either), can be used to produce a DFC. SORT 1 output in TCC format is computer punched. Next, inter- and intra-word sensitivity is manually achieved, i.e. WF's of the same word are brought together under an occurring or creatable DF, and homoforms are simultaneously separated. Subsequently, cards thus rearranged are 'read in' and computer preparation of camera copy ensues.

Still another method, which is language-specific and mostly automated, is linguistically based but should be either dismissed outright or used as an intermediate step toward the creation of a DFC: WORDER output is checked against a table of endings. The sort-key ending is truncated if a match is made, i.e. if a given ending appearing in the table 'occurs' in that sort-key, e.g. *ogo* 'gen. sg. masc. neuter' in Russian adjectives is an 'ending' found in the sort-key, *molodogo*. The resulting sort-key substitute becomes *molod* and is written adjacent to the old sort-key. No doubt mistruncations will occur, hence the opening lines in this paragraph.

Additional insights in dealing with the problem of bringing WF's of the same word under one lemma can doubtless be gained from work on automated morphemic analysis (see Koubourlis and Nelson 1974). Mere phonological analyses relying on an *a priori* provided reference library (see Kay and Martins 1970 or Chapin and Norton 1968) or on statistical information gathered from the data by computer (see Harris

1955) or morphological analyses introduced via pre-editing (see Worth 1970) can assist in the transition from a TCC to a DFC.

In summary, providing part-of-speech tags via look-up tables or designating morphemic cuts, in particular desinential ones, or a procedure based on the freedom of occurrence of either phonemes or graphemes, are among the automatable ways that help bring together WF's separated by inflectional variation.

OTHER CONCORDANCE TYPES

One concordance type related to the dictionary-form concordance is the *cluster concordance*. A sample of this is my Mandelstam concordance which, I believe, will prove highly satisfactory from the point of view of the user. From the point of view of the editor, however, it is very time-consuming.

WF cluster and DF concordances are quite similar in that they both are intra-word and inter-word sensitive but differ only in intra-word alphabetical order. Both concordances use the dictionary form as the alphabetical reference point, thus guaranteeing the same degree of retrievability found in a dictionary.

The DF concordance insets all WF's of one word under the DF in strict alphabetical order. The WF cluster concordance gathers such WF's around the DF, before if they precede alphabetically, and after if they follow alphabetically. WF's thus moved (in order to eliminate WF diffusion) are inset. The advantage of the cluster over the dictionary-type concordance is that, whereas the reference point in a dictionary concordance, i.e. the DF itself, must be present and head the entry, the reference point in the cluster type need not be present and need not be in the initial WF (i.e. infinitive for verbs, nominative singular for nouns, adjectives, etc.). In either case, strict alphabetical order is observed on two levels, both among headwords and, within a headword, among WF's.

Ongoing experimentation with concordance data manipulation will no doubt contribute to an already expanding arsenal of high powered tools at the disposal of twentieth-century language and literary scholars.

Finally, another possible type of concordance, perhaps a special purpose one, is the *topical* (or thesaurus) *concordance*. This aims at bringing together under one heading semantically-related words found in a given source text, e.g. 'God', 'Lord', plus any other references to the deity. Especially for literary scholars, it is transparent that a topical concordance could be of unparalleled value in the scrutiny of an author's expression and content. However, some difficulties, not considered unsurmountable, can arise in the treatment of topical group membership.

REFERENCES

Chapin, P. & Norton, L. M. (1968) A procedure for morphological analysis. *Information systems language studies*, no. 18. Bedford, Mass.: MITRE Corp.

Dictionary of Pushkin's language. Akademija Nauk SSSR. Institut Jazykoznanija, 1956. *Slovar' jazyka Pushkina* (4 vols., ed Vinogradov, V. V. *et al.*). Moskva-Leningrad: ANSSSR.

Harris, Z. S. (1955) From phoneme to morpheme. *Language*, **31**, 2, 190–222.

Kay, M. & Martins, G. R. (1970) The MIND system: the morphological analysis program, RM-6265/2-PR. Santa Monica: The RAND Corp.

Koubourlis, D. J. (1974) *A concordance to the poems of Osip Mandelstam.* Ithaca: Cornell University Press.

Koubourlis, D. J. & Nelson, D. J. (1974) *Phoneme non-randomness and the mechanical morphemic segmentation of Russian.* Cambridge, Mass.: Slavia Publishers.

Worth, D. S. *et al.* (1970) *Russian derivational dictionary.* New York: American Elsevier.

P. BRATLEY
S. LUSIGNAN
FRANCINE OUELLETTE

JEUDEMO : a text-handling system

Despite the undoubted advances which have been made in the areas of syntactic and semantic analysis by computer, it still seems to be generally true that the computer's main contribution to literary endeavour is in the provision of concordances, word-indexes, and rather unsophisticated statistics. For every user who is faced by serious theoretical problems, there are probably a dozen who are still at the stage where the more mundane concerns of punching cards, writing FORTRAN, and plotting histograms loom sufficiently large in the foreground to hide entirely the theoretical difficulties which lie beyond. The system we describe is intended to remove at least part of this everyday burden from the literary user, thus freeing his energies for the more interesting and important aspects of his work.

This system is the latest in a series of such text-handling programs, of increasing sophistication and power. It is directly descended from such systems as COCOA (Russell 1967), developed at the SRC's Atlas Computer Laboratory, and CONCORD (Hamilton-Smith 1970), developed in collaboration by the Edinburgh Regional Computing Centre and the Dictionary of the Older Scottish Tongue. Other features have been borrowed from various information-retrieval systems, the most direct contribution coming from the Université de Montréal's DATUM project (Stewart 1972), which is concerned with the retrieval of legal decisions. Our aim, like that of our predecessors, is to provide the literary scholar who has little or no knowledge of computer science with a simple but at the same time highly flexible tool which he can use without assistance for the main functions of text-processing, such as making indexes, generating concordances, counting vocabulary, and performing a wide variety of statistical calculations.

OVERVIEW
It is convenient to distinguish three main steps in the typical text-processing task. First, we must describe the structure of the text with which we are concerned; secondly, we must describe the operations we wish to perform and specify any restrictions which must be placed on these operations; and thirdly, it may be necessary to define the format in which our results are to be printed. For instance, suppose we wish to search for a particular pattern of words within a particular section of the text, and that we have some special requirements for the format of the

output. In this case all three stages must be defined explicitly: we must describe the structure of the text so as to be able to specify the sections we require; the restrictions on the search, both on the pattern we are looking for and on the boundaries of the search, must be given; and the output format must be described in detail. On the other hand, it may happen that most of the stages can be omitted. If all we want is a straightforward vocabulary count, then there may be no need to structure the text (if we intend to use it all), no need to place restrictions on the count (if all the words of the text are to be counted without exception), and no need to specify an output format (if, for example, the system offers a default option which is suitable).

The facilities offered at each of these three stages by our system are sketched below, and described in more detail in the system User's Manual (Ouellette 1972). At the stage of describing text structure, they include the ability to define a hierarchy of word-separators, so that for instance blanks may be recognised as word-separators, commas as phrase-separators, and periods, colons, and question marks as sentence-separators; the ability to add a special code to each word, so as to distinguish between homographs or so as to specify grammatical function, for instance; the ability to describe more general structure within a text, for instance so as to distinguish between the speeches of the different characters in a play; and the ability to distinguish the fact that a text may be composed of sections in several different languages, each with its own alphabet, punctuation characters, and so forth. It should be noted that no fixed system of coding is imposed on the user, who can use whatever system he pleases to transcribe his text and mark the structural divisions.

At the stage when an operation is to be specified, most of the standard requirements are catered for. The system can be used to generate straightforward word-counts or key-word-in-context (KWIC) concordances for a whole text or for certain sections. If this is all that is required, no special files are built. On the other hand, it is possible to use the system to set up a number of indexes to the text, which give the reference of every word and of certain of the text-separators in such a fashion that it is subsequently possible to cite all occurrences of a particular word or pattern of words within a desired section of the text. These special indexes are saved automatically, so that the user, having once set them up, can come back at any subsequent time with requests for different words or patterns. The kind of patterns that can be specified allow the user to insist, for instance, that two given words be juxtaposed, that they occur in the same sentence, or within a certain distance from one another; words can be specified *in extenso* or by giving a root or a termination; and facilities are available by which an experienced user can build up arbitrarily complicated patterns.

The section of the text to which an operation is to be applied can also be specified in a variety of ways. For instance, in a play, we can apply an operation to all the speeches of one of the characters, and ignore the rest of the text. If a text contains sections in several different languages, we may decide to treat only some of them, or to omit some designated set. The sections of text to which an operation will apply need not be contiguous, so that very general structurings can be obtained.

At the output stage, a number of possibilities are at present offered by the system. Concordances, for instance, can be output with a variety of different contexts, defined in terms of a number of characters, or in terms of a sequence bounded by given punctuation marks. If desired, the context can be omitted completely, and simple references given to the patterns found, thus producing a straightforward index.

Despite the wide range of possibilities offered by the system, we hope that it should prove rather easy to use in practice. In the pages which follow, we give some examples of the kind of command-sequence needed to perform typical jobs, and it will be seen that some very complicated operations can be set up using comparatively few instructions. (All the instructions in the system have French mnemonics.) The system is much less complicated to use than any programming language, even an appropriate one such as SNOBOL, and it will ensure that even an unskilled user will be able to perform text-processing tasks with a high degree of computational efficiency, thus easing the strain both on his research grant and on the university's computing centre.

INSTRUCTIONS FOR DESCRIBING A TEXT

We assume that the user has found some way of getting his text into the computer, whether it be by punching cards, by a key-to-tape machine, or by optical character reader, and describe now the instructions available for specifying to the system how his text is to be interpreted. In the examples which follow, we assume most of the time that the input medium is a punched card, where the input character set is severely limited, to the upper-case letters, the ten digits, and a small number of special symbols.

The following terminology will be used. A *character* is something which is related to the method of input: thus a character might correspond to one column of a punched card, or one line of holes in a paper tape. A *symbol* is an entity represented by one to five characters: thus the symbol TH is represented by the two characters T and H. Symbols are divided into two classes, namely *letters*, which correspond to the letters of the alphabet in the language being treated, and *separators*, which correspond to everything else. For example, if we are working in Greek, the symbol TH might correspond to the letter θ; if our card punch lacks a semi-colon, the symbol ., might be used to correspond to this

when necessary. A *word*, as far as our system is concerned, is a string of letters between two separators.

For the sake of clarity, we are forced when writing commands to use the notation BLANC to represent the space character, and the notation FDL ('fin de ligne') to represent a fictitious character marking the end of a card, or the genuine carriage-return character at the end of a line on paper tape. Thus the symbol -BLANC is composed of two characters, a hyphen followed by a space.

It may sometimes happen that the string of characters representing a particular symbol is contained within the string of characters representing some other symbol. The system will in this case always form the longest symbol possible. Suppose, for instance, that the Cyrillic alphabet is transcribed using the letters CH, SH, and SHCH. In this case the sequence of characters SHCH will always be treated as one symbol, never as two. Similarly, it is possible to use such symbols as -FDL or -BLANC as separators even though - alone is treated as a letter of the alphabet.

THE INSTRUCTION ALPHABET

This instruction is used to specify to the system the transcription that has been used for a particular text. The instruction gives a list of the symbols which are to be considered as letters of the alphabet, and also gives by implication the order of these letters. For instance, suppose we have a French text to encode. We decide to transcribe é as E/, è as E%, ê as E*, ë as E″, and so forth. The corresponding instruction specifying the alphabet would have the form:

ALPHABET = A, A%, A*, B, C, C%, D, E, E/, E%, E*, E″, F, G, H,
. I, I*, I″, J, K, L, M, N, O, O*, P, Q, R, S, T, U, U%,
. U*, U″, V, W, X, Y, Z

(The period at the start of lines two and three is a continuation character for system instructions.) In this case we have defined an alphabet of 39 characters, in which the letter é, for example (transcribed E/), is a different letter from e and follows it in the alphabet. If on the other hand we wanted é and e to be distinguished in the citations produced by a concordance program, but treated otherwise as if they were one and the same letter, it is sufficient to omit the comma between them. Thus the instruction:

ALPHABET = A A% A*, B, C C%, D, E E/ E% E* E″, F, G, H,
. I I* I″, J, K, L, M, N, O O*, P, Q, R, S, T,
. U U% U* U″, V, W, X, Y, Z

defines a 26-letter alphabet, but preserves the difference between the accented forms of a letter when citations are printed.

THE INSTRUCTION SEP MOTS

This instruction serves to define the symbols which are to be considered as separating two words. For example, such symbols as spaces

and punctuation marks will usually be word separators. In the simplest
case, the required separators are simply listed:

 SEP MOTS = , . : ; () BLANC FDL

More usefully, we may define a hierarchy containing several levels
of separators. For instance, the lowest level of separators could mark the
end of a word, the next level could mark the end of a sentence, and the
third level could mark the end of a paragraph. (A separator at any level
is also a separator for all the lower levels.) The hierarchy thus established
can be used later to put limits on the search for certain words, for
instance by insisting that they occur in the same sentence, and to define
the context output with a word in a concordance. As an example, sup-
pose the lines of a poem are marked either by the end of a line on the
page or by the character /, that the special symbol *V occurs after each
verse, and the special symbol *P after each poem. The declaration of this
structure might be

SEP MOTS = NIVEAU 0 WORD	BLANC , .	
. NIVEAU 1 LINE	FDL /	
. NIVEAU 2 VERSE	*V	
. NIVEAU 3 POEM	*P	

Notice that separators, like letters, may be composed of several charac-
ters. Again, the period at the beginning of a line is a continuation sign.
The levels of separators are given in order, and each one, besides having
a number, has a name.

As a convenience to the user, any characters of his text whose role is not
stated explicitly are taken to be separators at the lowest (word) level. This
means, for instance, that he does not have to worry about listing all the
odd characters such as digits and punctuation signs which might happen
to occur in his text unless they are there for a very specific purpose.

THE INSTRUCTION SEP TAMPONS

A text will often contain dummy characters which appear in the middle
of a word, but which are not really part of that word. For instance, the
hyphen which marks the fact that a word has been broken across the end
of a line is one such character. The instruction SEP TAMPONS declares
these characters to the system, which will thereafter remove them from
the text as it is read. For instance, suppose we wish to transcribe French
using the following convention: in a compound word, there are no
spaces around the separating hyphen (GRATTE-CIEL, BOUCHE-TROU);
when a hyphen separates a verb from its pronoun, in a question for
example, the hyphen will be followed by a space (AVEZ- VOUS, A- T- IL);
and when the hyphen is the last character on a line, it indicates a broken
word. This convention can be described using the following instructions:

ALPHABET	=	A, B, . . ., X, Y, Z, -
SEP MOTS	=	-BLANC FDL
SEP TAMPONS	=	-FDL

Now the hyphen of a compound word is treated as a new letter of the alphabet, the hyphen followed by a space (-BLANC) is treated as a word-separator, and the hyphen followed by an end-of-line (-FDL) is ignored.

The instruction Sep Codes

It is possible with our system to attach a code to every word of a text. Such codes are commonly used to associate a grammatical category to a word, for example, or to distinguish between homographs. In the system indexes, the codes are conserved along with the words, so that words with the same spelling but different codes are counted as different words. A word index ordered by codes can also be produced. A simple example would be the following:

SEP CODE = []

allowing a text to be coded subsequently in the following format:

THE[D] CAT[N] SAT[V] ON[P] THE[D] MAT[N].

The instruction Langue

It may occasionally happen that a text contains a mixture of languages, each of which has its own alphabet and transcription system, its own required word-length, and so forth. For instance, this may happen with a text which consists of commentaries in one language on a work in another; it can also happen in the case of macaronic verse. Our system therefore allows the user to declare several different languages, and appropriate symbols to indicate a change from one to another.

It should be noted that although this facility is described in terms of using several different natural languages, it can be of great utility for other purposes. For instance, it may be convenient to attach lemmatised forms to all the words of some text. In this case, we could treat the original text as if it were in one language, and the lemmatised forms as if they were in another, so that the word-indexes, for instance, of the words of the text and of the lemmatised words would be printed separately. Again, suppose that several versions of a work are available on several different manuscripts. In this case, we could declare the lines from each of the manuscripts as if they were in different languages, which again would enable us to prepare separate word-indexes and so on for each of the manuscripts. Later, it would be sufficient to remove the relevant declarations from the deck of instructions, and the text could then be treated as a whole, if so desired.

The instruction LANGUE which declares a new language to the system contains two elements, a special symbol which is to be used to indicate a shift into the language concerned, and the name of the language. For instance, for a bilingual text we might declare:

LANGUE = ANGLAIS ((A
LANGUE = FRANCAIS ((F

Now a change into French will be signalled by the special symbol ((F,

et un retour à l'anglais par ((a. Each declaration of a new language must be followed by the necessary instructions to describe the alphabet and separators of that language.

THE INSTRUCTION SEP TITRE

Titles are used to divide a text into sections and sub-sections which can subsequently be specified in a request for a concordance or word-list, thus enabling the range of such a request to be limited to certain portions of the text. A title consists of a heading and a name, and possibly an optional commentary. All the titles with some particular heading define one way of splitting the text into subsections. If it is necessary to divide the text into subsections in several different ways, then each of these different ways can be described by a series of titles with a particular heading, since titles with different headings do not interfere with one another. The following example uses only one series of titles, with the heading SPEAKER:

```
SEP TITRE = /T  T/
/T SPEAKER PAT T/   I SAY, I SAY, I SAY. WHAT'S THAT ON
                    YOUR SHOULDER ?
/T SPEAKER MIKE T/   THAT'S A GRECIAN URN.
/T SPEAKER PAT T/   WHAT'S A GRECIAN URN ?
/T SPEAKER MIKE T/   ABOUT 5000 DRACHMA A YEAR,
                    ON AVERAGE.
```

This example shows four sub-sections of text, namely the pieces of text between each change of speaker. Subsequently it will be possible to ask for concordances of all the speeches made by MIKE, for example, or, by giving more detailed instructions, to ask for a word-search just in PAT's second speech. As already mentioned, a completely independent series of titles such as /T ACT 1 T/, /T ACT 2 T/, ... could be added to the text without in any way affecting the structuring imposed by the SPEAKER series.

Figure 1 gives an example of the instructions used to describe a rather simple text in French. Not all the possibilities of the system are used, of course, in this short example. We have key-punched some lines taken from the play 'Fantasio' by Alfred de Musset. The instruction REF = 10 GAUCHE indicates that the first ten characters on each line contain its reference number, and LONG MAX = 25 fixes a length beyond which words will be truncated.

RESTRICTED CONCORDANCES AND WORD LISTS

There are currently five commands which a user can give to the system to start system operations. These are VOCAB, KWIC, INDEX, LISTE, and CONCO. The first two of these furnish respectively a list of all the words present in a text, and a key-word-in-context (KWIC) concordance, again for all the words of a text. These two commands do not cause any

```
TRE          = DESCRIPTION DE LA PIECE FANTASIO D'ALFRED DE MUSSET
MMANDE       = INDEX
F            = 10 GAUCHE
? TITRE      = [  ]
NGUE         = FRANCAIS
PHABET       = A, A%, A*, B, C, C%, D, E, E/, E%, E*, E",
               F, G, H, I, I*, I", J, K, L, M, N, O, O*,
               P, Q, R, S, T, U, U%, U*, U", V, W, X, Y, Z, -, -FDL
PARATEURS    = NIVEAU 0 MOT BLANC , : -BLANC 'BLANC ... FDL
               NIVEAU 1 PHASE ; . ! ? ( ) "
P TAMPONS    = ' --FDL
NG MAX       = 25
ITION        = COL 3 REF 1
TIONS        = ALPHA P, FREQ
N
,1 0001 [ACTE I] [SCENE I] [P ROI]
;1 0002 MES AMIS, JE VOUS AI ANNONCE/, IL Y A DE/JA% LONG--
;1 0003 TEMPS, LES FIANC%AILLES DE MA CHE%RE ELSBETH AVEC LE PRINCE DE
;1 0004 MANTOUE, JE VOUS ANNONCE AUJOURD'HUI L' ARRIVE/E DE CE
;1 0005 PRINCE; CE SOIR PEUT- E*TRE, DEMAIN AU PLUS TARD, IL SERA DANS
 1 0006 CE PALAIS. QUE CE SOIT UN JOUR DE FE*TE POUR TOUT LE MONDE;
;1 0007 QUE LES PRISONS S' OUVRENT, ET QUE LE PEUPLE PASSE LA NUIT
;1 0008 DANS LES DIVERTISSEMENTS. RUTTEN, OU% EST MA FILLE ? (LES
;1 0009 COURTISANS SE RETIRENT).
```

Figure 1. An example of a command sequence in JEUDEMO

indexes to be built, since they are complete in themselves. On the other hand, the other three commands are concerned with indexes created by the system and permanently associated with a particular text. The command INDEX causes these indexes to be built, and then the commands LISTE and CONCO subsequently use them. LISTE causes a search for a particular word or pattern of words, and provides a list of references to all the places in the text where the pattern is to be found; CONCO acts similarly, but in addition to the list of references, each instance of the pattern is printed out within some context determined by supplementary instructions to the system.

It is clear that the user will not always want to apply these operations to the whole text. He may, for instance, only want the list of vocabulary for one or two of the languages present in a text; he may be concerned to look for a particular pattern of words only within certain parts of his text delimited by different titles; or he may not care to include in a KWIC concordance words whose frequency of occurrence lies outside a certain designated range. Restrictions of this type can be expressed by the instructions MOTS FREQUENTS and SECTION, which are described below.

It should be noted that the instruction MOTS FREQUENTS is generally used at a stage before the system indexes have been constructed, and indeed that it affects the construction of these indexes. SECTION on the

other hand can generally only be used in its full generality after the system indexes have been built.

THE INSTRUCTION MOTS FREQUENTS

This instruction serves to avoid keeping large quantities of unwanted information in the system's indexes. Normally, a reference is kept in the index for every occurrence of every word of the text. However, for very high frequency words, this may not be necessary, if, for example, it is certain that the user will never want to print concordances to these words. The instruction MOTS FREQUENTS specifies to the system a list of words for which it is not necessary to keep references. For example,

> MOTS FREQUENTS = FREQ 500 TOM DICK HARRY

specifies that it is not necessary to keep a list of references for the three words TOM, DICK, and HARRY, nor for any word which occurs 500 or more times in the text.

Different high-frequency words, or a different cut-off, can be specified for each language of a text.

SECTION BY LANGUAGE

Suppose our text is composed of three versions of a poem taken from three different manuscripts and that we decided at an earlier stage to treat each of these versions as though they were in a different language, named MANUS1, MANUS2, and MANUS3. If now we want a list of vocabulary for the third manuscript taken alone, it is sufficient to use the appropriate command (VOCAB) together with the instruction:

> SECTION = LANGUE MANUS3

If we wanted a combined list for the first and second manuscripts, we could use:

> SECTION = LANGUE MANUS1 MANUS2

or alternatively, to show the instruction in its negative form,

> SECTION = NON LANGUE MANUS3

SECTION BY TITLES

In this form the instruction refers to the heading of one of the series of titles which has been added to the text to define its structure. For example, in a previous paragraph we saw a text representing a conversation between two speakers, whose utterances were entitled SPEAKER PAT and SPEAKER MIKE. Should we now require to work only on the words said by PAT, it is sufficient to use

> SECTION = TITRE SPEAKER PAT

If we wished to confine ourselves to the first twenty speeches by PAT, we could use:

> SECTION = TITRE SPEAKER PAT*1 − PAT*20

while if for some unlikely reason we wanted to examine the first, ninth, and fourteenth speeches by this person, we could put

> SECTION = TITRE SPEAKER PAT*1 PAT*9 PAT*14

SECTION BY FREQUENCY

Should we happen to want a list of all the words which occur only once in a given text, we can use the command LISTE together with:

SECTION = FREQ 1

If we want all the words which occur five times or less, this becomes:

SECTION = FREQ 1–5

while to print all the words which occur less than ten or more than one hundred times, we might use:

SECTION = FREQ 1–9 101–*

Sections of different types can be combined, so that if PAT and MIKE had happened to be conversing sometimes in Irish and sometimes in Latin, say, we could refer to all the words which occur just once in PAT's speeches in Latin by

SECTION = TITRE SPEAKER PAT, LANGUE LATIN, FREQ 1

In general, when several conditions are given in this fashion, the section of text used is that which simultaneously satisfies all of the conditions.

THE COMMANDS VOCAB AND KWIC

It has already been mentioned that these commands neither use nor create permanent indexes associated with a text. Although they may be all that is required in certain simple cases, when a user is quite certain that he will be satisfied to have a vocabulary list or a simple KWIC concordance, they are generally most useful at the early stages of a particular project, when there are still likely to be misprints and errors in the text being studied. In this case, VOCAB and KWIC can be of great assistance in detecting errors up until the moment when a reasonably clean text has been obtained. At this point INDEX can be used to construct the system indexes with some degree of certainty that this work will not be wasted, and that from now on it is going to be necessary to use LISTE and CONCO for the more detailed aspects of the research.

VOCAB, as mentioned above, allows the user to obtain a list of all the words in a text, together with their frequencies and if appropriate with their codes. The list can be obtained in alphabetical order or in order of frequency by using the OPTIONS instruction. If required, one or more references can also be printed out with each word, although no context will be given.

The command KWIC produces a complete concordance to all the words in a text. The context provided can be either the line of the text on which the word appears, or else a given number of characters on either side of the keyword. The line of context can be printed so that the keyword is centred on the page, or it can be left in its original form. In the former case, it is possible to specify that identical keywords should be further sorted on their right- or left-hand contexts.

With either VOCAB or KWIC it is possible to use the instruction

MOTS FREQUENTS to give a list of words to be omitted, but not to specify a cutoff frequency; and the instruction SECTION can be used to control which languages are considered, but not to specify a control by titles or by frequency. The two commands can be combined in the form:

COMMAND = VOCAB KWIC

to obtain both a vocabulary list and a KWIC concordance.

THE COMMANDS INDEX, LISTE, AND CONCO

Using VOCAB and KWIC, it is possible to obtain a list of all the words in a text, or a simple complete concordance. However, it is not possible to use these commands to obtain, for example, a list of the words in inverse alphabetical order; it is not possible to define contexts for the keywords of the concordance in terms of the hierarchy of separators present in the text; and it is not possible to cite individual words, or words from individual sections of text. Whenever results such as these are needed, it is necessary first of all to construct the indexes to a text using the command INDEX, and then subsequently to use either LISTE or CONCO to obtain the desired output.

THE COMMAND INDEX

The command INDEX should only be used once on a particular text. When it is used, it can produce, besides the system indexes, one or more lists of words in any of a variety of different orders. If subsequently it is necessary to produce a word-list in an order which was not anticipated, the command LISTE should be used. LISTE offers the same possibilities of ordering as INDEX.

The command INDEX, like VOCAB and KWIC, must appear in a short program which defines the characteristics of the text to be used. As with the commands VOCAB and KWIC, the only form of the SECTION instruction which can appear is that which includes or excludes a set of languages.

The options available with this command are ALPHA, CODE, FREQ, INVER, TABLE, and TITRES; some of these options may have the letters A, C, D, or P added to extend the range of possibilities. The main options have the following significance: ALPHA asks for a list of words in alphabetical order; CODE asks for a list of words sorted according to their codes; FREQ asks for a list of words in ascending (sub-option A) or descending (sub-option D) order; INVER asks for a list of words in inverse alphabetical order, that is to say, in the order which would be obtained if the words were read from right to left instead of from left to right; TABLE asks for a table showing the number of words of each frequency in the text; and TITRES asks for the text's table of contents. The sub-options C and P, which can be added to most of the options, ask respectively for the codes to be printed, and for the words to be printed with the relative and cumulative percentages. Several options can be

required with the same command: if no options are demanded, this is as if one had asked for ALPHA and TITRES.

Further control over the lists produced by the INDEX command is given by the instruction EDITION, which can be used to specify the number of columns of words to be edited in a page, and the number of references to the text which are to be given for each word in the list. Figure 1 gives a complete command sequence using the command INDEX.

EXPRESSIONS

Once the system indexes to a text have been built, it is possible to ask for lists of words from particular sections of text, or to search in the text for particular words or groups of words. The pattern of words for which a search is to be made is defined by an *expression*, which can be described by a single instruction or by a series of instructions. When a series of instructions is used, this may either be so that different restrictions can be placed on different parts of an expression, or else in order to simplify the presentation of a complex expression.

In an expression, the sign + can be used to indicate the missing ending or beginning of a word, thus enabling the user to search for all words with a particular stem or ending. For instance, the pattern AM+ can be used to find all the words beginning with AM, such as AMI, AMANT, or AMOUR; the pattern +OUR will find all the words which end with OUR, such as AMOUR, BONJOUR, or COUR. Notice that this convention renders it inadvisable to use + as one of the letters of the alphabet when transcribing a text.

It is possible to add restrictions to an expression by specifying the codes of the words involved, their relative position, the distance between them, or the language in which they appear. Furthermore the SECTION instruction can be used in its full generality to restrain the area of search.

A reasonably complicated example of an expression is the following:

EXPRESSION = HARRY, TOM + DICK, BILLY THE KID + FRED+

where we are searching for sections of text which include the word HARRY, *both* the words TOM and DICK or else *both* the phrase BILLY THE KID and a word beginning with the letters FRED. Note that there is no confusion in the use of the sign + in this last example. The + at the beginning or at the end of a word indicates that a part of the word is missing while the + between two blanks in an expression indicates the search for the co-occurrence of two words (or sub-expressions).

Complicated expressions can be divided up into sub-expressions in the following way:

s1 = ELSBETH
s2 = PRINCE DE MANTOUE
s3 = FANTASIO
EXPRESSION = s1 + s2, s3

17

In this example we are looking for the co-occurrence of ELSBETH and PRINCE DE MANTOUE, or else for the occurrence of FANTASIO.

Restrictions can be applied either to sub-expressions, or else to a complete expression. First, restrictions can be applied to the codes of the words involved in an expression. Suppose that the characters [and] had been chosen as code separators (using SEP CODE) when a text was defined, and that, for instance, the word PERSONNE had had two homographs distinguished in the text as PERSONNE[PR] and PERSONNE[N]. Should we wish to search only for the latter of these possibilities, it is sufficient to add the required code, using the same separators, in the expression:
EXPRESSION = PERSONNE[N]

Secondly, the order of words in an expression can be restricted. For instance, the expression:
EXPRESSION = DOLCE + VITA − P
would cause a search for a section of text containing both the words DOLCE and VITA in that order (P : restriction on position).

Other restrictions can be imposed on the distance apart of the words in an expression, or on the language in which they appear. For instance, suppose that our text had been declared with three levels of word-separator, the levels being called MOT, PHRASE, and PARAGRAPHE respectively. Suppose furthermore that the text contained sections in three languages, called LAN1, LAN2, and LAN3. Then we could use any of the following expressions:
EXPRESSION = CAT + DOG − D 7
EXPRESSION = CAT + DOG − D 3 L
EXPRESSION = CAT + DOG − D 2 PHRASE
EXPRESSION = CAT + DOG − P, D PARAGRAPHE
These expressions would be used respectively to search for: the words CAT and DOG within a distance of seven words, within a distance of three lines in the original text (where a line is simply a physical unit, independent of the logical structure of the text), within a distance of two of the units called PHRASE in the logical structure of the text, and finally, within one of the units called PARAGRAPHE in the logical structure of the text. In the first three cases the order of the words is immaterial; in the fourth case CAT and DOG must occur in that order.
EXPRESSION = CAT − L LAN2
EXPRESSION = DOG − L NON LAN3
These two expressions request a search for the word CAT, but only in those parts of the text in the language LAN2; and a search for the word DOG, but only in those parts of the text which are not in language LAN3. Once again, it may be pointed out that expressions such as these may have little or no utility if the 'languages' used in a text are different natural languages, but that their true usefulness arises when the 'languages' are, for instance, different versions of the same work.

The command Liste

The command LISTE can be used in either of two different ways. In the first case, no expression is present with the command. In this case the command will furnish a complete list of all the words in the relevant section, in any of the orders possible with the command INDEX. On the other hand, it is possible to use LISTE with an expression, and in this case the list of words found will be given in alphabetical order. The first example given below shows how LISTE could be used to find certain given patterns of words in the first act of a play, assuming that the acts have been titled ACTE I, ACTE II, and so on, and that there is a level called PHRASE in the hierarchy of separators.

```
TITRE       = AN EXAMPLE OF THE USE OF 'LISTE'
COMMANDE  = LISTE
SECTION     = TITRE ACTE I
s1          = FILLE DU ROI
s2          = ELSBETH + FANTASIO − D 2 PHRASE
s3          = PRINCE + MANTOUE − P, D PHRASE
EXPRESSION = s1, s2, s3
```

Notice that the command precedes the associated instructions SECTION and EXPRESSION. A list of occurrences will be given for the group of words FILLE DU ROI, for each occasion when the words ELSBETH and FANTASIO occur within a span of two sentences, and for each occasion when the words PRINCE and MANTOUE occur in that order within the same sentence.

The second example shows how we could obtain a list in alphabetic order and a list in inverse alphabetic order of all the words used in act one of the same play:

```
TITRE       = WORD LIST OF ACT ONE
COMMANDE  = LISTE
SECTION     = TITRE ACTE I
OPTIONS     = ALPHA, INVER
```

The command Conco

This command is used to cite in context particular words or patterns of words. If no context is explicitly defined, then a default option is used. If the search is for a group of words, at least enough context will be given to include the whole group.

Context can alternatively be explicitly defined by the instruction CONTEXTE. For instance, suppose as before we have a text in which three levels of separators have been defined, namely MOT (the lowest level), PHRASE, and PARAGRAPHE. Then any of the instructions below could be used:

```
CONTEXTE = 120
CONTEXTE = 3 L
```

CONTEXTE = 2 PHRASE

CONTEXTE = PARAGRAPHE

These instructions define the context to be printed respectively as 120 characters, three lines, two of the units separated at the level called PHRASE, and one of the units formed by the separators of level PARA-GRAPHE. It will be recognised that this instruction bears a close analogy to the restrictions on distance used in an expression.

In certain simple cases, the instruction OPTIONS can be used. This is the case when the expression sought contains only single words, and no groups or co-occurrences, when the required context is less than 135 characters long (so that it will fit on one line), and when the keyword is to be centred. If all these conditions are satisfied, then the instruction:

OPTIONS = TRI DROITE

for instance, can be used to change the order in which citations are printed. Normally citations are given in the order in which they occur in the original text. However, using OPTIONS it is possible to arrange for all the citations of a particular keyword to be sorted on the right- or left-hand context of the keywords, as was also the case for the command KWIC.

We give below an example of the use of the command CONCO. In this example we are concerned to cite all the words of a given text which begin with the letters ANNONCE. Sixty characters of context will be given for each occurrence. The word cited will be centred on the line of output.

TITRE = EXAMPLE OF THE USE OF 'CONCO'

COMMANDE = CONCO

EXPRESSION = ANNONCE +

CONTEXTE = 60

EDITION = CENTRE

Although in this case no SECTION is defined, so that the whole text will be examined, it would have been perfectly acceptable to do so.

CONCLUSION AND PERSPECTIVES

In this paper we have described a text-processing system intended to bring relief from some of the everyday chores of indexing, concordan-cing and so on to the hard-pressed scholar in the humanities. Such a system can of course never meet all the calls upon it, and there will always remain specialised applications for which it will be necessary to write special programs. Whether, when this happens, the scholar should call in an expert in computer science, or whether he should try to learn enough about programming in some suitable language to meet his own needs is still a subject for debate. For the moment, we will be content if our system can meet some of the basic requirements of the user from the humanities, enabling him to realise some rather sophisticated text-

processing operations with a high degree of computational efficiency and comparatively little effort, thus freeing him from much routine work and allowing his creativity to be applied at a much more fruitful stage.

The system is at present in the final stages of implementation on the Université de Montréal's CDC Cyber 74. The program is written in FORTRAN and runs under the Scope 3.4 operating system. Much of the system was in fact designed with an eventual conversational implementation in mind. When this facility is available a user at a terminal will be able to cite words or patterns of words from the text he is studying and receive the answer at his terminal very rapidly, and at rather low cost. Our plans for the future also include the provision of on-line programs to assist the user with other routine chores such as lemmatisation and encoding of text.

Acknowledgements
The system design has benefited greatly at all stages from the advice and help of Jean Baudot, Jean-François Grégoire, and Pierre Stewart, all of the Centre de Calcul, Université de Montréal. A preliminary system manual, written before the actual implementation, was sent to several of our colleagues at other Universities and computer centres, and we are most grateful to all those who took the trouble to send us their criticisms and suggestions.

The work described in this paper has been supported to a great extent by grants from the Conseil des Arts du Canada and the Canadian National Research Council.

REFERENCES
Hamilton-Smith, N. (1970) CONCORD *User's Specification*. Edinburgh Regional Computing Centre.
Ouellette, Francine (1972) *Système de Traitement de Texte*. Centre de Calcul, Université de Montréal.
Russell, D. (1967) COCOA *Manual*. SRC Atlas Computer Laboratory.
Stewart, P. (1972) *Système* DATUM. Centre de Calcul, Université de Montréal.

R.H.RASCHE

FORTRAN as a medium for language analysis

Recently A. Colin Day (1971) has advocated FORTRAN as a medium for computer-assisted linguistic research, arguing that it is preferable to other high level languages which are more specifically designed for character string manipulation. His primary consideration in advocating this choice is the acceptability of the FORTRAN language to a broad range of available computer hardware, and secondly, the higher level of processing efficiency that is available to the FORTRAN user.

I agree completely with Day's goal of wider machine acceptability of linguistic programs. It appears to the naive observer that much of the past work in computer-assisted linguistic research has limited value because of compiler restrictions, or because of short-sighted design considerations which essentially limit the usefulness of the programs to the one task for which they were constructed. On the other hand, as an economist, I think that efficiency should be given prime consideration in the choice among available compilers. The data base which is potentially available to linguists is so broad that sampling techniques must necessarily be employed. However, even with very small sampling fractions, the analysis will require close to infinite wealth unless the most efficient computing techniques are employed.

The concept of efficient programming implies that the program design should seek to economize on the use of scarce resources. The resource which FORTRAN can be particularly good at economizing, relative to other compilers, is CPU cycles, or if you like, computing time. Since CPU time is typically the scarcest and most expensive factor of the several which are embodied in a modern data processing system, the skilful use of FORTRAN programming can potentially produce a given amount of computer-assisted linguistic processing at a cost substantially below alternative processors. My quarrel with the approach advocated by Day is that it throws out much of the efficiency which is available with a FORTRAN-based system. I shall attempt to describe below how Day's scheme cripples the programs written in FORTRAN, and illustrate techniques which can circumvent these problems and achieve a much higher level of efficiency. It should be noted that Day has restricted himself to a discussion of FORTRAN programming at the BASIC level while I shall implicitly assume the availability of a compiler at the FORTRAN IV level.

The Nature of Modern Data Processing Systems

The basic unit of information in modern data processing systems is a binary digit or 'bit'. All information, character or numeric, which is fed into such a system, is converted into strings of such bits. The arithmetic unit (central processor or CPU) does not usually operate on individual bits, but rather on bit strings of fixed lengths, typically known as 'words'. Usually, the bit string representations of several characters can occupy successive segments of a fixed length 'word'. Some machines, such as the IBM 360-370 systems, can be made to operate on shorter fixed-length bit strings called 'bytes'. For the purposes of linguistic processing it is convenient that the fixed length of the byte and the length of a bit string needed to uniquely represent a character are the same. Thus, if the FORTRAN program can be structured to make the machine process individual bytes, individual characters can be manipulated, regardless of where they happen to be positioned within the computer words.

Character Storage in a Fixed-Length Computer
Word Environment

Two problems arise in the storage of character data when using the FORTRAN compiler. The first is how to minimize the amount of storage space required to accommodate one text word, the second is the problem of accommodating the varying length of text words within the constraint of fixed-length computer words.

The first of these problems can be solved by 'packing' the character string which forms a text word into a string of binary digits (bits). An application of this technique is discussed extensively by Day. It can be seen easily from his example, that the cost of such efficient storage of individual words is the extensive use of arithmetic operations to 'pack' and 'unpack' the characters. The procedure which Day proposes requires a division, a multiplication, and two addition operations, plus a table look-up procedure to reduce each character to an integer number between 1 and 50. These digits are then 'packed' by treating them as digits to the base 51. Since it takes six binary digits (bits) to uniquely represent integers from 1 to 50, the end result of all these operations is that characters are stored using slightly less than six bits of information per character.

On the other hand, when a character is read under an A1 format in FORTRAN, it has a unique internal representation as a bit string of between six and eight binary digits depending on the machine being used. If treated as an integer number, the character appears to have a large value because the fixed-length computer word is capable of holding more than one character and the A1 format puts the one character read into the leftmost part of the computer word. An alternative to the

approach described above is to design a FORTRAN subroutine which, when called, can pick out the one character from the leftmost storage position, and place it in any user-specified position in another computer word. By successively reading individual characters and moving them to sequential positions within a given computer word, it is possible to achieve the same packing as the Day procedure without substantial loss of storage capacity, and with much greater efficiency in terms of machine cycles. Such a routine, which we have developed for IBM 360-370 hardware and CDC 6000 series hardware, is the STRSTN subroutine which is discussed below.

The second problem in linguistic applications of FORTRAN is the compact storage of text words. The technique illustrated by Day is to pack text words as continuous character strings, with pointers which indicate the beginning position of each text word and its length. An alternative approach is to utilize the ability of most FORTRAN compilers to handle double-precision operations with almost the same speed as single-precision operations. A double-precision operation is the manipulation of two successive fixed-length computer words as a single unit. By using such double-precision manipulations, character strings of up to twelve or twenty packed characters, depending on the particular machine, can be treated as a unit. Two problems arise; the first concerns text words that are longer than the number of characters which can be accommodated by the fixed double-precision word length. In our own work we have chosen to truncate the text word after the first n characters (where n has been set to 15). The cost of this procedure is the inability to distinguish word forms in the truncated cases. On first sight this may seem alarming, but it should be realized that the frequency of such truncations, at least in English, is extremely low, and truncated words are easily identified. If 100 per cent accuracy is desired (or necessary, as in concordance construction), the cost of looking up the truncated occurrences and adjusting the machine tabulations by hand is trivial relative to the costs of allowing the machine to accommodate the rare case.

The opposite problem arises when the text word is shorter than the computer word. In this case, there exist unfilled character positions, and a loss of efficiency with respect to the use of the storage capacity of the machine.

Machine storage capacity does not approach the level of scarcity (expensiveness) of CPU cycles given today's computer technology. In many machines, the capability exists to expand or contract the available core size to accommodate the size of the job within limits (MVT in IBM terminology). Second, rapid-access mass storage devices such as discs and drums have been greatly improved, and the technical ability to use these facilities efficiently has been incorporated into many FORTRAN language compilers. Third, computer technology appears to be on the

verge of a widespread introduction of virtual memory software which for almost all conceivable situations removes the problem of core requirements from the concern of the computer user (for example, see recent IBM announcements for implementation on 370/145 and 370/168 series). Finally, it is only necessary to store a dictionary of the words which appear in the text, and not the multiple occurrences.

The advantage of forcing the text words into the fixed-length computer word environment is the speed with which comparisons of words can be performed. Assume that the entire dictionary of words which have appeared in the text is stored in a double-precision vector. Suppose that a new text word has been assembled from a string of individual characters, and that the problem is to determine whether or not this new word has ever previously occurred in the text. This can be accomplished by treating each element of the dictionary vector as if it were numeric and comparing it against the variable in which the new word is stored, using a simple DO loop and logical IF branch out of the loop if a match is found. In general, all internal operations on text words can be performed as operations on single numeric FORTRAN variables once this scheme has been adopted. This allows the linguistic researcher to take full advantage of the 'number crushing' capabilities of FORTRAN which have been so highly developed over the past decade.

CHARACTER MANIPULATION SUBROUTINES

My own introduction to linguistic computer processing was through the PL/1 language. This language was chosen for the problem because it was designed to have the algebraic capabilities of FORTRAN, and also great flexibility in handling string data. The initial programming in PL/1 showed that it was a feasible solution to the problem, but also demonstrated that we could never afford to use the resulting program for extensive research. The structure of the PL/1 program revealed that three basic string-processing routines were required: (a) a routine which could indicate the location of a substring of arbitrary length within a longer string (INDEX); (b) a routine which could extract a substring from a longer string (SUBSTR): and (c) a routine which could insert a substring from a longer string at some designated point without destroying the rest of the string (STRSTN).

All of these string manipulation functions are available in the PL/1 language, in a general form which permits manipulation of strings and substrings of arbitrary length. However, this generality is extremely costly in terms of machine cycles. Since the substrings which are of interest in linguistic processing are words, individual characters, or individual punctuation characters, the truncation approach discussed above places an upper limit on the substring length. Further, this limit is within the bounds of the FORTRAN language to handle the substring as a single variable.

A general strategy for developing linguistic processing routines written in FORTRAN consists of two parts: (a) extremely efficient character-manipulation functions to perform the three functions discussed above should be constructed, and (b) the processing programs which utilize these string functions should be written in a form of FORTRAN acceptable to a wide range of machines.

It is clear that the operations performed by the string-manipulation routines are the most frequently used parts of linguistic programs. It is also clear that the construction of these functions is dependent upon the particular brand of machine which is being used. Therefore, the possibility of having to abandon FORTRAN as the language for constructing these routines should be admitted. The cost of this should not be too high, since the routines would have to be constructed only once for each type of machine, and then could be utilized by a wide range of programs. In fact, such highly efficient routines have been constructed in FORTRAN for IBM 360-370 systems, and for the FORTRAN extended compiler of the CDC 6000 series machines.

AN EXAMPLE OF TEXT READING IN FORTRAN

The FORTRAN code illustrated in figure 1 is an example of how the character-manipulation routines described in the preceding sections can be used to read words from an unstructured input medium and retain them in an array which can be operated on further by the computer programmed in FORTRAN. For purposes of this illustration, the code has been written in a form consistent with the IBM 360-370 FORTRAN G and H compilers, since these compilers are likely to be those most frequently available. Further, to keep the illustration simple, a word is defined as a string of characters delimited by blanks. It is not difficult to expand the code to search for initial, terminal, or isolated punctuation characters, which can be separated or eliminated. The following definitions will be helpful in understanding the logic of the technique:

WORD: an array in which the words have been discovered in the input source. J is a pointer which indicates the position of the current word in the array.

WORK: a two-element array which serves as a work space in which to construct the word string. It is capable of holding thirty-two characters, which is larger than any English word which I can think of.

HOLD: an array which contains the image of the current line of the input source medium (here taken to be an eighty-character card image).

DREAL: a FORTRAN function which returns the leftmost eight characters of the sixteen-character string argument.

K1: a pointer which indicates the current character position being extracted from HOLD.

```
            CØMPLEX*16 WØRK(2),WØRD(100),SUBSTR,CHAR,BLANK2
            REAL*8 BLANK,DREAL
            DATA BLANK2/8H        ,8H          /,BLANK/8H        /
            REAL HØLD(20)
            .
            .
C               BEGIN WØRD READING CØDE
            J=1                                                        1
            K2=0                                                       2
  1         K1=0                                                       3
            READ 5 (HØLD(K),K=1,20)                                    4
  5         FØRMAT(20A4)                                               5
 10         WØRK(1)=BLANK2                                             6
            WORK(2)=BLANK2                                             7
 15         K1=K1+1                                                    8
            IF(K1.EQ.81) GØ TØ 25                                      9
            CHAR=SUBSTR(HØLD,K1,1)                                    10
            IF(DREAL(CHAR).NE.BLANK) GØ TØ 20                         11
            IF(K2.LE.0) GØ TØ 15                                      12
            WØRD(J)=WØRK(1)                                           13
            J=J+1                                                     14
            K2=0                                                      15
            GØ GØ 10                                                  16
 20         K2=K2+1                                                   17
            CALL STRSTN(WØRK,K2,1,CHAR)                               18
            GØ TØ 15                                                  19
 25         IF(K2.GE.1)WØRD(J)=WØRK(1)                                20
C               END OF WØRD READING CØDE
```

Figure 1

K2: a pointer which indicates the current character position being stored in WORK.

In statements 1–3 the word position pointer is initialized to 1 and the input and output character position pointers are initialized to zero. In statement 4 the card image is read into the HOLD array. Statements 6–7 initialize the work area to a string of thirty-two blanks. In statement 8 the input pointer K1 is incremented by one position, and statement 9 checks to see if the card image has been exhausted of character positions. If this condition were met in a general routine, the program would be directed to read the next line image, i.e. to go to FORTRAN statement number 1. In this example, which is restricted to the reading of one card, the program just checks to see if there is a residual character string in the work area, and if so places that string in the current position of the WORD array (line 20). If the input image has not been exhausted, then one character is extracted from the K1th position of the HOLD array by the routine SUBSTR, and placed in the leftmost character position of the variable CHAR (line 10). The SUBSTR routine fills the remaining character positions to the right in CHAR with blanks. In line 11, the leftmost eight character positions of the variable CHAR are compared with a string of 8 blank characters. If the two are identical then the character

extracted from HOLD has been a blank and two possibilities exist; either we have found a terminal blank and completed a word, or we have identified a blank which precedes a word. Line 12 checks the pointer for the WORK array to see if there are any non-blank characters stored there. If not, the blank identified in line 11 is a leading blank and the program returns to FORTRAN statement 15 and prepares to extract the next character from HOLD. If there are non-blank characters in WORK, then the blank identified is a terminal blank, and the leftmost sixteen characters in the work area are transferred to the current position in the WORD array (line 13). In this latter case, the WORD array element pointer (J) is incremented by one, the output position pointer (K2) is reset to zero, and control is returned to FORTRAN statement number 10 where the WORK array is reset to blanks before the next character is extracted from HOLD.

If a non-blank character has been found at line 11, then the program is directed to FORTRAN statement number 20 (line 17). At this point, the output position pointer, K2, is incremented by one position, and the subroutine STRSTN stores the leftmost character position in the variable CHAR into the K2th character position from the left of the array WORK (line 18). Finally, control is returned to FORTRAN statement number 15, where preparation is made to extract the next character position from the HOLD array as previously described.

Once all the word images have been extracted from the card image (HOLD) and stored in successive locations of the vector WORD, then all operations on words can be performed by direct manipulation of the elements of WORD as if they were numeric FORTRAN variables. The only inconvenience arises where the word storage vector has been declared as a COMPLEX vector. In this case logical IF statements cannot act directly on the whole variable. Instead, dual comparisons must be made of the first half of two-character strings (the real part of the variable) and the second half (the imaginary part of the variable). This is handled in straightforward fashion using library functions which extract the real and imaginary parts of complex variables.

IBM's 360-370 FORTRAN IV (H extended) compiler accepts standard library routines DREAL and DIMAG which perform these functions. In our own work we did not have this compiler and the associated library available, so we wrote our own simple routines to handle this function:

```
DOUBLE PRECISION FUNCTION DREAL (C)
COMPLEX*16 C
DOUBLE PRECISION D(2)
EQUIVALENCE (C,D(1))
DREAL = D(1)
RETURN
END
```

REFERENCES

Day, A.C. (1971) FORTRAN as a language for linguists. *The Computer in Literary and Linguistic Research* (ed Wisbey, R. A.), 245–57. Cambridge: Cambridge University Press.

Ross, D. & Rasche, R. H. (1972) EYEBALL, a computer program for description of style. *Computers and the Humanities*, **6,** 213–21.

Music

Analysis of tonal music at the level of perception

The relationships that exist between the tones and the tonal structures in a piece of music are usually described in one of two ways: as 'intervals', calculated by counting lines and spaces between notes on the score, or as ratios, obtained by comparing frequencies, either presumed or acquired experimentally, in a musical performance.

The tonal relationships which a listener perceives, however, are not adequately, appropriately or accurately defined by either of these descriptions. For example, two consecutive notes of a melody may be acoustically and notationally identical with two others, but the relationship which the auditor perceives between the two notes in each pair may be entirely different. MUAN, the program to be described in this paper, provides numeric ratio descriptions of melodic and harmonic relationships which, I believe, reflect the relationships we perceive as auditors, as against those we might count on the score or measure on the oscilloscope screen.

The difference between perceived relationships and those we might obtain from visual or acoustic sources can be quickly grasped by playing the musical phrases in figure 1(a), (b), (c) and (d). The specific relationship to which I draw attention exists between the second and third tones of the melody in each example. Acoustically, the relationship between these two tones in all four cases is identical when played on a fixed pitch instrument; notationally, the relationship differs in pairs— two examples show a major second (C to B♭), and two a diminished third (C to A♯).

Most listeners agree that the relationship they perceive between the second and third melody tones in each of these examples is distinguishable from the relationship they perceive between these tones in each other example. The difference between the examples is, of course, the harmony provided for the third event. Thus, the harmonic relationship between the second and third event establishes the context by which they gauge the relationship between the second and third tones of the melody. The ability to recognize different tonal relationships which are informed by different contextual conditions is one of the functions of the human perceptual mechanism, and it is this particular function which MUAN simulates.

The ratios which MUAN discovers are independent of both intervallic and acoustic consideration. More importantly, MUAN reflects our

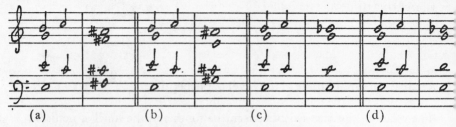

Figure 1. We perceive the relationship between the
second and third melodic tones in each of these
examples as markedly different though the notes are
notationally identical in pairs and acoustically identical
throughout.

qualitative assessment of tonal relationships by providing simple ratios
for relationships we perceive as simple, and complex ratios for relation-
ships we perceive as complex. MUAN names the relationships between
C and B♭ in the illustration as 8 to 7 and 9 to 8, and between C and A♯
as 28 to 25 and 256 to 225.

Basic to an understanding of MUAN is the view that much of the
'meaning' in music is contained in a network of abstract relationships
which is conceived in the mind of the composer and communicated to
the auditor through a sonic description of it. The musical score, then,
is but a visual encoding of the sonic image of the network; the musical
performance, an acoustic decoding of the visual encoding of the sonic
image of the network. The network is reconstructed in the mind of the
auditor through the activity of his perceptual mechanism acting upon
the acoustic data supplied by the performer.

This sequence of encoding and decoding musical information fits an
auditory model proposed by Licklider (1959) which has been applied
to most of the features of tonal music by Boomsliter and Creel (1961,
1970). In capsule form, the theory is that pulses of a wave train are
counted, coded to a time base, and synchronized with remembered and
anticipated wave trains. In the act of synchronization, the incredibly
complex acoustic ratios are resolved to simpler ratios which fit the
conditions imposed by the preceding and anticipated events. The rela-
tionships we perceive in music, then, are determined by the simultaneous,
retrospective, and anticipated tonal contexts, these contexts all being
formed out of synchronized neural data. The theory leads to the con-
clusion that the significant relationships in tonal music are not impressed
upon us in the form of acoustic energy, but are produced within us from
acoustic stimuli.

Not all of the events in a piece of music are unequivocal. When the
relational position of an event is uncertain because the structure within
it is incomplete, for example, I theorize that the mind develops parallel

solutions to the relational problem it poses. One solution may be selected by the auditor as most logical in the light of the preceding event, while another may be selected to establish a plausible relationship with the following event. MUAN acknowledges this condition, and provides multiple solutions for relationships with preceding and following events whenever the event under perceptual scrutiny is ambiguous or equivocal.

The theory of the relational structure of tonal music which undergirds MUAN can be summarized as follows:

1. The only directly perceived Structural Unit (SU) in tonal music consists of a root and at least two, but not more than three, tones. Measured from the root, and including it, these tones are related to the root in the order of their perceived complexity, as the unison, perfect fifth, major third, and minor seventh. (Traditional 'intervallic' names of these relationships are employed here only to assure understanding among musicians.)

2. The relationships between the tonal components of an SU can be described by the first four prime numbers: unison, 1; perfect fifth, 3; major third, 5; minor seventh, 7. These numbers are simply abstract descriptions of relationships which are perceived by human beings on a scale of increasing complexity, and they have nothing whatever to do with the overtone series or any other acoustic phenomenon. Obviously, they have nothing to do with music notation.

3. By applying the mathematical principle of symmetry, or invariance, the SU may be transposed (CEG to GBD), mirror imaged (CEG to CA♭F), compounded (CEGB=CEG+BGE), elongated (C—E—G— spread out in time), and partially depleted (CE) without destruction of its invariant character. On the other hand, no tone of an SU is ever changed or altered, chromatically or otherwise.

4. Every tone in a piece of tonal music is a member of at least one SU. There is, then, no such thing as an 'inharmonic tone' in tonal music.

5. A key may be defined as composed of three SU's of the same type whose roots are disposed at the function 3 (the perfect fifth). There are no minor SU's in a major key, and no major SU's in a minor key.

6. Keys may be related to one another numerically by employing the first three prime numbers, their multiples and submultiples. As examples, the key of G may be said to be related to the key of C by the function 3 (the perfect fifth); the key of F, by the function 1/3; the key of E, by the function 5 (the major third); the key of D, by the function 9 and the function 5/9, and so forth.

7. 'Key Groups' may be constructed out of keys whose relationship is 5 and 1/5. The boundary for the key group is logically set at the enharmonic comma, 128/125. With this boundary, a key group contains four major and four minor keys; for example, the major keys of F♭, A♭, C and E, and the minor keys of G♯, E, C and A♭.

8. A 'Universe of Keys' may be formed from five key groups, each key group related to its adjacent group by the function 3. The boundary of the universe of keys is the syntonic comma, 81/5.

9. Since every tone in the universe of keys is described numerically by virtue of its membership in a numerically derived SU, every tone in every key holds some specific numeric relationship with every other tone. There are 83 different tonal numerics in the 40 keys of the universe. When compared, these numerics form 3403 tonal relationships, 283 of which are different.

At the heart of MUAN is an array called LISTAB. The LIST portion of LISTAB is a set of 228 numbers disposed in three columns of 76 numbers each. The numbers in each of the three columns are related by 3 and 5, their multiples and submultiples; the numbers across each row are related by 7 and 1/7.

The TAB part of LISTAB is a set of letter names of notes. These are distributed opposite the numbers in LIST in accord with the key signature of the piece to be analyzed. The key signature is supplied as data. The letter names of the notes are assigned so that the name of the key-note of the major key indicated by the key signature falls opposite the number 14175 in column 2 of LIST. All other note names take appropriate positions opposite other numbers in LIST. Thus, if the key signature of the piece to be analyzed contains no sharps or flats, CNA (C natural) appears opposite 14175, GNA opposite 42525 (14175 X 3), FNA opposite 4725 (14175/3), and so forth; if the signature contains one sharp, GNA is found opposite 14175, DNA opposite 42525, and CNA opposite 4725, and so forth.

The five key groups and the universe of keys, both of which contain the names of notes and their associated numerics, are derived from LISTAB. The order in which the keys are placed in the key group and universe arrays is determined by the key signature of the piece.

Data for MUAN, in addition to the key signature, includes the letter names of the notes in the piece to be analyzed, their time value, and the octave in which each appears. MUAN assembles the piece in an array called MU.

Three passes are conducted through MU. The first pass seeks out each unequivocal SU. The numerics which are appropriate for the root and the tonal complement of the structure are found and placed in an array called NUM. If an event containing a complete SU also contains a note which is not a member of the SU, or, if the event does not 'add up' to a complete, identifiable SU, or, it it proves to contain a compound of two or more SU's, that event is flagged for consideration in the second and third passes.

Pass 2 begins at the end of the piece and works toward the beginning. In this pass the harmonic and melodic relationships between each

flagged event and the following event are considered. The most plausible, i.e. simplest numeric, relationship is determined, and the numerics which describe that relationship are assigned to the root and individual tones of the flagged event. Pass 3 begins at the beginning and works toward the end. The same exercise is conducted, but the ambiguous event is related to the preceding event rather than the following.

MUAN changes a note name to its enharmonic equivalent when this is required to 'make sense' out of a structural relationship, and changes it back again if this is required to 'make sense' out of a relationship with a structure on either side. MUAN also deals with the syntonic comma, generating two sets of numerics for an event which is involved in that relational circumstance.

When the three passes through MU are completed, every tone in the piece is supplied with at least one numeric which is related to the key signature, the tones which sound with it, and those which precede and follow it. The numerics are obtained solely on the basis of relational context within a stringently defined architecture of musical structures and keys.

After the numerics have been computed, a large variety of information can be extracted from them. To date, the principal items I have asked for are: (a) the melodic relationships between consecutive notes in each voice; (b) the harmonic relationships between consecutive events; (c) summaries of compound events; (d) summaries of ambiguous events; (e) durations of harmonies; (f) a graphic representation of the harmonic flow of the piece. Output for a study of relational patterns in music is contemplated.

One of the more interesting results from the analyses thus far conducted concerns the nature of the relationships revealed. The majority of the melodic and harmonic ratios found in a sampling of Bach chorales, for example, are the low order, classic diatonic ratios: 3/2, 5/4, 5/3, 9/8, 10/9, 16/15, and the like. But there is a surprising number of ratios of greater complexity, such as 81/80 (the syntonic comma), 128/105, 160/147. In addition there is a strong representation of fairly exotic relationships—1323/1280 and 1701/1600, to name two.

Another interesting result from the analyses has to do with ambiguity. As in the case of language, depth of meaning in music seems to be related to ambiguity, both in degree and kind. Within the tonal system of composition, an ambiguous event is easily identified, but the degree and kind of uncertainty which such an event represents are difficult to define. Even in the Bach chorales it is not uncommon for MUAN to supply four structural solutions for a single ambiguous event. Such an occurrence, however, is usually well 'set up' with strong clues pointing to the structural solution for the perceptual problem. In contrast, consider the first two harmonized measures of *Tristan*. These two bars,

which consist of only four events, contain, according to MUAN, eleven different structural units, complete or implied, and fourteen structural appearances. One of these structural appearances is found as the first event, five are compounded in the second event, six in the third, and two, consisting of the same E major chord related by the syntonic comma, in the fourth. Our perception of this mysterious music is thus reflected by the complexity of the MUAN analysis.

An ambiguous event represents a relational problem for the auditor. It demands 'work' and a solution if the auditor is to complete his reconstruction of the composer's relational network. I theorize that the number of relational problems posed in a piece of music, the degree of their difficulty, and the success the auditor enjoys in solving them are important elements in the auditor's 'appreciation' of the piece. MUAN may be useful in the test of this hypothesis.

Execution time on a CDC 6600 for an analysis of a typical Bach chorale is about fifteen seconds. Storage required is 125K (octal) words. The program is written in FORTRAN.

Acknowledgements
The Center for Human Learning at the University of Minnesota contributed computer time for partial development of the program. I gratefully acknowledge this support.

REFERENCES

Boomsliter, P. C. & Creel, W. (1961) The long pattern hypothesis in harmony and hearing. *J. Music Theory*, **2**, 1–24.

Boomsliter, P. C. & Creel, W. (1970) Hearing with ears instead of instruments. *J. Audio Engineering Society*, **4**, 407–12.

Licklider, J. C. R. (1959) Three auditory theories. *Psychology, the Study of a Science* (ed Koch, S.). New York: McGraw Hill.

MUSTRAN II : a foundation for computational musicology

MUSTRAN II, which is an augmented version of basic MUSTRAN, is designed so that any music written in the European system of music notation can be encoded for computational processing. The basic MUSTRAN notation, described in more detail elsewhere (Wenker 1970), includes most symbols defined in the European system of musical notation and also includes a wide range of symbols used by ethnomusicologists.

The augmented MUSTRAN II system adds the capabilities of including the musical symbols and conventions not defined in basic MUSTRAN. In addition, MUSTRAN II allows the optional encoding of the graphical characteristics of music known (or suspected) to be required, or desired, for the purposes of computer-controlled music printing. Additional features are being included to facilitate the use of the computer as a music performing machine. Finally, certain shorthand capabilities have been added to simplify the task of encoding music which has repetitive features.

In all of the program modifications which differentiate MUSTRAN II from basic MUSTRAN, upward compatability has been maintained. Data properly prepared for basic MUSTRAN can be processed by MUSTRAN II. Similarly, data properly prepared for MUSTRAN II that does not make use of any of the special features devised for MUSTRAN II could be processed by the older basic MUSTRAN programs.

Both basic MUSTRAN and MUSTRAN II are, as the name indicates, MUSic TRANslators. They read music in a mnemonic, human oriented notation—called the MUSTRAN notation—and translate it into a binary table suitable for machine processing. In generating this translation they perform error checking, attempt error correcting, and produce an annotated listing of the results of the translation, flagging erroneous or invalid symbols, places where error correcting was attempted, and other suspect points in the translation. Since the annotated listing prints both the original symbols given to the computer and the symbols derived from the binary table produced as output by the translation, it is easy for the user to determine if the machine has corrected his errors or if that single piece of music must be re-translated.

In designing both basic MUSTRAN and MUSTRAN II certain criteria were considered to be essential. These include: (a) the mechanical limitations of the keypunch; (b) the basic notation must be simple for

a keypunch operator to learn; (c) as much as possible, the notation must be mnemonic and 'similar' to normal notation so that musicians can understand it with a limited amount of training; (d) the notation must be unambiguous; (e) the notation should be designed such that the computer can translate music rapidly and efficiently; and (f) the computer should be able to detect and correct errors in the data (Wenker 1964, 8–12). Error detection and correction capabilities are highly important in any form of data encoding, yet, as many scholars (including those in the humanities) have learned the hard way, this capability has frequently been ignored.

DISCUSSION OF THE NOTATION

The MUSTRAN II notation includes, as far as is known, all music symbols used in the European system of music notation, all requirements for computer controlled printing of this music, and facilities to simplify the encoding of this wealth of notation. Obviously, it will be impossible to present all of this notation in this limited paper. The major component of the MUSTRAN notation which must be completely ignored is the notation derived from ethnomusicology. With the exception of orthographic information and the added ability to differentiate between various symbols used to represent the same function, this notation has been adequately described elsewhere (Wenker 1970).

In order to save space, the description of many symbols has been reduced to a diagram of an arbitrary musical example created to illustrate the music symbols to be presented and, under the diagram, the complete MUSTRAN notation for the entire example. This presents the notation for each new music symbol, the proper placement of the notation, and reviews previously discussed music symbols with their notations.

The remaining music symbols include some discussion along with the musical examples. Some of the mnemonics of the MUSTRAN notation are identified in the illustrations of this paper by underlining the first letter of each word supplying a mnemonic letter for the notation; capitals are used in the text.

The description of music notation given here has been divided into three sections. The first section covers the basic symbols of music notation. As a result of this, most of the notations described here are ones that appear in basic MUSTRAN. Some enhancements have been added; these are indicated by use of asterisks beneath the new notations. Knowledge of this first section alone will be adequate for the encoding of most single voice music although, naturally, certain desirable features will not be covered.

The second section completes the description of the standard music notation symbols. Again, most of these symbols are ones that also appear in basic MUSTRAN. To save space, only a limited number of the symbols

in each group of symbols will be illustrated here. Features available in both basic MUSTRAN and MUSTRAN II that will not be discussed here due to space limitations include grace notes, held notes (formata), triplets ('groupettes'), repetition symbols, trills, etc., indications to performer, and octave transpositions (see Wenker 1970 for these notations).

The third section describes the new symbols included in MUSTRAN II and defines and illustrates the additional orthographic capabilities. Space limitations preclude the extensive exposition of this new material.

It should be indicated here that the materials presented in section three take a much larger percentage of the available space than their importance in music notation warrants. This disproportional representation is caused by the fact that this paper is primarily on the capabilities of MUSTRAN II which are not available in basic MUSTRAN. These same limitations and restrictions are also responsible for the extensive amount of symbols and notations demonstrated and illustrated here in such rapid order.

BASIC MUSIC NOTATION

The two important conventions of the MUSTRAN notation are the definition of note length and the identification of vertical position.

basic note length

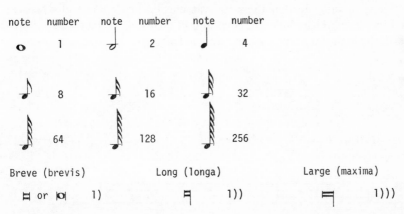

The number and characters given above to define basic note length are used in the MUSTRAN notation wherever the basic time value of a note is needed; this includes notes, rests, basic note value in time signatures and metronome figures, and so forth.

basic note position

1A-,2B-,4C,8D,8E,1F,2G,2A,1B,2C+,2D+,1E+,8F+,8G+,4A+,2B+,1C++,

Positions outside of the range of the above diagram require additional plus or minus signs. This notation is mnemonic for the G clef; the same positional notation may be used for other clef signs leaving the computer to do all transposing.

identification of Staff type

GS, GGS, G8S, FS, C1S, C3S, C4S,

The above notations define the clef signature to be used and identify to the computer that the notes will be keypunched as if the G clef were used. Therefore, the computer will automatically transpose all notes to the proper clef. For MUSTRAN II, the letter S can be followed by the letter Z to indicate that the data was encoded by a musically trained individual who has done the encoding in terms of the true clef. Therefore, the computer will do Zero transposing.

dotted notes

GS,4G-.,2D..,1A...,1)E+..,4B+.,

Rests

C3S,1)))R,1))R,1)R,1R,2R,4R,8R,16R,32R,64R,128R,256R,

accidentals and Naturals

C4S,1$$G,2$A,4B,8*C+,16**D+,32NND+,64NC+,128N*A+,128N$G,

normal Key signatures

GS,K1*K,　　　　　　K1N2$K,　　　　　K3$K,
****　　　　　　　　　******　　　　　　****

Note that the key signature presentation given here is not available in basic MUSTRAN which has only a more general technique of encoding key signatures. The more general technique is, of course, also available in MUSTRAN II.

The characters K0K, (K zero K) can be used to delete any key signature or to explicitly state that there is no key signature.

time signatures

Signature	Notation	Signature	Notation
$\frac{2}{4}$	2=4,	\mathbf{C}	4=4C, *
$\frac{3}{4}$	3=4,	$\mathbf{\Cent}$	2=2C, or 4=4C, *　　　*
$\frac{4}{4}$	4=4, .	$\frac{6}{8}$	6=8,

The character 0=4, (zero=4) can be used to delete any time signature or to explicitly state that there is to be no time signature.

Metronome count

M $\quad\downarrow$ = 60　　　　MM \downarrow. = 100　　　M.M. $\quad\downarrow$ =120-130

M2=60,　　　　　　MM4.=100,　　　　　M.8=120-130,
　　　　　　　　　　　　　*　　　　　　　　　*

bar lines

Single bar lines are represented by /, and double bar lines are represented by //, . If it is desired to specify, for orthographic purposes, that the bar line is to be heavy or light, then H or L can be given following the final slash. This in turn can be followed by A B or C to indicate that the bar line is to be extended to the staff Above, Below or both ways (Combined).

tied notes

The letter J is used to indicate that one note is Joined to the preceding note of the same voice. This second note obtains its pitch from the first note. Observe that the earlier publications on MUSTRAN erroneously

state that J is given on the first note. This is the only alteration made
since the notation was first described in 1963.

GS,K1$K,6=8,16C,16CJ,/,8F,8F,8F,8A.,16G,8F,/,16A,16C+,4C+J,

end

The end of the piece of music is indicated by the keypunching END
as the final set of characters.

ADDITIONAL MUSIC NOTATION

The preceding description has encompassed enough music notation for
many projects utilizing computer encoded music. This would include
projects encoding only incipits, single line melodies, or separate voices.
However, for projects which require encoding of complete pieces of
music or multiple voices on a single staff, additional notational capabili-
ties are required.

dynamic accentuation

Most of the music symbols discussed in this topic are used to indicate
the relative volume of sound of a single note or a series of notes. When
these symbols are used to refer to a series of notes, the MUSTRAN
notation of the symbol is separated from the preceding and succeeding
data by the usual commas. When a symbol is used for a single note, the
MUSTRAN notation appears in the data pertaining to the note.

GS,4CW3W,8DWSFW,WMFW,8E,WFFW,4E,4G,8*F,2G,

Only a few of the available dynamic accent symbols appear in this
illustration.

crescendo and decrescendo

Crescendo and decrescendo symbols have been separated from other
dynamic accent notations because these symbols have specific beginning
and ending positions normally indicated by the notation.

WCBW, crescendo--begin

 WCEW, crescendo--end

WDBW, decrescendo--begin

 WDEW, decrescendo--end

The symbols 'cresc.' 'decresc.' and 'decr.' are indicated in MUSTRAN II by WCBCW, WDBCW, and WDBRW, respectively.

Long Rests

When an instrument or voice is silent for a period of several measures, a single whole rest is used with the number of measures of silence desired appearing above the rest. For such Long Rests the MUSTRAN notation consists of LR followed by the number of measures of silence required and a comma. In normal usage, this music symbol is preceded and followed by bar lines.

multiple staffs

Music which requires several instruments or voices is conventionally notated on different staffs. For the MUSTRAN notation, such staffs are identified by numbers. All music notation following the occurrence of a staff number is considered to belong to that particular staff until a new staff is named. The MUSTRAN notation of a staff consists of L followed by the number of the staff and a comma. At the first occurrence of a staff identification, this notation *must* be followed by the appropriate clef signature and time signature. From that point on the computer will keep track of these signatures and they will not have to be repeated.

The notation for certain instruments requires a transposition of the music. The MUSTRAN notation for this consists of: L followed by the staff identification number, + indicating that the transposition raises the pitch or − indicating that the transposition lowers the pitch, the number of semitones of transposition required, and a comma. This transposition value must be given at the first occurrence of the staff number. After that, if no transposition value is given when the staff number re-occurs, the most recent value for the staff will be used.

The following diagram illustrates the use of multiple staffs with transposing instruments. In this diagram, the music is read across this page, but the MUSTRAN notation is read first for the left-hand side of the diagram and then for the right-hand side of the diagram as would be done by the keypunch operator in preparing music one page at a time.

Piccolo

L1+12,GS,4=4,2E,4C+,4A,/,

L1,8G,8G,2C+.,//,

Viola

L2,C3S,2=8,8B,8F,/,LR3,/,

L2,4$D+,/,LR3,//,

B♭ Tenor
Sax

L3-14,GS,4=4,2A...,16D,/,

L3,2A,2AJ,//,END

The keypunch data would actually appear like this:

L1+12,GS,4=4,2E,4C+,4A,/,L2;C3S,2=8,8B,8F,/,LR3,/,L3-14,GS,4=4,

2A...,16D,/,L1,8G,8G,2C+.,//,L2,4$D+,/,LR3,//,L3,2A,2AJ,//,END

multiple voices on a single staff

The description of the notation of multiple voices on a single staff will be simplified by the use of the term 'note cluster', where 'a note cluster is a group of notes and rests on one staff which are performed with all of them beginning simultaneously.' This definition does not require that they end simultaneously, but only that they begin simultaneously. Normally, a note cluster appears on a staff as a series of notes and rests arranged in a column which is perpendicular to the staff. In this column the notes may or may not be joined together by a vertical line.

The MUSTRAN notation for note clusters consists of using Y in place of the usual comma as the character that separates the notes within the note cluster. Thus the notation GS,4CY4EY4G, indicates that the notes C, E, and G are performed simultaneously, while the similar appearing notation GS,4C,4E,4G, indicates that a single voice is to perform the three notes C, E, and G sequentially.

The convention has been established that the keypunch operator, in preparing the note clusters pertaining to the staff under consideration, reads them starting from the 'lowest' of the notes and rests. The only exception to this is cases in which the voices cross. When this occurs the first note to be keypunched is the note to be performed by the 'lowest' voice, the next note to be keypunched is the note to be performed by the 'second lowest' voice, etc.

GS,4=4,4DY4FY4A,4A-Y4RY4A,4B-Y4EY4R,4CY4GY4E,//,END

If a single note is to be performed simultaneously by more than one voice, it must appear in the MUSTRAN notation once for each voice using the note. If two or more voices become silent at a particular moment, the notation of the note cluster must have a rest for each silent voice.

In multiple voice music rests are frequently left out of the original symbolic music notation because the horizontal position of a note alone is sufficient to determine when it is to be performed. At present, these rests must be supplied.

<div align="center">additions</div>

By use of the 'additions' defined here other materials may be included with music transcriptions and identified as such in the MUSTRAN notation. These additions could include the text of the songs, the part of speech of each word of the text, etc.

In the MUSTRAN notation the method of indicating that an addition is to begin is to use the 'prime' character (') followed by the desired message. The end of the message is indicated by the occurrence of another prime character. Both primes must be present or the computer will attempt to interpret the message as being MUSTRAN notation. Between these two prime characters, any character can occur except the prime character itself.

Additions can occur between note clusters, at the beginning of notes or rests, and at the end of notes or rests. If the addition occurs between note clusters, the second prime character is followed by a comma to separate the addition from the next piece of data in the MUSTRAN notation.

In the following example the convention has been adopted that the letters written to the left of a note or rest stand for an addition which appears at its beginning; letters written to the right of a note or rest stand for an addition which appears at its end; and letters written below the staff and between note clusters stand for an addition which appears between notes. In the MUSTRAN notation in the illustrations all additions have been underlined for clarification.

GS,4=4,'AB',2CY2EY4G,4'CD'A,4FY4AY8C+,'EFGH',8A'HIJK',
4CY4E'LMNOPQRST'Y8G,8'U⁺C+'VWXYZ',//,END

Notations Added in Mustran II

All of the following notations are capabilities which have been added in MUSTRAN II. They are unavailable in basic MUSTRAN and, if present in the encoding of a piece of music, will prevent the proper translation of that piece of music by the programs of basic MUSTRAN.

Head shape

GS,2H1C,4H1D,2H2E,4H2F,2H3G,4H3A,2H4B,4H4B,8H5B,8H6G,8H7F,

eXtra symbols

A large number of various symbols exist which were excluded from basic MUSTRAN. A partial list of these symbols is given here. The list is open ended and new symbols (up to a total maximum of 255) can be added as symbols missing from this list are found or as new symbols are added to music notation.

Symbol	Notation	Symbol	Notation	Symbol	Notation
1	X1,	2	X2,	3	X3,
4	X4,	5	X5,	↑	X11,
→	X12,	↓	X13,	←	X14,
⌐	X15,	⌐	X16,	⌐	X17,
L	X18,	U	X19,	+	X20,
o	X21,	℘.	X22,	*	X23,
>	X24,	∧	X25,	∧	X26,
V	X27,	V̌	X28,	⌐	X29,
⊔	X30,	{	X31,	}	X32,
⊏	X33,	⌐	X34,	(X35,
)	X36,	?)	X37,	⌒	X38,
⌒	X39,	╱	X51,	╱╱	X52,
╱╱╱	X53,	≣	X54,	≣	X55,
⊃	X57,	⸮̌	X58,	⌐	X59,
⊂⊃	X60,	⊏⊐	X61,	⌐⌐	X62,

These symbols can all appear by themselves, or with the deletion of the comma, as part of the information pertaining to a note. This total flexibility is allowed even though it is recognized that some of these symbols appear only with notes and others never appear with notes.

GS,8CX1,8GX3,8EX2,X31,8AX26,8BX28,X32,X33,4A,X53,4F,X34,

Additional special symbols will be defined and illustrated below during the discussion of symbol position and size.

Stem direction

Two complementary techniques have been defined to control the direction of the stems on notes. The following three codes have been defined for use when the stem direction is to be controlled:

SA (Stem Above) the stem goes up;

SB (Stem Below) the stem goes down;

SC (Stem Combined) the notes have stem in both directions.

A simpler technique has been devised for use in multiple voices on a single staff where in a note cluster the lower voices are to have down stems and the higher voices are to have up stems. This consists of using YY in place of Y for the highest voice which is to have a down stem. The computer will then have sufficient information to recognize that all notes in the note cluster following the note using YY will have up stems and the remaining notes in the note cluster will have down stems. Both techniques are shown in the following illustration.

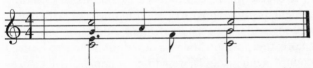

GS,4=4,/,2CY4E.YY4GY2C+,4ASA,8FSB,2CY2GSCY2GSCY2C+,//,END

Beaming

To indicate the number of beams to be applied to a note the letter B followed by the beam identification number is used. Each note connected to the same beam will repeat this beam identification number. Within a beam system each time beams are added, the beam identification number is followed by a plus sign and the number of beams to be added. Similarly, each time beams are terminated, the beam identification number is followed by a minus sign and the number of beams to be terminated. Once all notes connected to a beam have been processed, the beam identification number can be reused.

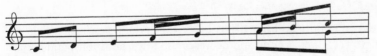

GS,8CB1+1,8DB1-1,8EB2+1,16FB2+1,16GB2-2,/,8AB3+1YY16AB4+2,16BB4-1,
8GB3-1YY8C+B4-1,/,END

slur lines

Slur lines are indicated by a K followed by a slur identification number. These symbols are given for the first and last notes which mark the beginning and ending of the slurs. If, for some reason, it is desired to

have the slur line go in the direction opposite to the expected direction (curving away from the stem on the first note or down if the first note is a whole note), then the slur number can be followed by a minus sign.

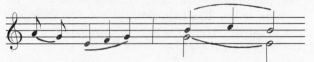

GS,8AK1,8GK1,4EK2,4F,4GK2,/,2GK3-YY4BK4,4C+,2EK3YY2BK4,

symbol position and size

The basic technique for indicating the size and/or position of a symbol consists of using two equal signs followed by S (for smaller) or S S (for even smaller) followed by the basic position identification (a letter from A to G followed by one or more plus or minus signs giving the vertical position of the symbol in terms of the current staff number as defined in the discussion of basic note position). If only size or portion information is desired, the position identification or the S (SS) can be left out. This position and size description can be used as a suffix in encoding clef signatures, accidentals, time signatures, metronome counts, dynamic accentuation, crescendo and decrescendo symbols, additions, and extra symbols. Furthermore, this position and size description can also be used as a suffix in encoding held symbols, repetition symbols, trills, turns etc., identifications to performer symbols (not discussed here), micro-accidentals, estimated pitch modification symbols, absolute pitch specifications, complex key signature usage of pitch modifying symbols, portamento, phrase marks, and breath marks (ethnomusicological symbols not discussed here). Since the positional information is purely for vertical control, it will not be influenced by the clef signature.

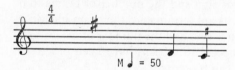

GS,4=4==SSA+,K1*K,M4=50==A-,4D,4*==D+C,

In order to supply additional flexibility for certain symbols which can be lengthy (e.g., crescendo and decrescendo lines, additions, and certain of the extra symbols), this basic position can be followed by an optional staff number (L followed by the number of the staff) and a second basic position identifier (A through G and possible plus or minus signs). This additional information (defined *only* for dynamic accents, crescendo and decrescendo, additions, and extra symbols) supplies the vertical position of the end of the symbol.

The additional 'extra symbols' previously mentioned are defined in the following table.

Symbol	Notation	Symbol	Notation	Symbol	Notation
———	X80,	-----	X81,	· · · ·	X82,
⤴———	X85,	⌁———	X86,	———⌐	X87,
⌇	X90,	⌇	X91,	⌇↓	X92,
↓	X93,	⌇↓	X94,		

Certain of these symbols require both beginning and ending position definitions. For this reason, the syntactical description of an extra symbol allows the addition of a second identification number following the full position description. This identification number is used for both the beginning and ending symbols and informs the computer that these two symbols are to be connected together using the type of line appropriate to the connection.

```
GS,4E'A'==B-,WCBW==D,4B'B'==G+,WCEW==G,4G'C'==B-,X92==FE+;
4D+'D'==F+,X85==A+1,4D'EFGH'==EG,X81==C2,X81==E2,4A,X87==A+1,
```

rest position and size

The description given above for a basic position, (= = followed by size, a letter and plus or minus signs) can also be used to indicate size and/or position of rests if this is desirable.

FINAL REMARKS

It must be emphasized that all notations discussed in this paper, or in any of the previous publications on MUSTRAN, have been run successfully on the computer. Thus, this is a presentation of a fully working system. The basic MUSTRAN programs have been distributed to users at universities using equipment of three different manufacturers. Because the same translator is used at these different sites, there are no dialects or incompatible versions of the MUSTRAN notation.

Scholars are applying the MUSTRAN notation and programs to a wide range of topics. In effect a system is being developed which will allow the musician to prepare programs to compose music, perform it, analyze it in order to refine the composition program, and after he is satisfied with his composition, print the music for copyright and publication and produce sound recordings of all or part of the music for performance purposes. Thus, this is a solid foundation for all areas of computational musicology.

Acknowledgements

In order for this article to be self-contained, text and examples have been incorporated from the earlier publication of MUSTRAN (Wenker 1970). I wish to thank the City University of New York Press for permission to include material from this earlier paper.

REFERENCES

Wenker, J. (1964) *A computational method for the analysis of Anglo-American folksongs.* MA thesis in Folklore, Indiana University.

Wenker, J. (1970) A computer-oriented music notation including ethnomusicological symbols. *Musicology and the Computer* (ed Brook, B. S.), 91–129. New York: The City University of New York Press.

Art and Poetry

Computer-assisted poetry:
the writing machine is for everybody

Nearly everyone who writes about computer-assisted poetry begins by tracing the idea to Jonathan Swift's description of the Grand Academy of Lagado in *Gulliver's Travels*, first published in 1726. The writing machine developed by the Lagadonians was mechanical rather than electronic, but its output would certainly resemble most efforts so far to produce poetry by computer. Yet in recalling Swift's imagined machine, recent writers draw attention to the similarity between the ancient process and the modern rather than to the products: the use of a fixed syntagmatic structure and the selection by randomizing procedures of the contents of that structure. Seldom is a parallel drawn to the ambitious goal of the machine's inventor in Swift's account: 'by his contrivance the most ignorant person at a reasonable charge, and with a little bodily labour, may write books in philosophy, poetry, politics, law, mathematics and theology, without the least assistance from genius or study' (Swift [1726] 1960, 148). Present-day projectors appear to be moving in this same direction, and programs to produce novels and 'physics-type essays' have already been formulated (Klein 1973, Mendoza 1968). 'The poem-game', as Margaret Masterman says of her own contributions to mechanizing poetry, 'has succeeded, beyond all hope, in its primary objective which is that of enabling non-poets to be able to make poems—by play' (1971, 176).

Automating poetry is, on the whole, a fairly harmless activity: for the most part, it is carried out not by poets but by programmers wishing to relieve the tedium of more predictable computing activities. In the United States, at least, the cost of executing such poems is nominal since excess computing time is often available for the purpose. But computer-assisted poetry (like other computer applications in the arts) has somehow gained the reputation of being avant-garde and modernistic in character, and while the conception of automatic writing is part of the stock-in-trade of twentieth-century avant-garde movements, there is nothing in the products themselves to justify that reputation. In fact, the widespread fascination with computer art arises from a kind of mid-century enthusiasm for the mystery of the machine, however malevolent and sinister this mystery may seem to most artists and critics. These feelings are nowhere more evident than in the art work that is the touchstone for the theme of modern man and modern machines, Jean Tinguely's self-destroying sculpture, *Hommage à New York*,

whose birth and death was celebrated in the sculpture court of the
Museum of Modern Art in 1960. Kinetic sculpture of a less ephemeral
kind likewise reflects this love-hate relationship, since, for the most part,
it is designed to fibrillate uselessly rather than to perform the real work
we expect of real machines. The impulses that give rise to such efforts
help account for the ambivalence with which the products of computer
art are generally greeted, and most artists seem relieved to find that such
art is typically banal and uninteresting, a relief usually undercut by
promises from computer artists that better things will emerge once
certain technical problems are resolved. Without raising more general
questions about computer applications in the plastic arts and in music,
I propose to review the antecedents and present achievements of com-
puter-assisted poetry and to evaluate possible future developments.
Nonetheless it is important to keep in mind the cultural underpinnings
that affect our view of such art; as Louis Milic has observed, if pro-
posals were put forward for generating poems or pictures by water
wheel, it is unlikely that books would be published or conferences held
on the subject of hydraulic art.

The history of aesthetic speculation that culminates in the computer
poetry of the last decade is not nearly as long as the regular citation of
the Academy of Lagado would suggest. While mechanical techniques
for the creation of poetry have been suggested from time to time, they
are nearly always presented in an ironic or satirical context, at least until
the dadaist movement of the twentieth century. Irony and satire are, of
course, essential elements of both dada and surrealism, but they must
be seen in a different light from their use by earlier writers. Swift's
academician in Lagado hoped to find order and meaning by accident
and we are to regard him as a fool and his proposals as frivolous; the
dadaists despaired of finding order by any means and their proposals
are fervent manifestos that mock an art that would imitate an orderliness
that does not exist. Swift's irony mocks irrational creation; the dadaist's
a rational and harmonious mimesis. Nowhere is this impulse more
evident than in Tristan Tzara's recipe for making a poem (reprinted in
Peterson 1971, 35), a set of instructions that might easily be converted
to computer processing:

Pour Faire un poème dadaiste

Prenez un journal
Prenez des ciseaux
Choisissez dans ce journal un article ayant la longueur
que vous comptez donner à votre poème
Découpez l'article.
Découpez ensuite avec soin chacun des mots qui forment
cet article et mettez-les dans un sac.

Agitez doucement.

Sortez ensuite chaque coupure l'une après l'autre.

Copiez consciencieusement

dans l'ordre où elles ont quitté le sac.

Le poème vous ressemblera.

Et vous voilà un écrivain infiniment original et d'une

sensibilité charmante, encore qu'incomprise

du vulgaire

Such a recipe articulates a much broader-based aesthetic than that accompanying most computer poetry, an aesthetic based on a world view of 'natural poetry', 'the conscious inclination of the poetry of art to reduce itself to the condition of unconsciousness and spontaneity typical of cosmic poetry' (Poggioli 1968, 194).

In the late 50s, William Burroughs provoked three of his friends into joining him in an experiment that reflects some of the same assumptions underlying Tzara's proposals. What Burroughs was doing was to reduce conscious control of imaginative acts in order to release imaginative exuberance, just as Shelley and Wordsworth asserted the triumph of hot imagination over cool reason through immersion in untamed nature. By forcing the imagination to assert its power, these Romantic poets expressed the same mixture of fear and contempt that underlies present-day responses to computer art. Burroughs, in a more extreme assault on technological thinking, exploited the accidental and aleatory in an assault on the predictable and the commonplace. Burrough's ideas resulted in a number of aesthetic explorations of randomization, among them the publication in Paris in 1960 of a small book, *Minutes to Go*, containing sample texts constructed by Burroughs, Brion Gysin, Sinclair Beiles, and Gregory Corso. Just what they were up to is best explained in a poem by Gysin in imitation of Tzara's earlier manifesto (Beiles *et al.* 1960, 4–5):

Pick a book any book cut it up

cut up

prose

poems

newspapers

magazines

the bible

the koran

the book of moroni

la-tzu

confucius

the bhagavad gita

anything

letters

business correspondence
ads
all the words

slice down the middle dice into sections
according to taste
chop in some bible pour on some Madison Avenue
prose
shuffle like cards toss like confetti
taste it like piping hot alphabet soup

pass yr friends' letters yr office carbons
through any such sieve as you may find or invent

you will soon see just what they really are
saying this is the terminal method for
finding the truth

piece together a masterpiece a week
use better materials more highly charged words

there is no longer a need to drum up a season of
geniuses be your own agent until we deliver
the machine in commercially reasonable quantities

we wish to announce that while we esteem
this to be truly the American Way
we have no commitments with any government
groups

the writing machine is for everybody
do it yourself until the machine comes
here is the system according to us

Gysin's prediction has, of course, come true: as Swift's satire promised long ago, we can now piece together a masterpiece a week and the machine is available in commercially reasonable quantities. It is time to examine these texts on their own merits just as we would treat poems from any source—computer, human, or the proverbial monkeys beating out page after page on those proverbial typewriters in infinite time. To do so, however, is discouraging since none of the poems impresses us with a sense of pure aesthetic delight. Or to put the matter more bluntly, not one of them is a very good poem and some of them are downright awful.

All of the poems so far published reflect an attempt by the author-programmer to simulate (or stimulate) by computer not only a particular human activity—writing poems—but also particular products. Each poem reflects what its creator thinks a poem should look like, and since only a few of those engaged in the enterprise have any sense of what

poems really look like, the computer poems tend to emphasize the super-
ficial poetic qualities that arise not from looking at an anthology but
from the properties poems in general are thought to possess. In the
earliest effort of this kind known to me, the notion of 'poeticalness'
apparently arises from the bizarre and generally uninterpretable quality
of the language (Worthy 1962, 97):

Roses

Few fingers go like narrow laughs.
An ear won't keep few fish,
Who is that rose in that blind house?
And all the slim, gracious, blind planes are coming,
They cry badly along a rose
To leap is stuffy, to crawl was tender.

In a remark that would doubtless have pleased both Tzara and Gysin,
the poet-programmer candidly stated: 'Obviously we are avoiding the
problem of meaning at this time' (Worthy 1962, 98). For the only
begetter of this composition, the notion of 'what poems are like' seems
to arise from a feeling that poems are obscure or delphic utterances. For
others, the 'essence of poetry' floats upward from schoolday memories
of Swinburne or Tennyson, mixed with more recent memory of Gibran
or McKuen.

If this seems unjust, perhaps a more recent effort will confirm the
point:

The torrid willing hair
Inviting Mercury
Close to the shores and trees
Behind the grasses and flowers
Erotic Mercury
Torrid Alicia
Willing Helen
Above the shores

Here the author-programmer reveals his conception of the vocabulary
of a certain kind of poetry though not its structure. Poems, he seems to
think, have people in them of a mythological kind, Mercury and Helen,
for instance; or at least people with fancy names like 'Alicia', characters
clearly descended from Swinburne's Atalanta and Tennyson's Guine-
vere. The attributes of the fancy folk are also 'poetic' in some sense:
'torrid', 'willing', and 'erotic'. And poems, of course, have nature in
them somehow, and so the author-programmer supplies the computer
with 'shores and trees', 'grasses and flowers', amid which his characters
burn with a passionate intensity.

The creation of such poems is, needless to say, a result of the specific in-
structions of the poet-programmer. In this case, an arrangement of slots is

provided along with sets of words of the kind just described. The slots for
'The Torrid Willing Hair' take a form something like the following:

The epithet epithet body-part

epithet name

preposition *the* nature-word *and* nature-word

preposition *the* nature-word *and* nature-word

epithet name

epithet name

epithet name

preposition *the* nature-word

The computer then prints out a series of poems on this model, selecting
according to a pseudo-randomizing technique the particular word that
will appear in the slot from the vocabulary provided for that set. Both
the arrangement of slots and the inventories of word types are provided
by the human programmer. The computer merely produces the parti-
cular arrangement that constitutes the particular poem. Hence the
computer will produce an indefinitely large number of poems that
resemble 'The Torrid Willing Hair'. For instance:

The passionate inviting body

Erotic Helen

Among the vines and vines

Upon the sand and valleys

Erotic Apollo

Erotic Mercury

Passionate Cherie

Along the vines.

Nearly all computer poetry so far produced proceeds along these
lines, though some poet-programmers have provided a more complex
arrangement of slots, a wider variety of vocabulary from which the
computer selects, or a set of contingency rules to introduce thematic
linking in the poem produced.

Not all the poems produced with computer assistance reach the kind
of banality of 'The Torrid Willing Hair' or 'The Passionate Inviting
Body'. Nearly all, however, are somehow redolent of a sense of the
'poetic' that gets stuck somewhere in the past. The following inventory
of these poetic strategies gives some sense of this quality:

1. The unexpected clash of images:

Furtive is mahogany

And delirious are the shadows of its pants.

Such a clash is achieved, obviously enough, by combining attributes like
'furtive' and 'delirious' that we usually associate with human beings
with such non-human nouns as 'mahogany' and 'pants'. Having identi-
fied the 'secret' of this text, we find the pattern of successive couplets
from this program quite predictable:

Gracious is money
And avuncular are the buttonholes of its bed.
2. The deliberately inarticulate:
beautiful wine happily feel crazy
gotta suddenly cant be happy after pat
3. The would-be visionary:
My elations loiter
Elation-Breasts
Performing acid hammers
Appetite like zones.
Such visions are, more often than not, of an erotic rather than transcendental character (MacLow 1969, 100–1):
Breezes sunlight nipples and are
Rarely
Clitorises are
Nymphomaniacs women merely ostensible are hungry
Are freeing deepbosomed breasts damozels rounded
4. The poetic interrogation:
Policeman, why do you fulfill your eyesockets
In the rivers of New York?
5. The forced rhyme (Shea 1968, 31):
The genteel bird house flashed bright swiftly in the besieged town
While the supple woman whispered with menace for the proper noun
6. The neo-realist pastiche (Borroff 1971a, 24):
The roses are vomiting.
Enough! How they squeeze their fierce ribs!
The car of discussion
Has shut the sky.
In the darkness of the picture,
Intensely, ravenously, carelessly,
The roses vomit.

Despite this list, it would be unfair to assume that all poet-programmers have misunderstood poetic traditions. In some cases, the clash of present and past is an obvious virtue. Consider, for instance, some computer-assisted lines by Louis Milic:

Margaret, are you saddening
Above the windy jumbles of the tide?

These lines do more than recall a poetic device, theme, or strategy; they remind the reader very particularly of Gerard Manley Hopkin's lines:

Margaret, are you grieving
Over Goldengrove unleaving?

And the similarity between Milic's computer-assisted lines and Hopkin's poem is, of course, no accident since Milic has used Hopkins as part of the input to the program that generates the poems. A similar program,

designed by Robert Ian Scott, creates parodies by combining elements from contrasting poets, in the following case the structure of Frost's 'Stopping by Woods on a Snowy Evening' with the vocabulary of Eliot's 'Preludes' (Scott 1969, 15):

> Whose vacant lots these are I think I know
> His world is in the city though
> He will not hear me waiting here
> To watch his vacant lots settle down with smoke.

Such efforts are reminiscent of Gysin's recipe:

> cut up
> Hopkins and Whitman
> Eliot and Frost
> Auden and Yeats
> slice down the middle dice into sections
> according to taste.

The compositions of Milic and Scott, unlike such efforts as 'The Torrid Willing Hair', are no mere salad of stale poetic vegetation. They remind us of their originals and may make us think better (or worse) of those originals for having read them. Why is Hopkins better than the computer? Before we dismiss the question as unworthy of an answer, we had better be sure that we *know* the answer. Hopkins *is*, after all, better than the computer, but the machine has done something useful if it has jarred loose our too willing acceptance of the human poet by making us ask why.

Other computer-produced texts ought to raise questions of a similar kind. Noreen Greeno's texts in *Woodworks*, as well as Marc Adrian's experimental work (Adrian 1968), remind the reader of the kind of concrete poetry in which the choice, size, arrangement, and juxtaposition of the words on the page foreground certain qualities of words that we unthinkingly read and write everyday. The same is true for the *Babel* poems of Leslie Mezei, the *Automatergon* texts of Greta Monach, and the 'textured-animated poetry' of Arthur Layzer's film, 'Morning Elevator'. All of this work compels us to question our assumptions about how we expect the written language to look and behave. Mezei shows us the word imitating its referent in *Babel*, with the towering word reaching arrogantly to a heaven beyond the page, or, in another instance, the same word exploding and collapsing before our eyes as if from some inner pressure. Layzer's lapidary effect transforms the kinetic energy of the compositions of Adrian, Mezei, and Monach into actual kinesis where not only space but also time is a function of the composition. Whether these texts constitute great art is not really the problem. Certainly they demand as much attention as do those of others who have reached the same conclusions by different means.

Computer art, for all its similarities to the art produced by traditional

techniques, does make demands on perceivers that are different from the usual ones. For those who have seen the sheer volume of poems that a computer can generate in a few minutes, the vast quantity of material naturally recalls the story of the sorcerer's apprentice. Filling the sorcerer's laboratory with water was a damaging act that the apprentice came to regret. But should we feel similar regret when the machine room begins to fill up with poems? I suspect that regret is not the appropriate emotion for such a state of affairs, and my suspicion is reinforced by a letter from Robert Gaskins, the creator of one of the most interesting programs to generate haiku. Having produced a satisfying number of haiku with his program, Gaskins hit on the idea of harnessing the program to a CRT display that for at least part of the day stood idle at his computing center. Instead of the vacuous blankness of the idle tube, haiku appeared on the screen, were slowly scrolled to the top, and disappeared forever (unless a passerby happened to copy one down). Thanks to this operation, Gaskins produced hundreds of thousands of poems in the course of a few months, each with a life-span of only fifteen or twenty seconds. Gaskins and his computer by this means became the most prolific poetic collaborators of all time, but more important that that, they provided an instant wastebasket to save the world from being inundated by their poems. We need have no regrets over the disappearance of Gaskins' poems since, after all, we can always get new ones by turning on the machine. The trouble lies in the feeling thus engendered that one of these poems is just as good as another, that it doesn't matter about the one we've just missed since there'll be another one along in a minute.

While a belief that poems are ephemeral is generally acknowledged in computer-assisted schemes, the problem of judgment is seldom given much attention. The traditional task of separating good poems from bad has been replaced by that of selecting better from worse. The definition of what constitutes a 'better' computer poem is left undefined in most published accounts of such work, but programmer-poets usually acknowledge that their samples have been picked from a larger collection of duds. At the moment, it is hardly worth the trouble to point out that the conflation of 'good poem' and 'good computer poem' is a category mistake; the future may force this question to more serious attention. In Margaret Masterman's view: 'Here we have got genuine art—creating new techniques—which will emerge as soon as more business executives who have on-line consoles in their offices, find it more fun to write poems on them than to explore the current state of the market, or to model their own firm's production flow' (1971, 176). Assuming that tolerant corporations will allow the executive to spend his time in this way, Gysin's prediction will be wholly fulfilled: 'This is the terminal method for finding the truth.' It might be argued that

any method that directs a businessman's attention to poetry has some virtue, but there is no reason to confuse such activities with those of the poet. The emphasis of computer-assisted poetry is inevitably on process rather than product; the result will be no more worthy of aesthetic admiration than the usual products of a complex craft, analogous, perhaps, to our reception of a model of the Eiffel Tower built from matchsticks.

Writing in the *Yale Review* recently, Marie Borroff reported: 'My own experiments in computer-generated poetic imagery have shown that such imagery can be startlingly and unpredictably effective, breaching the norms of expression to attain enhanced meaning exactly as does the language of real poets' (1971b, 483). Such a conclusion must be questioned on two grounds: either the computer's imagery is distinguishable from that of human poets in some deep sense, or we ought to call into question the language that real poets use. If so brute and dumb a beast as the computer can simulate this language, then we ought to begin to recognize that the imagery produced by using such means is used up, its novelty resulting from mere accident, and its ability to stimulate from unmotivated juxtaposition. Computers, after all, neither write nor speak; they combine for us the elements that we provide according to the rules we write. If they can be said to create, it is only creation by accident. There is no way to motivate the choices the computer will make for us in a way that replicates human creativity. While it is conceivable that machines will eventually be programmed to produce a substantial variety of well-formed sentences (and perhaps be able to distinguish well- from ill-formed ones), there is little likelihood of a rhetorical component that reaches out from the creator of language to the audience. Our knowledge of what happens in the normal interaction of speaker and hearer is now at such a rudimentary state that it is hard even to imagine what instructions we might give to a programmer to enable him to assemble a rhetorical component that would simulate person-to-person, rather than man-machine, interaction.

The example of Burroughs and his collaborators is once again instructive. Gregory Corso was an unwilling participant in the enterprise, but having participated, he concluded that the real value of the experiment in random juxtaposition was to purge poetry of spurious 'poetic' language: 'Poetry that can be destroyed should be destroyed, even if it means destroying one's own poetry—if it be destroyed. I join this venture unwillingly *and* willingly. Unwillingly because the poetry I have written was from the soul and not from the dictionary; willingly because if it can be destroyed *or* bettered by the "cut up" method, then it is poetry I care not for, and so should be cut-up. Word poetry is for everyman, but soul poetry—alas—is not heavily distributed' (Beiles *et al.* 1960, 63). Should computer-assisted poems enable us to distinguish

the poetic from the pseudo-poetic in the way Corso suggests, it would be a welcome outcome to the efforts devoted to producing them. Such a result is not entirely unlikely: where the product is the source of interest rather than the process, aesthetic explorations are likely to be given new directions in the face of a successful machine, as happened, for instance, in the shift away from literalist portraiture that followed the development of photography.

The argument that computer poetry can do no more than satiate whatever enthusiasm exists for a poetry of random juxtaposition is, perhaps, unduly pessimistic. The contrary course of argument is much easier: it is tempting to predict that present efforts reflect only an early stage of a developing art. The supposition that computer poetry will open new possibilities for creativity requires only a willingness to regard the computer as qualitatively rather than quantitatively different from other machines. A series of technological revolutions has conditioned us to such optimism; few want to be skeptical of new premises, to be in the position of those who decried as impossible the circumnavigation of the world or flight in heavier-than-air machines. All that is needed, it seems, is more detailed and explicit knowledge of linguistic creativity, since explicit knowledge is computable.

Despite such temptations as these to predict a glorious future for computer-assisted poetry, I believe that the technique has no interesting potential. Present attempts can be refined, of course, if programmers concern themselves more seriously with the history of poetry and the nature of poetic value. But computers are merely iterative devices designed to execute specific instructions. Tightly constrained, they can produce poems, but the necessarily rigid instructions make them into mere reproducing machines on the order of a typewriter or printing press. Loosely constrained, they inevitably produce verse of the kind we have been examining, since they contain no evaluation mechanism to distinguish between promising and unpromising lines of development. While an evaluation mechanism has been suggested (e.g. by Shirley 1972), its creation depends upon 'punish' or 'reward' commands issued by the human programmer as proposed lines of development appear on the console. Excessive 'punishment' can determine a favourable outcome but the use of the computer becomes uninteresting in the process; excessive 'reward' leads eventually to the same point. To accept the possibility of an interesting middle ground, one must also accept the capacity of the computer to behave creatively. 'The human brain' says Marvin Minsky (who is willing to accept the idea of computer creativity), 'is just a computer that happens to be made out of meat'. If that conception of the human brain is accepted, then so too must be the possibility of computer-created poetry. As one utterly skeptical of that view, I suggest that those willing to devote energy and time to the

problem begin with a more restricted problem but one concomitant with creative behaviour—the problem of teaching the computer to laugh.

Acknowledgements

An earlier version of this paper was presented to the CIRCUIT meeting of the Computer Arts Society at the Cranbrook Academy of Art in May 1973. I am grateful for the comments of John Hollander and Louis T. Milic on that occasion and for those of John Morris, John Allen, and Yorick Wilks at the ICCH meeting. I also wish to thank the gentleman at Cranbrook who denounced *Computer Poems* as 'an insult to human intelligence' before throwing his borrowed copy at the podium. Had we had a chance to clarify our positions, I suspect that we would have found ourselves in agreement.

Unless otherwise noted, all examples of computer-assisted poetry cited above are drawn from those anthologized in Bailey 1973. The bibliography that follows includes references to additional collections of published computer poems by these and other authors.

REFERENCES

Adrian, M. (1968) Computer texts. *Cybernetic serendipity* (ed Reichardt, J.), 53. London: W. & J. Mackay.

Bailey, R.W. (1970) Automating poetry. *Computers and automation* (April), 10–13.

Bailey, R.W., ed (1973) *Computer poems*. Drummond Island, Michigan: Potagannissing Press.

Beiles, S. *et al.* (1960) *Minutes to go*. Paris: Two Cities Editions.

Borroff, M. (1971a) Computer as poet. *Yale Alumni Magazine* (January) 22–25.

Borroff, M. (1971b) Creativity, poetic language, and the computer. *Yale Review*, **60**, 481–513.

Computer poems and texts, in *Cybernetic serendipity* (ed Reichardt, J.), 53–62. London: W. & J. Mackay, 1968.

Coombs, D.H. (1969) Poetry and the machine. *Spirit*, **36**, iii, 85–105.

Electronic poetry. *Electronic Age*, **22**, iii (1963), 30–1.

Ferrero di Roccaferrera, G.M. (1969) Poetry by computer. *Computers and automation* (August), 34–5.

Gilbert, I.S. (1968) Modern poetry technique and the machine. *Chicago Jewish Forum*, **27**, 119–22.

Greeno, N. (1973) *Wordworks*. Ann Arbor: privately printed.

Jones, A.I. (1971) Computers and poetry. *Poetry Australia*, **39**, 58–63.

Klein, S. *et al.* (1973) *Automatic novel writing: A status report*. University of Wisconsin, Computer Sciences Department, technical report 186.

MacLow, J. (1969) [Computer poems.] *Stony Brook* 3/4, 99–102.

Masterman, M. (1971) Computerized haiku. *Cybernetics, art and ideas* (ed Reichardt, J.), 175–83. Greenwich, Connecticut: New York Graphic Society.

Mendoza, E. (1968) Computer texts or high-entropy essays. *Cybernetic serendipity* (ed Reichardt, J.), 58–62. London: W. & J. Mackay.

Milic, L.T. (1971a) *The 'returner' poetry program*. Mimeograph, Cleveland State University.

Milic, L.T. (1971b) The possible usefulness of poetry generation. *The computer in literary and linguistic research* (ed Wisbey, R.A.), 169–82. Cambridge: Cambridge University Press.

Milic, L.T. (1972) *Erato*. Cleveland: Cleveland State University.

Morris, J. (1967) How to write poems with a computer. *Michigan Quarterly Review*, **6**, 17–20.

Nemerov, H. (1966–67) Speculative equations: Poems, poets, computers. *American Scholar*, **36**, 395–414.

Peterson, E. (1971) *Tristan Tzara: Dada and surrational theorist*. New Brunswick: Rutgers University Press.

Poggioli, R. ([1962] 1968) *The theory of the avant-garde* (tr. Fitzgerald, G.). Cambridge, Mass.: The Belknap Press of Harvard University Press.

Scott, R.I. (1969) The mechanical bard: Computer-composed parodies of modern poetry. *West Coast Review*, **4**, i, 11–15.

Shea, D. (1968) Poetry by computer. *Avant-Garde* (September), 30–31.

Shirley, R. (1972) Poet and program. *Bulletin of the Computer Arts Society*, **25**, 11.

Stevens, P. & Scott, R.I. (1970) Mindlessly mass-producing poetry by computer, or a multiple-version poem for all Canadian places and seasons? *University of Windsor Review*, **5**, ii, 27–34.

Swift, J. ([1726] 1960) Gulliver's travels. *Gulliver's travels and other writings* (ed Landa, L.A.), 1–239. Cambridge, Mass.: The Riverside Press.

Wheatley, J. (1965) The computer as poet. *Queen's Quarterly*, **72**, 105–20.

Worthy, R.M. (1962) A new American poet speaks: The works of A[uto] B[eatnik]. *Horizon*, **4**, iii, 96–9.

H. KAWANO
Randomly-generated graphics produced on an I B M 360

RUTH LEAVITT
Computer graphics

Graphics produced with light-pen input and
CalComp output.
Facing. Variations on a herringbone stretch,
programmed in FORTRAN IV with CalComp output.

A. LAYZER
Textured animated poetry and the film Morning Elevator

Three frames from *Morning Elevator*, a 16 mm
computer-generated film with computer-generated
sound track by the author. The program to effect the
word texturing was written in FORTRAN, and the
musical setting was prepared with the aid of Bell
Laboratories MUSIC V synthesis program.

D. DONOHUE and J. SKELTON
SPLAT: *a computer language for artists*

Sample of work produced using SPLAT (Simplified
Programming Language for Artists). The SPLAT
compiler is written in ALGOL for a Burroughs B6700
system, and the output medium is a CalComp plotter.

List of Participants

Akehurst, R., French and Italian, University of Minnesota, Minneapolis
Allen, J. R., Romance Languages, University of Manitoba, Winnipeg
Armstrong, Christine, Medical Research Council Speech and Communication
 Unit, University of Edinburgh
Bailey, R. W., English, University of Michigan, Ann Arbor. Session Leader
Baillie, W. M., English, Ohio State University, Columbus
Beebe, R., Linguistics, Monash University, Clayton, Australia
Bender, T. K., English, University of Wisconsin, Madison
Berry-Rogghe, Godelieve, L. M., Atlas Computer Laboratory, Chilton,
 Didcot, Berkshire
Bhatia, T. K., Linguistics, University of Illinois, Urbana
Bratley, P., Informatique, University of Montreal. Session Leader
Brewer, R. K., Computer Science, Kansas State University, Manhattan
Chen, S-C., Computer Systems Laboratory, Washington University, St Louis
Chuang, H. Y. H., Computer Science, University of Pittsburgh, Pennyslvania
Cole, W. P., formerly Keeper, Catalog of American Portraits, Smithsonian
 Institution, National Portrait Gallery, Washington D C. Now Technical
 Information Manager, Office of Archaeology and Historical Preservation,
 National Park Service, Washington DC
Cowles, Kathleen, University of Massachusetts
Davenport, O., Computer Science, Jackson State College, Mississippi
Dilligan, R., English, University of Southern California, Los Angeles.
 Session leader.
Dixon, J. E. G., French, University of Winnipeg
Donohue, D., Mathematics, University of Denver, Colorado
Donohue, J., English, University of Massachusetts, Amherst
Ducretet, Marie-Paule, French, Erindale College, University of Toronto,
 Clarkson, Ontario
Ducretet, P., French, University College, University of Toronto
Fifield, M., English, Ball State University, Muncie, Indiana
Fink, J., English, Rhode Island College, Providence
Finkenstaedt, T., University of Augsburg, Germany
Fisher, D. D., Head, Computing and Information Science,
 Oklahoma State University, Stillwater
Follett, B., English, Dartmouth College, Hanover, New Hampshire
Fortier, P., Romance Languages, University of Manitoba, Winnipeg
Frautschi, R. L., Head, French, Pennsylvania State University,
 University Park
Fujimura, O., University of Tokyo
Gale, S., Geography, Northwestern University, Evanston, Illinois
Gilbert, Penny, Romance Languages, University of Manitoba, Winnipeg
Goldstein, E. M., Faculty of Education, University of Ottawa
Hanson, A., Computer Science, University of Minnesota, Minneapolis.
 Session leader.

Harmatiuk, Sandra, English, University of Notre Dame, Indiana
Harshman, R., University of California, Los Angeles
Hashimoto, S., 2–28–2 Komazawa, Setagaya-Ku, Tokyo
Hawk, L., English, University of Southern California, Los Angeles
Hefferlin, R., Head, Physics, Southern Missionary College, Collegedale, Tennessee
Hertlein, Grace, Computer Science, California State University, Chico. Session leader.
Holloway, W. W., Computer Science, Worcester Polytechnic Institute, Massachusetts
Houck, C. L., English, Ball State University, Muncie, Indiana
Hofstetter, F. T., School of Music, Ohio State University, Columbus
Hutchins, J., Anthropology, California State University, Sacramento
Hutchinson, L., Linguistics, University of Minnesota, Minneapolis
Jacobson, Sibyl, English, University of Jyväskylä, Finland
Jones, Elizabeth, P., Computer Center, Clemson University, South Carolina
Jordan, Sara R., Computer Science, University of Tennessee, Knoxville
Jory, E. J., Classics and Ancient History, University of Western Australia, Nelands
Josephs, E., Univac Park, St Paul, Minnesota
Kahn, E., English, University of California, Berkeley
Kawano, H., Metropolitan College of Technology, Tokyo
Klein, S., Computer Science, University of Wisconsin, Madison
Kline, E., English, University of Notre Dame, Indiana
Koubourlis, D. J., Russian, Editor of Language Series, University of Idaho, Moscow
Laffal, J., Director, Research and Psychological Services, Connecticut Valley Hospital, Middletown
Lambert, R. S., History, Clemson University, South Carolina
Langenbruch, T., Modern Languages, Georgia Institute of Technology, Atlanta
Lansdown, J., Computer Arts Society, London
Laske, O. E., Institute for Sonology, Utrecht State University, Holland
Laurette, P., French, Carleton University, Ottawa
Layzer, A., Physics, Stevens Institute of Technology, Hoboken, New Jersey
Leavitt, J., Computer Science, University of Minnesota, Minneapolis. Session leader.
Leavitt, Ruth, 5315 Dupont Ave S, Minneapolis
Legendre, L., Institute National de la Recherche Scientifique, Quebec
Lieberman, D., Computer Science, Queens College, Flushing, New York
Lieberman, R. K., History, LaGuardia Community College, Long Island City, New York
Locke, D., Humanities, Illinois Institute of Technology, Chicago
Lusignan, S., Informatique, University of Montreal
McConnell, J. C., Computer Center, University of Manitoba
MacDonald, R. A., Modern Foreign Languages, University of Richmond, Virginia
MacFadden, F. R., English, Coppin State College, Baltimore, Maryland
Marchand, J. W., Germanic Languages and Literatures, University of Illinois, Urbana. Session leader.
Martindale, C., Psychology, University of Maine, Orono
Maxwell, E. R., Linguistics, Northeastern Illinois University, Chicago
Menon, K. P. S., Health Computer Sciences, University of Minnesota, Minneapolis

Mitchell, J. L., English, University of Minnesota, Minneapolis.
 Session leader, editor.
Modena, J., English, Ball State University, Muncie, Indiana
Morris, J., Pattern Analysis and Recognition Corporation, Rome, New York
Morton, I. A., 1500 Goodrich Ave, St Paul, Minnesota. Session leader.
Munnich, U., German and Russian, Michigan State University, East Lansing
Neglia, V., Watchum Systems, University of Waterloo, Ontario
Nelson, G., Creative Arts, Division of Music History, Purdue University,
 West Lafayette, Indiana
Neuhaus, H. J., Englisches Seminar, Westfälische Wilhelms-Universität,
 Germany
Oakman, R. L., English, University of South Carolina, Columbia
Oliver, J. B., University of Southwestern Louisiana, Lafayette
Ouellette, Francine, Centre de Calcul, University of Montreal
Parins, J. G., English, University of Arkansas, Fayetteville
Peavler, J. M., English, Northern Illinois University, De Kalb
Pepyne, E., Director, Division of School Services, University of Hartford,
 Connecticut
Piper, J. R. I., Medical Research Council Speech and Communication Unit,
 University of Edinburgh
Pritchard, J. Diane, Computer Science, Worcester Polytechnic Institute,
 Massachusetts
Rasche, R., Economics, Michigan State University, East Lansing
Raskin, J., University of California, San Diego, La Jolla
Ray, J., Computer Center, University of Nebraska, Omaha
Rayapati, J. P. R., English, Cheyney State College, Pennsylvania
Reel, J. V., History, Clemson University, South Carolina
Rosenberg, B. A., English, Pennsylvania State University, University Park
Ross, D., English, University of Minnesota, Minneapolis
Roy, G. R., English, University of South Carolina, Columbia
Salem, André, Engineer-Statistician, University de Nancy II, France
Sankoff, David, Centre de Recherches Mathematiques,
 University of Montreal
Sapora, R. W., English, Western Maryland College, Westminster
Schneider, Jr, B. R., English, Lawrence University, Appleton, Wisconsin
Sedelow, Sally, Computer Science, University of Kansas, Lawrence
Seidel, Gillian, Centre for Contemporary European Studies,
 University of Sussex, Brighton
Sherman, D., Linguistics, University of California, Berkeley
Skelton, J., Mathematics, University of Denver, Colorado
Smith, D., Linguistics, University of Georgia, Athens
Smith, J., English, Pennyslvania State University, University Park
Smith, R. N., Linguistics, Northwestern University, Evanston, Illinois
Sondak, Norman, Head, Computer Science, Worcester Polytechnic Institute,
 Massachusetts
Spevack, M., Englisches Seminar, Westfälische Wilhelms-Universität,
 Germany
Spolsky, B., Linguistics, University of New Mexico, Albuquerque
Spolsky, Ellen, English, University of New Mexico, Albuquerque
Stewart, A., Humanities, Illinois Institute of Technology, Chicago
Su, K. L., School of Electrical Engineering, Georgia Institute of Technology,
 Atlanta
Suchoff, B., Director, Special Collections, Center for Contemporary Arts
 and Letters, State University of New York, Stony Brook

21

Swigger, K., American Civilization, University of Iowa, Iowa City
Takefuta, Y., Speech Communication, Ohio State University, Columbus
Taylor, R. F., Music, Paul Creative Arts Center, University of New
 Hampshire, Durham
Tepaske, J. T., History, Duke University, Durham, North Carolina
Terbeek, D., Linguistics, University of Chicago, Illinois
Thill, R., Head, German Section, University of Nebraska, Omaha
Tilley, E. A., English, State University of Arkansas
Vines, R. F., Modern Languages, Ohio University, Athens
Waldo, T. R., English, University of Florida, Gainesville
Wang, W. S-Y., Linguistics, University of California, Berkeley
Way, Florine, Dovack Consulting Services, Tallahassee, Florida
Weil, G., Chef de Section Biblique, Inst. de Recherche et d'Histoire des
 Textes, University de Nancy II, France
Wenker, J., Sperry-Univac, Pascatawny, New Jersey
Wesselius, Jacqueline, Ecole Pratique des Hautes Etudes, Paris
Whitney, T. G., Consultant, Computer Center, Ohio State University,
 Columbus
Wittlich, G. E., Music, Indiana University, Bloomington
Wood, C., German, University of Minnesota, Minneapolis
Wood, G. R., English, Southern Illinois University, Edwardsville
Wright, N. B., English, University of Iowa, Iowa City
Wyatt, J. L., Foreign Languages and Linguistics, University of Texas,
 Arlington
Zarri, G. P., Centro di Cibernetica and di Attivita Linguistiche, University
 of Milan, Italy
Zoller, P. T., English, Wichita State University, Kansas

Other session leaders:
Alkon, P., English, University of Minnesota
Clayton, T., English, University of Minnesota
Francis, W. N., Linguistics, Brown University
Friedman, Joyce, Computer Science, University of Michigan Chair, SIG
 for Language Analysis and Studies in the Humanities, ACM
Hacker, D., English, University of Minnesota
Hancher, M., English, University of Minnesota. Editor, *Centrum*
 (Working Papers of the Minnesota Center)
Kumar, K. P. S., Electrical Engineering, University of Minnesota
MacLeish, A., English, University of Minnesota
Madden, W., Chairman, English, University of Minnesota
Maly, K., Computer Sciences, University of Minnesota
Meyers, L., San Francisco State College
Modell, J., History, University of Minnesota
Nachtscheim, S., Humanities Consultant, University of Minnesota
 Computer Center
Patton, P., Director, University of Minnesota Computer Center
Raben, J., English, Queens College, City University of New York.
 Editor, *Computers and the Humanities*
Stenberg, W., Mathematics, University of Minnesota
Swanson, D., Classics, University of Minnesota
Wilks, Y., Computer Science, Stanford University Artificial
 Intelligence Project

Index